EXPERIENCE

This book was supported by the MIT Center for Art, Science & Technology, which is funded in part by the Andrew W. Mellon Foundation, and by a contribution from the Council for the Arts at MIT.

© The contributors, 2016

All rights reserved. No part of this book may be reproduced in any form by any electronic or mechanical means (including photocopying, recording, or information storage and retrieval) without permission in writing from the publisher.

Additional copyright credits are found on pages 349–51.

Distributed by the MIT Press
Massachusetts Institute of Technology
Cambridge, Massachusetts 02142
http://mitpress.mit.edu

Library of Congress Control Number: 2016930590

ISBN 978-0-262-03514-9

10 9 8 7 6 5 4 3 2 1

This book was set in ITC Cheltenham, Graphik, Lydia Condensed, and Berthold Akzidenz Grotesk, and was printed and bound in China.

Design: Kimberly Varella with Becca Lofchie, Content Object Design Studio

Cover
Olafur Eliasson
See-through compass, 2015
Heat sensitive ink on printed graphic and text substrate

Endpapers
Carsten Höller
Smelling Zöllner Stripes, 2015
Paper, ink, Estratetraenol (front) or Androstadienone (back), silicon dioxide, dimensions variable

Page Edges
Tauba Auerbach
Gradient Flip, 2015
Ink on paper

EXPERIENCE

Culture, Cognition and the Common Sense

Jones, Mather, Uchill, Eds.

Distributed by the MIT Press
Cambridge, Massachusetts
London, England

SEE-THROUGH COMPASS Olafur Eliasson . cover
SMELLING ZÖLLNER STRIPES Carsten Höller endpapers
GRADIENT FLIP Tauba Auerbach . page edges
FOREWORD Leila W. Kinney . 6
PREFACE Editors . 8

I. OPENING

MODELING Caroline A. Jones . 13
MEDIATING Rebecca Uchill . 35
ANALOGIES David Mather . 57

II. SEEING

AMPHIBIAN Tauba Auerbach . 75
PROCESSING Bevil R. Conway . 87
MATHEMATIZING Alma Steingart . 111
MORALIZING Michael Rossi . 119

III. SOUNDING

CLOSED BOOK Alvin Lucier . 129
I AM SITTING IN A ROOM Alvin Lucier . 130
MUSIC FOR SOLO PERFORMER Alvin Lucier 133
RESONANCE Alvin Lucier / Brian Kane . 134
FEELING Adam Frank . 143
MODULATION Mara Mills . 151
TRANSDUCING Stefan Helmreich . 163

IV. SENSING

ACTIONS Tomás Saraceno 171

SOCIAL STRINGS Tomás Saraceno 174

INTUITING Josh Tenenbaum 187

TRACKING Natasha Schüll 195

SELF OF SENSE Leah Kelly 205

LIGHTNING Douglas Kahn 215

UNDERSTANDING Alva Noë 225

V. EXPERIENCING

ON EXPERIENCE Tino Sehgal / Arno Raffeiner 233

BODILY FRAMING Vittorio Gallese 237

"CONSCIOUSNESS" William James 249

VISUAL AND TACTUAL Edmund Husserl 263

HAVING AN EXPERIENCE John Dewey 269

EXPERIENCE PROCESS: SPACE POEMS Renée Green 277

EXPERIENCE BOOK Michel Foucault / Duccio Trombadori 289

HISTORICIZING EXPERIENCE Joan W. Scott 295

AISTHESIS Jacques Rancière 309

SENSITIZING Bruno Latour 315

WAITING FOR GAÏA Bruno Latour 325

INDEX .. 341

CREDITS .. 349

FOREWORD

Experience: Culture, Cognition, and the Common Sense is the first full-length publication sponsored by the MIT Center for Art, Science & Technology (CAST). The center's mission is to create new opportunities for art, science, and technology to thrive as interrelated, mutually informing modes of exploration, knowledge, and discovery. From the beginning, we envisioned CAST to be a multidisciplinary platform, where many kinds of creators and thinkers could meet as equal partners and could learn from what might occasionally be a disorienting but nonetheless beneficial synergy. We have functioned at times as a presenting organization for MIT and its visiting performing and visual artists, as a research unit working with science and engineering labs, as a fabrication space through art and design studios, and as a sponsor of symposia, classes, workshops, and lectures.

The inaugural CAST symposium in fall 2014, titled "Seeing/Sounding/Sensing," was one of the most exciting and productive of these activities. Bringing together artists, scientists, philosophers, and scholars in the humanities, the event convened a common discussion on visual, aural, and sensory-motor faculties, broadly conceived, with the intention of purposefully blurring boundaries between disciplines and breaking out of the usual certainties about knowledge production. A particularly notable juxtaposition occurred in the "Sounding / Resonance" session. MIT cognitive scientist Josh McDermott explained his lab's attempts to grapple with some of the "ill-posed" problems involved in analyzing auditory reception, including experiments that isolate how sound waves interact with room acoustics before entering the ear, the very phenomenon that the composer Alvin Lucier exploits in *I Am Sitting in a Room* (1969). The session served as a provocative introduction to Lucier's performance of this piece, which, in a historical echo-effect fitting for the occasion, was directly inspired by pioneering work at MIT by the late Professor Amar Bose, an acoustic engineer.

Two MIT faculty with outstanding talents for lateral thinking and bridge-building among disciplines, art historian Caroline A. Jones, and anthropologist Stefan Helmreich, provided intellectual vision for this event, along with David Mather, who was the Center's Andrew W. Mellon Foundation postdoctoral fellow at the time. We are enormously grateful for their collaboration and leadership.

Caroline A. Jones, David Mather, and the current Mellon postdoctoral fellow Rebecca Uchill have extended the momentum of the symposium by assembling this ambitious and inventive book. The expanded rubric for the book is "experience"—so crucial to philosophies of mind historically, so fundamental to the operations of art, and so provocative for contemporary neuroscience. Like CAST itself, "experience" invites cross-modal thinking and interdisciplinary conversation.

The editors are primed for this conversation. All art historians, they bring various research interests to the project at hand. A scholar of museums as sites for understanding the intersections of subjectivity and *Erlebnis* in Weimar Germany, Rebecca Uchill is also currently active as co-curator of "Experience Economies," a lively forum for interdisciplinary discussions on art, culture, and the marketing of experience. David Mather curated sound and media installations in Los Angeles prior to receiving a Getty postdoctoral fellowship for his work on color and motion in Italian Futurism. Caroline A. Jones, who has a longstanding interest in art and science, has written extensively about the continually evolving interaction between these domains and

contemporary artists who cross between them. As editor of *Sensorium: Embodied Experience, Technology, and Contemporary Art* (2006), she used the ancient format of the abecedarius to collaborate with numerous thinkers to present an array of relationships between the human body and technology, in conjunction with the exhibition by that name at the MIT List Visual Arts Center. It is therefore no surprise that she and her coeditors have created a hybrid format for this publication.

Experience is not a conventional academic book. The volume aims to *produce* experience through a variety of innovative designs that rethink the familiar form of the codex. It restages encounters with histories of sensory mediation and theories of experience through essays from humanists, papers by neuroscientists, ingeniously designed pages by artists, and a rich set of dialogues, conversations, and transcripts that convey a vibrancy appropriate for the topic; we might call the collection as a whole a collective experiment in speculative aesthetics. As the preface makes clear, these speculations are motivated by deep concerns for how we might make a common sense around crucial social and environmental issues. We deeply appreciate the imaginative approach adopted by the editors and the inspired individuals whose contributions make up the final volume.

Many voices inform this collection, and many individuals have made possible its realization. The Executive Committee of the Council for the Arts at MIT provided generous funding for the production of the book. We owe special thanks to Council members Rick and Terry Stone and to Susan Poduska, whose efforts made possible this support. We extend our warm gratitude to the Council for their embrace of this inaugural CAST publication. Roger Conover, Executive Editor at the MIT Press, provided important advice about the pragmatics of the book, and support for its distribution. The book also benefitted tremendously from the enthusiasm and dedication of project manager Sharon Lacey, especially in the book's final stages. Let me express my heartfelt thanks to Sharon and to reproductions manager Sydney Dobkin for their crucial work on the project.

Philip S. Khoury, Associate Provost with responsibility for the arts; Adèle Naudé Santos, former Dean of the School of Architecture and Planning; and Deborah K. Fitzgerald, former Kenan Sahin Dean of the School of Humanities, Arts, and Social Sciences, endorsed the establishment of CAST and have helped it flourish. Hashim Sarkis, Dean of the School of Architecture and Planning, and Melissa Nobles, Dean of the School of Humanities, Arts, and Social Sciences, have continued this exemplary support, for which we are extremely grateful. The center is funded in part by a generous grant from the Andrew W. Mellon Foundation, and we owe special acknowledgement to the foundation's Vice President Mariët Westermann, who has been a supportive partner in CAST's growth and success.

We hope this book is the beginning of a lively and ongoing set of experiences stimulated by the MIT Center for Art, Science & Technology.

— LEILA W. KINNEY
Executive Director of Arts Initiatives,
and Executive Director, CAST

PREFACE

Experience is perpetually on the move. Across cultural and historical contexts, it both happens to us and is actively theorized according to a combination of solid research, operative assumptions, and shifting cultural affinities. The concept of experience, as well as the visceral term anchoring it, have resonant force—calling up complex formulations of individual psychology, life history, the sensorial spectrum, societal norms, technological filtering, and shifting historical epistemes. For the editors of this volume, it also indicates a central problematic: If we can only know reality through our experience, how should we understand the production of experience itself? In crafting this book as a collection of voices responding to this question, we aim to engage familiar and abstruse concepts of experience as specifically material endeavors, in history, and at present.

We use three additional terms in our subtitle. *Culture* signals our commitment to framing experience as a category of aliveness whose phenomena always emerge within specific cultural environments—including a bacteria's ambient soup, a spider's resonant communication across a web, or a human's visual, musical, or olfactory composition. To use this term is also to acknowledge what human society does to make itself present to itself (and to other societies), in turn reorganizing it for further experience. Despite an editorial preference for creative and art-making practices, this book also includes the cultures of anthropology, philosophy, and neuroscience. We appreciate that culture, in whatever form or context it appears, transpires at the intersection of numerous shared conditions that might be material, conceptual, economic, and sociohistorical; it is constructed and constructive.

Cognition signifies the durational processes of neuronal signaling and other activities through which humans and other creatures sense their environments and internal states, interpret sensory signals, act upon them, and feel the reverberations of those actions. This category connotes the experience of being alive. For the contemporary neuroscientists generous enough to think with us in this volume, as well as the historical philosophers and psychologists gathered in these pages, cognition implies a degree of plasticity for human psychophysical processes; in this sense, it can be as active and adaptable as consciousness itself.

Our inclusion of *the common sense* (with an assertively definite article added to *sensus communis*) suggests that culture and cognition are two productive forces within a wider field of shared experience. Whether merely imagined or desired, *the* common sense is an urgent contemporary problematic, perhaps more aspirational than actual. How can we make common goals and understandings from our individual experiences of reality? We approach cognition and culture as mutually dependent and complexly interwoven categories that not only condition thought-as-experience, but also extend beyond that Kantian sense of a transcendental, reasoning individual in order to manifest the active, social processes of our thinking together. An interest in locating experiences of commonality—and difference—has propelled this book's production.

This project was inspired by a two-day symposium sponsored by the Center for Art, Science & Technology (CAST) at MIT in September 2014. Many of those participants graciously agreed to continue those conversations here. We have expanded well beyond the symposium remit, however, to enrich the discourse with a selection

of new and historical contributions that traverse some of the vast territories of experience. The section titles reflect an overall transformation from a one-time event to a polyvocal, multifaceted object. "Opening" contains three original introductory essays (one by each of us) to introduce the central concerns of the book. It is no coincidence that each essay focuses on the historical modalities of experience activated by artists and scientists working from 1900 to 1945—an epoch of unparalleled technological change and radical cultural experimentation that marks both how experience is understood by contemporary humans and how we have become subjects of the contemporary as a result of such experiments. The three middle sections ("Seeing," "Sounding," and "Sensing") refer to the 2014 symposium and continue the spirit of that event by combining artistic contributions with further scientific and humanities-based research. The final section, "Experiencing," incorporates foundational excerpts and artists' responses, which underscore culture, cognition, and the challenge of forming sensory knowledge in common. We intend this multivalent collection of texts, images, and conceptual projects to offer a way of approaching how different disciplines might inform and learn from each other.

Experience would not have been possible without the unwavering support of CAST, led by Executive Director Leila W. Kinney, along with the guidance of Professors Philip S. Khoury and Evan Ziporyn. Invaluable assistance was provided by a number of CAST associates: Sharon Lacey for project management, Sydney Dobkin for image research and permissions, Heidi Erickson for in-house design work, as well as general support from Stacy Pyron DeBartolo, Katherine Higgins, and Dain Goding. We also appreciate Kathaleen Brearley and Anne Deveau in the History, Theory, and Criticism section of the Department of Architecture for making the two postdoctoral fellowships associated with this project collegial and welcoming.

We are grateful to a number of friends and colleagues whose consultation and expertise helped to make the contributions to this book possible: Frédérique Aït-Touati, Javier Anguera, Stefano Arrighi, Jeremy Blatter, Han Kyoung Choe, Elizabeth Coffey, Chelsea Deklotz, Russell Douglas, Geoffrey Garrison, Luca Girardini, Claire Golomb, Stefanie Hessler, Victoria Hindley, Pamela Horn, Mark Jarzombek, Forrest Larson, Anna-Maria Meister, Ignas Petronis, Kathryn Politis, Stanley So, Dan Streible, Sissel Tolaas, Jordon Troeller, Jim Zhao, and Xiaorui Zhu-Nowell. Tremendous thanks are due to Roger Conover and Jason Kehoe at the MIT Press for their consultation on the production of this volume, to Amy Techner for reading with us across a range of disciplinary voices and conventions, and to Joyce Goldenstern for indexing the vast terrain of *Experience*. Finally, we thank our visionary collaborator Kimberly Varella of Content Object Design Studio, whose thoughtful interpretation of our content, and expertise in the art of book production, has made the object *Experience* what it is.

In the conceptualization, research, planning, design, and printing of this publication, experience has, for us, become an open-ended imperative we now present to you: Go ahead.

— CAROLINE A. JONES, DAVID MATHER
 & REBECCA UCHILL

I.

OPENING

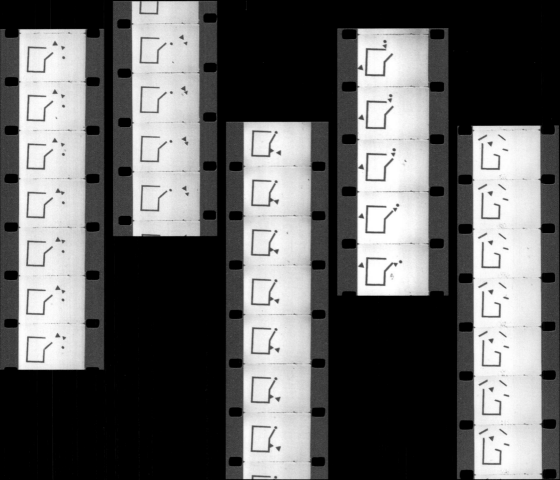

MODELING
Caroline A. Jones

Let us begin with an artifact: a 16-millimeter movie from 1943. It appears to be an "experimental film," since each frame contains nothing more than geometric shapes in black on white. To capture something of the experience it was intended to provide, we need to imagine a darkened room, and a rectangle of light beaming through the celluloid ("Perutz Nonflammable," to be exact).[1] The projected image shows an outline of a rectangle with an opening on its right side; near this opening the shape of a triangle arrives. (FIG. 1) Soon a smaller triangle and a circular disk also enter the frame from above. The rectangle remains static, but the disk and triangles become quite literally animated, and each moves in a manner that comes to seem *characteristic*. That is, they are given movements that model different characters. A few moments into the film, for example, the small triangle moves next to the large triangle, and executes a series of emphatic "touches." The larger triangle also moves, but more slowly; it seems heavier and more deliberate. How these movements come to be interpreted by human viewers—and how context affects those interpretations—are questions that introduce this essay's theme of modeling. Varieties of modeling sharpen the interdisciplinary motivations for this book: How, and how differently, do art and science model experience? Models, I submit, make of experience a common sense.

The model movements in this particular animated film were constructed using a fixed film camera that was aimed at a glass on which the filmmakers had arranged cardboard shapes (the small and large triangles, the disk, the static rectangle) for frame-by-frame exposure.[2] In the sequence I described above, the small triangle's first "touch" is separated from the second by eight frames, but then only five frames go by before a third touch occurs. The third touch segues to a fourth in only six frames. (Remember that it takes 24 frames to constitute a single second in conventional film projection.) It is through these minute, frame-by-frame differentials that the filmmakers model the rapid oscillations characteristic of small, vivid creatures. As executed by the smaller triangle on the "body" of the momentarily static larger triangle, the movements are experienced by viewers as playful and largely harmless ("spirited, cocky, snappy").[3] Movements plotted for the larger triangle are as many as 48 frames apart (taking two seconds instead of multiple touches

FIGURE 1
Selected frames from the 16mm film by Fritz Heider and Marianne Simmel, completed in 1943, sometimes known as "Perception of Geometrical Figures." Sequences are animated as follows: (1) little triangle touches big Triangle (4 or 5 frames); (2) big Triangle touches little triangle (from 19 to 48 frames); (3) big Triangle "corners" little triangle; (4) little triangle and disk prepare to leave the frame; (5) big Triangle, now alone, "breaks" the rectangular shape.

1
Based on original prints now housed at the Harvard Film Archive, the stock is a European product: Perutz Nonflammable.
2
"We had cardboard figures for our three characters and the room, and we placed them on a sheet of glass, on which the camera was focused from below." Fritz Heider, *The Life of a Psychologist: An Autobiography* (Lawrence: University Press of Kansas, 1983), 148.
3
Fritz Heider and Marianne Simmel, "An Experimental Study of Apparent Behavior," *American Journal of Psychology* 57, no. 2 (April 1944): 243–59; quote from page 249.

[4] These phrases come from two different subjects' descriptions. Ibid., 246–47.

[5] Ibid., 244.

[6] Ibid.

in less than one). They are correspondingly experienced quite differently from the small triangle's quicker pace—viewers in 1943 described these movements as heavy, aggressive, even violent.

Such minimal descriptions of the first few seconds of this three-minute film convey little of the viewing context, which was a psychology laboratory at Smith College in Northampton, Massachusetts, during World War II. Nor does the foregoing suggest the richness of the experience that bloomed in viewers, most of whom produced robust narratives when prompted by the experimenters to describe what they saw: "A man has planned to meet a girl and the girl comes along with another man." Or, "the two innocent young things walk in. Lovers in the two-dimensional world"—"maybe the big bully said some bad word."[4] The spare geometric forms in black and white, through the simple magic of their carefully plotted movements, model for human observers a full set of behaviors, emotions, and moral outcomes. If the film were understood as an art production, its abstract modeling would be assigned to the intention of an artist. But as part of an experimental protocol, the abstract model is presumed to be devoid of content. At least, this is what the filmmakers—Fritz Heider and Marianne Simmel—report. They produced a kind of neutrality, they explained, by eliminating cinema's historical obsession, the human figure: "We have presented situations and activities without the face."[5] They designed their experiment to specify which components of a perceptive field would yield invariant attributions by respondents, and which kinds of movements would stimulate which kinds of causal interpretations, revealing "the dependence of the response on stimulus-configurations."[6] For the purposes of this essay, the 1943 "Heider-Simmel" film (which went by many titles in the decades after its making, from *Perception of Geometrical Figures* to *Warring Triangles*) will be taken to exemplify a range of affective, social, historical, scientific, and aesthetic models appropriate to midcentury views of experience and cognition. The surviving artifact, with its black shapes on transparent, yellowing celluloid, will be parsed as signs of many other forces, from cultural views of democracy to the aesthetics of empathy to the intuitive physics and intuitive psychology of interest to neuroscientists today.

Physics and psychology both have an interest in the "nervous system," a loose name for the physical infrastructure that enables those cognitive and unconscious functions that many of the authors and artists in this book are attempting to understand, stimulate, or model. On the one hand, the word "system" reveals this model to be a conceptual heuristic. On the other hand, even heuristic models drive practitioners to seek evidence in the body itself. When anatomist Rufus Benjamin Weaver of the Hahnemann Medical College in Philadelphia pledged to dissect the *entire human nervous system* in 1888, he did so with the confidence of a positivist, imagining that if he could painstakingly follow each nerve out of the brain of a single individual, the assembled map would tell the whole story.

I. OPENING

Modeling

7
The gaps between neurons, called synapses, were intuited by Cajal but could not be photographed until 1954, when they were finally seen in electron microscopy.

When his university's former cleaning woman Harriet Cole left her body to the college in her will, Weaver seized the opportunity: splaying her nerves out carefully, one by one, he mapped her paths for initiating action, summoning consciousness, and sensing the world. Cole's selfless act, anticipating her death of tuberculosis at age 35, facilitated Weaver's astonishing feat. Over several months, the anatomist preserved the undissected parts of her body in alcohol, while coating each excavated nerve one by one with white lead. Pinning the preserved and hardened nerves to a support, and providing glass eyes to complete the model, Weaver felt he had nailed the case: nerves formed a continuous, self-sufficient system, monitored by a brain, in which vision ruled the roost. Yet soon after Weaver finished his triumphant anatomical display, future Nobel prizewinner Santiago Ramón y Cajal argued that nerves were independent units. Unlike the circulatory system, they were not "tubes" that needed to be connected to function. They had *contiguity without continuity*, somehow functioning as separate cells, isolated one from the other by spaces (nervously dubbed "synapses," from the Greek "to join together," as if by so-naming these voids it would model a reassuring *something* in between).[7] If Camillo Golgi countered that the nerves formed a reticulated meshwork, a *system*, Cajal would just as fervently point to his slides of stained tissues: nerves were absolutely autonomous, clearly independent one from the other. What bridged the gap?

Between the arguments of anatomists at the cellular level and the mysteries of consciousness at the cultural level yawned an even greater gap, ceaselessly probed in the century since the Golgi-Cajal debates, and still motivating neuroscience today. Neuroscience is a cluster of disciplines, plied by trained psychologists, biologists, physicists, neurologists, computer scientists, engineers, and others. It is a dynamic domain that has gone on since Golgi to identify chemical signaling between neuron cells (the basis for most psychopharmaceuticals), varying electromagnetic brainwaves (alpha, beta), the metaphor of the electrical "spark" bridging the axon at one end of a cell and the dendrite extending toward it from another. Since the 1980s, all these complex models have been dominated by one master narrative: the computer. In that sense, Weaver's scary and hilarious image of a preserved human nervous system remains a potent analogue: the giant processor holds the "motherboard," which drives signals down wires as "output," while other wires carry information from the periphery as "input"—signals that need merely to be held intact until they can be conveyed back to the mainframe for processing.

This book exists to complicate that model. Experience is our heuristic, and we intend both to provoke experiences in these pages, and to examine how culture and technology deeply weave the texture of human consciousness. As art historians, we are particularly concerned to make space for art in these discussions—art as a

8 Anonymous, "Harriet Cole: Drexel's Longest-Serving Employee," July 19, 2012, online at http://www.drexel.edu/now/archive/2012/July/Harriet/.

9 Madison Bentley, editor of *The American Journal of Psychology* (Cornell University), letter to Fritz Heider, January 13, 1944, Heider Papers, box 28, folder 32, professional papers, 1944, Kenneth Spencer Research Library, University of Kansas, Lawrence.

10 Heider and Simmel, "An Experimental Study," 246, 252.

11 This mirroring relation suggests psychoanalytic theorist Jacques Lacan's interpretation of the viewer's relation to the screen of projection, associated in his writing with the "mirror phase." For a useful gloss see Juliet Mitchell and Jacqueline Rose, eds., *Feminine Sexuality: Jacques Lacan and the école freudienne* (New York: Pantheon Books, 1985).

12 Andras Angyal, MD, of Worcester State Hospital, letter to Fritz Heider, February 2, 1945. Fritz Heider Papers, box 28, folder 34, professional papers, 1945. Dr. Angyal suggested the film could be used as an "addition to the existing projective techniques," imagining it would be diagnostic of rigidity in psychopaths, for example.

culturally produced modality for instigating special kinds of experiences that both stretch cognition and model it.

As for Weaver's specimen, it can serve as a cautionary emblem of the overweening confidence that sometimes overtakes us: We've figured out where consciousness is! We know how it operates! In its day, Weaver's model was so impressive that it won him the Premium Scientific Award at the 1893 World's Columbian Exposition in Chicago. Used for teaching at his home institution in Philadelphia for decades, the physical specimen served as the basis for the black-and-white illustration he copyrighted in 1888, its digital ghost now haunting the internet. (FIG. 2) The university caretakers of what's left of Harriet Cole no longer think of her preserved nerves as useful for science; they describe the display as "more like a piece of art."[8] Of that historical distinction, much can be made.

Heider and Simmel's experimental film also oscillates between science and art, drawing considerably on art to produce its science. As art, the film's modeling of emotions would have been fully expected, put there through the deliberate aesthetic choices of a human maker, possibly accompanied by evocative music. But as a psychology experiment, the silent film is merely a configured stimulus, read as intentionally empty to confound obvious interpretation. In fact, the editor who agreed to publish Heider and Simmel's paper was concerned about the number of cognitive operations they were collapsing in their account: "You have used the term 'perception' in the traditional sense to cover everything which follows the exposure of a set of receptors to stimulation." He went on to suggest that their subjects "obviously employed a number of the psychological operations beyond perceiving," among them "imagining, inspecting and comprehending."[9] These gerunds label the processing of experience, which was precisely what Heider and Simmel set out to test. Do the triangles "possess" different characters? Or does the modeling of these shapes' characteristic behaviors happen only in perception? The viewer perceives, inspects, then comes to a conclusion about the moving shapes she sees—but is that conclusion "imagined," or is it a truth that preexists the viewer, finally "comprehended" by the one who sees the film? In our ongoing experience of the world, how do we test what we *imagine* to be the case, in order to *comprehend* which models might contribute to a common sense?

For these scientific psychologists practicing during the Second World War, the essential model unifying "perceiving, imagining, inspecting and comprehending" was *projection*. Projection is the psychological term for what humans imagine to be the case, when they possess insufficient information to confirm it. This is a surprisingly common situation—we rarely know what is around a corner on a new walk, yet our stride is no less confident as we approach. "Projection" is not usually reserved for this operation, yet it bears consideration for the whole shadow theater of perception, which nonetheless gives us a fully material and embodied world.

I. OPENING

The modeling of projection is often tied to views of causation. What just happened? What is likely to happen? Per Heider and Simmel, "Events and persons gain their significance by the way they are causally connected." In other words, the movements of the disk and triangles in the film are given causal interpretations based on their relation to each other, and to the static rectangle (with its hinged "door"); causality then assigns significance to the moving shapes by allowing a narrative to be crafted about them. In their initial experiment, Heider and Simmel simply asked subjects to tell them "what happened" in the film. All but one respondent interpreted the shapes as animate creatures (most saw them as "persons, in two cases [as] birds"). The lone dissenter who described the film in purely geometric terms nonetheless allowed causality, and creeping anthropomorphism: "The larger triangle, now alone, moves about the opening of the rectangle and finally goes through the opening to the inside. He [sic!] moves rapidly within, and, finding no opening, breaks through the sides and disappears." In the second experimental protocol, Heider and Simmel ran their subjects through a questionnaire, opening with the leading question "What kind of *person* is the big triangle?" [emphasis added] In this protocol, viewers interpreted the shapes as human actors, having been told to do so. When the open "hinge" moved in the rectangle while touching a triangle, everyone viewed the actors moving a door, rather than a door moving the actors. However, when the film was shown in reverse, viewer interpretations "show much more variation and, presumably, more projection" than in the conventional forward screening. That is, *causality is disrupted* when the film is projected in reverse; stories become more difficult to produce, and common-sense narratives are harder to come by. Models have their own implicit causal trajectory, and when the actions are reversed it no longer *follows* that intuitive human narratives are at play. Yet reversal is a crucial aspect of film magic: the reversal of entropy, the upending of gravity, the door that moves people rather than the people who move the door. For Heider and Simmel, quantitative measures became more difficult to generate in the reverse condition, proving that their modeling, their "stimulus-configurations," were indeed significant in shaping viewer experience.[10]

In the Heider-Simmel film, "projection" as a model of cognition implies a kind of mirroring, an inverted symmetry between the film and the viewers.[11] The viewers are blank, until the film, also somewhat "blank," projects situations without faces onto the previously blank screen and into their heads. The entire experimental protocol assumes a viewer who takes up the projected image and supplies meanings that are supposedly absent from the artifact itself, producing a "projected" narrative. In the end, this seductively empty animation became modestly famous. One early enthusiast even proposed that the little three-minute film be deployed as a "projective test" along the lines of the Rorschach or the Thematic Apperception Test (TAT).[12]

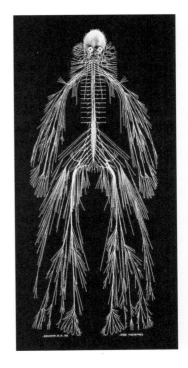

FIGURE 2
The nervous system of Harriet Cole of Philadelphia, preserved and mounted by anatomist Rufus Benjamin Weaver over five months in 1888, for the Hahnemann Medical College (now part of Drexel University), here reproduced by Weaver from a photograph.

Caroline A. Jones

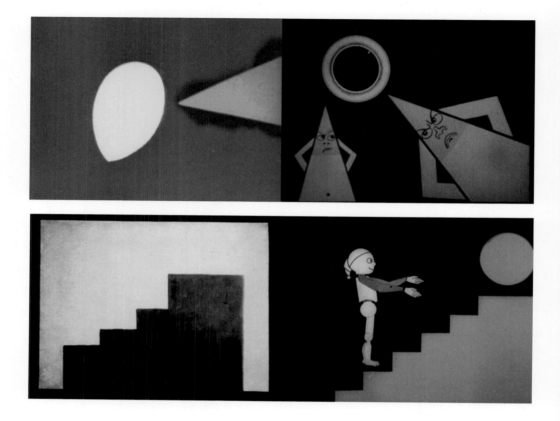

FIGURE 3

Selected film stills from Walter Ruttmann animations. Top left: *Lichtspiel Opus I* (1921), an abstract animation screened in Frankfurt in 1921, compared with top right: *Der Sieger* (*The Victor*, 1922), a filmed advertisement for Excelsior Tires produced by Julius Pinschewer. Bottom left: Ruttmann's *Lichtspiel Opus II* (1922), compared with bottom right: Ruttmann and Lotte Lendesdorff, *Der Aufstieg* (*The Climb*, 1926), a commercial produced by Julius Pinschewer for the "Große Ausstellung Düsseldorf 1926 für Gesundheitspflege, soziale Fürsorge und Leibesübungen" (1926, Düsseldorf Great Exhibition for Healthcare, Social Care, and Physical Exercise, or *GeSoLei*).

Projections, on every side: probes of consciousness, tests of pathology, and models of experience.

Historically, the Heider-Simmel film is a landmark of the profoundly significant transfer of Gestalt theories from their German-speaking sites of origin (Berlin, Graz, and elsewhere) to the United States. It also marked an origin point for American attribution theory: "The relatively abstract nature of the material used in this experiment made it possible to study some of the more elementary factors of causal attribution in social perception"—as Fritz Heider put it in a follow-up paper.[13] Austrian immigrant Heider made the film in collaboration with his student at Smith College, the even more recent transplant from Germany, Marianne Simmel. Through Heider, Simmel would have been taught the characteristic Gestaltist view, typified by Wolfgang Köhler's 1915 statement that his experiments confound "transformations from more retinal vision, and ascribe primary influence in this process to *experience*."[14] [emphasis added] But the arrival of this branch of psychology from war-torn Europe brought more than its famously holistic and experiential approach to cognition. Gestalt psychologists were also equipped with a deeply sophisticated aesthetic culture nurtured on experimental film.

It is no coincidence that film and psychology bloomed together in early 20th-century Germany, with a parallel track in the United States.[15] The founder of Gestalt psychology, Max Wertheimer, wrote one of his most influential papers on "apparent motion" (1912), with the new medium in mind.[16] Across the Atlantic, Philadelphia-born Edwin Boring used Thomas Edison's movie entertainment *Van Bibber's Experiment* (1911) to test the reliability of human witnesses, judging film to be a stable "event test" that could be endlessly repeated for experimental verification.[17] Mere decades old, film's modeling of reality was transforming philosophy and the new science of psychology. What kind of experience were we having, lost in the moving picture's virtual reality? Why were these skittering black-and-white images so absorbing and persuasive? Film's capacity to produce fulfilling experiences, to stimulate narratives, and to constitute persuasive illusions prompted a retooling of existing theories of perception and cognition. New theories were invented ("persistence of vision" was one; montage and suture were others).[18] Film inaugurated a media revolution that touched every level of culture, particularly in its conjunction with experimental psychology in Berlin. Wertheimer, Walter Benjamin, Siegfried Kracauer, Rudolf Arnheim, and others were compelled to theorize the impact and political import of moving pictures. As the feverishly prolific filmmaker Walter Ruttmann wrote in 1928 from the heart of Berlin's Gestalt and experimental film worlds:

> Film is—thank God!—not simply an artistic affair, but also and above all a human-social affair! . . . Art, living art, is no longer what we learned it was in school: no longer a flight

[13] Fritz Heider, "Social Perception and Phenomenal Causality," *Psychological Review* 51 (November 1944): 358.

[14] Wolfgang Köhler, "Optische Untersuchungen am Schimpansen und am Haushuhn," *Abhandlungen der Königlich Preussischen Akademie der Wissenschaften*, no. 3 (1915): 69, as translated and excerpted in Mitchell G. Ash's indispensable *Gestalt Psychology in German Culture, 1890–1967: Holism and the Quest for Objectivity* (Cambridge: Cambridge University Press, 1995), 164.

[15] The bibliography on this conjunction is vast and growing. See Thomas Elsaesser, *Weimar Cinema and After: Germany's Historical Imaginary* (New York: Routledge, 2000); Thomas Elsaesser, "Film History and Visual Pleasure: Weimar Cinema," in Patricia Mellencamp and Philip Rosen, eds., *Cinema Histories, Cinema Practices* (American Film Institute and University Publications of America, 1984); Stephen C. Foster, *Hans Richter: Activism, Modernism, and the Avant-Garde* (Cambridge, MA: MIT Press, 1998); Detlef Mertins and Michael W. Jennings, eds., *G: An Avant-Garde Journal of Art, Architecture, Design, and Film, 1923–1926* (Los Angeles: Getty Research Institute, 2010); Walter Schobert, "'Painting in Time' and 'Visual Music': On German Avant-Garde Films of the 1920s," and David Macrae, "Ruttmann, Rhythm, and 'Reality': A Response to Siegfried Kracauer's Interpretation of *Berlin: The Symphony of a Great City*," both in *Expressionist Film: New Perspectives*, ed. Dietrich Scheunemann (Rochester, NY: Camden House, 2003), 237–70; Miriam Bratu Hansen, *Cinema and Experience: Siegfried Kracauer, Walter Benjamin, and Theodor W. Adorno* (Berkeley: University of California Press, 2011). For the US case, I am indebted to the work of Jeremy Blatter, notably "The Psychotechnics of Everyday Life: Hugo Münsterberg and the Politics of Applied Psychology, 1887–1917," PhD diss., Harvard University, 2014. Russians also occupied the interface between psychology and film— Dziga Vertov attended the Petrograd Psychoneurological Institute (1914–16) before becoming one of revolutionary Russia's most important filmmakers.

from the world into higher spheres, but rather an act of entering into the world and explaining its nature. Art is no longer abstraction, but rather the taking of positions! Any art that does not contain a pronouncement belongs in the antiquities museum. Of course, it is a matter of indifference what this pronouncement applies to: feminine beauty; socialism; or technology, nature and their various imbrications. What is important is simply the fact of taking a position.[19]

Ruttmann's "indifference" to the *kind* of position would facilitate his involvement in various models of cinematic persuasion—modeling consciousness, frame by frame, in art films, advertising, entertainment, and eventually propaganda. (FIG. 3) As film scholar Michael Cowan demonstrates, avant-garde cinema in Weimar Germany was not an elite bulwark against mass cultural experience; it was a central conduit for these mass psychological effects.[20]

Ruttmann was part of a large German filmmaking community that was internationally connected to film artists from all over Europe. Berlin featured renowned titans of Expressionism such as Fritz Lang, but also emerging figures such as Ruttmann, Hans Richter, Viking Eggeling, Oskar Fischinger, Lotte Reiniger, and László Moholy-Nagy—the latter six becoming masters of the alternate reality of animated film. This young generation held a primary commitment to abstraction, linked to music and dedicated to mind-expanding experience. Ruttmann's "light play" works from 1921 to 1923 joined Richter's "Rhythm" films from the same period, promoted in the avant-garde magazine *G* that Richter had just founded (given the subtitle *Material zur Elementaren Gestaltung*—Material of Elementary Design—with its brilliant embrace of mediation, as Rebecca Uchill discusses in this volume). Their abstract animated films were the impetus for the major festival on "Absolute Film" held in 1925 at Fritz Lang's film studio UFA, following which Fischinger's works from 1926 were given titles such as "*Farblichtmusik*" (color-light-music) and "*Raumlichtkunst*" (space-light-art). The echoes of a Wagnerian *Gesamtkunstwerk* were very conscious, as Fischinger staged presentations merging the older technology of slide projection with up to five film projectors, surrounding the audience in a dazzling visual display.

Such artists and entertainers circulated among several domains in 1920s Germany. Working between art and commerce, they were clearly marked by the experimental interest in human perception suffusing their intellectual community, and began at the ground level to make films combining color, geometry, and synchronized musical accompaniment, when doing so was technically challenging.[21] For the films illustrated in Figure 3, for example, Ruttmann would have painstakingly dyed each frame of the celluloid to obtain color effects. Slowly, these animators shifted to more conventional representational imagery—especially after being exposed to the works of René Clair, Fernand Léger, and Man Ray in the Berlin International Film Festival of 1925. In place of the German animators'

[16] Ash, *Gestalt Psychology*, 299. Max Wertheimer's "Apparent Motion" paper is "Experimentelle Studien über das Sehen von Bewegung," *Zeitschrift für Psychologie* 61 (1912): 161–265.

[17] Edwin Boring, "Capacity to Report Upon Moving Pictures as Conditioned by Sex and Age: A Contribution to the Psychology of Testimony," *Journal of the American Institute of Criminal Law and Criminology* 6, no. 6 (March 1916): 820–34.

[18] Joseph and Barbara Anderson, "The Myth of Persistence of Vision Revisited," *Journal of Film and Video* 45, no. 1 (Spring 1993): 3–12.

[19] Walter Ruttmann, as translated by Michael Cowan from Ruttmann, "Die absolute Mode," 1928, in Cowan, "Absolute Advertising: Walter Ruttmann and the Weimar Advertising Film," *Cinema Journal* 52, no. 4 (Summer 2013): 49–73; quote from page 52.

[20] Cowan, "Absolute Advertising." There is a huge literature on the film medium and mass psychology; see the primary theorist Siegfried Kracauer, *Mass Ornament: Weimar Essays*, trans. Thomas Y. Levin (Cambridge, MA: Harvard University Press, 2005).

[21] Given the technologies of the day, films had to be colored by hand and music scored and performed live, outside the celluloid.

[22] Cowan, "Absolute Advertising," 52–53.

[23] Ibid.

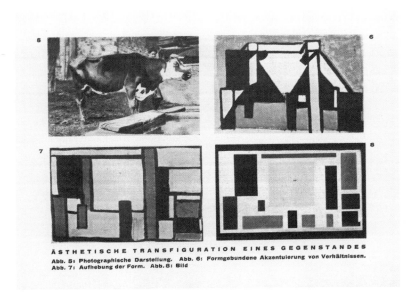

FIGURE 4
Theo van Doesburg, *Aesthetic transfiguration of an object*, ca. 1917, showing the artist's transformation of a realistic photograph of a cow to its absolute abstraction into geometric form for the final illustration, pure *Bild* or "image." Illustrations 5–8 from Van Doesburg's contribution to the Bauhaus book series (number 6, *Grundbegriffe der neuen gestaltenden Kunst*, 1925; 1966 edition).

frame-by-frame constructions, tightly linked as they were to musical composition, the Paris-based practitioners shot live, and composed on the cutting table. Through aggressive cutting, repetition, and montage they "cut into reality," as Benjamin would describe it, rather than staging a fantasy world. Ruttmann's anti-representational position from his earlier 1917 "Art and Film" essay would now be tempered. Triangles would be given faces and fingers; figure-ground play would become literal play: a boy and his ball. Figuration had come into the Berlin stronghold of abstractionists, and entered "the very medium generally associated most closely with abstract film-making: animation."[22]

In other words, rather than moving from traditional figuration by slow stages to an avant-garde abstraction, in the manner of Theo van Doesburg in the wake of Cubism, for example (FIG. 4), these German animators drew on the experimental rigor of Gestalt psychology to build from abstract shapes to the figurative agents they implied. Eggeling, Richter, and Ruttmann, in particular, used the medium of animated film to build empathy with moving forms in a simulated physical world. As they moved away from abstraction, Gestalt's "unconscious form principles" were deployed to anthropomorphize shapes in service of a social or commercial message.[23] Once Walt Disney brought Fischinger to Hollywood, the circuit would be completed, as drifting clouds and Technicolor sunsets appeared behind Fischinger's still-abstract forms, dumbing film down for the commercial hit *Fantasia* (1940).

The model for these Berlin film artists thus shifted from projection to representation, or from suggestion to literalization. (Disney was literal from the start.) These were not the powerful *analogies*

Caroline A. Jones

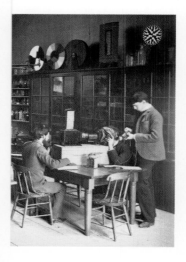

FIGURE 5
The Psychological Research Laboratory, Harvard University, 1893. Professor William James, who founded the laboratory, hired Hugo Münsterberg to come from Germany to direct the laboratory in 1893; shown here is the first configuration of the newly renamed Psychotechnics Laboratory in Harvard's Dane Hall.

FIGURE 6 (FACING)
"Interior of a Laboratory Room," illustrating Münsterberg's Psychotechnics Laboratory, from a pamphlet provided to visitors attending Harvard's exhibit at the 1893 World's Columbian Exposition in Chicago, Illinois.

24
See Jeanne Riou, "Joseph Roth's 'Bekenntnis zum Gleisdreieck,' Technology, Experience and the Feuilleton in the 1920s," in Science, Technology and the German Cultural Imagination, ed. Christian Emden and David R. Midgley (Bern: Peter Lang AG, 2005), 157–79. The sachlichkeit work of Otto Neurath is an interesting hybrid, given its creation of the "isotype" as an abstracted, geometricized human figure, now the universal form vocabulary for signage around the world. For the links between logical positivist philosophy and art/architecture at this time, see Peter Galison, "Aufbau/Bauhaus: Logical Positivism and Architectural Modernism," Critical Inquiry 16, no. 4 (Summer 1990): 709–52.

that David Mather explores in the practice of Italian Futurists, bridging the cosmos and our own afferent/efferent nerve signals; the Berliners' abstractions invited *projection*, proving that humans could construct meaning and experience from minimal perceptual cues. In a changed political context, figuration—giving the stimulus "a face"—would shape meaning more efficiently, and forcefully herd a common sense. The filmmakers' shift would parallel other visual artists' gradual move from abstraction in the '20s to social realism on both left and right in the 1930s. The German artistic movement that bridged these historical trends, clearly drawing on ideas from the scientific community, was *Neue Sachlichkeit* (New Objectivity), with the "objectivity" being theorized in science and philosophy as actively as it was being promulgated in the arts.[24]

Film thus served as the quintessential model for human consciousness in the first half of the 20th century, functioning for psychologists as an invariant experimental prompt, even as it was burgeoning as an art. For a young film critic such as Rudolf Arnheim (educated for his PhD in 1923 by Gestaltists Wertheimer and Köhler, but then working full time for the leftist journal *Die Weltbühne*), pure form in film could "create simultaneously an illusion of reality and new expressive forms that transcend reality," forms whose robust effects had been proven by science. Refusing verisimilitude, abstract films "create pictures beautiful in form and of profound significance" in weaning viewers from the false ideal of naturalism.[25] In contrast to this experimental attitude, the situation in the United States was largely "naturalist." Thomas Edison had been awarded a patent for his kinetoscope, with an 1888 application that claimed it would do "for the Eye what the phonograph does for the Ear, which is the recording and reproduction of things in motion"—and after a number of supposedly scientific films the inventor smoothly retooled himself as a producer of entertainments "with a good moral tone" designed to further elevate the middle class; this is the legacy that would beget Disney.[26]

On the more academic front, Hugo Münsterberg, the German psychologist brought over in 1893 by William James to establish the first experimental psychology laboratory in the United States, published *The Photoplay: A Psychological Study* in 1916, while devoting his career to "applied psychotechnics" with training films and projective tests.[27] (FIGS. 5–6) Harvard's official photographs of Münsterberg's lab suggest the imagery of mad science: heads in vices, men at cranks and dials, wires from a cyborgian apparatus aimed at the brainstem. The experimental culture Münsterberg had learned in Wilhelm Wundt's lab in Leipzig was what James wanted, but what he also got was a psychologist who became passionately interested in film. Intensified by the ostracism of all things German during the First World War, Münsterberg's turn to cinema was part of a retreat into Cambridge movie theaters; he came out with a manuscript (*The Photoplay*) that some consider the first work of critical

film theory. Heider and Simmel, on their separate paths through Germany in the 1920s and '30s, were also osmotically affected by film's early modern phase, when the medium was spreading into so many sectors of social, cultural, intellectual, and scientific activity. One has only to compare the details from their 1943 film frames to the earlier images by Ruttmann to sense the shared vocabulary of film animation that Heider, as the lead scientist, brought with him when he accepted the job at Smith in 1933.

Heider, a student at the Berlin Psychological Institute during the most fervent years of the film and Gestalt psychology scenes, had also been an active member of cultural groups in Graz, Austria, where he ultimately finished his PhD. Abstract art was a visual resource, although language and narrative had to remain the disciplinary media of experimental psychology. As he and Simmel explained in the paper they wrote about their film-in-experiment, "A few 'anthropomorphic' words are used since a description in purely geometrical terms would be too complicated and too difficult to understand."[28] Abstraction "without the face" was crucial for eliciting projections, but communication in the scientific paper required anthropomorphic shortcuts. The rectangle was simply referred to as "a house," the hinged line as "a door." The visual

25
Ash, *Gestalt Psychology,* 302. The first phrase is Mitchell Ash, summarizing Arnheim; the second is from Arnheim, *Film as Art* (1932), first translated by L. M. Sieveking and Ian F. D. Morrow for a London publishing house in 1933; Arnheim published his own abbreviated translation (Berkeley: University of California Press, 1957), quote from pages 59–60.

26
See W. Bernard Carlson, "Artifacts and Frames of Meaning: Thomas A. Edison, His Managers, and the Cultural Construction of Motion Pictures," in Wiebe E. Bijker and John Law, eds., *Shaping Technology/ Building Society* (Cambridge, MA: MIT Press, 1992), 175–98. Quotes from page 183 and 188, respectively, sourced in note 8, page 196, as Edison to Seeley, October 8, 1888, patent caveat 110, cat. 1433, Edison Archives, Edison National Historic Site.

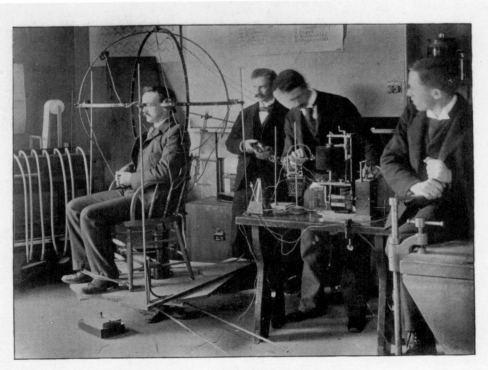

INTERIOR OF A LABORATORY ROOM.
(INFLUENCE OF DIZZINESS ON LOCALIZATION OF SOUND.)

vocabulary of abstraction was necessary to remove "the face," but verbal description would allow human figurative references to return. "Unconscious form principles" would guide the artistry of their film, but not the burden of scientific proof.[29]

In his autobiography, Heider owned up to the story he had embedded in his non-figurative film: "As I planned the action of the film, I thought of the small triangle and the circle as a pair of lovers or friends and I thought of the big triangle as a bully who intruded on them."[30] Converting this love triangle to literal triangles was characteristic of Heider's wit, ensuring the survival of this artifact through screenings at Harvard's newly formed Social Relations department, and at the Psychology department from which it had split, beginning in the late 1940s, where it was shown by visiting professor Max Wertheimer. The film continued being relevant through the early '70s when it was shown by Heider's friend from Berlin, Rudolf Arnheim, then teaching in Harvard's brand-new Visual and Environmental Studies department, and is still a touchstone for cognitive neuroscientists such as Josh Tenenbaum, who showed it at MIT in 2014 and discusses it in his essay, *Intuiting*, in this volume.[31]

Modeling is a practice common to both artists and scientists, and a customary activity of humans in general; our modeling behaviors distinguish us as a species. We model ideas, we model clay, we model with pictures, texts, clothing. What were Fritz Heider and Marianne Simmel modeling when they made their enduring film? The short answer was *projection*. But on a larger scale, they were modeling complexity in the human psyche. Their film experiment refuted behaviorism and the reductive engineering model of "stimulus-response." They were not interested in Galvani-type models of a nervous system stripped of consciousness, in which an electrical impulse makes a frog's leg kick, in the absence of the frog's body.[32] They modeled instead the deeply social and contextual nature of attributions—how we learn to classify information and give it significance (or not). How we assemble, from the simplest elements, complexity. How we assign causality. How we come to like, or dislike, certain behaviors. Their film experiment advocated for the value of life experience in guiding our interpretations of the world.

Both Gestalt psychology's films-in-experiment and avant-garde artists' experimental films probed questions of experience still current today. Films' flickering black and white shapes were perfect for the Gestaltists who sought to go beyond stimulus-response behaviorism to ask why such experience was felt as a convincing whole. For Heider, duration was key. The psychologist's notebooks from the 1920s through the 1970s are filled with meditations about how internal experiences of time signal the beginning or end of an experience, or punctuate memory, or give a role to surprise. He surmises, "There exist *network-like structures between data and constructs* . . . a hierarchy of concepts into *depth* which makes for the systematic and formal component in science and perception."[33]

[27] Blatter, "The Psychotechnics" (2014); Jeremy Blatter, "Hugo Münsterberg: Psychologizing Spectatorship between Laboratory and Theater," chapter 1 in *Thinking in the Dark: Cinema, Theory, Practice*, ed. Murray Pomerance and R. Barton Palmer (New Brunswick, NJ: Rutgers University Press, 2015).

[28] Heider and Simmel, "An Experimental Study," 243–59. "Accepted for publication January 13, 1944." This quotation is from page 245. In Heider's papers are notes on Theramin performances, modern art publications, color theory, meetings of the German Philosophical Society, Wilhelm Dilthey on *Erlebnis* (Experience), Heinrich von Eggeling's 1911 publication on physiognomy, and other jottings of a wide cultural appetite. The dialectic between abstraction and anthropomorphism characterized this European cultural scene.

[29] For discussion of Gestalt psychology's key concepts, from *Prägnanz* to the *phi* phenomenon, see Ash, *Gestalt Psychology*.

[30] Heider, *Life of a Psychologist*, 148.

[31] Max Wertheimer is shown as having checked out Heider and Simmel's film, then called *Warring Triangles*, from the Harvard Psychology Department collection for teaching during a visiting professorship in the early 1950s; see "film notebook, Harvard Psychology Department," Harvard Film Archive, Harvard University. The film was shown to the author by Arnheim in his introductory classes at VES in the early 1970s, and again by Josh Tenenbaum at MIT during a public lecture in 2014.

[32] Luigi Galvani is honored with our adjective "galvanic"; his experiments inspired Mary Shelley to write her famous novel *Frankenstein*. An Italian physician, Galvani set up his experiments at the University of Bologna, where he attached a wire to the muscles of a fresh, but dead, frog, aimed the wire up to the sky during a thunderstorm, and documented that bursts of lightning made the frog's legs twitch as if they were alive.

[33] Fritz Heider, *Notebooks*, Vol. 2 "Perception" (Munich-Weinheim: Psychologie Verlags Union, 1987) 184, §500. Emphasis in the original.

I. OPENING

(FIG. 7) Notice the large-scale domain of "science," on the one hand, and the individual person's "perception," on the other. The Gestaltists believed that what unifies scientific knowledge also organizes everyday cognition. Our experience of coherence and meaning is produced by activities of modeling—processes of sifting impressions, cascades of calculations, and attributions of significance carved from determinations of causality, which are in turn embedded in and generated by environments we have come to know.[34] In this regard, an important influence on Heider's studies in Austria and Germany had been the biologist Jakob von Uexküll, who used the term *Umwelt* to describe the complete but incommensurate lifeworlds that can coexist in a single ecological niche, bounded by the limits of creaturely perception, sensing, and body portals: the human experience of life at one scale, the spider, laboring on its web in the corner, at another, the fungus stretching for a mile just under the surface of the earth, an equally incommensurate third.

In formulating his notion of the *Umwelt* (environment or "surrounding world"), Uexküll took questions common to philosophy and anchored them in the basic equipment of creaturely sensation, asking: *What is experience*? For Heider, this would fundamentally become a question about being human (rather than spider or fungus). In one form or another, the question of how we model a world from sensory experience has been at the heart of Western philosophy from the Greeks through René Descartes, taken up with fervor by empiricists such as John Locke and David Hume. More proximately to our century, the phenomenology of Edmund Husserl or the physical sensationalism of Ernst Mach attempted to parse the question with scientific precision, sharpening it into one form of modeling in particular: What is before the eyes? How does this phenomenal apparition from electromagnetic wavelengths stimulating rod and cone firings come to make up a convincing world? The American pragmatists, beginning with William James, held this operation to be self-evident: the world moves in and through us; there is no consciousness without world as its content. The German philosopher Martin Heidegger had rejected Mach's physicalism—but Husserl moved him. Heidegger's model set out to distinguish between "lived" experience—*Erlebnis* (from the root "*Leben*" or live, a formulation fashionable in the rapidly modernizing urban world of Berlin) and the cumulative kind of experience traditionally considered by philosophy—*Erfahrung*. In the latter word, the German root *fahren* conveys a duration, a moving-through, a voyage of the reflective kind. These were distinctions Marianne Simmel (as Georg Simmel's granddaughter) and Fritz Heider (as one who knew Ernst Cassirer personally) would have understood.

The historical moment of Heidegger's warnings against unreflective, pell-mell, experience-as-*Erlebnis* marked a crisis in the scientific and philosophical modeling of consciousness, not to mention its political instantiation. (He condemned the Nazis

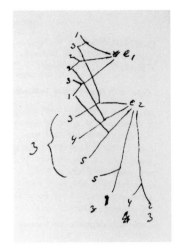

FIGURE 7
Fritz Heider, sketch from *Notebooks*, Vol. 2 "Perception" (Munich-Weinheim: Psychologie Verlags Union, 1987). Heider notes on page 184, "There exist *network-like structures between data and constructs*," here sketched as "perception as solving equations." Emphasis in the original.

34
The relationship between the environment and learning is complex for Heider. Discussing a formative seminar with Max Wertheimer in Berlin during the early 1920s, in which the founder of Gestalt theory had those who attended experiment on their own visual blind spots and then hypothesize what caused the curious phenomenon, Heider recalls: "It was a remarkable demonstration of the hypothetico-deductive method and, at the same time, of Gestalt laws, because the way in which the blind spot appears is mainly determined by Gestalt principles and not by experience. *We see, not what we have 'learned' to see, but what fits best.*" Heider, *Life of a Psychologist*, 43. The notion that what "fits" might also be determined by experience in a particular environment is what Heider's colleague James Gibson brought to the field with his "environmental perspective" on visual perception.

for being possessed by *Erlebnistrunkenholdigkeit*—lived-experience-drunkenness.)[35] Was "experience" indeed something that happened suddenly, a violent and unexpected break in habit? (*Erlebnis*) Or was it something hard-won, wrested from life and reflective thinking, a habit of mind? (*Erfahrung*) The former was touted by the likes of Ernst Jünger, in paeans to war and manhood familiar from Friedrich Nietzsche's accolades to the superman. The latter was tarnished by accusations of academicism and dry scholastic metaphysics, dreadfully outmoded in the rush to war. The crisis was one that Theodor Adorno hoped to resolve after the cataclysm of another world war. Returning to G. W. F. Hegel's supposedly "idealist" philosophy, Adorno argued in the 1960s that the 19th-century German philosopher prefigured a phenomenology that was above all *experiential.* Heidegger himself had pointed out that Hegel's original title for *The Phenomenology of Spirit* was *The Science of Experience of Consciousness*, which Adorno saw as an indication of Hegel's anticipation of Husserl (whom he wanted to read very differently than Heidegger had). The Hegelian and Husserlian model Adorno invoked is not projection, but introjection: the world suffuses us, and blooms from within into a consciousness of being.

Hegel's "science" of experience, Adorno's experiential philosophy, and even Heidegger's metaphysics, took art to be a crucially productive site for experiencing the event-of-being, and for modeling its progressive effects. Adorno wanted to consider as well the way art works from within the *polis*: art demonstrates to science the broad political and cultural context forming what sense we make of experience.[36] Similar thoughts had guided Arnheim, in rejecting verisimilitude as "false artifice," and celebrating abstraction as open to the prior experience of a democratic people. More like John Dewey's vision of "art *as* experience" (as Dewey's 1934 book had proclaimed) than Heidegger's labored view, Adorno's model replaces notions of art as representation or "expression." Art is not the semiotic conveyance of a fixed message—it is a range of marks, indices, rituals, and materials that humans make, arguably uniquely, to stimulate perception. We do these things to draw upon prior layers of experience, in order to produce, paradoxically, the genuinely new—what contemporary philosopher Alva Noë calls our "strange tools" of art and concepts, seemingly so crucial for reorganizing ourselves.[37] Art perpetually shifts in culture because what art models necessarily changes over time, and what we want art to reorganize us into, also changes.

Avant-garde cinema, music, and abstract art were very much on Adorno's mind in crafting his philosophy. Less well known is the fact that he studied with Gestaltists (the psychologist Schumann served on the philosopher's dissertation committee). Adorno would later problematize the holism of Gestalt as "unconsciously synthetic," reconciling experiential fragments solely on the basis

[35] Heidegger's neologism *Erlebnistrunkenholdigkeit* (experience-drunkenness) cited by Rüdiger Safranski, *Martin Heidegger: Between Good and Evil*, trans. Ewald Osers (Cambridge, MA: Harvard University Press, 1998), 312, drawn from handwritten notes later collected in the *Gesamtausgabe*, vol. 65: *Beiträge zur Philosophie (vom Ereignis)* (Frankfurt: Klostermann, 1975), 67. See also Martin Heidegger, *Hegel's Concept of Experience*, translated into English and with a section from Kenley Royce Dove's translation of Hegel's *Phenomenology of Spirit* (New York: Harper & Row, 1970). Heidegger's wariness of *Erlebnis* is further glossed in Michael Inwood's entry on "Experience" in *A Heidegger Dictionary* (Malden, MA: Blackwell, 1999), 62–63. Inwood summarizes Heidegger's view from "The Age of the World Picture" and his writing on Nietzsche: "'Fortunately, the Greeks had no experiences,' [Heidegger wrote,] hence they did not believe that the point of art is to provide them," 63.

[36] In his reading of Hegel, Adorno explicitly works to counteract this kind of statement by Heidegger: "But man will never be able to experience and ponder this that is denied so long as he dawdles about in the mere negating of the age." From Martin Heidegger, "Age of the World Picture" [1938], in Heidegger, *The Question Concerning Technology and Other Essays*, trans. William Lovitt (New York: Harper & Row), 136. See Theodor Adorno, "Aspects of Hegel's Philosophy," in Adorno, *Hegel: Three Studies* [1963] (1993), quote from page xxiii. Heidegger had of course published his own view of Hegel's notions of "experience," for which see note 35 above.

[37] Alva Noë, *Strange Tools: Art and Human Nature* (New York: FSG, Hill and Wang, 2015). See also Noë's essay "Understanding," in this volume.

of social conventions—"Gestalt is an instance or model, indeed an epitome, of ideology as such: reflex and reinforcer of the habitual familiarizations, the ideological conditionings" of false consciousness. Habit, and notions of the "common" sense, were anathema to Adorno, who saw the role of art as precisely to break habitual views and produce uncommon subjects. Yet Adorno's "negative dialectics" reveal the suffusing influence of Gestalt psychology.[38] Its impact on Heider and Simmel was even more profound. How film was experienced by viewers, the emotions it summoned, and what aspects of consciousness it modeled, were questions it seemed logical to ask through abstract animated film, if you were two immigrants in America during the dark days of World War II.

Aesthetic productions solicit interpretive projections, and science wants to measure them. Modeling consciousness across science and art motivated Heider and Simmel to make their film. Gestalt consciousness models also profoundly marked their friends, colleagues, and mentors who navigated between the fields of psychology and art history, such as Ernst Gombrich, Rudolf Arnheim, and Anton Ehrenzweig. Arnheim's first book, written at the precocious age of 28, was *Film as Art* (1932), generated in the thick of the Berlin experimental film scene. Arnheim's 1954 *Art and Visual Perception*, written after he had immigrated to the United States like so many of his colleagues, was careful to incorporate Heider and Simmel's findings. Page 1, figure 1 of Arnheim's text recalls their 1943 film, and presents the quintessential Gestalt stimulus: a disk in a box. Fixed in print, Arnheim's disk aimed to stimulate (and thus illustrate) the human desire for balance and order. Slightly off center, the disk is disconcerting; it should be right in the center! or definitively up at that top right corner! (FIG. 8) Unless, in the manner of Expressionist film, we enjoy its odd placement, savoring the tension that results. Or unless we decide to view it as an intermediate stage in the projection of a three-dimensional figure in two-dimensions, à la Tauba Auerbach: imagining the passage of a sphere, and then its disappearance from the plane.

Gombrich and Arnheim had their greatest effect on the teaching of art teachers and art history—not only in English, but also in the many languages into which their wide-ranging works were translated. In the case of Ehrenzweig, the conversation that connected cultural theory and the human perceptual apparatus—arguably Gestalt's greatest accomplishment—directly influenced the production of art.[39] The impact of these and other Gestalt-trained theorists (such as Kurt Lewin at MIT) was equally strong on psychology itself, as their vivid debates on seeing and being were taken up by US psychologists and theorists of perception such as James J. Gibson, who in turn influenced legions of American artists and designers in the late 1960s and '70s with his Uexküll-like notion of the environment, which has shaped the "affordances" we have for engaging with it.

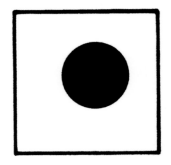

FIGURE 8
Rudolf Arnheim, figure 1, page 1, *Art and Visual Perception* (Berkeley: University of California Press, 1954).

38
Steven Helmling, "Constellation and Critique: Adorno's Constellation, Benjamin's Dialectical Image," *Post Modern Culture* 14, no. 1 (September 2003). The "Schumann" who was on Adorno's dissertation committee was likely Friedrich Schumann (1863–1940), who also taught cofounders of Gestalt psychology Kurt Koffka and Wolfgang Köhler.

39
Ehrenzweig's *Hidden Order of Art*, published in English by the University of California Press in 1967, deeply influenced Robert Smithson, whose art and theories marked a generation of practitioners in the 1970s and beyond. See Caroline A. Jones, *Machine in the Studio: Constructing the Postwar American Artist* (Chicago: University of Chicago Press, 1996).

What happened to this conversation? At the peak of Gestalt's influence, twin revolutions erupted: computation and microbiology. The experiments that had modeled consciousness by making an abstract film—and asking questions of subjects after they'd watched it—gave way to animal models, electroencephalography, open-brain-pan stimulating of specific neurons, algorithmic simulations, and ever-more-massive statistical crunching of language data for semiotic evidence of hardwiring in the brain. Where a given intellectual such as Heider or Arnheim could hope to replicate the experiments outlined in published psychology papers from before the war, today's aspiring interdisciplinary researchers can hardly hope to proceed without access to the $500/hour MRI machine, and some working knowledge of computational arcana, statistical analysis, and machine learning algorithms.

But there is hope for a renewed conversation. Given the maturation of the computational, microbiological, and even pharmacological components of contemporary cognitive neuroscience, there is an inherent interdisciplinarity within the field itself, and a sense that a new synthesis may be possible. At the same time, the old questions have new relevance. As computational neuroscientist Tenenbaum comments about the Heider-Simmel film, "How do we get so much from so little?"[40] He and the other contributors to this book are beginning to get a handle on the answer.

The short version is that we take what we can get to model a world. The less we have to work with, the more we need to fill in ("project")—and modeling itself is an active component of consciousness in experience, drawing on ways the world has already molded our receptive senses and expectations, and the ways our sensory systems have evolved in this world. Between Tenenbaum's statistical modeling of consciousness, the practices of artists from Auerbach to Olafur Eliasson, and the phenomenologically steeped philosophy of Alva Noë, there is surprising common ground: consciousness forms dynamically from a rich engagement with the world and its physics. These are experiential intuitions that art then takes up and models through its "strange tools," in turn altering the toolmakers. Human developmental psychology interests all of these practitioners, as they tackle the mystery of clustering, categories, and consciousness of the human sort. Why does art exist? Because we want and need it, to model different relations with the world, simulating and stimulating experience.

These relations are one of the many ways to constitute the self. Biochemically inclined neuroscientist Leah Kelly theorizes how technologies and systems of intero- and exteroception entwine to form the self in perpetual negotiation with the not-self, just as anthropologist of science Natasha Schüll understands consciousness and identity as fluid constructs amenable to cyborgian supplementation and biofeedback. "Psychology," which once sufficed to encompass Heider and Simmel's interrogations of social attributions and phantom

limbs, now gives way to multiple disciplines stretching to comprehend the central, autonomic, and enteric nervous systems, whether buttressed by self-tracking devices or modified by chemical signaling from pharmacopeia and immuno-friendly bacteria enhancing the embodied self.

The demands on art have changed in such a context. Eliasson, an artist engaged in modeling experience for decades, increasingly plunges the visitor into disorienting environments that aim to shift the human *Umwelt,* sensitizing us to the cosmos. In his 2014 installation "Contact," visitors were asked to imagine other spheres of imagined gravity—in the relativistic understanding of gravity as a specific geometry of curved space-time and torqued attractors. (FIG. 9) This play with consciousness invites us to remap it, willingly dis-Orienting ourselves by standing on the brink of a model for a black hole, imagining information frozen on its event-horizon. Such lofty thought experiments have clearly influenced the younger artist Tomás Saraceno, but while he contemplates extreme upper-atmosphere flight, he also anchors us in the precarious geometries of spider webs and "space-time foam." Space-time foam suspends the human in an infantilizing environment in which the best ways to move are intuitive and somewhat purposeless. Similarly, the spiders that live in Saraceno's studio also exhibit intuitive and spontaneous cognition. He wants to model their effortless synthesis of materials that

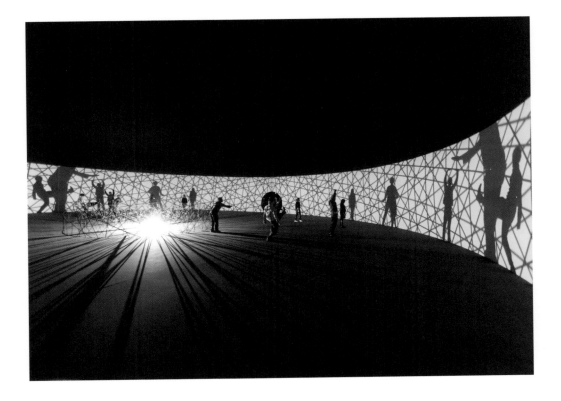

FIGURE 9
Installation view of Olafur Eliasson, *Map for unthought thoughts,* 2014, Fondation Louis Vuitton, Paris.

FIGURE 10
Tomás Saraceno, test recording in studio with a *Nephila* spider, Berlin, July 2015. Photograph by Caroline A. Jones.

FIGURE 11 (FACING)
Tauba Auerbach, *Untitled (Fold)*, 2012, acrylic on canvas/wooden stretcher, 64 × 48 in. (162.6 × 122 cm).

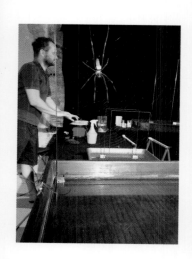

extend sensing to the flutters of prey, to the readiness of wind to carry them, or to the resonance of a potential mate, dancing and thrumming across the room. (FIG. 10)

Bevil Conway, vision scientist, and visual artist Tauba Auerbach also share an interest in intuitive cognition—that is, our unthinking processing of color. Both Auerbach and Conway conceive of color as fundamentally affective, dynamic, and fundamental to consciousness on numerous scales. The evolutionary accident of color vision clearly became salient for human survival; Conway boldly predicts that it will be mapped in close relation to the facial recognition areas of the human brain, while Auerbach theorizes that it may be key to modeling levels of consciousness itself, portal to the utopian goal of achieving higher dimensional awareness. Will interference between wavelengths speak to a tetrachromat (four-color-receptor female)? Hard to say, if you aren't one; but her hallucinatory *Fold* paintings and tautly woven chiral frets invoke the strange geometries of life in fourth-dimensional space-time (FIG. 11, and also see Auerbach's essay in this volume).

Concentrating on a single sensory modality for these researchers (seeing color, hearing resonance, or sensing actions), is not intended to segment, denature, or instrumentalize those senses. Rather, as we learn from composer Alvin Lucier and those responding to his work, among them Adam Frank, Stefan Helmreich, and Brian Kane, the attentive listening of which humans are capable may foment staggeringly transcendent leaps in consciousness. If Lucier's impetus comes out of science and technology (in the person of Edmond Dewan, who through the 1960s and '70s offered Lucier reports of neuroscientific "eavesdropping" on specific wavelengths of brainwaves, or news of Amar Bose's attempts to eliminate resonance), his creative estrangement of those tools puts human audition to the test, opening auditors to new levels of affect and joy. Lucier's resonating rooms or books, Auerbach's pressuring of color and peripheral vision, or Eliasson's demand that we think of space-time durationally, are exercises in expanding experience. The interests these artists have in "higher dimensions" may relate to neuroscientists' explorations of consciousness, and to mathematicians' investigations of color—historian Alma Steingart tracks how humans' capacity to "train up" on color perception (or, we might surmise, fine sonic discriminations) models an access to unities and dimensions otherwise beyond our ken. Only the experience of generating meaning or shifting focus—only by "playing" the game (in color, in mathematics, in sport, in meditation)—can we experience the effects of consciousness, the feeling of thinking.

That feeling is, in some sense, the reason why "experience" is the topic at hand, and the obsessional focus of the modeling going on in this book. Unburdened by the *Erlebnis* and *Erfahrung* distinction, the French philosopher Michel Foucault explains it this way: his books each model experience by becoming one, and his

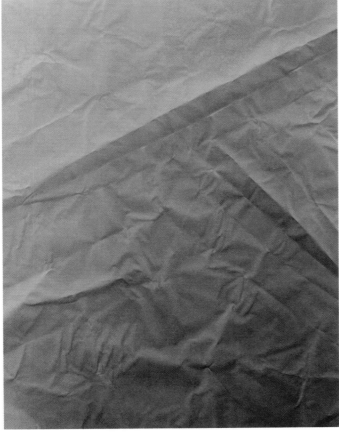

writing agonistically models consciousness in order to change it. For Foucault, experience has the task

> of "tearing" the subject from itself in such a way that it is no longer the subject as such, or that it is completely "other" than itself so that it may arrive at its annihilation, its dissociation. It is this desubjectifying undertaking, the idea of a "limit-experience" that tears the subject from itself, which is the fundamental lesson.[41]

As Douglas Kahn explores in his meditation on "Lightning," these limit-experiences have to stay just this side of death to become culture, experience "tearing" the subject from the everyday without detaching him or her from the kind of shared discourse that can make a common sense. This, too, is captured by Foucault:

> Starting from experience, it is necessary to clear the way for a transformation, a metamorphosis which isn't simply

[41] Michel Foucault, "How an 'Experience-Book' Is Born," in *Remarks on Marx: Conversations with Duccio Trombadori*, trans. R. James Goldstein and James Cascaito (New York: Semiotexte 1991), 33–34. [Note to the reader: while the present volume includes a different translation of this interview, as excerpted from *The Essential Foucault*, I use the Semiotexte translation here for variety, and to indicate complexities in the historical path of this text into English. For further discussion, see Samuel Rocha, "Review Essay of Two Versions of Foucault's Interview with Duccio Trombadori," *Foucault Studies*, No. 7 (September 2009), 99-109.]

FIGURE 12
Performers Luigi Cerri and Matthieu Protin in scene 3, "Advertisement," from *Gaïa Global Circus*, concept by Bruno Latour, Frédérique Aït-Touati, and Chloé Latour; text by Pierre Daubigny; live projection by Elsa Blin. Performed at the Comédie de Reims, France, November 30, 2013.

individual but which has a character accessible to others: that is, this experience must be linkable, to a certain extent, to a collective practice and to a way of thinking.[42]

The ultimate act of modeling, on this account, is to collaborate on the common sense. If we take up the new theories of Vittorio Gallese, innovator of the "mirror neuron" concept, then we will be thinking together about "embodied simulation"—modeled by the quintessential role of film (and its digital affines), or theater, or performance, or sculpture, or photography, or even the reduced and thereby intensified stimulus of painting in our common cultural lives. Can art move us, per Tino Sehgal, through the shock of *Erlebnis* to the knowledge of *Erfahrung*? Would Foucault's limit-experience serve to tear us, precisely because we have been made ready to receive that rupture? Can the embodied simulations of aesthetic forms return us to the collective project of sharing *aisthesis*, our individual body systems of sensing?[43] This, for which Jacques Rancière sounds a clarion call, is also what Bruno Latour dreams of in his project to sensitize us to Gaïa—the collective life-form of our planet. Latour both interrogates and performs interdisciplinarity, philosophizing about the challenges presented by different media in this sensitization process—from popular science to graphic novels to puppetry—and then puts some of these media to work in his collaboratively generated *Gaïa Global Circus* project. (FIG. 12) But when our "intuitive physics" (per Tenenbaum) are as limited as they are, incapable of intuitively grasping even well-established Newtonian

theories of angular momentum, how do we engineer ourselves up for a more exquisite sensitivity? Renée Green's meditative "probes" are one way to get us started. Maybe Saraceno's spider simulations will push us as well, bringing on a resonant social drumming, even if our *Umwelt* grows out of purely mammalian senses. Maybe, although we are mostly individual monads humming to specific wavelengths that proved useful on this planet, we can collectively tune ourselves to the concert of all the wavelengths of Being, and then do something to sustain and cherish that resonating life.

What we do for the moment, in all its urgency, is write experience books.[42] As Joan Scott suggests, we take the inadequate and compromised category of "experience," and accept its usefulness in collectivizing politically localized and grounded forms of life. Without imagining we have all that much in common, we foray into the forging of a common sense by discursive and sensory means, forging politics as we go, hoping they will coalesce as *the* common sense. Experience, as a concept and question, models future action. Science helps us understand that culture is what we've made to change ourselves. Neuroscience in particular can take the effects of challenging art—or the underdetermined stimulus of triangles and disks moving in a black-and-white film—as exemplary of how the common is measured, stretched, stitched, and shared. How we might evolve differently, pressured by our own short-sighted and long-term disasters to tune ourselves more attentively to the social resonances rather than the predatory selfishness in our "nature," will be up to culture. Art is the kind of modeling that can effect the change.[43]

[42] Foucault, "How an 'Experience-Book' Is Born," 38–40.

[43] The Greek term for perception through the body's senses, transliterated as *aisthesis*, has a variant spelling, *aesthesis*, which is closer to the Latinate word derived from it, *aesthetics*. Since 1980, the use of the transliterated Greek has been gaining, in part as a way to counter philosophical claims on aesthetics with a term that connects to its simpler meaning of bodily sensation. In this book, both spelling variations will be found, referencing William James's 19th-century and John Dewey's early 20th-century American spelling "esthetics." All connote different common senses for this charged domain of experience.

FIG. 1

MEDIATING

Rebecca Uchill

"ES KOMMT DER NEUE INGENIEUR" (Here Comes The New Engineer), announced the young artist Werner Gräff, in the inaugural issue of the journal *G: Material zur elementaren Gestaltung* (G: Material for Elemental Form-Creation).[1] Gräff's New Engineer was to be a purveyor of a "new, magnificent technology—of tensions, of invisible movements, of remote influence, of speeds that cannot yet be imagined in the year 1922."[2] This prophecy was not simply a tribute to technological advancement, but a radical vision for how the world might be understood differently if mediated through mechanical expertise. Opposing the "purposeless" and "detached" art movements of Cubism, Suprematism, and Expressionism, with their problematic "tendency to redesign form subjectively" (as a 1924 contribution by Russian artist Nathan Altman put it), *G*'s acolytes aspired to realize human experience untainted by subjectivity, through modes of visualizing and rendering that did not similarly reflect "the individualism of an anarchically divided society."[3] Through the mediations of their chosen new technologies (film, photography, innovative typographic design), the so-called G-Group sought to engineer a visioning—and experiencing—process that emulated the precision, standardization, and nonsubjective universalism of a machine.

In that heady first decade of the Weimar Republic, the editors of Berlin-based *G* sought to understand and perfect the urgent mediating forces of their day: the mass-media apparatuses of print and film, as well as the filters of sensory perception and human comprehension, honed through lived experience. That *Erlebnis*, felt by a perceiving subject, and expressed through artistic means and new metropolitan realities, was a contested matter in period writings about culture and the impact of war by Siegfried Kracauer on the left and Ernst Jünger on the right, in critiques of Expressionism channeled by Weimar art critics Wilhelm Hausenstein and Franz Roh, in debates about the political commitment of neoclassicism or realism between cultural theorists Georg Lukács and Ernst Bloch after the demise of the republic, and in postwar musings by philosophers such as Martin Heidegger. *G* reflected and presaged these pervasive Weimar-era thematics and their reverberations, attending to the ways that technological, social, and perceptual regimes worked in concert to engineer human experience and subjectivity.

FIGURE 1
The cover of issue 5/6 of *G*, 1926, with the word "film" repeated multiple times.

1
G (short for *Gestaltung*, or form-creation) is alternately indexed as "G [quadrat]" in reference to the appearance of a square shape— "G □"—on its title page. In 1924, the journal changed its name to *G: Zeitschrift für elementare Gestaltung*. This essay presents original German quotations from *G* as they appear in the 1986 compilation of reprints published by Marion von Hofacker, Der Kern Verlag, Munich. Translations from the journal to English are taken from the 2010–11 translation and reprint edited by Detlef Mertins and Michael W. Jennings, published under the title *G: An Avant-Garde Journal of Art, Architecture, Design, and Film, 1923–1926* by Tate Publishing, London, in association with the Getty Research Institute, Los Angeles. Other translations, when not otherwise attributed, are my own. The title of Gräff's article contained the misspelling "Ingenier," which, along with similar irregularities, have been silently corrected in this text for the sake of clarity.

2
The essay was published in the 1923 publication noting a December 1922 date of authorship. *G* 1 (July 1923), n.p.

3
Nathan Altmann, "Elemental Viewpoints," *G* 3 (June 1924). In Mertins and Jennings, *G: An Avant-Garde Journal*, 137.

This volume, *Experience,* is similarly concerned with understanding the contemporary permutations of its title topic, formulated and filtered through different disciplinary modes of understanding culture, cognition, and the slippery construct of "common sense." Like *G*, this book endeavors to operate at the intersections of the sciences and humanities, and, through its art- and design-based contributions, to create aesthetic experiences that extend the printed form. In so doing, we attempt to invest experience with the full complexity of its constitution—messy, multifold, and explained variously by its many interpreters, in strange contradictions and surprising correlations equally true to its lived apprehension.

Published from 1923 to 1926, *G* was headed and edited by avant-garde filmmaker Hans Richter, who collaborated with a rotating roster of attributed editors drawn from his art world peers: Austrian architect Frederick Kiesler, Russian artist and graphic designer El Lissitzky, the Germans Mies van der Rohe and Gräff, along with many others.[4] Though short-lived and manifesting in only five publications (including one double issue), *G* demonstrates that a small journal can represent a significant enterprise, focusing the principles of a collective within an object of collaborative labor. *G*'s contributors extolled the virtues of a world wrought of expert construction, both in terms of its tangible infrastructures and its assimilation into consciousness through cultivated perceptual abilities. *G* envisioned a coming culture clear in function and purpose, articulated through the defining features of advanced technology, including dynamic modern design and the moving picture. Polemically asserted in the periodical's pages, such a future would require the use of "elemental" forms to reorder apprehension of the world by its human inhabitants.[5]

This commitment to the "elemental" was propelled by the "Anruf zur elementaren Kunst" (Call for Elementary Art) published in 1921 in *De Stijl*, another journal of the period originating in the Netherlands. That polemic was signed by artists Hans Arp, Raoul Hausmann, and László Moholy-Nagy (whose names later appeared in *G*, either as contributors or subjects of articles), along with the Soviet avant-gardist Ivan Puni; the authors thereby rejected the style and "arbitrariness" (*Willkür*) of the individually motivated artist. "Elementaren Kunst," as summarized by historian Éva Forgács, was characterized by being "anti-philosophical and anti-individualist," aspiring to "the genuine, new design work of the present, free of both beauty and usefulness."[6] The anti-style of these *De Stijl* authors was a universalism constructed of basic geometries and abstraction; it preceded the motivations of a German 1923 *Neue Sachlichkeit* movement, which championed the virtues of "functionalism, utility [and] absence of decorative frills" (as summarized by Weimar translator John Willett).[7] *G* reflected these desires for intentional, elementary form, with only nonfrivolous embellishment.

[4] Gräff reported on his editorial role in the journal in Werner Graeff, "Concerning the So-Called G Group," *Art Journal* 23, no. 4 (Summer 1964): 280–82. However, a year later, in a letter to the editor of *Art Journal*, Raoul Hausmann disputed Gräff's published recollection of the journal, particularly the extent of Gräff's role in its conception: "He followed Mr. Richter around and had no influence upon the direction of the magazine. . . . I would certainly not have collaborated on the magazine in which a young Bauhaus-student without any background had a leading voice," in "More on Group 'G'," *Art Journal* 24, no. 4 (Summer 1965): 350, 352.

[5] The proximate field of Gestalt experimental psychology also designated as "elemental" stimuli in the world that were to be organized as holistic meaning in the mind. Many thanks to Caroline A. Jones, whose close reading of this essay surfaced this insight.

[6] Éva Forgács, "Definitive Space: The Many Utopias of El Lissitzky's *Proun Room*," in *Situating El Lissitzky: Vitebsk, Berlin, Moscow*, ed. Nancy Perloff and Brian Reed (Los Angeles: Getty Research Institute, 2003), 65.

[7] See John Willett's succinct unpacking of the concept of *Neue Sachlichkeit,* and its translation from the German, in John Willett, *Art and Politics in the Weimar Period: The New Sobriety 1917–1933* (New York: Da Capo Press, 1996), 112.

Accordingly, the first page of the first issue offered a typographically innovative text coauthored by Gräff and Richter, using strategic punctuation to promote a "modern form-creation (in art)," wherein art was safely ensconced in parentheses. To Richter and Gräff, creativity was desirable only insofar as it resisted the pitfalls of subjectivity, signifying, for them, an individualist psychology crucially constituted by—and, in turn, producing—experience. It was therefore incumbent upon experts to facilitate modes of seeing the world that would clarify experience and appeal to a basic interpretation of reality, not occluded by emotion or otherwise socially fragmenting. "Weariness with the old artsiness and the fact of vital human interests represent the prerequisites of any new form-creation. Our 'emotions' impede us from seeing what is truly essential for us."[8] The motif of emotions clouding vision would be taken up in various ways throughout G's run, with many authors looking to technology, engineering, film, and non-expressive art as means to eliminate affect and improve sight, representation, and knowledge acquisition. In their words (and punctuation): "A subjective attitude is ruinous in all realms of life and the true cause of all catastrophes — — in art as well. **The new artists act collectively.**"[9] It was an exaggerated idea of subjectivity, understood as a turn inward to a disordered interior psyche, and disengagement from common external realities, that they opposed. The group objected to what they called the "catastrophe" of outdated, noncollective artistic expression, favoring the nonhuman mediation of experience through new technology, and its potential for offering a version of reality that might be cast as "common sense." Mediating the world through representational technology became a core strategy of this anti-individualist project.

Richter and Gräff's first essay for *G*, constituting an introduction to the overall project, sought to refute the "individualistic and emotional" tendencies that its authors perceived in both modern art and modern life: "We have no need for a beauty that, as a mere flourish, is pasted onto our (precisely oriented) existence—we need instead an inner order for our existence."[10] A manifesto "On Elemental Form-Creation" by (leading *De Stijl* protagonist) Theo van Doesburg appeared immediately below, refuting an antiquated relationship to form, predicated upon personal tastes: "In the decorative conception, creative activity was dependent on personal taste, whim, or intuitive assessment of the elements of the artwork. Such capricious work did not, however, meet the demands of our time: PRECISION."[11] The criticism might be construed as targeting a diffuse array of artistic precedents, from the traditions of academic beaux-arts training, to the most recent avant-garde developments, from Impressionism (the "petit sensations" informing the delicate sensitivity of the trained artist), through Symbolism (an emphasis on the decadent aesthete's rarified tastes), up to the most radical Cubist reductions (which still circulated around varying simultaneous perspectives from a *single point of view*), and including the highly emotive canvases

[8] Hans Richter and Werner Gräff, introductory essay for G 1 (July 1923), n.p.

[9] Ibid. Bold in the original.

[10] Ibid.

[11] Theo van Doesburg, "On Elemental Form-Creation," G 1 (July 1923), n.p.

[12] Naum Gabo and Antoine Pevsner, "Theses from the Realist Manifesto: Moscow 1920," G 1 (July 1923), n.p. This translation from the English reprint of Mertins and Jennings, G: An Avant-Garde Journal retains the sentence fragment in the German original: "Als Frundzug der realen Außerung der Zeit." For the extended manifesto in its original format and language, and in translation, see Gabo: Constructions, Sculpture, Paintings, Drawings, Engravings (London: Lund Humphries; Cambridge, MA: Harvard University Press, 1957), 151–52, and insert.

[13] Richter and Gräff were both pioneers of abstract film. Gräff would also consult with Richter on his booklet for the 1929 Film und Foto exhibition in Stuttgart. Willett, Art and Politics, 148.

[14] "Bereits die Zeitung wird mehr in der Senkrechten als in der Horizontalen gelesen, Film und Reklame drängen die Schrift vollends in die diktatorische Vertikale." Walter Benjamin, "Einbahnstraße." In Gesammelte Schriften IV, with Theodor W. Adorno and Gershom Scholem, ed. Rolf Tiedemann and Hermann Schweppenhäuser (Frankfurt: Suhrkamp, 1991), 103.

[15] See Maria Gough, "Contains Graphic Material: El Lissitzky and the Topography of G," in Mertins and Jennings, G: An Avant-Garde Journal, 21–51. Building on the research of Peter Nisbet, Gough suggests that Lissitzky intended to include examples of G in a proposal for an exhibition of his typo-lithography from 1923. On Lissitzky's responsibility for the nickname G, see Eckhardt Köhn, "'Nichts gegen die Illustrierte!' Benjamin, der Berliner Konstruktivismus und das avantgardistische Objekt," in Schrift Bilder, Denken; Walter Benjamin und die Künste, ed. Detlev Schöttker (Berlin: Haus am Waldsee e.V., 2004), 51; as well as Hans Richter, Köpfe und Hinterköpfe (Zürich: Verlag der Arche, 1967), 68–69.

comprising the latest handiwork of the Expressionists. New political imperatives for social collectivizing, and new popular technologies of mechanical vision—photography, and particularly, the prolific industry of film—demanded a complete revision of the "sensing artist" model in favor of something elemental, no longer beholden to "intuitive assessment" or "individual taste."

Relentless in its repetition of like sentiments, the first issue of G pulled in reverberations of these premises from across the cultural sphere. Alongside Gräff's short essay under the fold of the back page ran a selection from the "Theses from the Realist Manifesto: Moscow 1920," coauthored by the revolutionary Russian artists Naum Gabo and Antoine Pevsner. From that longer manifesto statement, G excerpted short claims about the task of the artist to expand all aspects of modern life: expressive, spatio-temporal, and material. For *material*, think the materialism of lived, social realities, as well as the material of a *medium* in serving as a *means* for art—key period terms examined later in this text. The Realist Manifesto excerpt ended with a direct, abrupt position statement: "We reject the thousand-year-old error that sees the static as the only element of art. We affirm the cinematic as a new element of art. As an essential feature of the expression of our age."[12] Cinema, in this assessment, was a new "element" for addressing, expressing, and *forming* a social body of perceiving individuals in the new democratic republic that Germany had established. With its focus on new technologies of all types, G was meant to both entice and produce a more modern subject, turning citizens away from an enduring, "static" art and its associating characteristics of individual expression, intuition, and taste. G sought alternatives in the precision and order of the "essential" medium of modernity—cinema—illustrated in a filmstrip demonstration by Richter, printed as a runner across the full inner spread of the journal.[13] (FIG. 2)

How did the editors of G deploy the centuries-old medium of print in the service of a movement away from "static" expressivity, and into the arenas of the modern, form-creating, technological, and even the "cinematic"? Certainly a journal was not an obvious platform for achieving these aspirations. Cultural theorist Walter Benjamin, in colloquy with his contemporaries in the G-Group, would later refer to the "autonomous existence" of script in the "refuge" of the printed page, contrasting it with the "brutal heteronomies of economic chaos" that came when print was "dragged out" into the street and incorporated into advertisements or screen projections. The spatial arrangement of print would inflect its reception, Benjamin continued, in the short section on the "Attested Auditor of Books" (Vereidigter Bücherrevisor) in his 1928 *Einbahnstraße* (One-Way Street, also to be further considered in the forthcoming pages), in which he offered the examples of a newspaper's "vertical" plane and the "dictatorial perpendicular" of mass-media typography.[14] The reader opening a book, Benjamin suggested, was challenged to

I. OPENING

attend to its "archaic stillness," having experienced the bombardment of printed words, in various configurations, through everyday mass media.

G was calibrated to intervene in that stillness: the journal's dynamic design in its first issue included heavy lines wrapping around the folded page, in defiant refusal to bracket standard columns. Text and illustrations ran at occasional right angles, requiring the reader to physically turn the page 90 degrees, simultaneously emphasizing Benjamin's "perpendicular" and refusing its "dictatorial" qualities. (N.B.: The reader will note that a similar impulse guides certain portions of the design for this book, *Experience*.) One of these sideways texts, along the interior margin of the broadsheet, gave the instruction (archly adapted from Karl Marx's 11th thesis on Ludwig Feuerbach): "Art should not explain life but change it." On the exterior fold, between the two statements by Richter/Gräff and Gräff, ran a cautionary note: "Just no Eternal Truths," accompanied by what could be perceived as funerary symbolism in the icon of a crucifix overlaid by a palm frond, further emphasized by an image of a pointing hand. (FIG. 3) The reader feels invited to tear the words "Eternal Truths" along the fold. Along with its insistent call to sever any enduring premises inherited from the past, *G* promoted modern design for mass consumption, and new technological means at large, as key tools for tearing apart the "eternal truths" of history and its archaic subjectivities.

It was Lissitzky who designed this inaugural issue and suggested the nickname *G* for the journal.[15] The Russian-born artist was a founding member of the "International faction of constructivists" (with Van Doesburg and Richter), a group championing the social utility of "elementary construction" and had founded and coedited another avant-garde journal, *Veshch'/Gegenstand/Objet* one year after moving to Berlin in 1921.[16] He also participated in the first issue of *G* with an authored text, in which he described his philosophy of spatial design for his proto-installation artwork, the *Proun Room*, designed for the Grosse Berliner Kunstaustellung of 1923. The work, he wrote, demonstrated a "principled organization of space"; it represented a "new room" possessing an inherent "equilibrium" that "must be mobile and elemental" (so as not to be overlaid by decoration or changed by human intervention).[17] In his own, earlier, comparison between the creative artist and the technological engineer, Lissitzky described the term *proun* (an acronym for "project for the affirmation of the new") as signifying a new relationship between artist and the world, hedged upon creation rather than on the superfluous operation of pure representation. "When [the new world] needs a mirror, it has photography and the cinema."[18] The "creative intuition" and dynamic spatial engagements of proun production, Lissitzky held, were more complex than the traditional artistic task of creative composition or engineering functional design: "Composition is a discussion on a given plane with many variations; construction is a confirmation of the one for a given necessity. Proun

FIGURES 2 AND 3 (NEXT SPREAD)
Hans Richter, "Demonstration of the Materials"; "Nur keine ewige Wahrheiten" (Just no Eternal Truths) on the margin between the front and back covers. Both in G 1, Berlin, July 1923.

16
For more information on Lissitzky and company's adaptation of the term "constructivism" see Christina Lodder, "El Lissitzky and the Export of Constructivism," in Perloff and Reed, *Situating El Lissitzky*, 27–46. Richter describes the group's adaptation and later rejection of the term in his short text "To Constructivism" in *G* 3 (June 1924): "At the congress in Düsseldorf in May 1920 the name constructivism was adopted in a broader sense by Doesburg, Lissitzky, and me, as the opposition. What is operating under that name today no longer has anything to do with elemental form-creation, our demand at the congress. At that time, the name constructivism was taken up as the watchword of those who sought rules for artistic expression and meaningful contemporary projects—they were opposed by a majority of individualists (see the report on the congress in *Style* 5, no. 4)." Reprinted in Mertins and Jennings, *G: An Avant-Garde Journal*, 174.

17
El Lissitzky, "Prounen Raum: Grosse Berliner Kunstausstellung," *G* 1 (July 1923). The paragraph continues, with original boldface and underlines: "The equilibrium that I want to create in this space must be mobile and elemental **so** that it cannot be destroyed by a telephone or normalizing office furniture, etc. The room is there for humans, not humans for the room. . . . We no longer want the room to be a painted coffin for our living bodies."

18
El Lissitzky, "Overcoming Art," in *Between Worlds: A Sourcebook of of Central European Avant-Gardes, 1910–1930*, ed. Timothy O. Benson and Éva Forgács; trans. Steven Lindberg (Los Angeles: Los Angeles County Museum of Art; Cambridge, MA, and London: The MIT Press, 2002), 186. The original essay "Preodolenie iskusstva," written in Vitebsk in 1921, was published as "Die Überwindung der Kunst," *Ringen* 10 (1922).

FIG. 2

has no axis perpendicular to the horizon, as the image does. It is constructed in space and brought into equilibrium, and because it is a structure, one has to walk around it, see it from below and explore it from above. The canvas has been set in motion."[19] Enhanced by its reduced spectrum of "purest" colors and comparisons between shades taken "from the realm of black and white" to build multidimensional structures in space, Lissitzky's proun signified motion, not stasis, as well as renunciation of the standard right angle of the picture.[20] Similarly, Lissitzky's designs for the layout of *G*'s first issue implied movement, defiance of the maligned "perpendicular," and participatory navigation around the space of the printed page. It would not have escaped the attention of *G*'s editors that the experience for the reader would in many ways be more like cinema than the operations of the conventional book.

It would seem that *G*'s producers were not satisfied to leave the print format unchallenged, and each new issue of the journal brought new experiments with the medium. The design of *G* changed dramatically with its third issue, from a broadsheet into a booklet format, accompanied by a typographic shift to a "modern" sans-serif font.[21] Gräff later recalled that "we were unable to find a printer in Berlin who had enough simple modern type on hand for a whole issue. But to our way of thinking, only modern type was 'elemental,' for it alone reveals clearly that it is constructed, whereas the customary printing types, even though constructed, imitate the character of handwriting."[22] Mies personally paid the bill for this essential typography (using US dollar bills retrieved from a secret hiding place).[23] It is this maneuver that prompts Weimar cultural historian Eckhardt Köhn to refer to *G* as "one of the most important periodicals that appeared in the Weimar Republic, given its rare circumstance of a print design that absolutely matches the design ideas developed in the theoretical contributions—independent of commercial interests."[24]

Though the format of *G* changed throughout its run, its formal and thematic celebrations of dynamism—posited as refusals to capitulate to the threats of archaic stasis or modern-day individualism—did not. And, again and again, *G* published statements presenting film as a key technology for engineering a better form of consciousness. (FIG. 1) Richter explicitly looked to film as an ameliorative response to the "Badly Trained Soul" (the title of his June 1924 article for *G*, also sometimes translated as "The Badly Trained Sensibility"). Through cinematic address, one could critique the assumption that "feelings" were inherent, uncontrollable, and without order. "Feelings, it is said, come in one's sleep, hatch on their own, are simply there! That is wrong. Feeling is a process as precisely organized and *mechanistically exact* as thinking."[25] Richter offered the moving picture as a kind of mediation of the visual apparatus that could circumvent the habit of "sentimental passivity" produced by what he characterized as a still, nostalgic "postcard view":

19 Ibid., 186.

20 Ibid. See also Maria Gough's extensive consideration of Lissitzky's contribution to G, as she notes the artist's regard for print design as connoted in his July 1923 statement in *Merz*. "The printed sheet, the everlastingness [*Unendlichkeit*] of the book, must be transcended. The ELECTRO-LIBRARY," in Gough, "Contains Graphic Material," 22 and 47, note 3.

21 Serifs returned to the journal's typography in the March 1926 issue. For more on the "Make-Overs" in G, see Gough, "Contains Graphic Material," 43–44.

22 Graeff, "Concerning the So-Called G Group," 281.

23 See ibid. and Richter's own elaboration in Hans Richter, *Begegnungen von Dada bis heute Briefe, Dokumente, Erinnerungen* (Cologne: Verlag M. DuMont Schauberg, 1973), 54–55.

24 "Dieses Heft ist eines der wichtigsten Zeitschriftenexemplare, die in der Weimarer Republik erschienen sind, da hier der seltene Fall vorliegt, daß unabhängig von allen kommerziellen Erwägungen die Form des Heftes absolut mit den Gestaltungsideen übereinstimmt, die in den theoretischen Beiträgen entwickelt werden." Eckhardt Köhn, "Nichts gegen die Illustrierte!" in Schöttker, *Schrift Bilder, Denken*, 51. Mertins and Jennings note that not all aspects of the layout were in full unison with the contributors' concepts; they cite Brigid Doherty's observation that Raoul Hausmann objected to the modernist type of his "From the Sound Film to Optophonetics" in the first issue. Mertins and Jennings, "Introduction: The G-Group and the European Avant-Garde," in Mertins and Jennings, *G: An Avant-Garde Journal*, 12 and 20, note 25.

25 Hans Richter, "The Badly Trained Soul," *G* 3 (June 1924). Emphasis added.

The film offers no "stopping points" at which one could return into memories: the viewer is—at its mercy—compelled to "feel"—to go along with the rhythm—breathing—heartbeat: . . . which through the up and down of the process can make clear what feeling and sensing truly is . . . a process—movement.[26]

Feeling and sensing were processes in motion, like a film canister unspooling before projected light, casting animated images on a screen. Propelled by the rhythm of his film, Richter's viewer would actively engage and learn new processes, garnering a greater relational understanding of position, proportion, and light—matters beyond the sentimentality of narrative.

Richter's "Badly Trained Soul" opened with a notable tribute to the Swedish avant-garde filmmaker Viking Eggeling, crediting him for "having found a creative perspective for the production of new forms [that] transcends any specialty (even that of film) and anchors the experiences of the senses in the realm of deepest knowledge." Particularly in these early avant-garde *animations* (see Caroline A. Jones's "Modeling" in this volume), film could be "elemental," and could regulate the senses formally, acting upon perception without appealing to the "emotions" that had been thrown into scare quotes and decried by Richter and Graff in issue 1 of *G*.[27] Film, as espoused in the practices of Richter and Eggeling, was a means of controlling or "anchoring" the potential unruliness of emotion and sensation, seeking a "mechanistically exact" structure for *feeling*. Architect Ludwig Hilberseimer's 1921 appraisal of Richter and Eggeling, published in another Berlin journal under an art section with the subheading "Bewegungskunst" (the art of movement), elaborated:

> Art is the control of the means with the utmost economy. Only a real discipline of elements and their most elemental application makes it possible to build further upon it. Art is not the subjective explosion of an individual but rather organic language of the deepest significance for all humanity. . . . Art charges the individual with the task of creating a great unity from the multiplicity of sensations.[28]

Art effects this control through a process of unifying, Hilberseimer's article put forward, reprising much of the language from Richter and Eggeling's 1921 "Prinzipielles zur Bewegungskunst" (Principles of the Moving Arts).[29] There, drawing on ideas originating in another pamphlet they published in 1920, "Universalle Sprache" (Universal Language), the authors asserted that art is "a human language" made up of elemental forms, like an "alphabet," striving for a "rhythmic unification."[30]

To Richter, film offered the best new material means for controlling and rhythmically unifying a modern consciousness. But

[26] Ibid. Punctuation here as in original.

[27] Unlike the abstract shape films that would ensue in the laboratories of Heider and Simmel, described in the essay by Caroline A. Jones in this volume, Richter emphatically sought to deemphasize the "individual 'sensuous shape,' the 'form'—whether abstract or representational." In ibid. Richter distinguishes in this quote between the "sinnliche Gestalt" and "Form," the *Gestalt* of the title term *Gestaltung* indicating the result of the action *gestalten* translated here as "form creation." Mertins and Jennings unpack the "highly polemical term" *Gestaltung*, referring to a "comprehensive" scope of design and "a new postrepresentational approach to the production of culture that foregrounded formative and constructive processes ahead of the forms themselves." Mertins and Jennings, "Introduction," 5.

[28] In describing art as a "means," Hilberseimer uses the term *Mittel*. *Sozialistische Monatshefte* (May 23, 1921): 467. I am indebted to the scholarship of Edward Dimendberg, who included an extended English-translated excerpt of this article in his "Toward an Elemental Cinema: Film: Film Aesthetics and Practice in G," where I first encountered it, and from which this translation is taken. In Mertins and Jennings, *G: An Avant-Garde Journal*, 58.

[29] "Prinzipielles zur Bewegungskunst" was published in *De Stijl* (attributed only to Richter). Dimendberg, "Toward an Elemental Cinema," 67, note 19. However, some historians speculate that Eggeling is also an (or the) author of this text. See, for example, Jan Torsten Ahlstrand, "Berlin and the Swedish Avant-garde—GAN, Nell Walden, Viking Eggeling, Azel Olson, and Bengt Österblom," in *A Cultural History of the Avant-Garde in the Nordic Countries 1900–1925*, ed. Klaus Beekman (Amsterdam and New York: Rodopi, 2012), 217.

[30] R. Bruce Elder, *Harmony + Dissent: Film and Avant-garde Art Movements in the Early Twentieth Century* (Waterloo, Ontario: Wilfrid Laurier University Press, 2008), 147.

this did not prevent him from attempting to approximate the same effects in print. Richter led the reader of *G* through a "demonstration of the materials," by printing and describing a sequence of frames from an abstract film in issue number 1. In a perpendicular passage alongside this illustration, using typographic elements to represent quadratic shapes and lines in the film, Richter explained:

> □ and ——— are aids [*Hilfsmittel*]. The true means of construction [*Konstruktionsmittel*] is light. . . . This film is not, in principle, the sort that uses the □ and the ——— as compositional means [*Kompositionsmittel*]. . . . The forms that emerge are neither analogies or symbols nor means to beauty. In its sequence of events (its screening), this film communicates very authentically the relationships of tension and contrast in the light.[31]

Significantly, Richter wants to excise "analogies" from his forms (a departure from Gino Severini's commitment to non-psychophysiologically perceivable "plastic analogies," as explored in David Mather's chapter that follows). Richter's film was neither intended to activate an experience of beauty through formal composition nor an opportunity to comprehend symbolic meaning, but rather an effort to generate an elemental experience of sensing itself, activated by a "sequence of events" wrought of light projected through printed celluloid.

As in his "Demonstration" in issue 1, Richter turned to the device of printing frames from his films to accompany his 1924 "Badly Trained Soul" article in the third issue of *G*, here illustrating *Rhythmus 21* (1921) and *Rhythmus 23* (1923). (FIG. 4) Richter's film excerpts, represented in *G* as durational linear strips, or in a grid of printed juxtapositions, contain no human subjects, no points of view, and no aspirations toward conjuring the so thoroughly misunderstood and misapplied *Empfindungen* (feelings or sentiments) of his critique. Critic Rudolf Kurtz's *Expressionism and Film,* published the same year as Richter's "Badly Trained Soul," astutely described Richter's abstract film in terms of a "rejection of the possibility for psychological comprehension."[32] Collectivization would not occur through appeals to emotional sensitivity; for Richter, film would produce a collective "new truth," a "strengthening of our consciousness," and the outcome of generational changes born of "a new optical outlook."[33] Though the print journal *G* could not foil the "postcard view" altogether, it could suggest filmic devices and thus attempt to refuse the indirect passivity characteristic of more traditional encounters with the printed word. The challenge that *G* took on could only be sharpened by the modern media condition that Benjamin would acknowledge in *Einbahnstraße*.

It is perhaps unsurprising, given his direct encounters with the G-Group, that Benjamin would have considered the implications of

31
Hans Richter, *G* 1 (July 1923), n.p.

32
Rudolf Kurtz, *Expressionismus und Film* (originally published Berlin, 1926). Reprint edition edited by Christian Kleining and Ulrich Johannes Bell (Berlin: Chronos, 1997), 93–94. Reproduced in translation in Michael Cowan, "Absolute Advertising: Walter Ruttmann and the Weimar Advertising Film," *Cinema Journal* 52, no. 4 (Summer 2013): 54. Cowan explains Walter Ruttmann's films in the context of positions on abstraction bracketing the Weimar period, from historian Wilhelm Worringer's seminal 1908 treatise juxtaposing the insularity of abstraction from the social "empathy" of representational form, to Nazi-era prohibitions against abstraction and primitivism. In the latter period, Cowan shows the legacy of the notions of "feeling" and "form" as taken up in Ruttmann's filmic evocation of the terms *Formgefühl, Gefühl für Formenschönheit* (feeling for the beauty of form) *Schönheit der Form* (beauty of form), and *Kraft künstlerischer Gestaltung* (power of artistic forming). Cowan, "Absolute Advertising," 72. For more on the postwar legacy of empathy in German aesthetic theory, see David Depew, "Empathy, Psychology, and Aesthetics: Reflections on a Repair Concept," in *Poroi: An Interdisciplinary Journal of Rhetoric Analysis and Invention* 4, no. 1 (2005): 99–107.

33
Hans Richter et al., "Film does not yet exist. . . ," *G* 5–6 (April 1926).

34
Benjamin's *Einbahnstraße* (*One-Way Street*), published in 1928, was written between 1923 and 1926, the same years that *G* was being published. Michael Jennings postulates that it was through *G* that Benjamin was introduced to some of the thematic foci that would define his concerns of the 1920s and 1930s: "industrial art; architecture; photography, mass culture; and, above all, the emergence of startlingly new cultural forms in France and Russia. . . . The 'Copernican turn' in Benjamin's thinking in 1924 is grounded, then, not just in his newly discovered Marxism. As nearly everything he wrote in the seven years after *One-Way Street* indicates, the dense intermingling of an idiosyncratic historical materialism and a less (cont. on page 46)

FIGURE 4
Excerpts from *Rhythmus 21* and *Rhythmus 23* printed alongside Hans Richter's "The Badly Trained Soul" in G 3, June 1924.

the printed page as a form of *mediation*, shaped by and constitutive of its readers' experiences, as revealed by cinema or radical typography.[34] Like *G*, the format of Benjamin's *Einbahnstraße* appealed to modern visuality with a cover photomontage and New Typography font.[35] When, in this text, Benjamin describes the print-saturated exhaustion that comes of encounters with mass media, we can imagine the corrective influence of *G* prepared to assuage these ills of the modern-day subject:

> Before a contemporary finds his way clear to opening a book, his eyes have been exposed to such a blizzard of changing, colorful, conflicting letters that the chances of his penetrating the archaic stillness of the book are slight. Locust swarms of print, which already eclipse the sun of what city dwellers take for intellect, will grow thicker with each succeeding year. . . . And today the book is already, as the present mode of scholarly production demonstrates, an outdated mediation between two different filing systems. For everything that matters is to be found in the card box of the researcher who wrote it, and the scholar studying it assimilates it into his own card index.[36]

idiosyncratic but so far unremarked 'G-ism' is determinative for his writing." Michael Jennings, "Walter Benjamin and the European Avant-Garde," in *The Cambridge Companion to Walter Benjamin*, ed. David S. Ferris (Cambridge: Cambridge University Press, 2004), 23. Benjamin was present at many G-Group meetings; his wife, Dora, also was a contributing editor. See Eiland and Jennings, *Walter Benjamin: A Critical Life*. (Cambridge, MA, and London: The Belknap Press of Harvard University Press, 2014), 172. Detlev Schöttker also points out that Benjamin brought *Einbahnstraße* with him to his next engagement with an avant-garde journal, publishing excerpts of the essay in the constructivist newspaper *i10*, which he joined after the close of *G*. D. Schöttker, *Konstruktiver Fragmentarismus: Form und Rezeption der Schriften Walter Benjamins* (Frankfurt: Suhrkamp Verlag, 1999), 160–61. Frederic J. Schwartz notes that László Moholy-Nagy's atelier was a common meeting place for the G associates, making the connection that Moholy-Nagy's typography was selected by Benjamin for the typeface for *One-Way Street*, although it is unclear if they met in the context of G meetings. (Schwartz, like Jennings, connects Benjamin's turn to avant-garde contemporary visual culture during this time to his position "at the margins of a circle of constructivists that included the photographers Werner Gräff and Sasha Stone [who illustrated the cover to *One-Way Street*], the painters El Lissitzky and Theo van Doesburg, the polymath László Moholy-Nagy, the critics Adolf Behne and Sigfried Giedion, the filmmaker Hans Richter and others.") F. Schwartz, *Blind Spots: Critical Theory and the History of Art in Twentieth-Century Germany* (New Haven and London: Yale University Press, 2005), 39–42 and 260, note 12.

35

The photomontage is by photographer Sasha Stone, the typography a style, not incidentally, that Germanist art historian Frederic J. Schwartz situates in terms of its status as a complex collaboration between the New Vision-ary Bauhäusler and the burgeoning field of advertisement-oriented psychotechnics. See Frederic J. Schwartz, "The Eye of the Expert: Walter Benjamin and the Avant Garde," *Art History* 24, no. 3 (2001): 401–44.

Rebecca Uchill

The printed page presents its reader with layers of mediation: knowledge as filtered through the interpretation (and "filing system") of the researcher, the reification of that experience as mediated by print composition, and the final assimilation of experience through the mediated transfer of abstracted words to a scholarly index. For all of these reasons, Benjamin argued, the traditional printed word on the page of a conventional book was an "outdated" form for mediating modern life (if one to which he would remain devoted).[37]

And yet, in the assessment of *G*'s producers as well, modern life was only comprehensible through its mediations—whether filtered through the barrage of print, dynamic film, or any other visual technology, including the body's very apparatus of perception, a kind of medium of its own. The human senses—retinal, proprioceptive, kinesthetic, auditory, tactile, and so on—were being thoroughly researched during this period in the new field of psychology and its philosophical partner, phenomenology (the excerpt from Edmund Husserl in this volume suggests the flavor of these ponderings). As recent scholars have explored, Benjamin's writings—like *G*—were generated in a German cultural discourse in which the Latinate word *medium* had "not yet acquired a place."[38] The concept of technological "media" was frequently characterized instead by the German word *Mittel*, or "means" (as in the terms *Hilfsmittel*, *Konstruktionsmittel*, and *Kompositionsmittel* employed by Richter in describing the operations of film). Germanist Tobias Wilke, for example, observes that Benjamin also uses the term *Mittel* (or *Apparatur*, or *Technik*) to describe technological media in his well-known essay "The Work of Art in the Age of Its Technological Reproducibility," but departs from the connotation of a material apparatus or technological "means" when describing the sensory system of human perception.[39] Significantly, for this sensorial apparatus, Benjamin uses the word *Medium* (medium): "The way in which human perception is organized—the medium in which it occurs—is conditioned not only by nature but by history."[40] (Doubtless, Benjamin knew the comment by Karl Marx in 1844 that the forming of the five senses is a "labor of . . . history," marking the body through the "labor of humanized nature."[41])

A historically produced consciousness, for Benjamin, is a medium that mediates the world, not through technological operations, but through the filter of experience. And, Benjamin argued, the social forces shifting the *medium* of contemporary perception in 1936 were affected by various technological *means*. Photography, for example, was the "first truly revolutionary *means* of reproduction" ("*ersten wirklich revolutionären Reproduktionsmittels*") causing the decline in peoples' ritual reverence of supposed authenticity, prefaced by the "*means* of painting (or literature)" ("*Mitteln der Malerei [bzw. der Literatur]*") used by the Dadaists—collage, "word-salad" poetry—tactics that destroyed artistic aura, evaded market standards, and confounded traditional viewing habits.[42] In examining

I. OPENING

the "decay of the aura" that art undergoes in photographic reproduction, Benjamin posited a new, technologically produced subject formed in modernity. Seen in this light, the desire to construct or control technological means, as reflected in many of the positions published in *G*, may be understood as impulses to affect the shifting medium of individual human consciousness. Rather than deprive a viewer of an authentic encounter between subject and object, technological means promised to shape all experience through a more precise version of sensitivity, and (in its defeat of mere subjectivity) as a thoroughly collective proposition. Consequently, in 1951, Richter would expand on this 1930s debate in an article with the telling title "The Film as an Original Art Form." Here he framed the question "To what degree is the camera (film, color, sound, etc.) developed and used to *reproduce* (any object which appears before the lens) or to *produce* (sensations not possible in any other art medium)?"[43] By producing new sensations, and inflecting experience, the camera expanded the topography of reality, rather than simply replicating (or diminishing) it.

Benjamin's conjecture of human-perception-as-medium preceded his analysis of technology-as-means for altering that perception in the "Work of Art" essay. As Benjamin scholar Miriam Bratu Hansen notes, the crucial concept of aura, a hovering domain in which human perception both interprets and invests an object with animist agency (and is thus available to be altered by the technological) is already present in Benjamin's 1931 "Little History of Photography."[44] Hansen refers specifically to this quote by Benjamin: "There was an aura about [people represented in early photographs], a medium that endowed their gaze with fullness and security even as their gaze penetrated the medium itself."[45] In Hansen's compelling analysis, perception is indeed a medium for Benjamin, rather than a "means":

> The aura is not an inherent property of persons or objects but pertains to the *medium* of perception, naming a particular structure of vision (though not one limited to the visual). . . . Aura implies a phenomenal structure that enables the manifestation of the gaze, inevitably refracted and disjunctive, and shapes its potential meanings.[46]

Hansen clarifies that Benjamin's use of medium is not the technological term used in "post-[Marshall] McLuhan" media theory. "Rather, it proceeds from an older philosophical usage (at the latest since [Georg Wilhelm] Hegel and [Johann Gottfried] Herder) referring to an in-between substance or agency—such as language, writing, thinking, memory—that mediates and constitutes meaning; it resonates no less with esoteric and spiritualist connotations pivoting on an embodied medium's capacity of communing with the dead."[47]

While embodied perception was an insulated medium, cinema was a popular *Mittel*, acting upon experiencing subjects. And certainly,

[36] Translation by Edmund Jephcott and Kingsley Shorter, published in Walter Benjamin, *Selected Writings, Vol. 1: 1913–1926*, ed. Marcus Bullock and Michael W. Jennings (Cambridge, MA, and London: The Belknap Press of Harvard University Press, 1996), 456.

[37] In his *Passagenwerk* or *Arcades Project*, Benjamin would attempt his own solution in a radical set of images, quotes, and scrapbook fragments that he would sift and recombine for decades, in a manner similar to Berlin art historian Aby Warburg, who crafted an assembly of ever-shifting images he called the *Mnemosyne Atlas*, 1924–29.

[38] Tobias Wilke, "Tacti(ca)lity Reclaimed: Benjamin's Medium, the Avant-Garde, and the Politics of the Senses," *Grey Room* 39 (Spring 2010): 39.

[39] Ibid. See the translation by Jephcott et al., in *The Work of Art in the Age of Its Technological Reproducibility and Other Writings on Media*, ed. Michael W. Jennings, Brigid Doherty, and Thomas Y. Levin (Cambridge, MA, and London: The Belknap Press of Harvard University Press, 2008).

[40] Benjamin, as translated in ibid., 23.

[41] Karl Marx, *Economic and Philosophical Manuscripts of 1844*, trans. Martin Milligan (Buffalo, NY: Prometheus Books, 1988), 108–109.

[42] These translations taken from Jennings, Doherty, and Levin, *The Work of Art*, 24, 38. Originals in *Gesammelte Schriften* VII, 356, 378.

[43] Hans Richter, "The Film as an Original Art Form," *College Art Journal* 10, no. 2 (Winter 1951), 157–61. Emphases in the original.

[44] Miriam Bratu Hansen, "Benjamin's Aura," *Critical Inquiry* 34, no. 2 (Winter 2008): 336–75.

cinema was establishing itself as a high-impact political tool while Weimar-era art theory debated the efficacy of subjectivity as well as its artistic catharsis in the art movement called Expressionism. As mentioned previously, an explicit rejection of Expressionism motivated the artistic tendencies that would be subsumed under the title of *Neue Sachlichkeit*, championing a "representative," "civilized" art of "pure objectification," as forwarded by critic Franz Roh in 1925.[48] In a similar vein, *G* associates Richter, Gräff, Hausmann, Lissitzky, and Van Doesburg suggested the modern cultural producer should not be an expressive individual, but should see and speak with collective intent, technological adeptness, aspirational objectivity, and a new clarity of vision.[49] *G*'s contributors defended the *Neue Optik* of photography against detractors who objected to the premise of artistic representation produced through machine capture.

"I knew a man who made excellent portraits. The man is a Kodak. —But, you say, he lacks color and a subtlety of brushwork. That slight shiver was once a weakness and called itself sensitivity in order to prove itself. Human imperfection, it seems, has more considerable virtues than the exactness of machines."[50] These lines appeared in Dadaist Tristan Tzara's "Photography from the Verso," published in the third issue of *G* (translated from French for the journal by none other than Walter Benjamin). Just as Gräff and Richter condemned human emotions for "impeding us from seeing what is truly essential," Tzara critiques popular resistance to the camera's lack of "human imperfection" as a condition of what he describes as "the petty swindles of sensitivity."[51] He also rejects more traditional forms of painting on similar grounds: "For a brief moment, I followed their idiotic voices. . . . They all ended up in the production of English postcards. . . . Well-groomed painting in gilded frames."[52] The "postcard" motif is conjured here not only as a hallmark of sentimentality, as in Richter's text that followed it in the third issue of *G*, but also as a symbol of pandering to popular taste and complicity in a commercial status quo. Contrastingly, for Tzara, photography could offer a more radically modern form of "sensitivity" in the physical substrate of light-sensitive paper:

> Once everything that is called art had developed gout, the photographer lit his thousand-candle lamp, and the light-sensitive paper gradually absorbed the black of several everyday objects. He had discovered the power of a tender and untouched flash of light, which was more important than all the constellations that are placed before us as a feast for our eyes. The unique, correct, and precise mechanical distortion is fixed—smooth and pure like hair passing through a comb of light.[53]

Tzara credits the photographic machine with a modern, precise, and still "tender" clarity of representation through exposure to light

Rebecca Uchill

[45] This translation taken from *The Work of Art in the Age of Its Technological Reproducibility and Other Writings on Media*, ed. Michael W. Jennings, Brigid Doherty, and Thomas Y. Levin (Cambridge, MA, and London: The Belknap Press of Harvard University Press, 2004), 282. Benjamin's original quote, "Es war eine Aura um sie, ein Medium, das ihrem Blick, indem er es durchdringt, die Fülle und die Sicherheit gibt," does not repeat the word "medium," but refers back to it in the second part of the sentence. *Gesammelte Schriften* II, 376.

[46] Hansen, "Benjamin's Aura," 342. Emphasis in the original.

[47] Ibid. Wilke makes a similar analytical point in the introductory lines to his later article, opining that the "widespread conception of Benjamin as a pathbreaking forerunner—and of the artwork essay as a cornerstone of modern-day reflections on the effects and properties of 'media'—is without doubt legitimate at many levels. What has been consistently overlooked, however, is a fundamental conceptual difference that separates the artwork essay from more recent accounts on the project of media theory, particularly from contemporary notions of what 'a medium' actually is." Wilke, "Tacti(ca)lity Reclaimed," 39.

[48] Franz Roh, "Post-Expressionist Schema" (originally published Leipzig, 1925). As translated and reproduced in *The Weimar Republic Sourcebook*, ed. Anton Kaes, Martin Jay, and Edward Dimendberg. (Berkeley, CA, and London: University of California Press, 1994), 493.

[49] Detlef Mertins and Michael W. Jennings characterize this group's objection to the emphasis placed by the *Kongreß der 'Union internationaler fortschrittlicher Künstler'* (Congress of the 'Union of international progressive artists') on subjectivity and individualism as a "violent" rejection. Mertins and Jennings, "Introduction," 9.

[50] Tristan Tzara, "Photography from the Verso," *G* 3 (June 1924): 39. Translation in Mertins and Jennings, *G: An Avant-Garde Journal*, 141.

[51] Ibid., 40. Translation in Mertins and Jennings, *G: An Avant-Garde Journal*, 141–42.

(rather than through the touch of the human hand). Benjamin would later quote these lines from Tzara in his 1931 "Little History of Photography," commenting that artists who "went over from figurative art to photography not on opportunistic grounds . . . today constitute the avant-garde among their colleagues, because they are to some extent protected by their background against the greatest danger facing photography today: The touch of the commercial artist."[54] The sensitivity of the camera remains, for Benjamin, dependent upon the ministration of the artist.

In his 1929 book *Es kommt der neue Fotograf!*, Gräff revisited the prophetic spirit of his earlier text for *G*, applying the same exclamatory heralding to "the new photographer" that he did when welcoming "the new engineer" of his 1923 treatise, this time celebrating the aesthetic regime as he had the technological.[55] No longer compelled to advocate for the importance of the camera or the new vision, Gräff treats that accomplishment as already achieved—the photograph has solidified its position as "more powerful" than the word, he writes, with cinematic elements (including transitions between image and text) now being adopted by writers on a mass scale.[56] Gräff's book offers cautionary advice about how to discern and create the best modern photographic and integrated multimedia compositions, now that these same devices have overrun popular media. Gräff's photographer is thus charged with manipulating the mediating machine, and his audience with filtering the mediated image through media-savvy interpretation. Benjamin is similarly concerned with encouraging the viewer to "read" the contemporary preponderance of photographic images in his conclusion to "Little History of Photography," making reference to Moholy-Nagy's prophecy "the illiterates of the future will be ignorant of the use of the camera and the pen alike."[57] In Benjamin, however, the quote is distorted in favor of *Medium* over *Mittel*:

> "The illiteracy of the future," someone has said, "will be ignorance not of reading or writing, but of photography." But shouldn't a photographer who cannot read his own pictures be no less accounted an illiterate? Won't inscription become the most important part of the photograph? Such are the questions in which the interval of ninety years that separate us from the age of the daguerreotype discharges its historical tension.[58]

Here, Benjamin's photograph is not defined by a flash of light on photo-sensitive paper, but also a composite of aspects that by necessity extend to the parerga of creator, context, interpretation, and the printed caption. His photographer is charged not only with producing pictures, but also with making them both legible and relational "texts," challenging the human medium to interpret the *Mittel* in terms of its circumstances of production.[59] The exactitude of

[52] Ibid.

[53] Ibid.

[54] Walter Benjamin, "Little History of Photography," in *Selected Writings, Vol. 2: 1927–1934*, ed. Marcus Bullock and Michael W. Jennings (Cambridge, MA, and London: The Belknap Press of Harvard University Press, 1999), 523–26.

[55] This extended photoessay, a collaboration with Richter, was included in the seminal *Film und Foto* exhibition. Herbert Molderings notes this work was one among a number of other modern photographic manifestos of the period that are conspicuously absent from Benjamin's contemplation, turning instead to the "sober, objective approach" of August Sander, Eugene Atget, and Karl Blossfeldt. Herbert Molderings, "Photographic History in the Spirit of Constructivism: Reflections on Walter Benjamin's 'Little History of Photography,'" trans. John Brogden, *Art in Translation* 6, no. 3 (2014): 330. First published as "Fotogeschichte aus dem Geist des Konstruktivismus—Gedanken zu Walter Benjamin's 'Kleine Geschichte der Photographie'" in *Die Moderne der Fotografie*, 2008.

[56] Werner Gräff, *Es Kommt der Neue Fotograf!* (Berlin: Verlag Hermann Reckendorf F.M.B.H., 1929), 117.

[57] László Moholy-Nagy, "A New Instrument of Vision," *Telehor* 1–2 (1936). For more on Moholy-Nagy's statement and its implications for the importance of the photographic apparatus in organizing "modern life and our perceptual experiences of it," and the "Bauhaus image" overall, see Edit Tóth, "Breuer's Furniture, Moholy-Nagy's Photographic Paradigm, and Complex Gender Expressivity at the Haus am Horn," *Grey Room* 50 (Winter 2013): 90–111. Moholy-Nagy's texts and photograms were not to be found in *G*. (Richter mentioned him only in passing in his aforementioned text "To Constructivism," namely to disparagingly observe that Moholy-Nagy, who had broken with the constructivist group and now was occasionally identified as a suprematist, "has a sensitive nose" for fashionable art.)

[58] Benjamin, "Little History of Photography," 527.

the photographic *Mittel* emerges, at the end of the decade, with caveats about intertextuality, historical contingency, and the inevitability of multivalence, while the *Medium* of the experiencing subject is urged to reequip itself as a more literate and discerning consumer of such materials.

Seeking to escape the imperfect mediating devices contained within the human self, to achieve the collectivizing potential for "objective" technologically produced subjects, *G* looked to the mediating *Mittel* as a means for taming subjectivity while cultivating a new modern sensitivity. Mechanical means for vision, such as the camera, operated as filtering devices in an important "middle" space between the optical medium of the viewer and the world beyond. By shaping the visioning encounters that create experience, Richter and his cohort variously proposed to form a technologically mediated collective. Richter recalled that *G* "owed its existence to an unmitigated optimism with regard to the resources ["*Mittel*," in Richter's original] and opportunities of our time."[60] Experiencing the world through the new "means" of the period, Richter's audience was optimistically conjectured to gain something otherwise perfectly unattainable: an "unmitigated" shared encounter, a clear and precise form of *Erlebnis*, and a newly common sense as members of a fledgling democracy.

Analyzing the technologies that mediate experience—whether by the means of machines or the mediums of our very bodily sensorium encountering this printed page—continues to occupy scholars across academic disciplines. From Donna Haraway's 1984 manifesto calling for humans to embrace their status as cybernetic organisms with a social conscience, to "operational images" intended for non-human, computer interpretation (a subject of fascination for artists Harun Farocki and Trevor Paglen), to the "trackers" who embrace wearable prostheses as consumer products to regulate the self (described by anthropologist Natasha Schüll in this book), contemporary experience and its interpreters continue to wrestle with the enduring mediations of technological means.

Understanding the polemics and benefits of technological mediations seems as urgent a task as ever. A lecture series in the computation discipline group of MIT's School of Architecture at the time of this writing takes as its point of departure the quote "The computer is a medium, not a tool"—a premise drawn from early computer interface theory. The series takes on the mandate "to contemplate computational technologies as media and interrogate their mediating effects on human creative endeavors," asking, "Can mediation itself become a locus of design?"[61] The mediums of historical experience and perceptual assimilation of the world also endure as objects of necessary analysis. Joan W. Scott's foundational text, reprinted in this volume as "Historicizing Experience," describes the ways that our world is known and constructed through experience that

59 According to Benjamin, "The creative in photography is its capitulation to fashion. . . . In it is unmasked the posture of a photography that can endow any soup can with cosmic significance but cannot grasp a single one of the human connections in which it exists, even when this photography's most dream-laden subjects are a forerunner more of its salability than of any knowledge it might produce. But because the true face of this kind of photographic creativity is the advertisement or association, its logical counterpart is the act of unmasking or construction. As Brecht says: 'The situation is complicated by the fact that less than ever does the mere reflection of reality reveal anything about reality. A photograph of the Krupp works or the AEG tells us next to nothing about these institutions.'" Ibid., 526.

60 "'G, die 'Zeitschrift für elementare Gestaltung,' verdankt ihre Existenz einem umfassenden Optimismus bezüglich der Mittel und Möglichkeiten unserer Zeit." Richter, *Köpfe und Hinterköpfe*, 67.

61 https://architecture.mit.edu/disciplines/computation/lectures/computation-lectures. See, for example, Brenda Laurel, *Computers as Theatre* (Reading, MA: Addison-Wesley, 1991).

simultaneously produces and reconstitutes subjectivity. The different ways that vision and feeling mediate the world are the subjects of neuroscientist Bevil Conway's and cultural theorist Adam Frank's contributions to *Experience*; both authors consider the availability of these means of sensing to be critically approached by aesthetic production and scientific analysis, an important undertaking in light of Bruno Latour's call to inculcate sensitivity as a political practice. Alva Noë approaches the conundrum by showing that while perception may still be seen as a type of mediation that filters a world, experience is similarly constitutive of knowledge, but delimited by agency and access to resources. And, as demonstrated in the contribution by Vittorio Gallese (invoking the work of Mark Hansen), Walter Benjamin's work continues to haunt discussions about the ways that technology can "eclipse" the mediation of "interior" (human) memory as the "privileged mode of storing experience."[62]

Artists also continue to serve as sensitive handlers of contemporary technologies and subjectivities, and the projects produced for *Experience* reflect this care and agility. As the curator for these projects, I began with the premise that the artist contributions should not document works that happened elsewhere, or operate as illustrations for the text-based works of other contributors, but exist as actual artistic works, available to be experienced through the book. In this way, I wanted to achieve parity with our invitations to scientists and humanists, who were asked to implement the practices of their fields of expertise to interpret experience on the printed page (i.e., through reports on experiments or cultural analysis). The works of art created specifically for the platform of these bound pages confront the mediation of the book format and incorporate it into their formal concepts. Some of these offerings neatly recast the book as a tool to be used in the service of an art experience. For example, Alvin Lucier's new composition *Closed Book* invites the reader to explore the book-object as a musical instrument possessing a range of sonic qualities. *Closed Book* expands on an earlier score, still unpublished (as of this writing), *Rare Books* (1997), dedicated to the late Elizabeth Swaim, director of special collections for Wesleyan University's Olin Library. In *Rare Books,* Lucier instructed the player to sonify a book that starts closed, and then opens, tapping on the right- and left-hand pages, revealing the differences in resonance ensuing from the shifting densities of pages as they are turned. In the new score, Lucier leaves the book closed, calling attention to the potentialities that are conjured within its very materiality, before cracking the spine or turning a page. Lucier has long experimented with the resonant properties of mediating technologies, as his *Music for Solo Performer* (1965) and *I Am Sitting in a Room* (1969) reveal.[63]

Other projects in this volume use the printed page to convey public renditions of experiences that were initially private. Renée Green's *Experience Process* imparts a long-form meditation that the

[62] See Mark Hansen, *Embodying Technesis: Technology Beyond Writing* (Ann Arbor: University of Michigan Press, 2000), 240.

[63] Notably, more recent performances of *I Am Sitting in a Room* used digital delay software instead of the tape recorder specified in the original score, including the performance at MIT on Saturday, September 27, 2014, as part of the public symposium "Seeing/Sounding/Sensing," presented by the Center for Art, Science & Technology (CAST) at MIT, which is available at http://arts.mit.edu/lucier. Lucier's instruction to make "versions that can be performed in real time" in the 1964 score would suggest an interpretation pointing to updated technologies, as they are available and accessible. For publication information, see the credits on page 349 of this volume.

[64] Renée Green, "Other Planes of There," *Yard* 1, no. 1 (Fall 2004). Republished in Renée Green, *Other Planes of There: Selected Writings* (Durham, NC, and London: Duke University Press, 2014), 167.

[65] The public symposium "Seeing/Sounding/Sensing" was presented by the Center for Art, Science & Technology (CAST) at MIT on September 26 and 27, 2014.

artist undertook in response to the themes of our *Experience* book, including writing in her journal. (FIG. 5) The mediations of time and distance between Green's experiences and those that she shepherds for us as readers are folded poetically into her instructions to seek out the sources and implications of evocative, possibly familiar, phrases: "The mechanic unconscious." "Estruturação do self." The printed series of Green's banners designed to surround her text allude to cultural precedents and historical protagonists near to the soul of this volume (including, for example, philosopher John Dewey); they raise the question of which voices from history remain proximate, and how. This is a longstanding consideration by Green, who ruminated in a note of 2004: "We are all born into preexisting networks of meanings and actions. How is it that some are viewed as reshaping what exists and others are viewed as caught within the web of the past? To what degree do these differences in perception have to do with what is granted acceptance by those able to position themselves as spokespeople for what passes as significant? What meanings can be discerned if these questions were deeply probed?"[64]

Some artworks in this book use techniques enabled by the present-day printing press that would have been unimaginable to the radical G-Group of the 1920s, even in their ambitions to push the print medium to its absolute limit. Olafur Eliasson's contribution to the cover of the book uses a thermal ink that reveals a drawing, underneath, when exposed to heat. The ink responds to some touches and temperatures more readily than others. *Experience* the book, like the concept, thus changes in different ways over the course of being handled or exposed to shifting conditions of environment. Carsten Höller's infusions of synthesized human pheromones in his *Smelling Zöllner Stripes* literally bookends our *Experience* with concepts of attraction/repulsion. These multisensorial projects—haptic, tactile, and olfactory—will evade digitized versions of *Experience* that may circulate in PDF or other archival formats, even as the digital may be threaded through their production. Parasitic on, but resistant to, the present-day ubiquity of *digital* reproduction, the projects use very different types of technologies for altering and activating perception than those *photo*-reproductive devices that concerned Benjamin and the theorists of *G*. In so doing, these projects refuse to participate in the "recording society" that artist Tino Sehgal, famous for his own refusals to schematize the experience of his artworks through documentation, characterizes as a "subtype of the Experience Society" in his contribution to this volume.

A number of the artist contributors to *Experience* were presenters in the "Seeing/Sounding/Sensing" symposium that preceded this book, and their text offerings both adumbrate their artist projects for the book, and further develop their conference presentations.[65] Tauba Auerbach's interest in the relational nature of color is noted in her text, and is evoked in *Gradient Flip,* her overlapping bands of

FIGURE 5
Page from Renée Green's notebook, August 9, 2015. Courtesy of the artist.

FIGURE 6
Carsten Höller and François Roche, *Hypothèse de grue*, 2013 ("Crane hypothesis," an allusion to Richard Kellogg Crane's 1960s theory of cellular co-transport of glucose, as well as to the mechanical "crane" devices designed by Roche to disseminate the pheromones). In this work, the compounds were distributed via a smoke machine integrated in a constructed installation, and spread in the gallery space. Metallic structure, bi-resin, fabric, polystyrene, PVC, polyurethane foam, smoke machine, timer and various substances; dimensions variable: maximum length: 196 ½ in. (500 cm) × base 37⅜ in. (95 cm); maximum width: 102⅜ in. (260 cm) × height: 90½ in. (230 cm). This documentation is from the exhibition *Belle Haleine–The scent of art*, Tinguely Museum, Basel, February 11–May 17, 2015.

color tracing the outer margins of these pages. When the book is open, carefully placed swatches of magenta and green are clearly discernable along the edges of the pages. But when it is closed, these inks form a carefully aligned interference pattern along the pages' long edge. Will these complementary colors blend (as they do in merging in the mid-zone), or will their minute separations by the width of a sheet of paper produce iridescent effects? Color is surfaced as an event that occurs in the contingent loci of the eye, the brain, and the configurations of things in the world (in this case, the pages of this book). Artist Tomás Saraceno's work described in this volume similarly trades in events. His text refers to the phenomenon of the "social" spider whose work is enhanced by working with others, or the events of his installation *Space Time Foam* (2012), in which visitors were forced into navigational collaboration as they maneuvered plastic membranes that perpetually shifted in response to the gravity of other bodies in motion. Saraceno also offers a literal centerpiece to the book with the title *Social Strings*. Against illustrations of ink-dipped spider webs "authored" by multiple spiders, Saraceno provides the reader with lengthy "web" strings affixed into the binding and meant for entanglement—between the reader and the book, linking ideas and text, or when used in a proximate tangle with a fellow reader's (copy of) *Experience*.

Artist Carsten Höller's work for this book also reflects social experience. Höller completed a doctorate in agricultural science at the University of Kiel, where he researched insect pheromones, and continues to work on olfactory communication and responses to pheromones in his artwork. (FIG. 6) In the famous pattern illusion on the book's endpapers, Höller has directed the printers to embed

synthesized versions of the human endocrine compounds Estratetraenol in the front, and Androstadienone in the back. While the status of human pheromones—animal signaling systems conveyed through odor—may be contested within scientific literature, popular beliefs hold that these compounds in mammalian sweat differentially attract, dependent upon sexual orientation. The social, political, cultural, and identity-hedged realities that frame the encounter of these compounds and their contribution (or lack thereof) to attraction in "lived experience" may be hard to sense in these paper-based infusions—but mental activity fills in many gaps in human sexual attraction.[66] It is possible that isolating perception to its elemental aspects may draw more attention to its actual contingencies (or, that you will simply helplessly *love* this book). Bruno Latour attends to another humanly imperceptible phenomenon in the complex theater work about climate change, *Gaïa Global Circus*. An excerpt from that theatrical production closes our book, followed on the back cover by Olafur Eliasson's *See-through compass*, which (repeatedly) enacts the exposure of a planet, spinning on its axis, as the heat sensitive overlay of the book cover is warmed. The world is framed as a proposition both inflected by and revealed to perception through the actions of humans, who may desire to train sensitivity to durations of change consequential on a planetary scale.

What is the pursuit of aesthetics, if not a willing mediation of experience through indulgence in the sensory? In the many thoughtful experience-mediations afforded to us by the artist projects in this book, as well as its overarching design by Kimberly Varella of Content Object Design Studio, experience emerges as a complicated nexus of the perceptual, the social, the inherent, the learned, the familiar, the untenable, and the possible. If experience, for better or worse, has has become a fungible object of commercial enterprise and the art world, it is a pleasure here to confront the topic from alternative approaches—to think and learn through the problematic conditions of experience and its conveyance through a broad range of critical sensory apparatuses—extending a tradition of print-based artistic mediations of experience for present-day subjectivities.

[66] The medical history of gender and attraction entails an entangled narrative of physio-cultural control and normative types. For one such history about synthetic hormone treatment as a "remedy" for lesbianism, and an overview of the racial politics of midcentury endocrinology, see David Serlin, *Replaceable You: Engineering the Body in Postwar America*, particularly chapter 3, "Gladys Bentley and the Cadillac of Hormones" (Chicago and London: University of Chicago Press, 2004), 111–58.

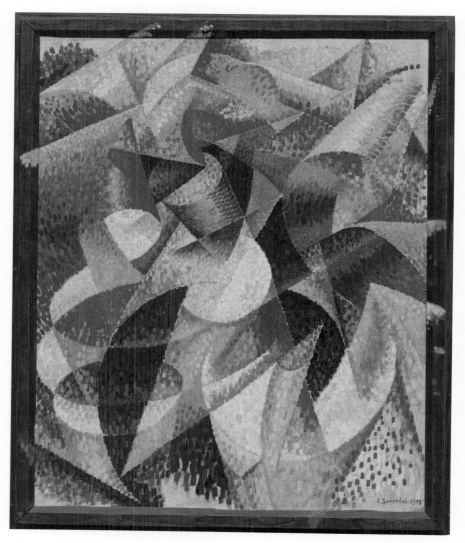

FIG. 1

ANALOGIES
David Mather

In early 1914, the Paris-based Italian Futurist painter Gino Severini coined the term *plastic analogies* to describe a method for representing modern perceptual experience. He did not intend these analogies to correspond with everyday perception, or with its conventional representations. Rather, he meant that an artist's knowledge, particularly firsthand, sensory knowledge, could be translated into any of the so-called plastic arts, so a viewer interacting with works of art could access experiential content directly from the forms.[1] Visual art, in his estimation, possessed a new, analogical way to communicate through three interrelated phenomena: an experiential source; a process by which it could be faithfully, but non-naturalistically transcribed; and someone other than the maker to interpret the result. Any referential literalness resulting from the visual recognition of artistic forms would only disguise the complex conceptual and cognitive processes that would otherwise enable the viewer to make sense of correspondences among sensory qualities, physical materials, and their meanings.

The key phrase *plastic analogies* first appeared in January 1914, though the artist used similar formulations in earlier texts to refer to "the plastic equivalent of reality" or to describe rendering sensation "in the plastic manner."[2] Initially, this phrase referred to imagistic composites that combined two or more symbolic forms into a single image.[3] For instance, Severini created the abstract geometric painting *Sea=Dancer* (1914) (FIG. 1), with the title specifying the linguistic or symbolic dimension of an analogy between a geographic feature and a moving human body. Yet these phenomena are not distinguishable in the work, and the artist even indicated that this particular composite accurately resembled neither, but evoked both.[4] What represents the analogous experiences of sea-undulations and dancer-gyrations are the chromatic and tonal modulations of semiopaque shapes, which, for a spectator, should connote expenditures of kinetic force analogous to both. Through this visual-kinetic approach, which had been inspired by the Cubists' fragmentation of the visual plane, Severini's artworks were created to expand the perception of human experience in a modern world—to refashion modern subjectivity.

Western notions of subjectivity were in crisis at the turn of the 20th century, in response to experiential conditions of modernity.

FIGURE 1
Gino Severini, *Sea=Dancer (Mare= Ballerina)*, 1914, oil on canvas with artist's painted frame; frame: 41½ × 33¹³⁄₁₆ in. (105.3 × 85.9 cm); canvas: 39⅜ × 31¹¹⁄₁₆ in. (100 × 80.5 cm). The Solomon R. Guggenheim Foundation, Peggy Guggenheim Collection, Venice, 1976; 76.2553.32.

1
Gino Severini, "The Plastic Analogies of Dynamism: Futurist Manifesto," reprinted in translation in Umbro Apollonio, ed., *Futurist Manifestos* (Boston: MFA Publications, 2009; originally published by The Viking Press in 1973), 118–25. This text is dated to December 1913–January 1914, however, because Marinetti declined to publish it, the text was only published late in Severini's life; see Maria Drudi Gambillo and Teresa Fiori, eds., *Archivi del Futurismo*, vol. 1 (Rome: DeLuca, 1958), 76–80.

2
An early version of the manifesto states: "The plastic equivalent of reality is then the simultaneous expression of emotive forms + designed forms." Gino Severini, "Le Grand art religieux du XXème siècle" (ca. August–September 1913; unpublished during his life), printed in *Luce + velocità + rumore: La città futurista di Gino Severini*, ed. Daniela Fonti, exh. cat. (Rome: Auditorium Parco della Musica and Skira, 2005), 42–43; my translation. In addition, his exhibition catalogue essay from April 1913 reads: "I believe that every sensation may be rendered in the plastic manner." See Gino Severini, "Introduction," *The Futurist Painter Gino Severini Exhibits His Latest Works* (London: Marlborough Gallery, 1913), 7.

3

This method was quite similar to the one Filippo Tommaso Marinetti recommended for literary texts: "The analogical style is thus absolute master of all matter and its intense life" (Filippo Tommaso Marinetti, "Technical Manifesto of Literature," 1912; reprinted in translation in Marinetti, *Critical Writings*, ed. Günther Berghaus [New York: Farrar, Straus and Giroux, 2006], 109). In "Destruction of Syntax–Untrammeled Imagination–Words-in-Freedom" (dated May 1913; published June 1913), Marinetti described how a friend, after an intense experience, "will breathlessly fling his visual, auditory, and olfactory impressions at your nerve ends, precisely as they strike him. . . . He will hurl huge networks of analogy at the world" (reprinted in translation in *Critical Writings*, 123). For further discussion of Marinetti's literary mode of analogization, see Cinzia Blum, *The Other Modernism* (Berkeley: University of California Press, 1996), 46.

4

In "Plastic Analogies," Severini refers to the analogy of sea and dancer, even though he likely meant works on paper that precede the painting mentioned here. Severini, "Plastic Analogies," 121.

5

Historian Martin Jay gives a riveting historical account of the kinds of questions asked about subjectivity and experience in his book *Songs of Experience: Modern American and European Variations on a Universal Theme* (Berkeley: University of California Press, 2005). For interconnected moments in this early 20th-century crisis of subjectivity, see ibid., chapter 7, "The Cult of Experience in American Pragmatism," and chapter 8, "Lamenting the Crisis of Experience."

6

On the "openness to the world" through which subjective interiors and exteriors blurred, see ibid., 360, 402, and 408.

7

After marrying Jeanne Fort in Paris in late August 1913, Severini left with her to visit the artist's family for three months in Pienza, Italy. From there, they departed in December for Anzio, Italy, where they spent six months due to the artist's poor health; this is where Severini completed work on his manifesto "Plastic Analogies." (cont. on facing page)

This crisis was not the product of new technology per se, despite coinciding with rapid technological invention.[5] Rather, it comprised a set of perceptual and philosophical conundrums that, in effect, rendered the boundaries of individuality itself problematic. Where does an individual end and the world begin? Will such distinctions apply in the future? Whether defined spatially, temporally, or metaphysically, the modern subject was constituted amid growing awareness of its intrinsic "openness to the world."[6] This new mode of self-awareness conspicuously implicated the senses, which were also being recast as opening onto that which was more than, or other than, the limits of the human. During the late 19th and early 20th centuries, vanguard European painters, including the Futurists, aimed to capture the experiences associated with modernity, and particularly urban life, through a range of non-naturalistic tendencies: initially foregrounding the fleeting or intoxicating qualities of visual perception, they shifted to consider other, nonvisual aspects of their experiences. Even within the artistic community that embraced Futurism, ideas would change considerably from 1910 to 1914, as an initial interest in literal forms of referentiality would give way to an emphasis on corporeal experience and, eventually, to an examination of forms devoid of identifiable referents. Although many avant-garde artists examined diverse implications of non-normative perception, the Futurists remained largely focused on conveying sensorial and bodily intensities, which exist outside of the conventional representations of everyday perception.

Shortly after authoring the first version of his manifesto on plastic analogies, Severini initiated a group of paintings and works on paper to directly manifest this idea. Completed during a 12-month period spent in Italy with his new wife, Jeanne, these visually abstract Futurist works made between the autumns of 1913 and 1914 are among the most significant of this movement's initial phase.[7] Particularly when interpreted alongside the artist's writings, Severini's compositions allude to experiences rooted in the senses, but they also point to a realm beyond the historically defined limits of perception. How his works end up eluding normative perception will emerge in this text, but a provisional answer would be through their renderings of non-sensory or imperceptible data. Even as these works appear frequently in contemporary exhibitions and in reproductions, they have not attracted the kind of sustained critical attention that would firmly establish their place within one of the central narratives of early 20th-century European visual art: the emergence of abstraction.

Although diverse, idiosyncratic, and at times unrelated practices of modernist painting are typically gathered together under a unifying *telos* of visual abstraction, the common, if often unstated, premise motivating these painters—from French Impressionism onward—was a desire to represent the conditions of perception outside of naturalistic themes and techniques.[8] Early 20th-century

I. OPENING

artists of various stripes came up with different answers to what these perceptual conditions might be: Pablo Picasso investigated compressed spatiality within the visual plane; Robert Delaunay found interest in optical effects translated into pigment; František Kupka and Wassily Kandinsky both courted the spiritual connotations of color and form; Kazimir Malevich and El Lissitzky invented highly rational, geometric patterns that could guide the formation of a new society. By moving away from more literal forms of visual reference, vanguard painters mostly attempted to depict phenomena in ways other than they might appear to the unaided or unaffected senses. Many of them also developed their own repertoires of verbal explanations, thus offering striking supplements to any formal or contextual analyses of their works, despite the conceptual divide between words and images. While an interest in the complex intertwining of experiences, representations, and spectatorship was neither unique to Severini nor limited to the Italian Futurists, his visual and textual practices may be productively distinguished from those of other abstract artists prior to World War I. For his part, Severini explored visual perception by putting bodily experience front and center—until the internal logic of his visual system briefly, but crucially, moved outside the body altogether.

The significance of early Italian Futurist visual art has been the subject of vigorous debate ever since the group's first exhibition of paintings in Paris in 1912. Published reviews included one by the French poet and critic Guillaume Apollinaire, who noted the Futurists' desire to paint moods, as well as their seeming disinterest in "plastic problems," while other critics described their works as cinematographic or mechanical.[9] Overall, their methods were considered more literal or less conceptually rigorous than those associated with other avant-garde movements, such as Cubism, Orphism, and, later, Dadaism. Likewise, their wide-ranging and breathlessly profuse texts can be, at times, self-contradictory and overly speculative, and they were mocked for theorizing the meaning of their own works in public events or published manifestos and other writings.[10] Perhaps most problematically, the Futurists exhibited loud, aggressive, and violently nationalistic behaviors at art openings and during the variety shows they organized, vociferously intervening in sociopolitical and artistic circles in Italy and around Europe.[11] The prevalent historical focus on these aspects of the movement highlights certain historical truths, but in so doing may deny or obscure the more conceptually challenging features of this movement's initial phase, which opened productive areas for visual thinking alongside, or in spite of, their nationalist rhetoric and behaviors, disruptive sociopolitical tactics, and bitter interpersonal rivalries.

As something of a reluctant Futurist, Severini did not display the same aggressive tendencies as his colleagues from Milan. When the other Futurists visited him in Paris, he noted their "materialistic exhibitionism" and their aversion to "the serious problems posed

Then the couple traveled north to Montepulciano, remaining there for most of an additional four months.

8
Hubert Damisch recently posed this problem of historicizing visual abstraction in early 20th-century art: "How does something with the appearance of a concept come to sink into, become an integral part of, what art, and most of all painting, gives us to see?" Hubert Damisch, "On the Move," in *Inventing Abstraction 1910–1925: How a Radical Idea Changed Modern* Art, ed. Matthew Afron, et al. (New York: Museum of Modern Art, 2013), 72.

9
Guillaume Apollinaire, "Chroniques d'art: Les futuristes," *Le Petit Bleu* (February 9, 1912); reprinted in *Apollinaire on Art: Essays and Reviews, 1902–1918*, reprint edition (Boston: MFA Publications, 2001), 203. Apollinaire's phrases "plastic problems" and "purely plastic concerns" very likely informed Severini's language and artistic development. Even as the Futurist painters represented motion visually, the term *cinematographic* was used to disparage their works, because this mechanical apparatus was considered, at that time, too literal and mechanistic in its representation of the world. See Roger Allard, "Les Beaux Arts," *La Revue indépendante*, no. 3 (August 1911): 134; and Henri des Pruraux, "Il soggetto nella pittura," *La Voce* 4, no. 44 (October 31, 1912): 13.

10
In his autobiography, Severini noted that Picasso detested the Futurists' debates about painting. Gino Severini, *The Life of a Painter*, trans. Jennifer D. Franchina (Princeton, NJ: Princeton University Press, 1995), 93. For more on Parisians' dislike of the Italian Futurists, see Gertrude Stein, *Autobiography of Alice B. Toklas* (1933); and a letter by Baroness d'Oettingen to Ardengo Soffici in 1912 (cited in Severini, *The Life of a Painter*, 97).

11
Severini mentions an unfortunate antagonism that his fellow early Futurists felt toward the Parisian art world. Severini, *The Life of a Painter*, 143; see also pages 93–94 and 123.

by art."[12] Despite these philosophical differences—exacerbated by geographic distance—he figured prominently in early Futurist efforts to probe the nature and limits of visual expression. His images and texts from autumn 1913 to spring 1914—those most closely associated with plastic analogies—came as the culmination of his research on how to visually represent corporeal experience. If one asks, "To what do these analogies refer?," the answer rests initially with a focus on the visceral and corporeal register of lived experiences, flooded with sensory stimuli. But in his later analogical works Severini probed a more general set of conditions—beyond the limitations of bodily connotations—signaling the transcription of practically anything into colored pigment. To appreciate the vast conceptual range articulated by his analogies, it can be useful to review the primary formal and conceptual avenues that defined Futurist radicalism up to this point: speed and sensation. Although not entirely separable, these avenues constituted two variations on the same experiential-transcriptional thematic, which were attuned to the sociohistorical problem of what it meant to be modern. Severini's plastic analogies originated in the wake of these other approaches.

Emerging in and through the processes of scientific and technological innovation, speed effectuated a new conceptualization of society and, according to Severini, it produced an altered perception of all types of phenomena—biological, experiential, physical, social, and historical.[13] This new reality of speed, of course, figured prominently in the founding of Italian Futurism in 1909—in the guise of bestial automobiles devouring space-time, followed by one careening into a muddy ditch outside a factory in Milan.[14] This was an originary moment for Futurist analogization: modern society was akin to a vehicle speeding out of control or, more specifically, to a vehicle whose velocity extended, and then abruptly affirmed, the limits of human control. The new subjects of this modernity could only partially modulate its chaotic processes; its excesses were otherwise constructed as exhilarating *experience*. Linked by Futurist poet and founder Filippo Tommaso Marinetti to excitement, danger, improvisation, and violence, all of which were qualities of the Futurist sensibility, speed had disrupted traditional ways of life, and the Futurists embraced it unflinchingly.[15] Yet, this seductive narrative of Futurist enthrallment with automobiles and other means of transportation measures only the most literal contours of their subject matter. Alongside references to kinetic apparatuses, their visual experiments moved steadily away from representing discrete objects and toward emphasizing sensorial qualities—what it felt like to experience the rapid and unsettling forces of modernization.

The trajectory from concrete references to the direct stimulation of the senses can be observed most clearly in the work of Giacomo Balla from 1911 to 1914. His sketches of automobiles started as fairly representational drawings, but he progressively abstracted his works until their specific referents became obscured. The resulting

12
Ibid., 93–94.

13
Severini noted: "Indeed, one of the effects of science that has transformed our sensibility and led to the majority of our Futurist discoveries is *speed*. Speed has given us a new conception of space and time, and consequently of life itself." Severini, "Plastic Analogies," 124–25. For a historical account of the perceptual effects of speed, see Wolfgang Schivelbusch, *The Railway Journey: The Industrialization of Time and Space in the Nineteenth Century* (Berkeley: University of California Press, 2014); see also Stephen Kern, *The Culture of Time and Space: 1880–1918* (Cambridge, MA: Harvard University Press, 2003).

14
Filippo Tommaso Marinetti, "The Founding and Manifesto of Futurism" (February 1909), reprinted in translation in Marinetti, *Critical Writings*, 11–16.

15
Filippo Tommaso Marinetti, "Destruction of Syntax—Untrammeled Imagination—Words in Freedom" (May–June 1913), reprinted in translation in Marinetti, *Critical Writings*, 120–23.

16
Among other scholars, Giovanni Lista has discussed the influence on Balla of Marey. Giovanni Lista, *Balla: Catalogue Raisonné* (Milan: Galleria Fonte d'Abisso, 1982), 45–47. Along with the photographic devices, Marey developed other instruments for recording human and animal processes, such as his plethysmograph and sphysmograph, which became part of a larger technical ensemble for analyzing life in motion.

17
See Marta Braun, *Picturing Time: The Work of Etienne-Jules Marey (1830–1904)* (Chicago: University of Chicago Press, 1992).

18
Severini, "Introduction," *Futurist Painter*, 7.

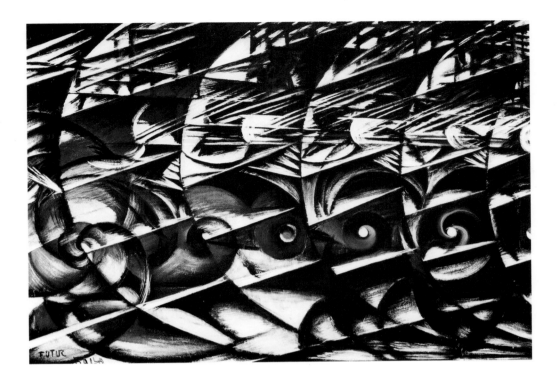

FIGURE 2
Giacomo Balla, *Abstract Speed*, 1913, oil on canvas. Private collection.

visual patterns highlight the visual and auditory sensations associated with vehicles observed from the side of the road. In *Abstract Speed* (1913) (FIG. 2), the moving object is unrecognizable within a field of superimposed glints and sonic reverberations that shudder across the frame. Unlike examples by other visual artists working within an abstract idiom, this type of kinetic abstraction grew directly from physical phenomena. The underlying idea was that a sensitive medium could register the indexical traces of moving objects—a method heavily indebted to the French physiologist Étienne-Jules Marey's chronophotography.[16] If the engine supplied the kinetic impetus for this image, the photographic camera was equally implicated in Balla's idea to transcribe kinetic sensations onto a flat surface as repetitive, sequential patterns.[17] Yet, even as technical instrumentation informed early Futurist images of modern life, the artists of this movement were increasingly interested in the role played by psychophysiological mechanisms for apprehending the underlying truths of experience.

For Severini, Balla, and other Futurists, this inquiry involved researching how to transcribe experiences while abandoning identifiable or symbolic forms. In April 1913, Severini contended that visual forms no longer needed to be fixed: "Since the forms which we perceive in space, and which our sensibility apprehends, undergo incessant change and renewal, how are we to determine beforehand the manner in which these forms should be plastically expressed?"[18]

19

Ibid.

20

Bergson's vitalist philosophy was a prominent source for the Futurists as they theorized their own image-making practices. Boccioni made notes on Bergson's philosophical concepts, and even transcribed passages from his text *Matter and Memory* (1899). Getty Research Institute, accession #880380, box 3, folder 29. According to art historian Linda Dalrymple Henderson, Lodge's ideas on the ether of space and an "electric theory of matter" were widely circulated in Italy, and Boccioni referred to the latter in his book *Futurist Painting and Sculpture* (1914); I am grateful to her for making me aware of this important historical connection. Henderson makes the case for the importance of ether to Boccioni in "Cubism, Futurism, and Ether Physics in the Early Twentieth Century," *Science in Context* 17, no. 4 (2004): 445–58.

21

The same underlying idea recurs in other philosophical works of this period, such as in William James's work on radical empiricism, authored in the first decade of the 20th century (one of his essays on this topic is reprinted in this volume), and in Edmund Husserl's phenomenological investigations, drafted initially in 1912 (an excerpt is reprinted in this volume). Another prominent version of this corporeal interrelation between the subject and the world would be expressed years later in Maurice Merleau-Ponty's elegant phrase "flesh of the world." Maurice Merleau-Ponty, *The Visible and the Invisible* (Evanston, IL: Northwestern University Press, 1968), 84, 123, 144, and 248–51.

22

See *Gino Severini: The Dance, 1909–1916*, exh. cat. (Milan: Skira, 2001), published in conjunction with the exhibition of the same name curated by Daniela Fonti at the Peggy Guggenheim Collection, Venice, May to October 2001.

23

For Severini, the vitalistic human body seemed to be a sensitive material for translating experience into other, artistic mediums: "The obsession to penetrate, to conquer the sense of reality with all mediums, and to identify with life through every fiber of our body, is always the basis of our research." Gino Severini, "La peintre (cont. on facing page)

So, these Futurist tracings of physical or kinetic motion were meant to trigger feelings of momentous historical and societal change. This materialization of a new Futurist visuality aspired to total perceptual inclusiveness: "I believe that every sensation may be rendered in the plastic manner."[19] As his research progressed over the course of 1913, tangible figures of physical motion dissolved into more abstracted, non-referential forms. This dissolution predicated a further rethinking of sensory perceptions in relation to their bodily framing as well as the visual mediums used to represent them. Initially, then, Severini's "plastic manner" emerged as a method for using colored pigments to represent—by analogy—other sensory, somatosensory, and sensorimotor stimuli.

Balla began to explore the visual effects of vehicular speed, but other early Futurists emphasized the movement and vitality of the human body. As much as the work of art, the body exhibited a propensity to adapt to its environment. It could function as a sensitive instrument for measuring the effects of widespread societal change. Severini and his close friend Umberto Boccioni, in particular, investigated ways of depicting the capacity of human corporeality to

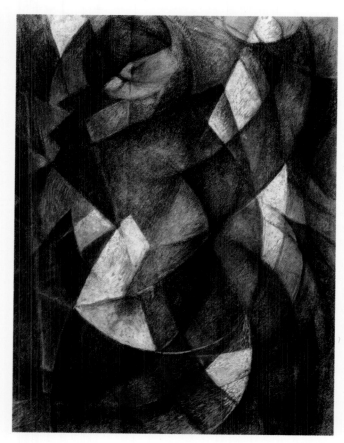

FIG. 3

register conditions that had been overlooked by earlier pictorial systems. Under the intellectual influences of philosopher Henri Bergson and physicist Oliver Lodge, the Futurists held human physicality to exist in a continuum uniting internal and external forces—that is, in the *continuity* from the most intrinsic human qualities to the furthest extent of our understanding of nature.[20] Given that internal and external processes were connected in this way, a human body was bound to express immaterial, imperceptible, or even metaphysical forces.[21] Severini began with dancers, such as those who performed regularly at the cafes and nightclubs he frequented.[22] In *The Blue Dancer* (1913) (FIG. 3), a monochromatic collection of contiguous geometric planes creates syncopated visual rhythms equated with the sensorimotor and somatomotor forces of a freely moving body. Boccioni, by contrast, focused on the psychophysical exertions of athletes—imagined as churning visceral masses of countervailing forces, whether playing sports or modeling a general template for the human spirit-body in motion. His open-ended figure in *Muscular Dynamism* (1913) (FIG. 4) maps the frenetic indeterminacy the artist associated with a modern subject's free will. Extending the figure past the edge of the frame was one of various techniques for indicating what unseen forces might transcend the material envelope of human existence.

For both artists, the Futurist body-in-motion amounted to more than empiricism's disparate collection of sensory data and more than rationalism's corporeal locale within which ideation transpires; rather, it composes a vitalist–material ensemble stretching between and integrating these distinct kinds of understanding: sensation and ideation. In terms of referentiality, the Futurists' visual systems shifted from external observable phenomena to internal conditions of perception, and, from there, to the psychophysical mediums that bridge external and internal processes.[23] Hovering in this continuum between internal and external phenomena meant becoming disassociated from a well-defined anatomy. The semiabstracted Futurist body inhabited a wide network of interrelated forces in the world and in the universe, signaling a cosmic interconnectivity that was not spiritual so much as it was visceral and experiential.[24] The new subject born of modernity had emerged into an accelerated and accelerating pace of modern life, and this experience could be transcribed visually and tactually.

For Severini, plastic analogies initially began by presenting an embodied and purely visceral subject, which appeared amid the composites of multiple symbols, as noted earlier. So when he returned to the dancing theme in *Sea=Dancer* (SEE FIG. 1), the artist further blurred the distinction between fore-, middle-, and background, and also transformed all the figural features into interlocking geometric planes. To locate the semblance of a figural outline, one can follow the vertical pink form ascending from the center-bottom of the frame, symbolizing a leg that converges with another long

FIG. 4

FIGURE 3 (FACING)
Gino Severini, *The Blue Dancer*, 1913, oil on canvas. Private collection.

FIGURE 4
Umberto Boccioni, *Muscular Dynamism*, 1913, pastel and charcoal on paper, 34 × 23¼ in. (86.3 × 59 cm). Museum of Modern Art, New York.

d'avant-garde: Le Machinisme et l'Art; Reconstruction de l'Univers," *Mercure de France* (June 1, 1917), reprinted in Severini, *Écrits sur l'art* (Paris: Éditions Cercle d'Art, 1987), 80, my translation. In *Matter and Memory* (1896), Bergson gives a similar description of the body as a central image of attention, to which all other images are conditioned. Henri Bergson, *Matter and Memory* (New York: Zone Books, 1988), 25.

24
This cosmic interconnectivity did not imply an interest in spiritualist practices. However, the Bragaglia brothers, who were briefly aligned with Futurism, used photography to picture human figures in motion, and their works were more explicitly linked to theosophical spiritualism and spirit photography. Even as the works of Balla, Severini, Boccioni, and Carrà became abstracted from painterly conventions (e.g., chiaroscuro shading), each sought to establish, each in his own way, formal and conceptual approaches to the complicated relationship between visual elements and sensory data.

blue form at a yellow circular pelvis, above which a torso of mixed shapes and colors—crowned with a head of yellow—dips to the left while rising to the right. Visual motion across this ensemble conveys the dancer's punctuated pose to the viewer's eye. Each plane is intensely colored with a distinct, bright hue that fluctuates tonally in relation to adjacent areas—vestigial volumetric shading in a more naturalistic vein. Implicit within this chromatic geometry is the play between straight and curved edges, as well as the adjacent pairing of complementary hues: red–green, orange–blue, and violet–yellow. While his plastic analogies *could* refer to bodily sources, as with the dancers, they were on their way to becoming free of the body's limits.

By the start of 1914, Severini's project for transcribing sensations went beyond what we typically associate with human perception. He conjectured: "[The artwork] encloses the universe in an enormously vast circle of analogies."[25] Extending the idea of cosmic interconnectivity, this extreme conceptual openness manifested a revised version of plastic analogies that would be more abstracted than his first analogical technique of compositing two or more discrete phenomena. The plastic method could now represent conditions or relationships that did not require direct sensory confirmation—visual forms could suggest qualities associated with anything comprehensible, not just those that are sensible.

But, while leaving the realm of embodied representation, Severini's images were not beyond reality. These visually abstract paintings involved a kind of realism or otherwise referred to reality, since the artist repeatedly mentioned a "need for absolute realism" and "a complex form of realism," necessarily different from objective or exterior realms.[26] For him, the abstracted image was no less connected to reality than a directly referential representation.[27] Art was linked "to the whole Universe, that is to say to all phenomena that are not really separate and that belong to the realm of our knowledge without any concept of time and space."[28] Similarly, Severini framed his artistic efforts as part of a wider goal to expand experience and knowledge: "Our universality derives from direct sense of that life that we possess through science and scientific philosophy."[29] By making his artistic process available to a much wider field of experience, Severini could now reconceptualize his compositional method to depict non-sensory and supersensible data—that which exists outside of what can be perceived. Around this time, he, like the other Futurists, began to use titles that were more conceptually advanced and less anchored by references to things or persons in the world.

An important series of paintings from the end of 1913 and early 1914 moved toward this widening network of analogies. The titles of these works share permutations of the phrase *spherical expansion of light*, referring to an idea Severini borrowed from fellow Futurist Carlo Carrà, who produced emanating, luminous patterns as visual analogies evoking the internal forces of material phenomena.[30] In

25 Severini, "Plastic Analogies," 121.

26 See ibid., 124; Severini, untitled essay, *Futurist Painter*, 7. In a text from 1917 (his last year as a Futurist), he transformed Emile Zola's well-known phrase "the sense of reality" into a call for representations without naturalism. The phrase, used originally to affirm specific historical and material conditions in an artwork (i.e., the novel), first appeared in Zola's article "Le sens du réel," *Le Voltaire* (August 20, 1878), and was republished in *Le Roman expérimental* (Paris: G. Charpentier, 1880). Like Zola, Severini deemphasized the role of pure artistic imagination when responding to his era's achievements. Severini, "La peinture d'avant-garde," in *Écrits sur l'art* (Paris: Éditions Cercle d'Art, 1987), 84, my translation.

27 Elsewhere, he writes: "For our art does not want to represent a *fiction* of reality, but wants to express this reality as it is" (Severini, "La peinture d'avant-garde," 92). Emphasis in the original, my translation.

28 In a French newspaper article in 1917, Severini affirmed that an artist can apprehend the world outside of immediate appearances: "the role of our modern art is to search and to set the direction, the finality, the extent of the phenomena, linking to the whole Universe." See Severini, "La peintre d'avant-garde," 92, my translation.

29 Severini, "Symbolisme plastique et symbolism littéraire," *Mercure de France* (February 1, 1916), reprinted in *Écrits sur l'art*, 68, my translation.

30 Severini, "Plastic Analogies," 124. The term *spherical expansion* appeared first in Carlo Carrà's manifesto "Plastic Planes as Spherical Expansions in Space" (published in March 1913 in the Italian Futurist journal *Lacerba*), and was later reiterated in Carrà's "Painting of Sounds, Noises, and Smells" (August 1913 in *Lacerba*).

FIGURE 5
Gino Severini, *Spherical Expansion of Light: Centrifugal*, 1913–14, oil on canvas. Private collection.

31
This type of tonal distribution of colors (light–dark and light–dark) is part of a chromatic theory attributing abstract qualities (even moral significance) to this polarity, as in Johann Wolfgang von Goethe's *Theory of Colors* (1810) and Wassily Kandinsky's *Concerning the Spiritual in Art* (originally published 1912).

32
Severini, "Plastic Analogies," 124: "Painting and modelling forms, other than with the entire spectrum of colours, would mean suppressing one of the sources of life in the object, that of irradiation." He also discusses the prismatic palette in his autobiography; Severini, *The Life of a Painter*, 138.

this later series, opposing colors are no longer emphasized through adjacency—a major difference from Severini's earlier analogical composites. Rather, bright hues are arranged in a prismatic sequence, forming a tonal progression from light to dark, from yellow through orange, red, and violet to blue (with green largely absent).[31] For the artist, this spectrum produced a powerful analog he termed *irradiation*, indicating the presence of any given phenomena beyond vision and the other senses. With less specificity than *Sea=Dancer*, these irradiating spectral hues manifested the second, universalizing mode in his evolving system of plastic analogies.[32] In *Spherical Expansion of Light: Centrifugal* (1913–14) (FIG. 5), for example, yellow marks on the white ground compose a center surrounded by adjacent forms of orange and red extending to violet, blue, and black near the edges; in the companion piece, *Spherical Expansion of Light: Centripetal* (1913–14), the center is dark blue and black with radiating bands of violet, red, and (in a single instance at the bottom of the image) red-orange. The artist's tonally determined chromatic arrangements align the radiating properties of energetic luminescence with perceptual experience in a much broader sense. Above all, Severini's paired subtitles—*Centrifugal* and *Centripetal*—refer to countervailing *forces* that configure an abstract binary relationship,

FIGURE 6
Gino Severini, *Spherical Expansion of Light (Centripetal and Centrifugal)* [*Expansion spherique de la lumière (Centripede et Centrifuge)*], ca. 1914, oil on canvas, 24 1/16 × 19 11/16 in. (61.1 × 50 cm). Munson-Williams-Proctor Arts Institute, Utica, NY.

rather than being attached to specific bodies, geographical features, or even concrete referents.

If Severini's theory of spherical expansion asserts a method for representing forces, what is actually pictured in the corresponding images? To what do these plastic analogies refer, if anything, whether tangible or intangible, external or internal, sensory or extra-sensory? Devoid of referential symbols, the geometric prismatic paintings apparently indicate a systematic pattern of perturbation. The series constructs a new vocabulary for mapping diverse kinds of forces, bringing them *by analogy* into the range of human vision. There may also be a physiological dimension to these analogies. *Centrifugal*'s expansion may suggest the movement of a stimulus propagating outward and triggering a nervous response that decays over time, while *Centripetal*'s dark center may evoke a neural circuit at the moment it consciously or unconsciously inhibits a nervous response to stimuli. Such a somatosensory interpretation is, in fact, supported in the artist's writings. In a text published a few years after these paintings, the artist used the terms *centripetal* and *centrifugal* to describe nerves moving either toward or away from the spinal column (now called *afferent* or *efferent* nerves).[33] The spectrum of adjacent pigments in these works thus manifests a useful visual analogy for the course of energetic stimuli as refracted through the "prism" of the human mind-body.

Even as these images with abstract titles may be read as analogies of bodily and neuronal experiences—phases of dynamic flux within a moving or dancing body—such categorical specificity appears to defy Severini's broader claim of universal translation beyond the perceiving individual. This seeming contradiction is typical of the visual and conceptual riddle Severini put forward: How could an image claiming to denote generalized phenomena (such as a cosmological event) also connote the more specific category of bodily activities (such as dancing)? The solution lies with shifting or conditional referentiality: even if his countervailing prismatic progressions *could* indicate bodily sources, they are no longer *necessarily* embodied, as were his dancers. In the development from moving figures to sensory perceptions and then to generalized energies, Severini aimed to increase the field of perception, while avoiding concreteness and specificity. This desire to generalize subjected the referential process to a wider network of associations, or plastic analogies, within which embodied perception functioned as one aspect of cosmic interconnectivity. Paradoxically, his richly textured depictions of experiential sensations articulated a visual logic that gestured toward a parallel world of conditions beyond the senses. This exhilarating dialectic between embodiment and supersensible interconnectivity ran strongly through Severini's pre–World War I painting.

The synthesis of the countervailing forces would come in *Spherical Expansion of Light: Centripetal and Centrifugal* (1914). (FIG. 6) Here, the artist interposed both types of tonal-chromatic progression (i.e., light-to-dark and dark-to-light), and the resulting prismatic patterns rotate around dark, light, and mid-range circles. Bounding these curvilinear forms are multicolored, rectilinear edges that appear mobile and scintillating, as with bouncing or refracting rays of light. Notably, the paint strokes lighten in hue as they radiate from each saturated edge, and this desaturation implies energetic force rather than any shading or highlighting of material surfaces. Their luminescence may mislead, however. These energetic emanations, while behaving *like* light, do not directly refer to light, but stand in for something else. Remember, they were intended as analogies, though it is not obvious what they analogize. Assuming these forms can refer to specific bodily sensations, this visual synthesis might connote the inward and outward fluxes of neuronal processes and other nervous system activity—a full complement of afferent and efferent firings. But, the expansion may not be literal, spatial, or embodied at all, but rather conceptual—endemic to a process of translation that can encode all manner of stimuli into the visible spectrum. For the early Futurists, conceptualizing such a highly adaptable chromatic logic of potentially infinite capacity for transcription was mind-expanding.

In his work, Severini deployed plastic forms as visual analogies for other types of sensory data—sonic, olfactory, tactile, kinesthetic, or proprioceptive. For instance, he noted: "Noise and sounds . . .

33 He refers to "our centripetal nerves" and "the centrifugal or motor nerves." Severini, "La peinture d'avant-garde," 83, my translation. Even today, the term *centrifugal* does not refer to a literal, physical force but rather to the perceptual effect produced by a material responding to centripetal force; it was a widely (but erroneously) paired with *centripetal* in the field of physics, though they can also function as a linguistic analogy for all manner of binaries, scientific or otherwise.

may be translated through forms."[34] For Severini (like Balla), auditory data could be made visible in the plastic domain of painting. In this sense, the *Spherical Expansion* pictures could analogize that which originated beyond the normative limits of sight—and perhaps even beyond the senses themselves. In a similar vein, transcribing diverse nonvisual inputs into a visual medium may suggest synesthesia, the neural condition that has historically been an irresistible creative analogy for indicating another reality—a cosmos unified at a higher level of cognition. Because Severini's concept of visual or plastic analogies covered such a wide range of sensory and somatomotor modalities, we might conclude that his luminous paintings instigate a mode of abstraction not limited to any specific qualities of sensation or perception. The colors do not represent light, but analogize energetic patterns that may or may not even refer to aspects of human perception. Thus, even as vehicular speed and bodily sensations were originally central to Futurist experimentation, several artists—Severini, Balla, and Boccioni—pioneered a method that presumed sensitivity outside normative human perception.

Along with expressing a sense of deeper reality, Severini gravitated toward a prevalent idea that additional dimensions of reality transcend the three perceivable spatial dimensions.[35] In fact, he wanted "to create new dimensions," an idea that fits into a more generalized tendency within modernist abstract painting that presumed the existence of phenomena beyond the visually defined spatial dimensions.[36] According to Severini, painters could use colors and forms to express other, nonvisual sensations—which he called fourth or fifth dimensions.[37] Severini's approach to representations of non-sensory phenomena suggests he believed that visually concrete, conceptually abstracted images were not limited to existing definitions of perception and understanding. He claimed to reveal "these intellectual events and these new objects" that can "exist virtually" and can refer to "a hyper-space" outside three spatial dimensions.[38] To make imperceptible data perceptible—that is, to transcribe into the range of human sensation what existed outside the immediately apprehensible—Severini would picture supersensible data by analogy. Notwithstanding its unfamiliarity, this type of abstract, perceptual image tries to make visible actualities that are not, have not been, or perhaps cannot be widely experienced.

Although Severini attempted to depict data beyond the human senses, and to expand the range of what is perceivable, the artist ironically found this very same conceptual shift to be dehumanizing in its effects of destabilizing or destroying the traditional objects of human understanding.[39] Much later in life, Severini admitted that he thought his earlier Futurist approach had gone astray: "I was very naive to believe that one could destroy the object in itself and, as a result, the existential world into which man is thrust and which constitutes part of him; in destroying existential reality, we destroy ourselves."[40] To move past the limits of human perception was, ultimately, to become

34 Severini, untitled essay, *The Futurist Painter*, 7.

35 "The work of visual art will be autonomous and universal by keeping its deep ties to reality; it will be a reality in itself, more alive, more real than the real object that it represents." Severini, "La peinture d'avant-garde," 82.

36 Severini, "Plastic Analogies," 118. As Linda Dalrymple Henderson has exhaustively shown, contemporaneous discussions in the arts about the fourth dimension, or about more than three dimensions, revolved around non-Euclidean geometry. The historical linkages among higher dimensions, unseen or imperceptible realities, and visual abstraction have been made explicit in this scholarship. By way of useful analogy, temporality became a prominent, but not the only, conjecture about the nature and significance of the "higher" dimensions. Linda Dalrymple Henderson, *The Fourth Dimension and Non-Euclidean Geometry in Modern Art* (Cambridge, Mass: The MIT Press, 1983; revised 2013). At times, she highlights Severini's paintings and writings on non-Euclidean geometry; ibid., 229 and 438–45.

37 Severini, "La peinture d'avant-garde," 86–87.

38 Ibid., 84, my translation.

39 His unpublished manifesto claimed: "This is a complex form of realism which *totally* destroys the integrity of the subject-matter—henceforth taken by us only *at its greatest vitality*" (Severini, "Plastic Analogies," 122). Emphasis in the original. Around this time, he also wrote: "The unity of time and space would be definitely destroyed in the painting. . . . These remote or opposing realities will be connected only by our thought and our sensitivity" ("Symbolisme plastique et symbolism littéraire," 69, my translation).

40 The note from May 1960 follows the reprinted manifesto "Plastic Analogies," 44, my translation. Cited in Anne Coffin Hanson, *Severini futurista: 1912–1917* (New Haven, CT: Yale University Art Gallery, 1997), 47 and 57 note 57.

less human. His actions and ideas had been violently disorienting, yet what he wanted, at least briefly, had been to transcend conventional ideas of human reality and to touch a reality outside the limitations of an individual subject.[41] Again, while his earliest Futurist works were grounded in empirical observations, as he moved deeper into abstraction, Severini's imagery signaled a category of phenomena that was not immediately tangible. Some viewers or critics may assume these phenomena to be imagined or intuited by the artist, as if murmured in a private language incomprehensible to others. But Severini's method did not necessarily presuppose mysticism or religiosity.[42] To the contrary, his work with plastic analogies predicates a search for a mode of referentiality that could expand normative perception, by permitting access to non-sensible, but actual phenomena—what he termed "reality as it is."[43] Through his plastic analogies, Severini contributed to a radical reorientation of perception that he hoped would spark a different type of sensitivity, which, in turn, could transform the modern perceiving subject.

As it was in Severini's time, human perception—as well as its representation and interpretation—is currently undergoing a massive reorientation. In this volume, the senses are treated as historically defined modalities that traverse complicated internal and external processes. These senses also constitute perceiving, participating subjects within their vivid social and cultural contexts. The diverse contributions to *Experience* can be approached as a specific collection of responses to the same underlying question: How does sensory perception factor into the production of knowledge?

At the same time, some contributors have extended their investigations to consider processes or conditions that exceed everyday perception. In "Amphibian," artist Tauba Auerbach discusses higher dimensionality in the context of simultaneous forms of consciousness, among which an individual may shift or may develop the capacity to shift. At one point, she invites readers to attempt to expand their perception beyond the presumed boundaries of vision. When discussing the complexities of mathematics and color, Alma Steingart brings together commentary by disparate writers and thinkers who probe the multidimensional domains beyond normative perception. In "Moralizing," Michael Rossi retraces Christine Ladd-Franklin's psychophysiology of vision, restricted neither to the eyes nor optical processing, but implicated into deeper registers of human existence. For Ladd-Franklin, a moral account of sensory perception needed to be grounded in an awareness of human fallibility and uncertainty, and it had to conform to human experience.

Sonic analogies proliferate this experiential relation to the senses and to sensing beyond them. Among a suite of texts on resonance, composer Alvin Lucier discusses (with Brian Kane) the spirit and history of his compositional approach, while Adam Frank frames Lucier's pioneering work within the scholarly field of affect studies, exemplified by psychologist Silvan Tomkins. What do we get when

41
A similar idea of transformed perception came from Enrico Prampolini around the same time in his text "Chromophony—the Color of Sounds" (August 1913), including the phrase: "A new state of perception concerning optical sensitivity in human beings" (reprinted in translation in Apollonio, 115). Prampolini also envisioned a necessary destruction: "Destroy, destroy, in order to rebuild consciousness and opinion" (ibid., 118).

42
An apparently contentious point for Marinetti and other Futurists was that Severini discussed his work in the context of religious art (even in 1913), and, later in his career, he composed overtly religious images. My argument here describes a trajectory parallel to, but not entirely exclusive of, this aspect of his thinking. The title for the first version of the manifesto on plastic analogies was "The Great Religious Art of the 20th Century" ("Le Grand art religieux du XXème siècle").

43
Severini, "La peinture d'avant-garde," 92, my translation. In an essay the previous year, he alluded to artistic translation: "For there are realities whose 'representation' can have a very broad and complex human meaning" (Severini, "Symbolisme plastique et symbolism littéraire," 69, my translation).

we substitute resonant feeling for the traditional expression of emotion that aesthetic experience is thought to entail? As with Severini's visual analogies, we achieve an extended or extrasensory auditory perception. In "Modulation," Mara Mills explains how research on hearing and vocalization from the mid-19th century was the basis for a reconceptualization of sound and hearing in terms of signal modulation, and how it was directly linked to thinking about electronic communication in the mid-20th century. Anthropologist Stefan Helmreich likewise examines vibratory activities beyond the range of human audition in a text that treats human sensory perceptions in terms that are less transparent or self-evident than usually described. For him, transduction may be the relay through which we experience intersubjective forces, prior to their accommodation into the common sense.

The ethical dimension of expanding perception returns in a pair of texts by philosophically inclined sociologist Bruno Latour. Can humans be sensitized to temporal and geographical scales beyond their creaturely ken? Each text draws attention to the ways the data on global climate change is not just disturbing, but likely requires rethinking human society with the cultural tools that help to shape it. As part of his appeal to intellectuals and artists to help make the public more sensitive to the conditions of the planet, Latour addresses some of the difficulties inherent to communicating with people who believe erroneously that, in order to be true, knowledge must be confirmed by direct sensory data. If, a century ago, Severini believed that human perception and understanding could be expanded through the use of tools and data related to measuring actual, if imperceptible, conditions, we now face a much greater imperative to increase human sensitivity to planetary conditions, in spite of the large constituencies and other sociohistorical factors that actively resist the interpretation of environmental data we already possess. Throughout the 20th century, a growing awareness of nonvisual and non-sensory data has vastly augmented the formal and conceptual terrain for generating images that do not accord with everyday perception and that provoke the extension and expansion of human sensitivity. In particular, color and sound have been crucial mediums for bringing this category of data into human understanding, bridging the domains of scholarly research, artistic experiment, and everyday experience.

As Severini asserted in his images and writings, the range of available or possible data increases dramatically when spatial position and other aspects of everyday perception no longer arbitrarily limit representation. Indeed, for him, images could indicate higher dimensions of perception and understanding—but would not necessarily imply spiritual or transcendent qualities. This historical conjecture relates surprisingly directly to present-day thinking. Consider the use of the term *dimensionality* in the fields of science and mathematics, which includes database engineering and management. It refers to the number of variables contained by or attributed

to a given set of samples or data, which may or may not contain spatial or perceptual data. A potentially infinite number of variables may be defined, tracked, or projected, and, within this conceptualization of dimensionality, the world and universe contain measurable data vastly different from what can be directly apprehended by human subjects. Such data includes, but is not limited to, metrics generated by meteorology, astronomy, and environmental systems. By similarly demonstrating sensitivity to phenomena outside or adjacent to our psychophysiologically determined sensorial fields, Severini's abstraction avoided some of the fallacies now associated with the dominant *telos* of modernist painting, such as psychologism, perceptualism, and spiritualism (which some scholars interpret as qualities that reinforce, rather than challenge, the limitations to human subjectivity). Alongside sensory negation, human destruction, and metaphysical purification—all qualities attributed to visual abstraction—there resides a speculative augmentation of the human subject, which invents and adapts tools and mediums in order to experience phenomena beyond the scope of the senses, though not beyond the realm of human sensitivity.

II.

SEEING

AMPHIBIAN

Tauba Auerbach

One time in kindergarten, I was in my room with a friend after school, and we wanted to close some shutters that were too high for us to reach. Without hesitating, my friend climbed up on my bed with her sneakers on to gain some height. As I watched her do this I was struck by a thought that changed me forever: "I would never stand on *her* bed with *my* shoes on because I was taught that this was rude, and therefore I will never be her, and she will never be me, and I will forever be trapped inside the bounds of my own consciousness." Obviously, it wasn't worded that way.

For weeks afterward I would wake up in the morning and lie in bed saying the word "me" over and over quietly, alternating between asking it as a question and giving it as a bewildered, unconvinced answer. I could feel myself trying to untangle a cerebral knot that I both loved and hated. A joyful type of frustration came along with contemplating my own ability to contemplate, but the experience mostly registered as a spiritual crisis. I felt totally deflated by the idea that I would never transcend my body or my mind, and even more so by the notion that I was separate from the universe and separate from other people. It was as though I was stuck on the inside of a membrane.

There's a photograph that I love in an issue of *Life* magazine from 1966, showing a mathematician and his cat tripping on acid together. (FIG. 1) Though I'm not in support of dosing one's pet, I definitely understand the desire to do so. Every time I hang out with an animal I wonder what his or her consciousness feels like from within. (This of course relies on my having gotten over a later childhood solipsistic crisis: "What if I am the only one who is conscious, and all of these other beings are my unwitting fabrication?" And I have. . . I think.) The distance between the man's conscious experience and his cat's might be considered an exaggeration of the distance between one person's and another's. And if the acid induces an alteration in each, perhaps they can attempt to commune in the shared experience of change.

The conundrum of being conscious remains a preoccupation for me, and I know I'm not alone. The desires to test, alter, and develop it follow my deep gratitude for being either custodian or instance of something so unlikely and mysterious. Unlike the five-year-old me,

FIGURE 1
This photograph by Lawrence Schiller was originally published with the following caption: "A San Francisco mathematician takes a trip on LSD with his cat, who is on the drug too." See Barry Farrell, "Scientists, Theologians, Mystics Swept Up in a Psychic Revolution," *Life* 60, no. 12 (March 25, 1966): 31.

FIGURE 2
The intertidal zone, seen from above in a stock photograph.

I now see this "thing" as porous and mutable—characterized by flux rather than constancy.

For me it's often useful to think in terms of visual models and metaphorical gestures. The model mimics the architecture of an idea, and the gesture invokes intention and the vector of time. As an artist, I work to occupy a part of my consciousness that resembles the frothy band at the edge of an ocean. Sometimes at the perimeter of a system, there's an area where its internal laws and logic neither drop off sharply nor fade out in a smooth gradient, but form unpredictable patches where things go a bit haywire, leaving the opportunity for something special to happen. The foam at the ocean's edge is like this—still made of water, but texturally different from the vast majority of the ocean, continuously shifting, incorporating and depositing sand and air, somehow both ephemeral and constant. (FIG. 2)

Because the froth is at an ocean's perimeter, it's easy to conceive of the gesture toward it as a simple outward motion—the age-old notion of "expanding the mind"—but this is to see the ocean alone as the system, independent of the planet, solar system, galaxy, or universe. If you regard the ocean as a part of its surroundings, occupying the froth requires more of a shifting dance, responsive to each tide and wave, full of constant, tiny adjustments. It's more about nuance than force. In general, I don't think that an expansive gesture alone gives rise to meaningful growth. I equally see the need to burrow inward, to tunnel into and inhabit every grain of self and being, in order to alter their limitations. To borrow a Sagan-ism—"we are made of star stuff"—so it follows that there is a lot to be gained in the quest toward connecting with what's "out there," by

going more deeply into what's "in here."[1] Inward and outward gestures (along with many others) can work together.

To watch a skilled musician improvise is to witness this type of dance. The player's ability is often built on a foundation of knowledge—a cohesive system like that middle part of the ocean where things hold together and the physics of sound and the muscular programming of practice reside. But to improvise, one needs to tap into something other than knowledge and virtuosic technique, to surrender to it just enough, but not so much as to lose one's grip entirely—to calibrate the condition of being in that effervescent band. Seeing someone operate from that place is like watching the music move through them, rather than watching them make it. It is transporting, sublime, communal.

In trying to become more amphibious, I've engaged in some of the usual experiments and practices: different types of meditation, movement, research, the occasional drug trip, lucid dreaming, puzzles. All of the above are humbling, illuminating, and have thus far led toward a kind of affirmative, ecstatic agnosticism: "I don't know!" But the most rewarding of all activities has been simply to spend time with ideas at the very fringes of my (and sometimes anyone's) understanding. To occupy oneself exclusively with what is known seems redundant. One idea that has been particularly bewitching to me is that of 4+n dimensional space. For me, hyperspace is simultaneously literal and symbolic, both a metaphor and a tool for consciousness and its augmentation. For readers who are unfamiliar, here is a very brief introduction, quoted from Claude Bragdon's 1913 *A Primer of Higher Space*:

> A point, moving a given distance in an unchanging direction, traces out a line. This line, moving a direction at right angles to itself a distance equal to its length, traces out a square. This square, moving in a direction at right angles to the plane a distance equal to the length of one of its sides, traces out a cube. . . . For the cube to develop in a direction at right angles to its every dimension a new region of space would be required—a *fourth dimension*. . . . In such a higher space the cube would trace out a *hyper-cube*, or *tesseract*, a four-dimensional figure related to the cube as the cube is related to the square.[2]

In drawing four-dimensional figures it's useful to call upon our existing literacy in reading three dimensions represented on two. One readily interprets the diagonal lines in a drawing of a cube as the lines extending out of the plane, into the third dimension. This ability is taken for granted, but it shouldn't be. It provides hope that one can become similarly literate in interpreting two- and three-dimensional representations of four-dimensional shapes.

[1] Eds.: Carl Sagan, astronomer, popular science writer, and genial broadcaster of cosmology, said the following on the first episode of his television series *Cosmos* (first airing on September 28, 1980):"The cosmos is also within us. We are made of star stuff. We are a way for the cosmos to know itself."

[2] Claude Bragdon, *A Primer of Higher Space* (1913), quote from second revised edition (New York: Knopf, 1923), 12. Emphasis in the original.

FIGURE 3
The author's renderings of one-, two-, three-, and four-dimensional entities, with their relations to bounding entities of lower dimensions.

FIG. 3A

FIG. 3B

FIG. 3C

FIG. 3D

Certain well-understood relationships between the familiar three dimensions can be translated to higher ones:
- A one-dimensional entity, a line, is bounded by a zero-dimensional entity, a point (FIG. 3A)
- A two-dimensional entity, a plane (in this case a square), is bounded by a one-dimensional entity, a line (FIG. 3B)
- A three-dimensional entity, a volume (in this case a cube), is bounded by a two-dimensional entity, a plane (in this case a square) (FIG. 3C)
- A four-dimensional entity, a hyper-volume (in this case a tesseract), is bounded by a three-dimensional entity, a volume (in this case a cube) (FIG. 3D)

To generalize: an n-dimensional entity is bounded by an (n-1) dimensional entity.

The same dimensional relationship of bounding holds true of slicing and cross sections:
- A one-dimensional entity, a line, is sliced by a zero-dimensional entity, a point
- A two-dimensional entity, a plane, is sliced by one-dimensional entity, a line
- A three-dimensional entity, a volume, is sliced by a two-dimensional entity, a plane
- A four-dimensional entity, a hyper-volume is sliced by a three-dimensional entity, a volume

If the volume in question is *all* of three-dimensional space, then everything we see would be merely the surface of, slice through, or cross section of a higher-dimensional space.

My initial contact with the idea of hyperspace produced a lot of the same feelings that I'd had as a child thinking about my own consciousness for the first time. I was both thrilled and irritated that I could neither move nor see beyond (or in this case, perpendicular to) my existing framework. So I began collecting and making things that I thought might bring me into better contact with this space in my mind: models of the regular polychora (the 4D correlatives to the regular polyhedra), books on the subject by mathematicians and architects, computer animations, novels, images, sounds, and objects. Over the course of my years-long friendship with this idea, four-dimensional space has come to feel much more familiar and knowable, in fleeting moments—like bubbles in the foam—dare I even say, "known." As a result, my experience of being in three-dimensional space has changed and deepened.

When this subject comes up in conversation people often ask if the fourth dimension is time. To this I would say, no, not exactly, but time might be a way to observe a fourth spatial dimension

FIGURE 4
The author's renderings of a sphere passing through a plane, the cross sections of the sphere on the plane, and the view of the sphere as witnessed by a two-dimensional being physically and perceptually confined to the plane.

FIGURE 5 (FACING)
(A) An example of a one-dimensional model of color as a section of the electromagnetic spectrum. (B) An example of a two-dimensional color model, by Wilhelm von Bezold, "Farbenlehre" (color concept), 1874, chromolithograph by Albert Schütze, Berlin.

obliquely. To indulge this point one has to go down a dimension and pretend to live as a planar being, confined to two dimensions.

Here, a three-dimensional sphere passes through a two-dimensional planar universe. (FIG. 4A) On the plane, the sphere registers only as a mutating circular cross section, beginning with a small dot appearing as if from nowhere, expanding, contracting, and then seeming to disappear. (FIG. 4B) A two-dimensional being living on the plane would see this cross section from its (zero-thickness) edge, and the sphere would appear as a dot expanding into a bigger and bigger line, decreasing into a smaller and smaller line until it was again a dot that would then disappear. (FIG. 4C) This being would never see the higher-dimensional shape in its entirety—but s/he would see evidence of it by way of change over time.

Like the sphere from the perspective of the plane through which it passes, consciousness seems to appear as if from nowhere, expand, change shape, contract, and then disappear. This is one of the reasons I've come to wonder, like Bragdon, if consciousness could be a four- (or more) dimensional material passing through this 3D slice of the universe, housed in bodies—the three-dimensional self merely a cross section of a four-dimensional self.

An important insight about hyperspace landed on me during a parallel inquiry into color. Color, too, exists at the edge of true understanding, acting on the part of one's being that resides in that frothy band. There's an extent to which one can measure it, reason about it, and

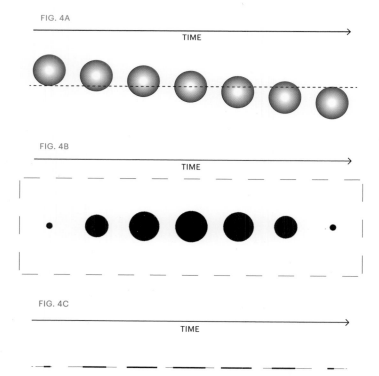

II. SEEING

FIG. 5A

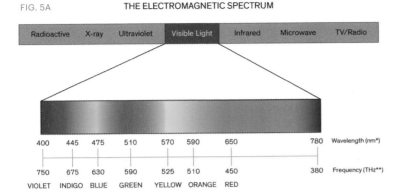

THE ELECTROMAGNETIC SPECTRUM

* In nanometres (nm); 1nm = 1×10⁻⁹ metre
** In terahertz (THz): 1 THz = 1×10¹² cycles per second

FIG. 5B

communicate about it, but color is so visceral and slippery that it always seems to outstrip logic and language. It's notable that color is an excellent tool for modeling, but resists being modeled itself, despite tireless efforts throughout history to do so.

The visible spectrum has variously been drawn as a line, a plane, and a solid, all off which come up short in some capacity. (FIGS. 5–9) Either the distribution of hues is too regular, entire variables such as saturation or value are omitted, or the models account for retinal responses while neglecting neurological processing. The most accurate "color spaces"—three-dimensional models for color—are unruly and inelegant. (FIG. 9)

Many people, including Isaac Newton, have attempted to draw a correlation between the visible spectrum and pitch, as the mathematical relationship between the lowest frequency and highest frequency in an octave is nearly identical to the relationship between the lowest frequency and highest frequency of visible light. (FIG. 10A)

Carl Hensel represented this idea in the form of a helix, making each cycle in the coil correspond to an octave. (FIG. 10B) But these acoustical models break down, too, particularly because mathematically organizing the audible spectrum is equally problematic. Neither equal temperament nor just intonation is a perfect tuning system.

All of these models of color are based on a "standard" human trichromat viewer with three classes of cone and one type of rod, but not every eye conforms to this standard. Entirely different geometry would be needed to describe the color vision of someone with partial blindness, color blindness, or tetrachromacy. A tetrachromat is a woman who expresses the gene for a fourth category of color receptor on her retina.[3] So far there are many women with the genetic makeup for this variation, and only two very tenuously confirmed functional tetrachromats. Time will tell. Rather than seeing a single extra color, tetrachromacy would introduce an additional

3
Eds.: Tetrachromats are female because the genes for the M and L cones reside on the X chromosomes, and a given woman, who will have two X chromosomes, "can carry the normal red and green genes on one of her X chromosomes and an anomalous gene on her other. This genetic pattern enables her to express four types of cone [rather than the usual three]." "The Tetrachromacy Project," Newcastle University, https://research.ncl.ac.uk/tetrachromacy/thescience/.

Tauba Auerbach

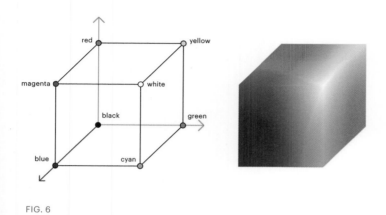

FIG. 6

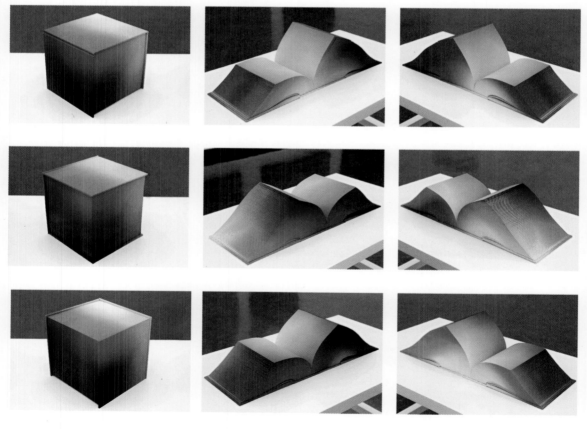

FIG. 7

II. SEEING

FIG. 8

FIGURE 6
Color space mapped according to the Trichromacy Theory. This model assigns an axis to each of the retinal cones' sensitivity ranges.

FIGURE 7
Tauba Auerbach, *RGB Colorspace Atlas*, 2011, shown closed and open. Top: green, center: red, bottom: blue. Set of three case bound books, digital offset print on paper, airbrushed cloth covers and page edges, each volume 8 x 8 x 8 in. (20. 3 x 20.3 x 20.3 cm), binding designed by Daniel E. Kelm and Tauba Auerbach, bound by Daniel E. Kelm assisted by Leah Hughes at the Wide Awake Garage, East Hampton, MA.

FIGURE 8
Colorspace mapped according to cone-opponency theory, assigning an axis to each pair of antagonistically related cone signals as they are processed at a more complex level in the visual cortex of the brain.

FIGURE 9
Colorspace mapped according to human hue perception, in the system published by Professor Albert Munsell in 1905.

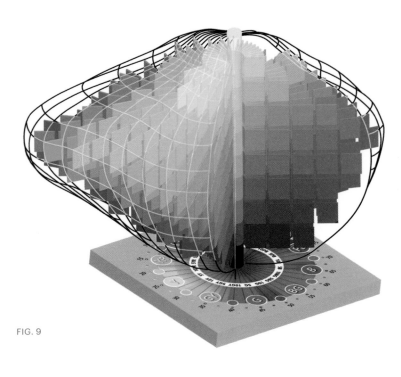

FIG. 9

FIG. 10A

FIG. 10B

FIGURE 10
(A) Isaac Newton's octave-based color wheel, 1704. (B) Carl Hensel's spiraling color map, evolved from the color circle (left), opened to form a spiral (lower left) and finally expanded into a helix, ca. 1915, from Rolf G. Kuehni and Andreas Schwarz, *Color Ordered: A Survey of Color Systems from Antiquity to the Present*, 2008, page 287.

FIGURE 11
Mathematician Francisco López's Klein Bottle, rendered by Professor Matthias Weber, Indiana University, Bloomington.

FIGURE 12
Monochromatic weaving from a series begun for the exhibition *Tetrachromat* at Bergen Kunsthall; Malmö Konsthall; and Wiels Contemporary Art Centre, Brussels, in 2011–12. Tauba Auerbach, *Panes/Trans Ray I*, 2013, woven canvas on wooden stretcher, 60 × 45 × 2 in. (152 × 114 × 4 cm).

input variable affecting every color. When I first learned about this possibility, I immediately wondered how one would map this woman's color space. Would it be a hyperspace?

It's often assumed that a tetrachromat's extra sensitivity would expand the range of her visible spectrum, but in fact her additional sensitivity would more likely be in between the colors that a standard viewer can detect. This woman's special power would not be about breadth but about depth and distinction—she would be able to differentiate between colors that look exactly the same to others.

Imagining the tetrachromat's visual experience is akin to trying to visualize a tesseract. In neither case is it strictly about thinking "beyond" one's perceptual capacity. Rather than existing outside of the dimensions we can perceive, a fourth dimension would be intimately interlaced with these three. If there is in fact a four-dimensional self, every bit of the three-dimensional self—even its most inner regions—would be in direct and constant contact with it, just as all parts of each circular cross section are in direct contact with the sphere through which it slices.

The irony in my childhood crisis is that it was in fact a moment of transcendence—of moving both beyond and more deeply into the self of moments before. Perhaps the membrane behind which I felt stuck takes the form of a non-orientable surface such as the one below. (FIG. 11) You *can* get to the other side; you just don't leave your own side to get there.

FIG. 11

II. SEEING

Amphibian

FIG. 12

FIG. 1

PROCESSING

Bevil R. Conway

Once a friend of mine performed a magic trick for me, and afterward I asked him, "How does it work?" He answered, "Can you keep a secret?" "Yes," I said. "Well, so can I," he responded.

Some people assert that when science demystifies a phenomenon, it takes away all the magic. They are feeding the common preconception that mystery begets interest. But demystification for the purpose of making visual experience boring has never been the goal of my research. I am interested in the magic of perception, and it is precisely that magic that drew me to neuroscience in the first place. To me, visual neuroscience is like enology. The more that wine makers learn about wine, the more deeply they fall in love with it, because the more they know about wine, the more mysterious it becomes. How does the mind make so much from a limited combination of alcohols, sugars, and aromas? This same essential mystery fuels my research on color: the more I study color perception and the neural mechanisms that support it, the greater the magic of seeing color.

Still, my interest in color is more than simple curiosity. From a neuroscientific point of view, color is a powerful tool for understanding how we take in information, process it, and produce perception, thought, and action. We need good tools for this science, because frankly, the astonishing magic of the brain's ability to transform sense data into meaningful behavior is too often taken for granted. Famously, at MIT in the 1960s, cognitive scientist Marvin Minsky challenged his graduate students to build a working visual system in a machine. This research followed on the heels of important discoveries by David Hubel and Torsten Wiesel showing that specific neurons in primary visual cortex are sensitive to specific angles of lines and edges.[1] Tuning to particular stimulus features, such as orientation, was rapidly taken up as a likely, and efficient, mechanism used by the brain to encode objects. So, according to legend, Minsky said, "We now know how the visual system works, so over the summer I want you to go and make a machine that does it."

And the graduate students went away, and they came back in the fall and said, "Well, it turns out it's more complicated than we thought, and our machine can't even recognize something as simple as a hand." This story reveals the great computational challenge that the visual system faces, and equally profound, the deep difficulty that researchers face in trying to replicate with machines what the

FIGURE 1
Faces rendered in pure color are almost entirely unrecognizable; the face shown is that of David Hubel.

1
D. H. Hubel and T. N. Wiesel, "Ferrier Lecture: Functional Architecture of Macaque Monkey Visual Cortex," *Proceedings of Royal Society of London, Series B, Biological Sciences* 198, no. 1130 (May 1977): 1–59.

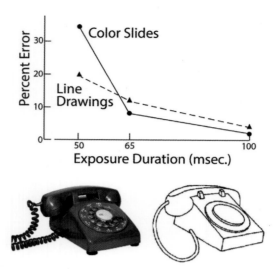

FIGURE 2
Color is not necessarily useful for object recognition. Recognition error rates are slightly higher for colored photographs than for line drawings.

brain does effortlessly. Neuroscience confronts this same challenge in simply trying to unpack how the brain functions within us.

Sight is a mysterious phenomenon that enables those who have it to see and experience the world. And we have to try and use this same perceptual nervous system to try to figure out how it works. As neuroscientist Nancy Kanwisher has commented, this part of the challenge is not an insurmountable problem—tow trucks can tow tow trucks. The problem lies instead with conceptual difficulties: we take for granted the operations of the brain because these operations are carried out so well. When I ask my eight-year-old nephew, "How do you see?" He says impatiently, "Don't be silly Uncle Bevil. I open my eyes." For him, there's no problem that needs solving. The hardest brain operations to explain are those that the brain appears to perform most effortlessly, and color seems most effortless of all. As Minsky also said, "We're least aware of what our minds do best."[2]

Color epitomizes the challenge of understanding vision. Our brains reflexively assign colors to things in the world—this red chair, that green grass, those yellow bananas—as if these phenomena themselves are actually colored. So, we've condensed the multitude of possible colors of a thing into a single idea that we can capture, hold still, in memory. We simplify, in spite of the fact that bananas are only briefly yellow. It seems as if these qualities are perfectly inherent—color seems to exist out there, in time and space. This is a powerful illusion created by our brains in the service of behavior, hidden from consciousness. Of course stimuli, objects, must be out there in the world, our experience tells us this. And these objects appear to be colored—no, they *are* colored. But our ability to see color without conscious effort belies an enormously sophisticated neural process. I think that the fact that we say, "Oh, that's red" with such confidence poses a difficulty so

profound, that it has led philosophers and scientists to ascribe redness to something out there. Neuroscience claims the opposite: color is something that's computed in the brain in a process that uses your prior experience about the visual world to interpret sense data. And while the experience of color is itself the result of extensive processing, it must feel effortless—for if we were made continually aware that color depended upon sophisticated neural processes, we might become so preoccupied that we wouldn't react in time to the angry red face confronting us.

We can begin to approach the problem of color by examining two questions, the first of which concerns the issue of behavioral relevance: What is the computational goal of color? *What is color for?* The second question involves how these goals are implemented in the brain: *How does color happen for us?*

Many scientists have assumed that color evolved to enable us to recognize objects—you may have heard the reflex answer to "what is color for," as "to detect ripe fruit." This is probably partly true, but I'm unconvinced that drawing a conclusion about a piece of fruit is the main job of color (a gentle squeeze can be more informative about ripeness). It turns out that, for most things in the world, color is not a necessary cue for object recognition or for basic survival (as one could guess by how late excellent trichromatic color vision evolved in our mammalian ancestors—among mammals, only certain species of primates, such as humans and macaque monkeys, have excellent color vision; color alone is insufficient for most visual tasks). In work by neuroscientists Irving Biederman and Ginny Ju (FIG. 2), reaction times for recognizing line drawings are compared to reaction times for colored photographs.[3] It turns out that people are typically a little bit quicker to recognize line drawings. So one initial hypothesis—that color is a universally useful cue for object recognition—is debunked. It turns out that for most images and scenes, if you remove all of the value information, that is, render the image entirely in color with no information about light-dark gradients, you grossly impair object recognition.[4] (FIG. 1) Such images are called "equiluminant" or "isoluminant" because all the colors in the image have the same gray-scale value—in a black-and-white photograph the image would be uniformly gray. Studies using equiluminant images have shown that in most circumstances color by itself is insufficient for object recognition. This is especially true for images of faces: the face in an equiluminant picture is barely detectable. Color is thus neither sufficient nor necessary for recognizing many kinds of objects. This is the reason that many vision scientists have steered clear of color, because it doesn't seem as if we need color for any fundamental visual operation. Some scientists have gone as far as to postulate that color emerged in evolution as an unintended embellishment.

But that conclusion seems absurd. Color processing requires special neural circuitry, as I will review below, and it is rare that evolution permits the allocation of such resources if there is no benefit.

[2]
Marvin Minsky, *The Society of Mind* (New York: Simon and Schuster, 1986), 29.

[3]
Irving Biederman and Ginny Ju, "Surface Versus Edge-Based Determinants of Visual Recognition," *Cognitive Psychology* 20, no. 1 (January 1988): 38–64.

[4]
Richard L. Gregory, "Vision with Isoluminant Colour Contrast: 1. A Projection Technique and Observations," *Perception* 6, no. 1 (1977): 113–19.

[5] See Gerald H. Jacobs and Jeremy Nathans, "The Evolution of Primate Color Vision," *Scientific American* 300 (April 2009): 56–63; Timothy H. Goldsmith, "What Birds See," *Scientific American* 295 (July 2006), 68–75.

[6] Pawan Sinha et al., "Face Recognition by Humans: Nineteen Results All Computer Vision Researchers Should Know About," *Proceedings of the IEEE* 94, no. 11 (November 2006), 1948–1962.

[7] Bevil R. Conway, "Why Do We Care About the Colour of the Dress?" *The Guardian*, February 27, 2015, online at www.theguardian.com.

[8] "Meet Instagram," online product advertisement from 2012. Emphasis added.

Color must confer some advantage. Moreover, across animals, and even within mammals, color has evolved more than once.[5] And as I alluded to earlier, color does prove useful for recognizing certain kinds of objects as long as it is not isoluminant. For example, color does help facial recognition under degraded image conditions. This function was demonstrated by computational neuroscientist Pawan Sinha and his colleagues at MIT, who asked subjects to identify faces in blurry photographs, such as those in Figure 3. As they showed, people were slightly better at recognizing faces if the photographs contained color (as opposed to black and white), leading them to conclude that the color in the images helped people identify important boundaries that establish diagnostic face features, such as the boundary between the hair and the face, or the location and spacing of the eyes.[6] But they also showed you get the same recognition benefit in a false-colored image, as at the right. In either case—the true color or the false color—the recognition benefit provided by color is pretty modest. Indeed, most people have very little difficulty identifying Diana in the gray-scale version, which suggests to me that although color is sometimes helpful in object recognition, object recognition is probably not the *main* job of color.

So we return to the question: Why did the visual system go to all the trouble of giving you color vision? The research of Sinha and his colleagues, and a number of other neuroscience groups, including those of David Brainard, Karl Gegenfurtner, Anya Hurlbert, Don MacLeod, Michael Webster, and Qasim Zaidi, among others, provide excellent, quantitative evidence for the role of color in object recognition. But this line of work often seems to overlook one key, albeit qualitative, point: Color counts for a lot in our experience of the world. We like color.[7] We spend a lot of money on jewels, whose only real distinguishing feature is their color; we pay extra for color technology; and we spend a lot of money buying paintings, which, as early modernists pointed out, are nothing more than arrangements of colored mud on a surface. Clearly, color is important for human behavior, and is implicated in something else besides object recognition or segmenting faces under degraded conditions. It seems to me that we must take seriously the fact that color is essential for some part of human behavior that we as a scientific community haven't yet made tractable. The obvious value of color to human behavior should give us clues about *what color is for*.

I'm not going to pretend that I have an answer, but my guess is that if we keep poking around, we'll make some headway. Consider again the false color image on the far right of the figure from Sinha's paper. (FIG. 3) Sinha and his colleagues don't talk about it, but don't you think Diana looks ill? It is an empathic feeling; it hits you right in your gut, immediately. I would suggest that it's even *pre-verbal*. As I kept coming back to this disturbing image, I couldn't figure out where the affective information was coming from until I went to sleep and woke up the next day. What I then grasped was the answer

a child might give to this question—the face has the wrong color; it looks unsettling. Diana looks sick.

The clues suggest that an important job of color is to convey *emotional* information. We find evidence of this impact of color elsewhere. Everyday software applications, such as Instagram, use color filters such as "Lo-Fi" and "Earlybird." A quote from the advertisement for this app clarifies the emotional intention: "Snap a photo. . . . Choose a filter to transform the look *and feel*."[8] These filters transform certain value aspects (darkness, brightness) and certain edge qualities (sharp, blurry), but they are profoundly and centrally about color. In fact, every digital color image or movie has undergone comprehensive color correction by a human practitioner. Dave Markun, an expert color-correction professional, spent five hours showing me how he color corrects documentaries to flesh out the story and keep viewers engaged. He applies a warm cast to a scene to suggest nostalgia and history, a blue cast to connote contemporary science, fact, and truth. But that's just the tip of the iceberg. The use of color to promote a particular agenda is an art that appeals directly to the unconscious aspects of perception, and as with many arts, the practitioners are doers, not commentators or theorists. It's not so easy to pin down the rules and objectives. And the rules are probably mutable.

The emotional information in color also returns us to the example of the false-colored Diana—color can be a powerful indicator of the state of someone's health. Color is used as an important metric within health practice, serving as a rapid diagnostic for certain kinds of changes in morbidity. Most important for these diagnostic judgments is the oxygenation state of hemoglobin in the blood: when carrying its full load of oxygen, the hemoglobin-bearing cell is bright red; when depleted, it's blue. There are other factors that affect skin color, including melanin and carotenoids. Obviously, melanin determines how dark your skin is, and it depends both on genetic factors (such as your race) and ultraviolet light exposure (how tanned you are). Skin carotenoid content depends largely on your diet: the more

FIGURE 3

Color can assist in recognition under degraded conditions. It also seems to signal illness. Left: low-resolution achromatic photograph of Princess Diana. Middle: true-color photograph. Right: false-color photograph. Andrew W. Yip and Pawan Sinha, "Contribution of Color to Face Recognition," *Perception* 31, no. 8 (2002): 995–1003.

FIG. 3

carrots and fresh vegetables you eat, the more carotenoids are in your skin and the healthier you look. Carotenoid content varies from face to face and, curiously, predicts aesthetic judgments of the face.

So skin color is clearly used for assessing how healthy humans might be, and other important socially relevant aspects of our behavior (such as picking up on anger or embarrassment). Although there is not much work on the subject, it seems likely (I think) that we use skin color to adjudicate social situations—to ascertain the relationships between people in new or evolving social contexts. Support for the idea that color was evolutionarily advantageous for social communication is provided by spectral analyses of skin-color changes, which are much more apparent to primates who evolved trichromatic vision (such as humans) than primate dichromats.[9] Although speculative, it seems plausible that the near-universal appeal of color—that we like it, and that it seems to move us emotionally—is linked to this evolutionary history.

Let's recap: I'm attempting to build an argument outlining what color is for—*why do we have it?* The central idea is that color is not just for detecting objects, but rather for providing access to special information that we can obtain only through color vision. Recall that the detection of most objects can be mediated largely by achromatic (colorless) shape cues, whereas the emotional content of an expression (an angry face) or a premature baby (jaundice?) is most immediately communicated through a specific color cue (red or yellow complexion). One's reaction time to these color-specific signals can be very rapid. And, as it turns out, the color in objects for which color is diagnostic (the yellow of a banana, the orange of a pumpkin) also quickens reaction times. The reaction time for the detection of an achromatic banana or a purple banana is slightly longer than the reaction time for a yellow banana.[10] We can infer from this research that the brain is using color information to facilitate the retrieval of a stored memory. Consistent with this inference, research has also shown that color for arbitrarily colored objects is not useful in recognition or memory.[11] I think we're starting to see that color isn't really a tool for recognizing generic objects. It's for recognizing certain specific kinds of objects: those that are behaviorally relevant (that is, we care about them, as with fruit or faces), and for which color is part of the behaviorally relevant state of the object (ripe fruit, sick face).

This hypothesis is supported by another attribute of color, color's ability to facilitate "pop-out," a form of feature attention (the theory that certain attributes of an object—shape, color—are perceived automatically and prior to object identification). Figure 4 shows a classic demonstration: the triangle formed by the red 2s is instantly visible; it *pops out* from the sea of green 5s. Note that the triangle is clearly evident when all the elements are black, but it takes much longer to find. The process of finding the triangle of 2s in the achromatic image requires a time-consuming visual search strategy that makes use of different neural circuits from those employed

9

Consistent with this hypothesis, trichromat primates tend to be bare-faced. See Mark A. Changizi, Qiong Zhang, and Shinsuke Shimojo, "Bare Skin, Blood and the Evolution of Primate Colour Vision," *Biology Letters* 2, no. 2 (June 2006): 217–21.

10

Aude Oliva and Philippe G. Schyns, "Diagnostic Colors Mediate Scene Recognition," *Cognitive Psychology* 41, no. 2 (September 2000): 176–210. See also David J. Therriault, Richard H. Yaxley, and Rolf A. Zwaan, "The Role of Color Diagnosticity in Object Recognition and Representation,"*Cognitive Processing* 10, no. 4 (November 2009): 335–42.

11

Timothy F. Brady et al., "Visual Long-Term Memory has the Same Limit on Fidelity as Visual Working Memory," *Psychological Science* 24, no. 6 (June 2013): 981–90.

12

Timothy J. Buschman and Earl K. Milller, "Top-down Versus Bottom-Up Control of Attention in the Prefrontal and Posterior Parietal Cortices," *Science* 315, no. 5820 (March 2007): 1860–1862.

13

Robert Shapley and Michael Hawken, "Neural Mechanisms for Color Perception in the Primary Visual Cortex," *Current Opinion in Neurobiology* 12, no. 4 (August 2002): 426–32; Karl Gegenfurtner, "Cortical Mechanisms of Colour Vision," *Nature Reviews Neuroscience* 4 (July 2003): 563–72.

14

Bevil R. Conway et al., "Advances in Color Science: From Retina to Behavior,"*Journal of Neuroscience* 30, no. 45 (November 2010): 14955–14963; Lafer-Sousa and Bevil Conway, "Parallel, Multi-Stage Processing of Colors, Faces and Shapes in Macaque Inferior Temporal Cortex," *Nature Neuroscience* 16, no. 12 (December 2013): 1870–1878; Qasim Zaidi et al., "Evolution of Neural Computations: Mantis Shrimp and Human Colour Vision," *i-Perception* 5, no. 6 (September 2014): 492–96; Bram-Ernst Verhoef, Katilin S. Bohon, and Bevil R. Conway, "Functional Architecture for Disparity in Macaque Inferior Temporal Cortex, and Its Relationship to the Architecture for Faces, Color, Scenes and Visual Field," *Journal of Neuroscience* 35, no. 17 (April 2015): 6952–6968.

during pop-out.[12] Color perception's role in feature attention is, incidentally, the basis for various tests of color blindness. How does the brain extract from a stimulus the information that is uniquely provided by color, as opposed to information on edge, value, texture, and other aspects of "shape"? Research from my lab and others suggests that color processing uses neural mechanisms that are somewhat distinct from those used to decode shape, although most other visual neurophysiologists believe the circuits responsible for color and shape are inextricably yoked.[13] Suffice to say, the various perspectives on the issue have helped define the problem and even hint at my primary goal here—addressing what color is for.[14]

It may be that the term "color vision" is too broad for the different behaviors made possible by sensitivity to color. We need to consider separately the different behaviors, because the different behaviors made possible by sensitivity to color could likely depend upon different neural circuitry. On the one hand, color provides a useful cue for object segmentation; on the other hand, color provides essential information about an object's surface properties. It is likely that different populations of neurons in the primary visual cortex carry out different operations.[15]

To turn the question around is also interesting: color might fuel pop-out because we *like* color. This hypothesis acknowledges an important property of color, one that has largely been ignored by neuroscientists: color seems to be inherently rewarding. Is color a *primary* reward? I don't think we have the scientific evidence to answer this question yet, but there is ample cultural evidence—the billions of dollars spent each year by consumers simply to have products in color. And it might not be irrelevant that depressed patients often describe the world as colorless, and patients with brain damage causing color blindness are often depressed.[16] Color seems to influence emotional states directly, suggesting that color and depression share some common circuitry.[17] Such a connection is supported by preliminary data showing that deep-brain stimulation (DBS) of a brain region in humans that has been implicated in depression, Area 25, results in both mood elevation, and immediate relief of impoverished color perception. Following Area 25 stimulation, "all patients spontaneously reported acute effects including . . . sharpening of visual details and intensification of colors."[18] One of my long-term ambitions is to trace the complete functional circuitry for color through the brain, in order to identify the circuits that bring about changes in affect.

The mysterious connection between color and affect underlies the near universal use of color terms to describe emotional states—"red with anger," "feeling blue," and so on—and informs the use of specific colors for industry logos—red connotes excitement, boldness, and youth. But, importantly, I do not think specific color-emotion relationships are connected by an inevitable reflex.[19] Instead, it seems clear that these associations are culturally entrained.

FIGURE 4 (NEXT SPREAD)
Color facilitates feature attention ("pop-out"). When the reversed figures are colored red, it is much easier to see them, and to discern the pattern they form.

15
Bevil R. Conway, "Color Vision, Cones, and Color-Coding in the Cortex"; Bevil R. Conway, "Color Signals through Dorsal and Ventral Visual Pathways," *Visual Neuroscience* 31, no. 2 (March 2014): 197–209.

16
Oliver Sacks and Robert Wasserman, "The Case of the Colorblind Painter," *New York Review of Books* 34 (November 19, 1987): 25–34.

17
Patricia Valdez and Albert Mehrabian, "Effects of Color on Emotions," *Journal of Experimental Psychology: General* 123, no. 4 (December 1994): 394–409; Li-Chen Ou et al., "A Study of Colour Emotion and Colour Preference. Part I: Colour Emotions for Single Colours," *Color Research & Application* 29, no. 3 (2004): 232–40; Xiao-Ping Gao et al., "Analysis of Cross-Cultural Color Emotion," *Color Research and Application* 32, no. 3 (June 2007): 223–29.

18
Helen S. Mayberg et al., "Deep Brain Stimulation for Treatment-Resistant Depression," *Neuron* 45, no. 5 (March 2005): 651–60.

19
Elizabeth Mayhew, "Our Latest Color Inspiration: Orange and Pink," *Washington Post*, April 22, 2015, online at www.washingtonpost.com.

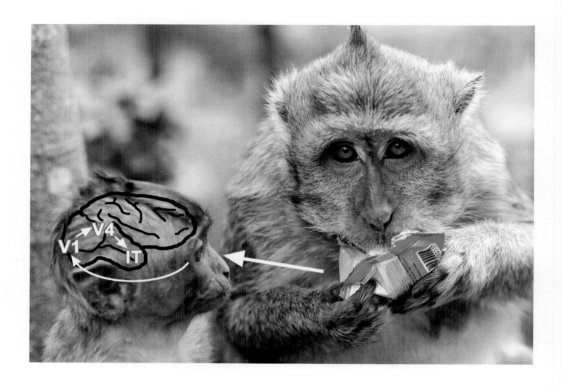

FIGURE 5
A schematic of a monkey brain showing four main stages of visual-object processing, and the direction of that process, moving through the retina, V-1, V-4, and inferior temporal cortex (IT).

Entrainment is made possible precisely because color is part of a trainable system, and this aspect of color allows color to be used for this special job. Color associations can change. We think of pink as the color of feminine girls today, but it wasn't so long ago that pink was thought to be the color for masculine little boys. Artists have often explored the emotional capacity of color, exploiting the human ability to liberate color from having to represent shape or segment objects in order to do wildly different sorts of things (recall Pablo Picasso's blue and rose periods). Again, in much of art, color isn't being used to encode shape or boundary information, but to accomplish other important goals that have more to do with social signaling.

So what is color for? I have summarized the current findings that color clearly helps in segmenting boundaries and facilitating object recognition. And I have urged neuroscience to consider the further evidence that color serves a host of other functions that touch on many aspects of perception and cognition, including things like emotion, reward, and social cognition. My over-arching hypothesis is that color comprises at least two somewhat mutually exclusive subsystems: one for image segmentation, and one that is a trainable system used for the detection of behaviorally relevant objects. Embedded within this hypothesis is our collective experience that color is both a low-level feature of objects—something out there in the world—and also an abstract stable idea—something inside our

brains. The specific banana has a specific color that enables you to detect its boundaries and see it as distinct from the other fruits in the bowl, whereas the generic banana has a yellowness that resides somewhat statically in your memory, regardless of the green or spotted brown banana in the bowl.

Now to the second question: How does color perception work in the brain to accomplish these multiple goals? Let me use the analogy of the computer to summarize current thinking about how information is processed in the cerebral cortex. There are two principles involved: serial processing and parallel processing. By serial processing we simply mean that information moves through a series of stages, one stage at a time, much as an assembly line is used to make a car. In the case of vision, the first stage of processing uses the retina; the second depends on a peanut-sized relay in the middle of the brain called the dorsal lateral geniculate nucleus of the thalamus (LGN for short); the third stage is accomplished by primary visual cortex (V-1), to first region within the cerebral cortex to receive visual signals. And then there are a host of subsequent stages implicated in turning retinal signals into perception. The regions involved are unimaginatively called V-2, V-3, V-4, and V-5 (also called MT); the final stages of object vision occupy the inferior temporal cortex (IT). (FIG. 5) Neurons within each stage extend thin arms, called dendrites, that receive input from other neurons. Each neuron then sends an electric output signal through a slender microscopic tube, called the axon, that makes contact through a chemical synapse with the dendrites of other neurons, forming an unimaginably intricate and elaborate circuit that makes up the brain.

In this way, the brain builds an extensive network for processing the light that hits the retina; note that this network can be characterized at different spatial scales: local micro-circuits within an area (for example there are many recurrent micro-circuits within V-1), and coarser stages, such as the retina, V-1, V-4 and IT. On this coarse scale, region IT (the inferior temporal region) is implicated in cognition, memory, and decision making; IT connects with many other parts of the brain, including the hippocampus (which houses circuits used in memory formation), the amygdala (important for determining emotional valence), and the frontal cortex (essential in holding and generating ideas). Figure 5 shows the major stages implicated in object recognition in the macaque monkey, but work by Rosa Lafer-Sousa, Nancy Kanwisher, and me shows there are homologous regions in humans. I use the macaque to illustrate these regions because this animal is our model organism: it is in macaque monkeys that we can tease apart the cellular mechanisms for visual processing.

Support for the heuristic of serial processing comes from the differences in response properties of neurons at the different stages. Neurons in the retina and LGN are each only sensitive to very primitive stimuli, like spots of light. Neurons in V-1 show slightly more

[20] Lafer-Sousa and Conway, "Parallel, Multi-Stage Processing"; Verhoef, Bohon, and Conway, "Functional Architecture for Disparity."

[21] For an introduction to these topics, please see Conway, "Color Vision, Cones, and Color-Coding in the Cortex"; Bevil R. Conway, "Color Consilience: Color Through the Lens of Art Practice, History, Philosophy, and Neuroscience," *Annals of the New York Academy of Science* 1251, no. 1 (March 2012): 77–94.

sophisticated response properties—many V-1 cells are sensitive to bars of light or edges. Meanwhile neurons at the highest stages of object processing, within IT, can be sensitive to specific facial identities. So we can see why many neurophysiologists like to say that the brain "constructs" a representation, because in a sense this is what the brain is doing: through the visual-processing network, the cortex is building up behaviorally relevant (and rather elaborate) representations, beginning with the pixels (to continue the computer metaphor) encoded by rods and cones in the retina, and ending with neurons that can support face recognition. But we can also find at each stage of the visual-processing hierarchy a great diversity of neural response types. For example, some neurons in the retina receive input from many hundreds of cones, so they have a relatively large view of the visual field, pooling impulses from a sizable patch of the retina, while other retinal neurons may receive excitatory input from a *single cone*, and are therefore capable of supporting very high spatial resolution (because they don't average over many cones). Similarly, in V-1 different neurons show different orientation preferences, some responding to vertical lines, others to oblique lines, and so on. Other V-1 neurons are sensitive to moving bars, and as I will describe below, we found some V-1 neurons that are well equipped to process color. Thus at each stage of the visual-processing hierarchy there are neurons that possess a variety of tuning preferences. They culminate in IT as a set of parallel channels thought to be responsible for color, faces, objects, and places.[20]

This model of vision—one in which a stimulus triggers activity in a hierarchical network—is a useful heuristic. But there are many exceptions. For example you can "see" vividly without using your eyes, simply by using your imagination. So we know that vision must be supplied not only by "bottom-up" (i.e., retinal) signals but also by "top-down" (i.e., higher-order) mental representations.[21] Top-down signals are probably part of feedback processes, in which neurons of a later, "higher" stage have established connections by sending their axons back to a prior stage, considered lower down in the visual-processing hierarchy. With such complexities in mind, we can return to the question: How is color processing implemented in the brain?

Beginning with that "bottom up" process, the perception of color is initiated in the retina by the absorption of light into three classes of cone photoreceptors, each equipped with a different colored pigment. These three types of cones are called L, M, and S, because they have peak absorption (i.e., sensitivity) in the long-, middle-, and short-wavelength parts of the visible spectrum. It's often said that the cones are responsible for color vision, but it's important to keep in mind that the cones are responsible for *all* vision during daylight—they also enable you to see blacks and whites, and they allow your brain to obtain information about motion, faces, emotional expressions, everything that you can see when the sun is up

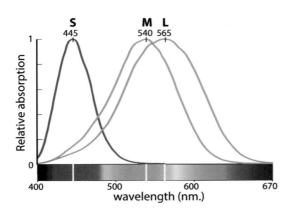

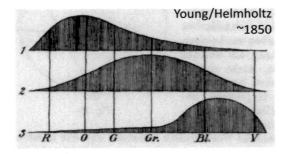

FIGURE 6
Spectral sensitivity of the three classes of cone photoreceptors (L, M, S) in the eye (top), as predicted by Thomas Young in 1802, and championed by Hermann von Helmholtz beginning in 1852 (bottom).

and light is relatively bright. There is a common misconception that "rods are for black and white, and cones are for color," but this is rubbish. Rods are used to extend the dynamic range of vision to low-light situations. They are pretty much silent in daylight conditions. And since you can see black and white during the day, you can be sure that cones must be able to convey that information! We are tricked into thinking of rods as being for black and white because under dim light conditions you only have one class of photoreceptors working, and you need more than one class of photoreceptors to see in color (you are, surprisingly, colorblind under very dim light conditions).

These three cone types don't actually translate into the perception of red, yellow, and blue, as Young and Helmholtz predicted. (FIG. 6) With the possible exception of the S-cone, the peak of each cone's sensitivity function does not align with a specific spot in the spectrum that we call by a color name. Note that the long wavelength or sensitive cone (L), the so-called red cone, has its peak *in the yellow-green part of the spectrum*, right next to the peak of the M-cone. This means that in order to see long-wavelength light as red (which we do), we are using only the very tail end of the sensitivity of the L-cone. It also means that neural processes must *compare* the activation across cone types to get at that tail end activation. Put another way, "red light" is not what makes the so-called red cone most active, and the cones do not represent primary colors in any way.

"Dot product" is a mathematical operation that takes two equally long sequences of numbers, and returns a single number. It is computed by adding up the products of the corresponding entries of the two sequences of numbers.

So how do colors feel primary and indivisible? This experience appears to arise from the elaborate neural machinery of vision, *not* as a result of the input to it. The compelling nature of primary colors is achieved in processing—and clearly these mechanisms work so well that they convince us into thinking the primary colors are either in the world or encoded by the retina. To make this point clearer: the relationship born by the retinal cones to wavelengths of electromagnetic energy is not at all like the tuned cilia that are present in the cochlea of the ear. These cochlear cilia indeed have precise relations to wavelengths of sound information, much as the olfactory neurons have incredible chemical sensitivity to specific molecules sensed as odor. This tells us right away that there's something very important in terms of the neural machinery (or "software," to use the contemporary analogy) that's supporting the extraction of color from those three cone types.

Color is a key model for understanding how the brain works because, on the one hand, a century of careful studies have documented the remarkable behaviors afforded by color vision—what we can call the output of the vision system. On the other hand, we can measure fairly accurately how the different classes of cone will respond to any physical stimulus—the input to the brain. Yet we are still struggling scientifically to understand how these relative activations inform the colors you see. This conundrum sets up the challenge precisely, exposing the critical operations that the brain must be performing on the retinal signals in order to generate perception and cognition.

Honing in on this input problem, we can begin by predicting the cone activations from a given stimulus. We can determine with very high precision the physical spectrum reflected off an object—the exact wavelengths of light coming from any section of a visual array. So we can measure what is out in the world as light rays come off an object and enter the human eye. Then we can compare those measurements to known sensitivities of the three cone types and predict with confidence the relative cone activations that will be happening as this stimulus begins to be processed. This calculation is easy: all you need to do is compare the overlap of the spectral power distribution (the graph that shows the amount of each wavelength entering the eye) and the sensitivity function of each cone type. The more these two graphs overlap, the more the cone will be activated. This calculation is called the dot product, but it really is intuitive.[22] Consider the case in which the stimulus reflects only ultraviolet light. Our cones are not sensitive to UV light—the cone absorption curve and the stimulus curve do not overlap at all. So the cones will not be active. Now consider a stimulus that reflects predominantly middle-wavelength light (the part of the rainbow you call "yellow"). This aligns perfectly with the peak of the L and M cone sensitivities, so the stimulus will cause a lot of activity in these two cone types. And this is why yellow is the brightest part of the rainbow: it is the

part of the spectrum that aligns most perfectly with the sensitivities of two distinct cone types.

The problem, as I alluded to above, is that knowing the relative cone activations elicited by a stimulus doesn't tell you the *color* of the stimulus. A given triplet of cone activations could appear as a very different color if one changes the context in which the stimulus is seen. There is a wonderful demonstration of this called the Paradox of Monge.[23] Consider an image that contains many patches of different colors. And consider specifically a red patch in the image. If you look at that image through a red filter, the wavelengths entering into the eye from the red patch are presumably unaffected by the color filter. Light has already been filtered by the paint, as it were, to extract everything but long-wavelength energy, which should, by all laws of physics, pass through the red filter mostly unaltered. This means that the relative cone activations caused by the red patch in the image should be the same with and without the color filter (and as Edwin Land showed, you can create circumstances in which this is exactly true, as opposed to approximately true, as in the Paradox of Monge).[24] Yet despite the laws of physics, that patch of red, seen through the red filter, is no longer seen as "red," but rather almost colorless. This paradox is compelling for two reasons. First, it dispels the widely held myth that the world looks redder through rosy colored glasses. Second, and more importantly, it underscores that there must be a considerable amount of neural processing on the retinal image in order to allow you to come up with a simple declarative statement "that patch is red" or, in the filtered case, "not red."

Put simply, color judgments of any sort are *context dependent*. The contextual information can include simple (bottom-up, or "low level") aspects of the image—the spatial distribution of colored patches in the scene. Or it can contain more complicated (top-down, or "high level") aspects of the image—what you expect to see in the scene, and what colors you have experienced as associated with those known stimuli. It has been clear for hundreds of years that the perception of an object's color depends on a whole host of operations that we take completely for granted, and that these operations rely on the spatial and temporal chromatic context in which we see the object. A simple way of characterizing the low-level operations would be in terms of a chromatic-opponent mechanism, in which a thing is seen as being red, because at that moment of perception, the background is decidedly *not red*. As for the high-level operations, they incorporate assumptions or implicit beliefs (which we call "priors") about what is being seen. These priors can be decisive in generating perception, and they are important because the output of the low-level operations is almost always still ambiguous.

A powerful demonstration of the importance of priors is provided by "the dress" photograph that bloomed in 2015 under the online hashtags #TheDress, #whiteandgold, #blueandblack. (FIG. 7) The colors of the pixels in the photograph, if extracted from the

[23] In 1789, mathematician Gaspard Monge arranged for a red cloth to be hung from a building across from the Paris academy. He then demonstrated to his colleagues that when the cloth was viewed through a red glass, it looked simply white, instead of looking *more red than ever*. Similarly, a yellow-tinted paper, when viewed through a yellow transparent glass, was interpreted as white. This "Paradox of Monge" is strongest under full daylight, when a range of colored objects is being viewed. See John Mollon, "Monge: The Verriest Lecture, Lyon, July 2005," *Visual Neuroscience* 23, no. 3–4 (May–August 2006): 297–309.

[24] Edwin H. Land, "The Retinex Theory of Color Vision," *Scientific American* 237, no. 6 (December 1977): 108–28.

FIG. 7A

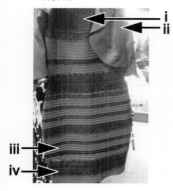

FIG. 7B

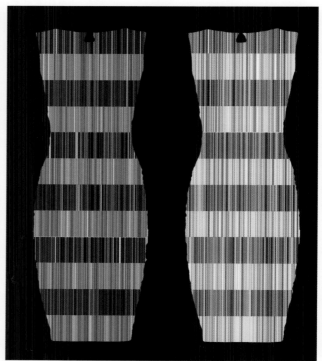

FIGURE 7
Striking individual differences uncovered by a 2015 viral Tumblr post known as "the dress" photograph. (A) The photograph, with the two components identified in four regions. (B) Participants using a digital color wheel reported colors in these regions as they saw them on the dress; we used these results to stitch together two depictions of the dress based on divergent color matches that people made. See note 7, and also Rosa Lafer-Sousa et al., "Parallel, Multi-Stage Processing of Colors, Faces and Shapes in Macaque Inferior Temporal Cortex." (See note 14.)

image and shown on a neutral background, are unambiguously brownish orange and light blue.[25] But people were divided about how they saw this image: the dress *was* white and gold or *was* blue and black. This poorly illuminated snapshot of a horizontally striped dress provided the data for a major scientific discovery, because it uncovered striking individual differences in color perception across a large population of humans.[26] It is probably the most compelling example of individual differences in color perception ever documented. The divide between those who saw the dress as white and gold, and those who insisted it was blue and black, is best explained by the difference in internal priors. We often want our scientific discoveries to come in a high-class format, but as it happens, the poor quality of the photograph explains why it was so effective as a bifurcating stimulus: the photograph does not have enough information in it to tell you, unambiguously, about the lighting conditions of the dress or its material properties. And as a result, in computing a color for the dress, you must rely on internal priors that guide you in interpreting the image—in sum, whether you assume it is illuminated by bluish daylight (a prior we could call the "short-wave bias"), and hence must *really* be white and gold, or whether you assume the dress is being illuminated under orangey-red incandescent light (the "long-wave bias"), in which case it must *really* be blue and black.

Beyond a bit of fun, the dress debate shows how important color is in social identity: we spontaneously formed camps, vigorously defending our group's particular perception of the dress. And the image underscores the profound importance of high-level priors in determining color.[27] In addition to short- and long-wave bias, priors include assumptions about *material*—whether the dress material was reflective (yielding a white-gold judgment) or matte. Similarly, a billiard ball (known to be shiny) might be seen without controversy as *red*, despite reflecting the surrounding room. Why don't you interpret the "color" of the ball to comprise a small image of you and the room? Presumably your experience of the material property, that prior, enables you to discount reflectance to achieve a constant color percept: "red." Together, these observations suggest that color occupies a place in the mind that is somewhat divorced from the fine time-scale of sensory stimulation: color is held constant even in the face of highly dynamic sensory stimulation. The relative combination of different wavelengths of light that are reflected from an object is the product of two variables: the spectral content of the light source that illuminates the object, and the absorptive properties of the object (what parts of the spectrum the object absorbs). The fact that the colors of objects appear to be constant over time and under different lighting conditions is remarkable because spectral information reflected from the object can (and does) change dramatically as viewing conditions change. Holding an object's color constant over time is the counterpoint to Tauba Auerbach's supposition that perceptual time implicitly involves processing the changes induced by living in three dimensions. (See Tauba Auerbach, "Amphibian," in this volume.)

How does the brain achieve this color constancy? Edwin Land, the founder of Polaroid and the inventor of instant color photography, proposed one simple model. He suggested that the brain might compute the color of an object by comparing the relative cone activations associated with the object with the relative cone activations of the immediately adjacent regions surrounding the object. One might think of this as a ratio of ratios. Such ratios are largely stable in the face of changes in the color bias of the light source. Land didn't know whether this model was implemented in the retina or in the cerebral cortex, so he hedged his bets and called the model "retinex" (see note 24). I spent about 10 years looking for a neural substantiation of this model, and discovered a small population of neurons in the primary visual cortex (V-1) that have the requisite properties. Such neurons are not found in the retina or LGN. The emergence of color-contrast computations in V-1 reminds us that vision does not operate like a camera; it is not achieved by the eye alone.[28] The neurons we found in V-1, called "double-opponent cells" because they perform both spatial and color opponent operations, could be the neural basis for color constancy.[29] These neurons are able to subtract out the spectral bias in the illuminating light source,

25
Adam Rogers, "The Science of Why No One Agrees on the Color of This Dress," *Wired,* February 26, 2015, online at www.wired.com.

26
Rosa Lafer-Sousa, Katherine L. Hermann, Bevil R. Conway,"Striking Individual Differences in Color Perception Uncovered by 'The Dress' Photograph," *Current Biology* 25 (2015): R545–46.

27
Bevil R. Conway, "Color Signals Through Dorsal and Ventral Visual Pathways," *Visual Neuroscience* 31, no. 2 (March 2014): 197–209; Rosa Lafer-Sousa et al., "Color Tuning in Alert Macaque V1 Assessed with fMRI and Single-Unit Recording Shows a Bias Toward Daylight Colors," *Journal of the Optical Society of America. A, Optics, Image Science, and Vision* 29, no. 5 (May 2012): 657–70.

28
This fallacy—the eye as self-contained camera—has historical roots that run deep in our culture. Even the National Institute of Health's vision section is called the "National Eye Institute," although much of the basic science it funds studies the cerebral cortex, not the eye.

29
Bevil R. Conway, "Spatial Structure of Cone Inputs to Color Cells in Alert Macaque Primary Visual Cortex (V-1)," *Journal of Neuroscience* 21, no. 8 (April 2001): 2768–2783; Conway et al., "Advances in Color Science: From Retina to Behavior."

FIGURE 8

(A) An illustration from Josef Albers, *Interaction of Color* (New Haven: Yale University Press, in association with the Josef and Anni Albers Foundation, 2009, plate VI-3), paired with (B) the same image that has been reproduced with white buffers added by the author around the "X" forms. (See note 21.)

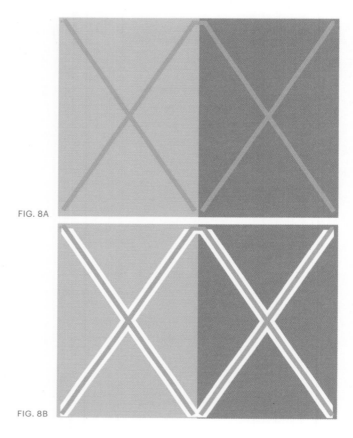

FIG. 8A

FIG. 8B

color-correcting the information provided to consciousness. Their existence shows that the very perception that there *is* color, hinges on something downstream of what's happening in the retina. One of the surprising things is the small spatial scale over which the color-contrast calculations take place, perhaps on the order of half a degree of visual angle. This neurophysiology aligns with an observation made by artists: that colors need to be next to each other in order to create the strongest color interaction.

In his book *Interaction of Color* the artist Josef Albers showed that a stripe of a constant physical pigment can appear to be two different colors depending on the background surrounding the stripe. (FIG. 8) The image gains appeal because of the clever interplay of foreground color and background color: the X on the left half of the image appears the same as the background color in the right half of the image and vice-versa for the X on the right half of the image. As Albers pointed out, the stripe appears as a different color *because* of the different backgrounds. The neurophysiology suggests that this interaction depends upon unconscious, very local operations. To prove it, I simply imposed a white buffer on Albers's original illustration to remove the local interaction. This addition restores a stable

percept of the line across the whole image, canceling out (and thus confirming) Albers's brilliant empiricism.

Color may not be an expansive enough term to cover everything that is happening in the extremely complex sector of visual processing. As we discover more of what color is *for*, we're going to need a much larger tool kit—and we are only at the beginning stages of assembling that set of tools. For instance, downstream from V-1 is a large swathe of cortical tissue dubbed the "extrastriate" cortex (this includes all visual areas not part of V-1, such as V-2, V-3, V-4, and IT).[30] It turns out that a lot of extrastriate cortex is involved in color, much more of it than I think anyone expected. How do we know? My friend Doris Tsao and I answered this question with the use of noninvasive whole-brain imaging methods (fMRI), coupled with careful experimental design. Many parts of extrastriate cortex are active in response, specifically, to color. (FIG. 9) In particular, we found that parts of the brain in and around area V-4, a stage that is midway between the retina and the highest stage of visual-object processing, show a bias for colored images over achromatic images. We called the color-biased regions in and around V-4 "globs" (marked with white arrows in the illustration) based on their response properties.[31] By using the fMRI to guide microelectrode recordings in monkeys (the microelectrodes are tiny wires that allow one to listen in on the activity of single neurons), we confirmed that the neurons in the globs are selective for color. (FIG. 10) The finest pixel in an fMRI map (called a "voxel" because it is volumetric) corresponds to many hundreds of thousands of neurons; fMRI is at best only an indirect measure of neural activity.[32] Amazingly we find that within the globs, most neurons give responses that are not only sensitive to color, but also highly selective for color. Figure 10 shows the response pattern for two glob cells, each precisely tuned to a specific color.

Both the cells shown in the illustration respond optimally to a stimulus associated with the perception of "green," and the cells happen to sit right next to each other in the brain. We discovered that if we record many of these adjacent cells, a striking pattern emerges: cells neighboring each other show a gradual *sequential* progression related to the color wheel. That is, cells tuned to orange reside next to ones tuned for red, which are next to ones tuned for purple, and so on.[33] The study in which we published this finding provided the first single-unit evidence for what we might think of as a microscopic *chromatopic* map. And this evidence sheds light on a long-standing problem: How does the cerebral cortex, a 2D sheet, represent a linear stimulus, the spectrum? The answer, suggested by the spatial layout of the color-tuned cells in the globs, is that the brain represents the linear spectrum by folding it into a circle, which is perhaps the optimal way to pack one-dimensional lines in a two-dimensional sheet. The consequence of this is that there are neurons straddling red and blue (where the circle closes), giving rise to magenta (aka purple). As Stephen Fry comments, "purple is a pigment of the imagination."[34]

[30] In cross section, V-1 has a distinct stripe running through it and thus it is "striate" cortex. Regions of cortex outside of V-1 are therefore called "extrastriate."

[31] Bevil R. Conway, Sebastian Moeller, and Doris Y. Tsao, "Specialized Color Modules in Macaque Extrastriate Cortex," *Neuron* 56, no. 3 (November 2007): 560–73.

[32] If fMRI tells you whether the home team is batting in the stadium, the microelectrode recordings allow you to bug individual conversations to figure out much more precisely what's going on in the game.

[33] Bevil R. Conway and Doris Y. Tsao, "Color-Tuned Neurons Are Spatially Clustered According to Color Preference within Alert Macaque Posterior Inferior Temporal Cortex," *Proceedings of the National Academy of Sciences* (USA) 106, no. 42 (October 2009): 18034–18039.

[34] Stephen Fry, host of the comedy game show *Quite Interesting* (or *QI*). Fry addressed magenta in "Lying," episode 10, season 12, aired by the BBC on December 12, 2014.

FIG. 9

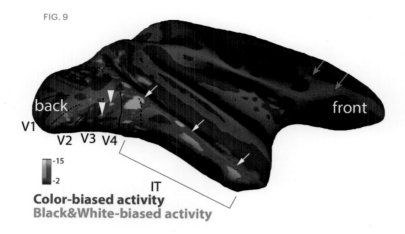

FIGURE 9
Color processing in extrastriate cortex. Color-biased regions identified with fMRI. Globs in V-4 (arrowheads); large color-biased domains in IT (white arrows); and color-biased regions in frontal cortex (gray arrows).

FIGURE 10 (FACING)
Responses to color in two neurons recorded within a color-biased region. The responses have been sorted by the color of the stimulus (y-axis). These particular cells show strongest responses to green colors. The stimulus onset is at 0ms; the delay following stimulus onset before the cells begin to respond corresponds to the visual latency of the cells (the time required for the signals to propagate through the visual-processing hierarchy to V-4). The polar plot shows a summary of the color responses, indicating the color that elicited the maximum response. (See note 33.)

Our perception of purple seems to be pretty compelling evidence of the active involvement of the brain in constructing our experience of the world, and color specifically.

We are presently running experiments in which we artificially activate neurons known to be tuned to specific colors using very small amounts of electric current, while the monkeys wired with these electrodes perform a color-related task. By artificially stimulating a purple-tuned neuron in the absence of any real visual stimulus, what does the animal see? Does it see purple? Are these neurons causally linked to our perception? Remember that the color-tuned cell is embedded in an entire network that must also incorporate top-down information and priors accumulated before this momentary firing.

To summarize in the form of a polemic: *color depends upon the firing of many neurons; color does not reside out there in the physical world.* Color experience is an extended process and seeing color is not a retinal reflex. With this assertion in mind, my long-range goal is to use the neurophysiology of vision to reverse engineer the problem of what color is for. Relevant here is our discovery of those color-biased domains within the inferior temporal cortex (IT, see Figure 9, white arrows), along with the color-biased activations in the frontal cortex (gray arrows in the region marked "front"); compare the scale of these regions to the smaller, finer globs in V-4 (arrowheads above V-4).

The patterns of activation in these cortical regions do not appear to be random; similar patterns are found across monkeys and humans. Pursuing this apparent stereotypy, we measured responses to faces, and discovered that the activation patterns for colors and faces appeared near each other, yet were essentially non-overlapping. The color-biased regions usually resided ventrally to the face regions and at corresponding locations along the temporal lobe. (FIG. 11) These results suggest that both systems are subject to a deep organizing principle that carves up IT into separate subareas, with each having one color region and one face patch. This discovery resolves

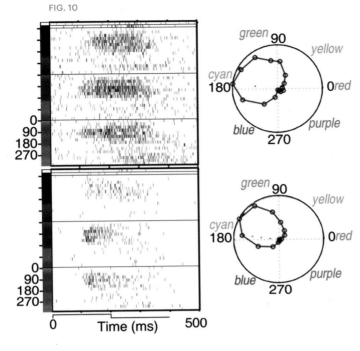

FIG. 10

[35] Winrich A. Freiwald and Doris Y. Tsao, "Functional Compartmentalization and Viewpoint Generalization within the Macaque Face-Processing System," *Science* 330, no. 6005 (November 2010): 845–51; Elias B. Issa and James J. DiCarlo, "Precedence of the Eye Region in Neural Processing of Faces," *The Journal of Neuroscience* 32, no. 47 (November 2012): 16666–16682.

the long-standing neurological puzzle of brain-damaged patients who acquire color blindness: they very often also acquire face blindness. The co-morbidity can be predicted if we understand the two systems as running in parallel adjacent streams through IT; strokes will impair adjacent parts of cortical tissue.

We were surprised to discover that so much of IT is involved in processing color, as revealed by our fMRI experiments. Recall that the visual-processing hierarchy has already achieved a representation of specific hues by the glob cells located in the mid-tier visual area, V-4. If that work is already accomplished by V-4, what are the higher-level computations in IT that depend on color? Determining the nature of the computations within the different IT compartments—how they are built up from antecedent stages, how feedback shapes ongoing activity, and how these mechanisms evolve with experience and connect to behavior—constitutes an important part of my lab's future directions.

Work already accomplished on the IT reveals that, in the face-recognition system, there is a hierarchy of tasks, from focusing on a specific feature like eyes to representing specific identities.[35] What would this mode of hierarchical computation predict for IT's role in color? If learned object-color associations are analogous to facial identities, we might expect to find behaviorally relevant and potentially rewarding object-color memories in anterior IT. Significantly, these parts of IT are richly connected with subcortical structures known to be connected with emotion and memory. However, we have very little hard data on how visual cognition interfaces with

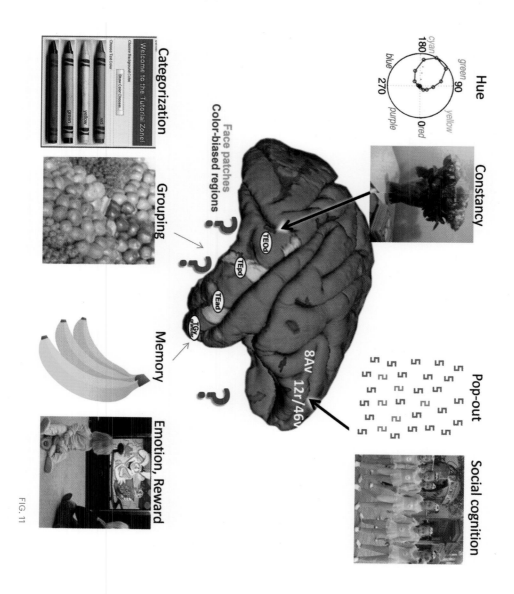

FIG. 11

those structures, such as the basal ganglia and the hippocampus. Tackling this important question will likely give us insight into the behavioral relevance of color, and perhaps even its role in affect (and how this goes awry in depression).

Conversely, in IT itself, higher-order computations such as color categorization and grouping might share some similarity with the kind of contextual calculations performed for faces by the middle patches of this region. This relation would leave the posterior regions responsible for coding specific hues along with the attendant color constancy calculations, which might be analogous to the computation of "eyes" by the posterior face patch. Finally, in recent preliminary experiments, the frontal cortex also appears to possess color-biased neurons in or around regions called 8Av and 12r/46v.[36] These areas have been implicated in the initial selection of behaviorally relevant stimuli, and seem like excellent candidates to mediate the feature attention (or "pop-out") aspect of color. Given the role of frontal cortex in other high-level cognitive tasks, it also seems plausible that these regions play a role in computing color as a marker of identity in social cognition.

I hypothesize that color-processing within IT will show that the computations within the face system are not unique, but constitute one manifestation of a canonical set of computations that IT performs. Moreover, the strong link to facial processing brings us back to where we started, suggesting the clear behavioral relevance for color in social interactions. We may not have determined definitively what color is for, but neuroscientific research confirms that there is a great deal of neural real estate implicated in color processing within those parts of the brain essential for higher-order cognition. Maybe by studying the neural computations taking place within these regions we will come closer to understanding what supports the indisputable human interest in color.

FIGURE 11
Theoretical framework to guide future investigation of the function of the color-biased regions in IT.

36
Forthcoming work by Maria Romero and Kaitlin Bohon, in the author's lab.

FIG. 1

MATHEMATIZING

Alma Steingart

FIGURE 1 (FACING)
"Views of the Tessaract [sic]," frontispiece from Charles Hinton's *The Fourth Dimension* (1904), accompanied by these remarks from Hinton's *A New Era of Thought* (1888): "The square Vermilion traces a Pale-green cube, and ends in an Indian-red square.... In this square he has two lines which he had before, the Blue line with Gold and Buff points, the Deep-yellow line with Light-blue and Red points.... The Black square traces a brick-red cube."

FIGURE 2
Four-color map problem—a solution to the problem hand-colored by Myrle V. Cross and published by Martin Gardner in 1975 as an April Fools' Day hoax, which claimed that the four-color theorem had been disproven.

In exhaustion, or in frustration, or just to refresh eyes trained too long on my computer screen, I shut them and rub my palms against my closed eyelids. A psychedelic swirl and burst of cardinal, celadon, and ochre projects itself onto the cinema screen of my visual cortex. Such cross-modal signaling, in which haptic and visual sensory inputs get switched, is the sort of hallucinatory spectacle that led Johann Wolfgang von Goethe to posit a corporeal subjectivity severed from Newtonian optics.[1] Seeing colors, for German Romantics, would no longer be neutral or objective. Rather, it was an inquiry into—and an embodied experiment in—the intermixing of sensory organs and sensations, what we know of the outside world and how we know it, objectivity and subjectivity.

We struggle against such Romanticism when, for example, we think of colors as mere variables, as an aid to understanding and doing mathematics. The history of mathematical knowledge bears a surprising relation to manifestly embodied sensory practices, despite the status of color as "mere" heuristic in the discipline. For most mathematicians today, there is nothing *specific* to color when it appears in mathematical problems and theorems. For them, it is merely one entirely arbitrary factor by which to mark some sort of difference. But is it really so arbitrary?

Color's frequent, almost perpetual, use by mathematicians to assign variables suggests on the contrary that color's role is *not* random. In what follows, I will excavate the history of this pattern. In 1957, for example, at the height of mathematical formalization in the United States, Vannevar Bush, initiator of the Manhattan Project and champion of the National Science Foundation, sent a letter to mathematician Solomon Golomb, who had recently published a short column in *Scientific American* reporting on a proof that a particular covering of a checkerboard with pieces of a specific shape was impossible. Golomb arrived at this proof by coloring each tile on the board, and Bush naively asked him whether the proof would still hold if the board had been colored differently. Golomb laughed at Bush's question, wondering how such a powerful champion of science could know so little as to think colors mattered to mathematics.[2]

A mathematician makes a similar joke, perhaps apocryphal, this time at a historian's expense: one evening, a mathematician and a historian amble across campus in the waning light, discussing the

1
Jonathan Crary, *Techniques of the Observer: On Vision and Modernity in the Nineteenth Century* (Cambridge, MA: MIT Press, 1992), chapter 3, especially pages 67–74.

2
Solomon W. Golomb, "Mathematics After Forty Years of the Space Age," *The Mathematical Intelligencer* 21, no. 4 (Fall 1999), 43.

[3] Thomas Lorie Saaty and Fritz Joachim Weyl, *The Spirit and the Uses of the Mathematical Sciences* (New York: McGraw-Hill, 1969), 2.

[4] Wittgenstein took Goethe's *Theory of Colours* with him on the trip. Ray Monk, *Ludwig Wittgenstein: The Duty of Genius* (New York: Penguin Books, 1990).

[5] Norman Malcolm, *Ludwig Wittgenstein: A Memoir* (Oxford: Oxford University Press, 1984), 133–34.

[6] Ludwig Wittgenstein, *Remarks on Colour*, trans. Linda L. McAlister and Margarete Schättle (Berkeley: University of California Press, 1977), III–9, 17e. Emphasis added.

[7] Ibid., III–293, 55e. For the philosopher, the sentence with quotation marks in the parentheses reiterates the two types of knowledge identified in the preceding sentences.

four-color map theorem. (FIG.2) The gist of the theorem, the mathematician tells him, is that for any possible map, one needs no more than four colors to ensure that any two countries sharing a border will have different colors. The historian is the butt of the joke: he responds, "Oh, yes. Blue, yellow, pink, and green, isn't it?"[3] Imagine the resounding deprecating laughter of mathematicians retelling this tale. Of course the colors themselves are irrelevant! What matters is the formal notion of mapping cartographic relations.

Allow me to try to silence the laughter of these mathematicians with another tale of mathematics and color. In 1949, suffering from inoperable metastatic prostate cancer, Ludwig Wittgenstein traveled home to Vienna in his final months to care for his dying sister, Hermine. He began thinking about color, a topic he took up with great enthusiasm after he returned to Cambridge.[4] He reported that his impending death cleared his head, and that, for the first time in years, he felt once again able to do philosophy.[5] Wittgenstein's abiding interest in color dates at least to his *Tractatus Logico-Philosophicus*, in which he elucidates both the notion of color-space and the color exclusion problems. But in his final days his thinking changed significantly, and after his death a sheaf of papers simply titled "Remarks on Colour" was discovered on his desk at the University of Cambridge. (FIG. 3)

In it, Wittgenstein writes that these remarks are neither about color as psychology nor as phenomenology, but instead that "here we have a sort of *mathematics of colour*."[6] For him, mathematics could not formalize color, nor was color a heuristic for marking variables. Rather, the bond between math and color runs much deeper. Indeed, the two domains might be thought of as *models for one another*. They are parallel examples of the indeterminacy of experience and language as grounds for mutual concept-work that frees us from solitary idiosyncrasy.

Perhaps, color and mathematics are both models for how we know what we know. They are both, to use his language, language games, and as such, the description (of a proof or a color) is always by necessity insufficient. "Can one describe higher mathematics to someone without thereby teaching it to him? . . . To describe the game of tennis to someone is not to teach it to him (and vice versa). On the other hand, someone who didn't know what tennis is, and learns how to play, then knows what it is. ('Knowledge by description and knowledge by acquaintance.')"[7] That is, we think about and act upon color in the same way as we do for math; the structural relation between perception and epistemology is the same, and concepts including number and "pure color" are irreducible to either phenomenal experience or structured realism. Rather, they are two-way relays between private minds and shared acts of knowing. To paraphrase: no one can adequately describe the color blue to a color-blind person. And, like tennis, in order to know what math is, one must first learn how to play.

To extend his thinking one step further: despite this seeming failure of an intersubjective handle on what we mean by color or mathematical objects, we treat such categories as "natural" ones that precede our own experience of them. And yet, our attempts to grasp tenuously at a private understanding of, for instance, transfinite numbers or cerulean blue is possible only because such language has already been appended to them. As Wittgenstein is at pains to teach us, their terminological identities may stabilize these concepts, but they are woefully insufficient at gesturing toward an experience of them, which is precisely the point. Returning to Wittgenstein's remarks, words designating colors can merely "characterize the impression of a surface over which our glance wanders."[8] This claim does not represent a Goethean theory of color any more than it is a statement about the psychology of perception. It is rather, as Wittgenstein says, a "mathematics of color" that might equally speak to a "color of mathematics."

Fast forward 50 years to another famous dead philosopher of color (and mathematical dilettante), David Foster Wallace. In 2001, Wallace published a short review-essay on language dictionaries, which later appeared in *Consider the Lobster*. Lowering the tone somewhat, Wallace invokes the teenage stoner:

> Eating Chips Ahoy! and staring very intently at the television's network PGA event, for instance, the adolescent pot-smoker is struck by the ghastly possibility that, e.g., what he sees as the color green and what other people call "the color green" may in fact not be the same color experience at all: the fact that both he and someone else call Pebble Beach's fairways green and a stoplight's GO signal green appears to guarantee only that there is a similar consistency in their color experience of fairways, and GO lights, not that the actual subjective quality of those color experiences is the same; it could be that what the adolescent pot-smoker experiences as green everyone else actually experiences as blue, and what we "mean" by the word *blue* is what he "means" by *green*, etc., etc., until the whole line of thinking gets so vexed and exhausting that the adolescent pot-smoker ends up slumped crumb-strewn and paralyzed in his chair.[9]

But rather than succumbing to such bloodshot solipsism, Wallace resurrects the specter of the dying Wittgenstein to argue precisely the opposite. For Wallace, channeling Wittgenstein, language is always built on consensus, and thus can never be private, apolitical, or detached from ideology. This is true of pain, of the color blue, and, notably, of transfinite numbers.[10]

Certain color propositions, like mathematical ones, Wittgenstein noticed, are timeless—internal facts, not external ones. Is the fact

[8] Ibid., III–67, 25e.

[9] David Foster Wallace, "Tense Present: Democracy, English, and the Wars over Usage," *Harper's Magazine* (April 2001), 47; reprinted as "Authority and American Usage," in *Consider the Lobster and Other Essays* (New York: Little, Brown, 2006), 87, note 32. Emphasis in the original.

[10] Wallace seeks to establish once and for all that there is no such thing as private language, and he does so by reference to color. Wittgenstein had, in arguing against solipsism, also drawn upon the twinned examples of math and color.

FIGURE 3
Christian Faur, original handmade artist book, 2008, based on Ludwig Wittgenstein's *Remarks on Colour*, trans. Linda L. McAlister and Margarete Schättle (Berkeley: University of California Press, 1977). Courtesy of the artist.

that pure yellow is lighter than pure red a matter of experience, Wittgenstein asks? To determine whether red is lighter than blue, he would need to see them. "And yet, if I had seen them, I would know the answer once and for all, like the result of an arithmetical calculation."[11] Those qualities of color that transcend experience, and those propositions that remain true when we close our eyes, are a matter of logic. Yet Wittgenstein also acknowledges the impossibility of drawing such a distinction when he wonders, "Where do we draw the line here between logic and experience?"[12] Where, indeed?

In the summer of 1911, Wittgenstein's blossoming interest in the foundation of mathematics brought him to Jena, where he visited Gottlob Frege, for whom the line was clear. For Frege, there was no room for experience in the foundation of mathematics: mathematics must be reducible to logic. Logic was the only way to establish the objectivity of an abstract concept such as number—a fact Frege set out to demonstrate by comparison to color. There "exist[s] a certain similarity between Number and colour," Frege wrote in *The Foundations of Arithmetic*. "It consists, however, not in our becoming acquainted with them both in external things through the senses, but in their being both objective."[13] Neither color nor number could be reduced to sensation, but a number (unlike a color) was not a property of external things. A surface was blue, Frege explained, independent of an observer, but assigning a number to an external thing always requires a choice by the observer.

In this regard, Frege was not alone. The discovery of non-Euclidean geometry unmoored mathematics from the lived world of everyday experience. While mathematicians had long treated Euclidean

geometry as the science of physical space, non-Euclidean geometry demanded that mathematicians reconsider the regnancy of Euclideanism. Not only were hyperbolic and spherical geometries now formally possible, but geometries of four and five dimensions were as well. Such geometries boggled empiricists, and some mathematicians began to believe that reason alone must account for mathematical knowledge, without recourse to experience.

French mathematician Henri Poincaré held that our adherence to Euclidean geometry was simply a matter of convention. "*The geometrical axioms are therefore neither synthetic a priori intuitions nor experimental facts.*"[14] Poincaré submitted that our choice of Euclidean geometry was guided by experience: most of our daily dealings, after all, accorded with it. But this was not necessarily so.

As an indication of what the mathematics of color could be, we need only to elaborate upon Poincaré's thought experiment on how higher dimensions might complicate our understanding of the relationship between subjective experience and a supposedly objective formal space. "Let us begin with a little paradox. Beings whose minds were made as ours, and with senses like ours, but without any preliminary education, might receive from a suitably chosen external world impressions which would lead them to construct a geometry other than that of Euclid, and to localize the phenomena of this external world in a non-Euclidean space, or even in space of four dimensions."[15] Their sensory systems would be arrayed just like ours, but, without prior education and without being inculcated into Euclideanism, they would necessarily be led into an altogether different geometric conception of the world. On the other hand, suggests Poincaré, if "we were suddenly transported" into their world, we would merely translate our experience into our existing Euclidean norms. Euclideanism is not a matter of necessity, but rather of indoctrination.

Poincaré thus distinguished between geometrical space and representational space. The former, being the proper object of mathematical research, is infinite and homogenous; the latter, a constituent of our senses, consists of our tactile, motor, and visual space. Poincaré mused that visual space could conceivably have four dimensions if our visual capacities of accommodation (that is, focusing an eye on objects at variable distances) and convergence (turning both eyes inward to achieve binocular focus) did not accord with one another. Poincaré then asks, would it "suffice to fit over the eyes glasses of suitable construction to put an end to the accord between the feelings of convergence and accommodation, are we to say that putting on spectacles is enough to make space have four dimensions and that the optician who constructed them has given one more dimension to space?"[16] In other words, in human vision, the two retinas register simultaneous sensations and, by focusing on an object, produce a conventional three-dimensional world through binocular vision. Poincaré suggested that our three-dimensional

[11] Wittgenstein, *Remarks On Colour*, III–9, 17e.
[12] Ibid.
[13] Gottlob Frege, *The Foundations of Arithmetic: A Logico-Mathematical Enquiry into the Concept of Number*, second revised edition, trans. J. L. Austin (Evanston, IL: Northwestern University Press, 1980), 34. Originally published in German as *Die Grundlagen der Arithmetik*, 1884.
[14] Henri Poincaré, *The Value of Science: Essential Writings of Henri Poincaré* (New York: Modern Library, 2001), 45. Emphasis in the original.
[15] Ibid., 46.
[16] Ibid., 244.

[17] Ibid. Emphasis in the original.

[18] Christopher White, "Seeing Things: Science, the Fourth Dimension, and Modern Enchantment," *The American Historical Review* 119, no. 5 (2014): 1466–1491.

[19] Charles Howard Hinton, *A New Era of Thought* (1888; reprint, London: Swan Sonnenschein, 1890), 68.

[20] In his review, Russell remarked that "the merit of speculation on the fourth dimension . . . is chiefly that it stimulates the imagination, and frees the intellect from the shackles of the actual." He nonetheless was not yet convinced that the fourth dimension really existed. Bertrand Russell, "Review of C. Howard Hinton, *The Fourth Dimension*," *Mind* 13, no. 52 (October 1904), 574.

[21] Hinton, *New Era of Thought*, 122.

[22] Martin Gardner, *The Colossal Book of Mathematics* (New York: W. W. Norton, 2001), 171.

understanding of space does not necessarily accord with an external reality, but is rather an effect of our physiologically enabled experiences. What if our optical sensations failed to supplement one another? Then the two visual sensations of red would be distinguished and "*the whole visual space would have four dimensions.*"[17] Poincaré was not the only one pontificating on the nature of the fourth dimension at the turn of the century, however. The topic was a lively one about which many mathematicians vociferously speculated.

Charles Hinton, who coined the word *tesseract* in 1888, was perhaps the greatest popularizer of the fourth dimension at the time. Hinton, a British-born mathematician, sailed to the United States at the age of 40 in 1893. In contrast to Poincaré's thought experiments, with which it is possible to *conceive* of the fourth dimension, Hinton set about teaching his readers how to *see* the fourth dimension. His calling was not purely educational: Hinton believed the world we inhabit is merely a three-dimensional shadow of a four-dimensional world that he imbued with mystical qualities.[18] In *A New Era of Thought,* he mused: "With the knowledge of higher space there comes into our ken boundless possibilities. All those things may be real, whereof saints and philosophers have dreamed."[19] Hinton believed he had access to such numinous realms.

Hinton's books serve at once as phenomenological manuals, as travel guides, and as colorful manifestations of the fourth dimension. While not all readers necessarily subcribed to Hinton's mystical interpretation of the fourth dimension, the book was taken seriously, as demonstrated by the fact that the esteemed Bertrand Russell reviewed it upon publication.[20] Like Poincaré, Hinton held that our perception of three-dimensional space is a mere matter of habit, albeit one that could be undone. To do so, he devised a system of 27 colored blocks, which could be manipulated, arranged, and memorized in successive steps. (SEE FIG. 1) One set of his instructions reads: "The square Vermilion traces a Pale-green cube, and ends in an Indian-red square." Others note: "In this square he [the viewer] has two lines which he had before, the Blue line with Gold and Buff points, the Deep-yellow line with Light-blue and Red points," and "The Black square traces a Brick-red cube."[21] Hinton believed that, by repeating these chromatic manipulations and committing them to memory, readers could gain the ability to perceive the fourth dimension.

If you feel confused, you are not alone. Years later, when Martin Gardner, who edited the popular "Mathematical Games" column for *Scientific American*, referred to Hinton in a *Scientific American* column, a worried reader wrote: "A shudder ran down my spine when I read your reference to Hinton's cubes. I nearly got hooked on them myself in the 1920s. Please believe me when I say that they are completely mind-destroying."[22] This is certainly not the first time that higher mathematics has been blamed for sinking mathematicians into derangement, the most prominent example being Georg Cantor

and his transfinite numbers. Non-Euclidean geometry was another topic that caused mathematicians to flirt with lunacy. János Bolyai, one of the discoverers of non-Euclidean space, was exhorted by his father, "For God's sake, I beseech you, give it up. Fear it no less than the sensual passions because it too may take all your time and deprive you of your health, peace of mind, and happiness in life."[23] David Foster Wallace also noted the destructive power of thinking about the fourth dimension: "There is something I 'know,' which is that spatial dimensions beyond the Big 3 exist. I can even construct a tesseract or hypercube out of cardboard." He then added, "I 'know' all this, just as you probably do . . . but now try to really picture it. Concretely. You can feel, almost immediately, a strain at the very root of yourself, the first popped threads of a mind starting to give at the seams."[24]

A mind destroyed, its peace ravaged, straining at its seams: Why the perpetual and popular anxiety that contemplating non-Euclidean geometry and the higher dimensions might undo reason, reducing us all to the unbalanced frenzied fulminations of dementia? Precisely because they, like color, risk rendering us, if not idiots, then idiolects who speak a language understood by no one else. If Goethe worried that color exemplified a fundamental break between the outside world and the sensoria by which we sense it, thus rendering all sensory bodies prone to abject hallucination, then Wittgenstein would tether color to mathematics as corresponding models for a theory of knowledge. Wallace inherits the line of experiential inquiry initiated by Goethe, reformulated by Wittgenstein, and colored by Hinton.

Here, then, is why, when philosophers, phenomenologists, and stoner-philosophers wrestle with the heady questions of phenomenology and epistemology, they cut their teeth on mathematics and color: neither can be explained through either science or perception. Mathematical and chromatic propositions pose analogous philosophical problems precisely because their truth *can be reduced neither to objectivity nor subjectivity, neither to logic nor empiricism.* Thus we arrive at accounts of mathematics and color in which the two are mutually reliant on one another. More so, they rely on the intensely social acts of experience, on the insufficient yet wholly necessary work of description, and on the socially enabled yet sometimes lonely experience of learning *how:* how to prove, how to play tennis, how to see in a trained and careful manner.

[23] Ibid., 167.

[24] David Foster Wallace, *Everything and More: A Compact History of Infinity* (New York: W. W. Norton, 2010), 23.

DEVELOPMENT OF THE COLOUR SENSE

ACHROMATIC

DICHROMATIC

TETRACHROMATIC

FIG. 1

MORALIZING
Michael Rossi

To deny the evidence of one's own senses. To insist upon illogic over reason. To cloak clear truths in imprecise terminology. These are the methods of confidence men and hucksters, false advertisers and charlatans—and yet, at the turn of the 20th century, American psychologist Christine Ladd-Franklin believed that this sorry state had come to pass in the scientific study of color.

A gifted mathematician admitted to Johns Hopkins graduate school under the neutralizing moniker "C. Ladd" (but denied a PhD in 1874 because she did happen to be female), Christine Ladd had her work on symbolic logic selected for publication by her teacher and mentor Charles Sanders Peirce—an acknowledgment that encouraged her to further develop her algebraic system.[1] She branched out into physiological optics in the 1890s, to which she brought uncompromising rigor in observation (she discovered the blindness of the retinal fovea in normal night vision) and a capacious grasp of theory (assembled in her 1929 publication *Colour and Colour Theories*).

Uniting these otherwise unconnected interests in logic and visual perception was Ladd-Franklin's deep commitment to a moral revolution in science. Science, thought Ladd-Franklin, was a matter of *making sense* of the world; upright scientists had to know how to believe and behave in order to experience the proper order of nature. Color perception was the perfect place to go looking for such a moralizing scientific practice, because of its curious existence on the borderlands of undeniable physical fact and highly personal subjective experience. Peirce himself believed that color was "as near to the first impression of sense, as any perception which it is in our power to extricate from the complexus of consciousness."[2] Given this position, moralizing color science was a key goal for Ladd-Franklin's logical corrections.

If a general consensus had emerged among physicists, physiologists, and psychologists at the end of the 19th century that color was *subjective*—not a property of objects, but the property of sensing beings—the precise *character* of this subjectivity was nevertheless a matter of great debate. Was color a function of the physiology of the retina, with its exquisite layer of light-sensitive cells, as followers of the great German physicist Hermann von Helmholtz thought? Or was color properly a higher-order activity—

FIGURE 1
Illustration of Christine Ladd-Franklin's proposed three stages of color perception. Note that each animal species represented a different sort of color vision—cats, for instance, possessed achromatic vision, while bees could see combinations of yellow and blue. The human residents of the house at far right could be expected to appreciate a full gamut of color sensations.

1
In 1882, Ladd married Fabian Franklin, a mathematician (later turned journalist). Thereafter, she hyphenated her name.
2
Charles Peirce and Russell Sturgis, Review of *Modern Chromatics* by Ogden Rood, *The Nation* 16 (October 1879): 260.

[3] See Steven Turner, *In the Eye's Mind: Vision and the Helmholtz-Hering Controversy* (Princeton, NJ: Princeton University Press, 1994); Ewald Hering, *Outlines of a Theory of the Light Sense,* [1920] trans. Leo M. Hurvich and Dorothea Jameson (Cambridge, MA: Harvard University Press, 1964), 108.

[4] LeConte Stevens, "Recent Progress in Optics," *Proceedings of the American Association for the Advancement of Science for the Forty Fourth Meeting held at Springfield, Mass, August–September, 1895* (Salem, MA: Published by the Permanent Secretary, 1896); this publication was reprinted in *American Journal of Science* 50, no. 298 (November 1895, series 3): 34; William Henry Howell, ed., *An American Text-Book of Physiology* (Philadelphia: W. B. Saunders, 1901), 337; Deane B. Judd, "Review of *Colour and Colour Theories* by Christine Ladd-Franklin," *Journal of the Optical Society of America* 19, no. 2 (August 1929): 104.

[5] J. P. C. Southall relates this anecdote in a footnote to Ladd-Franklin's "The Nature of the Colour Sensations," which appears as an appendix to the English translation of Helmholtz's *Handbuch Der Physiologischen Optik*, 1896. See Hermann von Helmholtz, *Helmholtz's Treatise On Physiological Optics*, vol. II, trans. James Powell Cocke Southall (Rochester, NY: The Optical Society of America, 1924): 455.

an aspect of mind—as disciples of the great German psychologist Ewald Hering thought?[3] Partisans of these viewpoints clashed bitterly between the 1890s and the 1930s—demarcating theoretical positions, marshaling minute observations into batteries of facts, and trading scathing barbs in print. At stake was nothing less than the nature of body and mind, of perceptual reality, and, by extension, the understanding of life itself.

To Ladd-Franklin, however, the issue was more than just a matter of reconciling careful observations with theoretical precision. Rather, she interpreted the gulf separating Helmholtz's and Hering's concepts as the result of deliberate ignorance. Her moralized perspective castigated these men of science for willfully and systematically ignoring fundamental aspects of human experience, in order to shoehorn facts into preconceived ideas. Such prejudice, thought Ladd-Franklin, was not simply incorrect, illogical, and even unscientific—it was *immoral*. Questions of logic, scientific process, and lived experience for this budding pragmatist were all *moral* questions, contributing to a deeply felt experience of right (honest, virtuous) conduct.

Scientific rectitude was a sensation, just like the sense of color. And color theory would be the ground on which such sensible rectitude could be built. Tackling the titans of color, Helmholtz and Hering, Ladd-Franklin propounded her own, formidable color theory—a magisterial synthesis of the competing paradigms. As evidence that her ideas were beginning to gain credibility, the keynote speaker at the 1895 meeting of the American Association for the Advancement of Science mentioned Ladd-Franklin's theory as one of the few American contributions that could truly match European work for scientific excellence. By 1901, an influential textbook noted that her theory was "in some respects more in harmony with recent observations in the physiology of vision" than any other, and when her book came out in 1929, one positive review noted that her theory had gained "increasingly wide acceptance" in the field.[4] (FIG. 1) Indeed, Helmholtz himself had responded favorably upon first hearing Ladd-Franklin's theory, murmuring, "*ach . . . Frau Franklin—die versteht die Sache!*" (Mrs. Franklin, *she* understands the matter).[5]

But what matter, precisely, did Ladd-Franklin understand? Hers was not an explanation of color that simply took better account of the facts. Even she admitted that her color theory wasn't really based on facts at all—and was barely a theory. Rather, in formulating what she viewed as viable (indeed, the ideal) theory of color, Ladd-Franklin articulated a scheme in which logic, resting on the bedrock of morality, would yield a theory of color that *accorded with lived experience*. Of course it would have to obey facts and cohere as a theory—but its concordance with experience made it *right, correct, good*.

In broad strokes, much of the debate over color sensations in Ladd-Franklin's day turned on questions of the number and

character of "primary," or "unitary," colors. For all concerned, it was clear that the great majority of human observers experienced wavelengths of radiant energy between roughly 400 and 700 nanometers (nm) as a gamut of colors.[6] But how was it that the finite bounds of human physiology could literally *make sense* of an infinite variety of discrete stimuli? To suggest that each distinct tint, shade, mixture, and hue corresponded to its own, precisely calibrated "nerve" in the human organism was both anatomically improbable and intuitively dissatisfying. Intuitively, humans experience colors as two main kinds of sensations, semantically distinct. "Secondary," or "mixed," colors are those that appear to be combinations of other colors. English speakers can describe *orange*, for instance, in terms of reddish-yellow or yellowish-red. Primary, or unitary, colors, on the other hand, are those that cannot be described in terms of other colors; many languages observe this distinction. Blue—the color between green and purple on the solar spectrum—nevertheless is not experienced or referred to as a mixture of green and purple; it is simply and only describable in terms of *blue*. Only a handful of colors possess this unitary quality, but knowing which ones they seemed to be, and how they came by their uniqueness, was central to discerning the experiential nature of all colors.

For Helmholtz and supporters of his "trichromatic" theory, the primaries were red, green, and a bluish violet. These colors were held to correspond to three types of nerve "fibrils" located in the retina of the eye, each type of which was primarily sensitive to long, medium, or short wavelengths of light. Taken individually these fibrils were responsive only to light within their own segment of the spectrum: only light of about 700 nm would fully excite long-wavelength-sensitive fibrils, yielding red; the other fibrils would remain dormant. However, under common viewing circumstances, all of the retinal nerve fibrils would be stimulated to various degrees, and combinations of these variable stimulations were the source of millions of perceivable colors. Yellow, for instance, was the result of equal stimulation of the green-sensitive and red-sensitive fibrils; to put it in colloquial terms, red light and green light mixed to form yellow light. Purple resulted from the excitation of red- and blue-violet-sensitive fibrils. White was the result of simultaneous excitations of all fibril types—a result in keeping with Isaac Newton's observation that white light is a combination of all colors of light. Black was not, strictly speaking, a sensation, but simply indicated the absence of stimulation. Thus did trichromatic theory verify the physiological basis of color experience.

To Hering and his supporters, however, Helmholtz had conflated the stuff of fibrils with sensations themselves. Hering agreed that the retina contained three kinds of receptors, but rather than holding a "piano-key" theory in which the three primary colors correlated with three distinct types of nerve-firings, he insisted that each of the three receptors yielded antagonistically *paired* sets of stimuli. One

6
In the late 19th to early 20th century, American scientists used several different metric units to refer to the wavelength of light. Peirce, for instance, favored "microns" or 1/100,000s of a meter; Ogden Rood, a contemporary of Peirce and Ladd-Franklin's used "1/10,000,000s of an mm." Particularly in later writings, Ladd-Franklin expressed wavelengths of light in "millionths of a millimeter," notated as "μμ." For the purposes of this essay, we use the contemporary notation for millionths of a millimeter—"nanometers"—for simplicity's sake. In current renditions of the electromagnetic spectrum, Hertz (Hz)—a measurement of frequency—is also used, with visible light falling between 4×10^{14} and 7.5×10^{14} Hz.

7

Hermann von Helmholtz, *Handbuch Der Physiologischen Optik*, vol 2. (Hamburg Leipzig: L. Voss, 1909), 378–80; Ewald Hering, "Beleuchtung eines Angriffes auf die Theorie der Gegenfarben," *Pflüger's Archiv* 41, no. 1 (December 1, 1887): 29, and 44, note 3. My translation.

8

Christine Ladd-Franklin, "On Color Theories and Chromatic Sensations," *Psychological Review* 23, no. 3 (May 1916): 237; Christine Ladd-Franklin, "Color-Introspection on the Part of the Eskimo," *Psychological Review* 8, no. 4 (July 1901): 401; Christine Ladd-Franklin, undated note, box 51, folder: the Color Triangle, Christine Ladd-Franklin and Fabian Franklin Papers, Rare Book & Manuscript Library, Columbia University in the City of New York (hereinafter MLCU). Emphasis added.

9

Ladd-Franklin, undated note, box 59, folder: Color, Christine Ladd-Franklin and Fabian Franklin Papers, MLCU. Emphasis added.

kind of receptor oscillated between red and green, one between yellow and blue, and one between black or white—for a total of four chromatic and two achromatic "primary" sensations. According to Hering, it was the variable responses of these three sorts of receptors as they wobbled between their "opponent" stimuli that would combine in the brain of the observer to form sensations of color, or dark and light.

Partisans of each theory defended their views with vigor. Helmholtz chided Hering for his "dogmatic certainty" and for relying on a spurious "inner observation," instead of facts. Hering, in turn, declared that the work of the Helmholtz camp was based on "quite arbitrary, demonstrably erroneous, and rather prejudicial assumptions," which he frankly could not believe they couldn't see for themselves.[7]

Ladd-Franklin, for her part, was well versed in both theories. While accompanying her husband on a sabbatical leave in Germany in 1891, she managed, with characteristic tenacity, to gain admission to the laboratory of Georg Elias Müller, an experimental psychologist and ally of Hering's. She traveled later that year from Göttingen to Berlin to do further work in Helmholtz's laboratories, where she worked with his disciple Arthur König on measuring the "basic sensations" of normal and color-blind vision. (She and König copublished the finding that normal night vision is functionally blind at the fovea.)

Ladd-Franklin came away convinced that both theories were incorrect in the most corrupt of ways. Helmholtz, overly concerned with facts derived from experiment, failed to understand color experience outside of the laboratory. Hering, overly taken with theory—almost as "a matter of religious faith," as Ladd-Franklin saw it—couldn't account for basic experimental facts. It was difficult to decide which faction had committed "the greater crime against the spirit of science," she thought, although in her personal notes she concluded, "The defect in the color-theory of Helmholtz is a defect of omission (while the errors of Hering consist in most *sinful* commissions)."[8]

Do the ends of scientific truth justify immoral means? For Ladd-Franklin, the former could not be obtained without a moral correction in the latter. The specific crimes—or sins—that both sides committed boiled down to a simple question about primary colors: *"Are there such things in the world of our experience?"*[9] How do people experience colors? This inquiry has to be the ground of any discussion. Experimental verification was good, and theory was useful, but the crux of the matter was to be found in the everyday experience of human sensation. When framed in this way, both Hering's and Helmholtz's models were not simply inadequate, they were offensive to basic common sense—and thus immoral.

Helmholtz's "errors of omission" included the experience of primary colors—for example, the sensation of yellow. For if

trichromatic theory indicated that yellow was a mixture of signals from red- and green-sensitive fibrils, there is nonetheless no human description of it as greenish-red or reddish-green. This absence indicated to Ladd-Franklin that yellow *must be* a primary sensation, as yet unaccounted for in Helmholtz's theory. "For the normal individual, yellow is just as real and just as 'unitary' a color sensation as is any one of the other three colors in the spectrum," remarked Ladd-Franklin in her notes.[10] Yellow "will doubtless become the great historical example of the way in which preconceived theoretical considerations have had the effect of extinguishing the plain deliverances of the consciousness."[11]

But Hering and his partisans were no better. In his psychological view of color, Hering had placed special emphasis on black and white as achromatic poles between which chromatic experiences of color occurred, theorizing that people experienced the *intensity* of colors as a function of their luminosity (as Ladd-Franklin paraphrased it).[12] Yet a simple query of one's own sensations would show otherwise. Did humans experience bright, saturated colors such as intense reds or blues as being somehow white? Not at all. Moreover, in their experimental work Helmholtz and König had rigorously proven that the sensation of pure red, for instance, was a product of the stimulation of red-receptive retinal cells—which accorded well with experience—just as white itself had been experimentally proven to be a product of the combined activities of red, green, and blue-violet receptors. In other words, Hering and his supporters ignored both common sense *and* laboratory data.

For these and other sins, Ladd-Franklin declared that Hering's adherents "wander in a nightmare (or fool's paradise) of imaginings + deny themselves (*verzichten*) the pleasures and profits of a *scientific* study of color."[13] A more moral theory would account for observation and experiment, but would measure against common-sense experience above all.

What, then, would a moralized theory of color look like? In 1892 Ladd-Franklin advanced her own. Accepting that there were simultaneous physiological and mental components of color— and postulating that the two had to combine for unitary sensation— Ladd-Franklin proposed an evolutionary theory. (FIG. 1) Adding geological time to the capacity to experience color, she proposed a three-phase model. At first, all optical sensations had been strictly monochromatic, governed by a single "molecule" in the ocular systems of (nonhuman) organisms that registered radiant energy from any part of the visible spectrum. In a second phase, the posited light-sensitive molecule split into two, sensitive to differential frequencies of radiant energy that would (one day) be called blue and yellow, respectively. Finally, in a third phase—the one inherited by most humans—the yellow aspect of the light-sensitive molecule split once more, this time into molecules responsive to red and green light. At this most recent stage, color as such became

[10] Ibid.

[11] Ibid., box 66, folder: Color, MLCU.

[12] Christine Ladd-Franklin, "On Color Theories and Chromatic Sensations," *Psychological Review* 23, no. 3 (May 1916): 240.

[13] Ladd-Franklin, undated note, box 50, folder: Contra Hering, MLCU. My translation. Note that Ladd-Franklin mixes the German *verzichten* in her English-language note. *Verzichten* means to forego or deny oneself something, but can also be translated as "to renounce" something.

FIGURE 2
Schematic of her hypothesized color-sensitive "molecule," from Christine Ladd-Franklin, *Colour and Colour Theories*. This diagram shows the different stages and states of receptors, or "resonators, sidechains, light-sensitive electrons or whatever the current photo-chemical theory calls for," as Ladd-Franklin wrote on page 129.

possible, in the fully color-receptive organism. Humans (and some primates such as the macaque) inherited retinal molecules keyed to red, green, and blue-violet chromatic light—Helmholtz's primary colors. Humans' experience of yellow and white as primary colors was an atavistic holdover from prior perceptual orders.

It was true, Ladd-Franklin acknowledged, that there was little in the way of hard proof for her theory.[14] But hard proof was secondary to the way in which her idea helped to make definite sense of chromatic stimuli. The molecules in her theory were "not so much intended as real molecules, but rather as diagrammatic molecules—as molecules, that is, which are possessed of such properties as would enable them to carry out the *logical* requirements of a light-sensation theory."[15] (FIG. 2) By "logical" Ladd-Franklin meant more than just formally logical; in Pragmatist thought, "logical" meant appealing to a (common) sense of that which was intuitively and incontrovertibly correct. Indeed, as she explained in an early formulation of her theory, "The requirements which a light sensation theory must meet are, at present, wholly of a *logical* nature, and the proper word for its designation is not theory, but hypothesis. The satisfaction which we should feel in a good hypothesis would be the satisfaction, not of the knowledge-loving, but of the logic-loving part of our emotional nature."[16] Ladd-Franklin had combined logic and experience to arrive at a theory of embodied sensation—one that felt right.

A sense of logical correctness was central to the "plain deliverances of the consciousness"—as undeniable as a sense of redness, or blueness, or, indeed, primary-ness. And just as it was *wrong* to deny the evidence of one's senses—a "crime against the spirit of science"—so, too did logical correctness both require a moral foundation and continue to build one. Thus when Ladd-Franklin wrote to her mentor Peirce to gloat that it was "sad to see how illogical all the [color] theories are—all except mine!" she meant that in her theory's scientific logic, it was both right and *morally* sound.[17] Peirce confirmed the syllogism in a letter to Ladd-Franklin written later that same year, explaining that "the science of logic must be

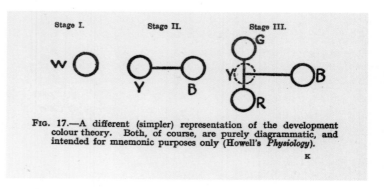

FIG. 17.—A different (simpler) representation of the development colour theory. Both, of course, are purely diagrammatic, and intended for mnemonic purposes only (Howell's *Physiology*).

based on the science of ethics"—that is, "sound reasoning depends on sound morals more than anything."[18]

Indeed, Peirce's reflection was part and parcel of his pragmatic view that humans experience the world as sensing, thinking beings. Humans live in societies, observed Peirce, and societies cohere around rules, laws, and morals. This moral-social existence shapes human experience, not least of all because morality informs people's actions—including actions like studying the scientific nature of color. Not even ostensibly transcendent types of knowing (such as reason and logic) can supersede society, and, by extension, morality. But this did not mean that truth was simply up for grabs in a universe of moral relativism, because, for Peirce, it was the very structure of the universe itself that furnished the possibility of truth.

Experience, verified by the logic-loving part of us, revealed this moral universe to the scientist. For Peirce, Ladd-Franklin, and a host of other thinkers at the turn of the 20th century, the best possible knowledge would be gained through science, insofar as the best possible science was grounded in a moral fundament. Indeed, for Ladd-Franklin, this equation applied as much to matters of social justice as it did to color: reacting to psychologist Edward Titchener's refusal to allow women into his "Experimentalists" club, she excoriated him for an attitude "so unconscientious, so immoral—worse than that—so unscientific!"[19] To behave according to the dictates of science *was* to be moral. To deliberately do the opposite was *immoral*. Whether the matter was the perception of color or the perception of rights, morality was a simple matter of scientific fact.

Ladd-Franklin's theory is today remembered mostly as an antecedent to contemporary zone theories of color, which hold that color vision is the result of multiple stages of color processing—beginning with the reception of light by trichromatic cone cells in the retina of the eye (as per Helmholtz), continuing with its interpretation via tetrachromatic neural opponent processes (as per Hering), and beyond. Yet of greater and more durable interest than her ostensible prediction of contemporary science are the ways in which Ladd-Franklin's work reminds us of the inseparable, historical affinity between morality, science, and experience. Ladd-Franklin was not just an interstitial figure in the emerging science of color, but a conscientious practitioner of science as an exercise of living, sensing, reasoning beings. In formulating her theory of color perception, Ladd-Franklin relied explicitly on the equivalence between her sense of color, her sense of logic, and her sense of moral rectitude. All met on the grounds of experience.

[14] She did believe that Ramón y Cajal's work bolstered her theory, as demonstrated in his 1898 discovery that color-sensing "cone" cells in the retina were evolutionary outgrowths of achromatic, light-sensing "rod" cells. See Christine Ladd-Franklin, "Cones are Highly Developed Rods," in *Colour and Colour Theories* (New York: Harcourt, Brace, 1929), 198–201.

[15] Christine Ladd-Franklin, "On Theories of Light-Sensation," *Mind* 2, no. 8 (October 1, 1893): 489.

[16] Ibid., 474.

[17] Christine Ladd-Franklin, letter to Charles Sanders Peirce, March 22, 1902, L237, Houghton Library, Harvard University.

[18] Charles Sanders Peirce, letter to Christine Ladd-Franklin, "Thanksgiving Day," 1902, box 73, folder: Peirce, C. S. #8, MLCU.

[19] Christine Ladd-Franklin, quoted in Laurel Furumoto, "Christine Ladd-Franklin's Color Theory: Strategy for Claiming Scientific Authority?" *Annals of the New York Academy of Sciences* 727 (October 1994): 91–100.

III.

SOUNDING

Closed Book (2015)

for one player.

Place this book or any other hardback book on a desk, table, or other flat surface. Throughout the course of the performance tap the body of the book in ways that reveal the resonant characteristics of the book coupled with the surface upon which it rests.

Begin by tapping steadily with the middle finger of your writing hand. After having established the speed, loudness and location of your tapping, slowly alter one of these variables. When you hear a slight change of sound, slowly alter a second variable, maintaining the change of the first one; then alter a third, maintaining the changes of the first two, and so on. From time to time tip the book up on one end, or lower it back down on the surface upon which it rests, continually tapping as you do so.

Take care not to alter the same variable, as well as the tipping up and lowering of the book, twice in a row, but ensure that one or more alterations come between.

At least once during the performance use the spine of the book as a bridge to move from the front to the back cover of the book and vice versa.

October 12, 2015
Middletown CT

I Am Sitting in a Room (1969)

for voice and electromagnetic tape.

Necessary Equipment:
1 microphone
2 tape recorders
amplifier
1 loudspeaker

Choose a room the musical qualities of which you would like to evoke.

Attach the microphone to the input of tape recorder #1.

To the output of tape recorder #2 attach the amplifier and loudspeaker.

Use the following text or any other text of any length:

"I am sitting in a room different from the one you are in now.

I am recording the sound of my speaking voice and I am going to play it back into the room again and again until the resonant frequencies of the room reinforce themselves so that any semblance of my speech, with perhaps the exception of rhythm, is destroyed.

What you will hear, then, are the natural resonant frequencies of the room articulated by speech.

I regard this activity not so much as a demonstration of a physical fact, but more as a way to smooth out any irregularities my speech might have."

Record your voice on tape through the microphone attached to tape recorder #1.

Rewind the tape to its beginning, transfer it to tape recorder #2, play it back into the room through the loudspeaker and record a second generation of the original recorded statement through the microphone attached to tape recorder #1.

Rewind the second generation to its beginning and splice it onto the end of the original recorded statement on tape recorder #2.

Play the second generation only back into the room through the loudspeaker and record a third generation of the original recorded statement through the microphone attached to the tape recorder #1.

Continue this process through many generations.

All the generations spliced together in chronological order make a tape composition the length of which is determined by the length of the original statement and the number of generations recorded.

Make versions in which one recorded statement is recycled through many rooms.

Make versions using one or more speakers of different languages in different rooms.

Make versions in which, for each generation, the microphone is moved to different parts of the room or rooms.

Make versions that can be performed in real time.

Music for Solo Performer (1965)

for enormously amplified brain waves and percussion.

The alpha rhythm of the brain has a range from 8 to 12 Hz, and, if amplified enormously and channeled through an appropriate transducer, can be made audible. It can be blocked by visual attention with the eyes open or mental activity with the eyes closed. No part of the motor system is involved in any way. Control of the alpha consists simply of alteration of thought content—for example, a shifting back and forth from a state of visual imagery to one of relaxed resting.

Place an EEG scalp electrode on each hemisphere of the occipital, frontal, or other appropriate region of the performer's head. Attach a reference electrode to an ear, finger, or other location suitable for cutting down electrical noise. Route the signal through an appropriate amplifier and mixer to any number of amplifiers and loudspeakers directly coupled to percussion instruments, including large gongs, cymbals, tympani, metal ashcans, cardboard boxes, bass and snare drums (small loudspeakers face down on them), and to switches, sensitive to alpha, which activate one or more tape recorders upon which are stored pre-recorded, sped-up alpha.

Set free and block alpha in bursts and phrases of any length, the sounds of which, as they emanate from the loudspeakers, cause the percussion instruments to vibrate sympathetically. An assistant may channel the signal to any or all of the loudspeakers in any combination at any volume, and, from time to time, engage the switches to the tape recorders. Performances may be of any length.

Experiment with electrodes on other parts of the head in an attempt to pick up other waves of different frequencies and to create stereo effects.

Use alpha to activate radios, television sets, lights, alarms, and other audio-visual devices.

Design automated systems, with or without coded relays, with which the performer may perform the piece without the aid of an assistant.

Edmond Dewan, Technical Consultant

RESONANCE

Alvin Lucier with Brian Kane

BRIAN KANE: Let's begin with your brainwave composition, *Music for Solo Performer* [1965]. This is often considered the starting point for your mature work. Can you give us a sense of how that piece came to be?

ALVIN LUCIER: In 1964 I was teaching at Brandeis. I had returned home from a Fulbright in Rome a couple of years earlier. As a student I had written a lot of tonal music, imitating Stravinsky, you might say. While in Europe I heard a lot of the newest avant-garde European music—[Pierre] Boulez, [Luigi] Nono, [Karlheinz] Stockhausen—and had driven up to Darmstadt to sit in on the classes and hear the latest music.[1]

And it struck me that it wasn't my music. If I made pieces imitating the hyper, complex, serial techniques of these European composers, I would be speaking a foreign language in dialect. So I didn't compose for several years. I thought, "This is bad. I want to be a composer and I'm not composing." I was at an impasse.

One day I happened to meet Edmond Dewan, a physicist who was working for the Air Force at nearby Hanscom Air Force Base. He was trying to learn why certain pilots were having epileptic fits when the propellers of their planes were spinning at certain speeds. It was a visual thing that triggered seizures in their brains. He was trying to figure that out.[2] Dewan had an alpha wave apparatus, consisting of a Tektronix differential amplifier and a set of electrodes. He tried to interest composers in this setup for musical purposes. Nobody was interested. They thought it was a gimmick. Well, I had a blank mind. I didn't think it was a gimmick. It's wonderful to have a blank mind; you can let anything enter, any idea. I was open to experimenting.

I borrowed Dewan's amplifier. It took me a while to figure out how to operate it. I would sit for hours at night in the Brandeis electronic music studio in the basement of the university library trying to distinguish alpha from electrical noise by listening and watching the meters on my tape recorder. Finally I started to generate alpha fairly consistently. A pair of KLH acoustic suspension loudspeakers were mounted on the wall of the studio. We had taken off the grill cloths, and as I was producing alpha I could see the cones of the speakers moving like pistons. They were doing work. I swear that the excursions were from a half to an inch in length! Now, speaker cones in those days were not made to do that. But that experience gave me the idea that loudspeakers could be performers. I imagined I could make a piece of music using bursts of alpha as the primary sound material.

For some time I didn't know what I was going to do with this idea. I had been talking to Sam Hunter, the director of the Rose Art Museum at

Alvin Lucier spoke with Brian Kane on Saturday, September 27, 2014, as part of the "Sounding/Resonance" session of the public symposium "Seeing/Sounding/Sensing," presented by the Center for Art, Science & Technology (CAST) at MIT. During his symposium visit, Lucier also participated in a conversation with Evan Ziporyn, Kenan Sahin Distinguished Professor of Music at MIT and Faculty Director of CAST. For videos of both, see http://arts.mit.edu/lucier. Portions of the interview between Ziporyn and Lucier informed the edited transcript presented here. All footnotes were added by the editors.

1
Pierre Boulez, Luigi Nono, and Karlheinz Stockhausen were all important European composers in the postwar period, based in France, Italy, and Germany respectively. Stockhausen was one of the leading figures of the Darmstadt School.

2
Edmond Dewan was the first scientist to demonstrate, in 1964, a human directly controlling an external machine using only brainwaves. He was affiliated with many area universities and was a research scientist at Hanscom Field Air Force Base in Bedford, MA, where he had a 52-year career. His widely cited papers range over subjects such as relativity, REM sleep, ball lightning, atmospheric turbulence, mesospheric bores, and the effect of the lunar cycle on human fertility. Dewan died in Lexington, MA, in 2009.

Brandeis, saying it would be nice to get John Cage to come up for a concert. He thought it was a wonderful idea. So I called Cage up on the telephone. He answered. Composers from Europe used to ask me how they could get to speak to John Cage. I'd answer, why don't you call him on the telephone? They'd say, "*What*?" You wouldn't call Pierre Boulez on the telephone, you wouldn't call [Karlheinz] Stockhausen. When Cage answered the phone, I said, "This is Alvin Lucier." He answered, "Yes, I know you." (We had met in New York in 1963 during Charlotte Moorman's *Avant Garde* festival at Judson Hall.) I said, "Would you like to come to Brandeis for a performance?" He said, "Yes, but you have to do a piece in the concert, too." I said, "I don't have any pieces." He didn't say anything. Then I blurted out, "I have been working with a brainwave amplifier—but I can't get it to work!" He laughed and said, "It doesn't really matter if it doesn't work. The intention to try to make it work is important even if you fail." I thought that was a wonderful thing to say.

I thought about it for a while. I had a lot of anxiety about it, too, because there were no models I could refer to, no structures. What do I do? But when I saw the cones of the loudspeakers bumping around 10 to 12 cycles per second, I thought that they could be drummers, they could play percussion instruments. So the piece started to come together in my mind.

I began by gathering a battery of 16 percussion instruments—16 is a number that I like—gongs, cymbals, bass drums, a cardboard box, and a metal trash can—anything that bursts of alpha could get to sound. Even the night before the concert, I didn't know what I was going to do. That was somewhat typical in those days. You designed your configuration of equipment, but you didn't know exactly what to do with it. And in the case of brainwaves, I wouldn't have considered structuring or putting a grid on them. They just flow from your head. You can't change them. And because they're a natural phenomenon they come in uneven bursts—sputtering, stopping, starting, rising, and falling. You can't control them, really, except by turning them on and off by opening and closing your eyes.

People often asked me why I didn't simply use an audio oscillator tuned to 10 to 12 cycles a second. What a stupid idea! It's as if you don't want the real thing; you only want an imitation of it. I thought that's not interesting. One composer suggested I record the waves, then compose a tape piece in a studio. (Splicing would have seemed like brain surgery to me.) What would be interesting, for heaven's sake, would be to sit in front of an audience and try to get in a meditative state, which you need to do to let the alpha flow. Try to do *that* in front of an audience!

I asked Cage how long he thought we should make the performance—8 or 10 minutes? He said that we should let it go for at least 40 minutes! That was a long time for a piece of music in those days. The night before the concert I set up the equipment and that was that. I didn't know what was going to happen.

The thing about *Solo Performer* is that during the performance you don't move. You sit quietly and let the alpha flow. You need to let your mind rest. I composed this piece in 1965. Can you imagine?

BK: The scientist Edmond Dewan was an important figure, since not only did he give you the equipment to allow you to do *Music for Solo Performer*, but seems to have given you the conceptual tools as well. But it seems to me that another important figure was David Tudor. Many times you've written that David Tudor saved your life.

AL: David Tudor and John Cage were fabulous. I have to go back to a concert they did at MIT in the '60s. There was a big snowstorm of blizzard proportions but they came anyway. I brought several graduate students from Brandeis. Due to the weather there weren't very many people in the audience—15 or 20 at the most.

John and David's persistence and engagement with the real world of music making was exemplary. They weren't waiting for the powers that be to ask them to play. My colleagues at Brandeis were getting bitter because the musical institutions weren't playing their works. If an orchestra played your piece once, that was enough. And here was David Tudor with his tables

of electronic equipment—cheap, battery-operated mixers and amplifiers. They were noisy, but had enormous gain. You wouldn't know what was plugged into what; his configuration of equipment was so complicated. David confessed to me once he sometimes didn't know what would happen when he turned a knob. I remember that during the rehearsal that afternoon John Cage asked David somewhat facetiously, "Can I plug this into this?" And David replied, "No, John, this is an amplifier and that is an amplifier." They didn't have access to the big synthesizers, so they got their own stuff. It was inspiring.

BK: In a piece such as *Music for Solo Performer*, was Tudor's model of homemade electronics an important component?

AL: Yes, but in the case of *Solo Performer* I used a sophisticated piece of scientific equipment.

BK: Tudor's work has been underrepresented in the history of experimental music.

AL: Yes. I was on a panel with him once in Munich and he started talking about John Cage. I interrupted him politely and suggested he talk about his own work for a change. He was so shy, yet he was one of the best pianists you ever heard in your life, a genius. People would give him scores and he would prepare them and perform them in ways that no one else ever could. John Cage's *Music of Changes*, for piano, for example, is one of the most complex keyboard works ever made. He would write a part of it, give it to David, who would learn to play it flawlessly; then Cage would write another part and Tudor would play that. In fact, Cage used to say, David Tudor is *Music of Changes*. Tudor was a noble, selfless person and a wonderful performer.

BK: Turning now to *I Am Sitting in a Room* [1969], it's the case that Edmond Dewan was a mediator for this piece as well, right?

AL: Yes. It's funny. I passed him in the hallway one day at Brandeis. All he said to me was that he had been at a lecture at MIT by a professor named Bose who was developing a loudspeaker system. He recycled sounds back through his speakers to test the flatness of their response. That's all he said. He didn't give me any details about it, what sounds he used. I'm not even sure whether the sounds went back into the room or not. I was simply struck by the idea of that repetitive process.

Repetition was in the air in those days. The Judson dancers were crucial to that concept. People don't talk about it much. I used to go to their events in the basement of the Judson Church on Washington Square, New York. The dancers would often make pieces whose forms were cumulative. One physical movement would happen, then another would be added to it, then another would be added to that. There were no dramatic moments. I remember being struck by dancer Trisha Brown's solo, *Accumulation with Talking* [1997], in which she told the audience about the dance while she was doing it. It was wonderful, and it demystified the creative process. I thought this would be a wonderful process to bring into sound.

I'd been in Milan during my Fulbright and had tried to make pieces in the Studio di fonologia at the RAI.[3] I made a bunch of sounds with analog oscillators and white noise generators but I never got anywhere. I didn't have any ideas about form that could match these materials. In conventional musical form, you do this and then you do that. You have contrast, fast, slow, loud, soft. All the various techniques you might use to make a piece of electronic music never worked for me.

But the idea of letting a process of repetition go, while keeping the same thing, and something happens when you do that, appealed to me. So one night I borrowed a couple of tape recorders from the Department of Music at Wesleyan [University] and took them into my apartment. I was living in a sordid apartment in Middletown [Connecticut] with a shag rug on the floor and long heavy drapes on the windows. (I tell you these details because they have to do with the acoustics of the room.) I had one loudspeaker and a microphone. I put the two tape recorders outside in the hall so they wouldn't make noise in the

room, unplugged the humming refrigerator, and waited until 11 o'clock at night. There was a bar nearby, but I knew that the cars would leave after it closed and the streets would be relatively quiet. I sat down and wrote out a text in real time. I didn't think too much about it.

It's wonderful when you're working and not thinking much about how you're doing it. You're on automatic pilot. Any composer will tell you that. I was in that state. I wrote the text out quickly, with pencil and paper. I thought, well, I could use musical instruments for this, but speech is such a wonderful sound source. It has a lot of noise in it—Ss and Ks and all those various sounds. I didn't want anything aesthetic. I simply wanted to tell people what I was doing.

So I began with the sentence, "I am sitting in a room"—and since it's a work that will probably be played in another room—"different from the one you are in now. I'm recording the sound of my speaking voice and I'm going to play it back into the room again and again, until the resonant frequencies of the room reinforce themselves . . . " and so forth. I thought that was a good way to avoid prayers or highfalutin poetry.

BK: The piece has become very significant in the imagination of a lot of composers and sound artists. It really is one of the first pieces of music where you get to truly explore the acoustics of a room, to make the sound of the room audible.

One of the things that I think is interesting about the piece is the question of your stutter. In the piece, you describe to the audience exactly what you're doing and what they're going to hear. But, it takes a very personal turn.

AL: There's a lovely piece that Bob Ashley made for me called *Fancy Free* [1970] in which I had to talk into four cassette tape recorders, and if I stuttered or even hesitated, performers would stop and rewind the tapes. That happens with everybody's speech. You stop and start; you hesitate a little bit. I think I was thinking of that example, because I do stutter. In *I Am Sitting in a Room* I say at the end," . . . to smooth out any irregularities my speech might have." Everyone has irregularities in their speech.

I was thinking about everyone's speech, not just my own.

BK: I recently came across a prose score in *Reflections* called *The Only Talking Machine of Its Kind in the World* [1969].[4] What you describe is a tape delay system, designed as "the only talking machine of its kind in the world, for any stutterer or stammerer or lisper or person with faulty or halting speech, regional dialect, or foreign accent, or other anxious speaker"—that's all of us by the way—"who believes in the healing power of sound." It's a piece that sets up a series of tape delays that operate on the voice, you say, to annihilate the peculiarities of speech.

AL: I said that?

BK: Yes.

AL: I had read somewhere that stuttering could be reduced about 70 percent by delaying it somewhere between 50 and 70 milliseconds, as you are speaking. You don't hear your speech as it happens; it comes back to you delayed, which causes your stutter to lessen. That was the idea I had. The other was that if you heard your voice coming back at you with various cumulative delays, you wouldn't stutter anymore, because you weren't trying to communicate. (You don't stutter when you sing, by the way.) It turned speech into sound in a way similar to *I Am Sitting in a Room*.

It was a weak idea. I only performed the piece once or twice. It's just tape delay. It's okay, I guess, but it doesn't interest me anymore.

[3] *Studio di fonologia musicale di Radio Milano* was established 1955 following a joint initiative by Luciano Berio and Bruno Maderna, playing a crucial role in the career of John Cage and many other experimental musicians. *RAI* refers to *Radiotelevisione Italiana* (known until 1954 as *Radio Audizioni Italiane*, hence the acronym); it is Italy's national public broadcasting system.

[4] Alvin Lucier, *Reflections: Interviews, Scores, Writings* (Köln: MusikTexte, 1995), 316.

BK: Let me ask you about the context for *In Memoriam Jon Higgins* [1985]. Do you want to describe the setup of that piece?

AL: By the early '80s, I'd done a number of installations and electronic works. Performers started asking me why I didn't write pieces for conventional acoustic instruments. I thought that was a wonderful idea. One of the reasons I became a composer was that I loved the idea of making works that other people could perform. So when Tom Ridenour asked me to make him a clarinet piece, I was delighted to give it a try.

You don't know how you get ideas; they just happen. I didn't want any musical language somehow. *I Am Sitting in a Room* uses English language, but at the level of structure, there's no language there. I thought what could I do with a clarinet? I began thinking that interference patterns are really interesting—acoustical beating, audible beating. Everybody knows what that is. When you tune two pitches close together, their waveforms coincide constructively and destructively, creating bumps of sound. When an old piano is out of tune, you can hear that twanging sound.

It doesn't have anything to do with musical language. It's physics, tuning a clarinet with another instrument or a sine wave close enough to create beating. That seemed like a wonderful idea—tuning creates rhythm. Electronically generated sine waves are perfect for creating audible beating phenomena because a sine wave doesn't have any overtones. It's pure. If you sing against a pure wave, for example, you can make this phenomenon very vivid.

Given the clarinet, now what do I do? I looked in a couple of instrumentation books and simply took the range of the instrument, from its lowest note to its highest. I made a sine wave sweep that moves up the entire range of the instrument so that when the clarinet plays across the rising wave, you hear beating. The farther apart the tones are, the faster the beating. If the waves are precisely in unison, there's no beating. As the clarinet plays across the wave, the beating starts fast, slows down, and as the wave reaches unison, there's no beating. It speeds up on the other side as the wave moves away from it. It's a lovely, simple gesture.

Other combinations then occurred to me. What if the player started above the wave and stopped as it arrives at unison? The beating would start fast and slow down to zero. Or if he started at unison the beating would speed up as the wave passed above and beyond it. Then I had to decide how fast the wave should move. I decided on 30 seconds a semitone, slow enough so that you don't really perceive it as moving. (I have never liked obvious dramatic glissandi in music.) That's very slow for music, but the resulting beating isn't slow depending on what octave you are in.

Tom told me that he could hold his tones for one minute. So the timings of the three gestures are: starting 30 seconds before the sweeping wave arrives at unison and holding it 30 seconds beyond, starting 60 seconds before and stopping when it reaches unison, or starting at unison and sustaining the tone 60 seconds after it has passed. And that was it.

I had a friend who told me this was boring; you couldn't have a sine wave sweep up at a constant speed throughout the entire length of a piece. He suggested I change the speed of the sweep by hand. But once you do that you would have caused a relationship and I'm not interested in relationships. Who cares about that? I'm interested in the acoustical phenomenon. Anyway, for each octave the frequency doubles, and so does the beating. So built into the piece is this constant changing of the speed of the beating. And God knows what the continuous rate of change is within an octave. I have no idea. So by the time the player gets to his or her high range, the beating is very fast, yet at the lower range it is slow.

It's wonderful. When you don't interfere with a process, you discover amazing things. What I started to hear was that, as the wave rises, its wavelength gets shorter and shorter, and the reflections off the walls cause the wave to move across the room. There's no manipulation in the electronics, no panning. However, if you sit in the audience, you think the sound is getting louder and softer. What's happening is that peaks and valleys of sound—the nodes and antinodes—are passing by your ears. At one moment you're in a crest of loud sound, then you're in a trough of quiet sound. This natural panning just happens.

And that's wonderful. Certain rooms are fabulous for that phenomenon. In very dry rooms you can hear places where there's practically no sound at all, and then it gets louder or softer, depending on where you are. The waves are naturally moving across the room. If I had interfered with the rising wave, because of some old-fashioned notion of form and structure and preference, I would never have heard that phenomenon. I had to *not compose.*

Clarinetist and composer Evan Ziporyn was talking to me about what it felt like to be simply holding a note. He's holding it but nothing is holding still. The speed and quality of the beating is changing; the waves are spinning around his head. These are wonderful things for a player to discover. Evan also said that as a performer, he knew he was never going to perform this piece perfectly. And I answered that that's the reason I have a performer and not another oscillator. Natural phenomena are much more interesting.

I once invited Abraham Adzenyah, a master drummer from West Africa, who was on the faculty at Wesleyan for many years, to visit my composition seminar and demonstrate his ability to keep a steady rhythm. If anyone could keep time, he could, but once we asked him to play steady repetitive drum patterns, the spaces between each stoke varied minutely. His rhythm was a little bit uneven each time. His playing was wonderful, partly because of that. It wasn't perfect.

BK: At a performance of *A Tribute to James Tenney* [1986] for two sine tones and double bass, I remember being able to hear the differences within each octave, where that experience was made so vivid and palpable. It was such an amazing, elegant demonstration of what I think of as the difference between acoustics and psychoacoustics (perhaps Pierre Schaeffer would say the difference between *l'acoustique* and *l'acousmatique*). I want to ask you about the sweeping sine tones. These are made by a function generator that sweeps across the frequency spectrum. This is a classic piece of scientific technology typically used to test the resonance of a circuit, right?

AL: Right.

BK: In a way, you've turned this test of resonance into an instrument for testing acoustical spaces and acoustic instruments. This makes me wonder how central the issue of resonance is to your music, or if there are other features of sound that are more important?

AL: It's very central. In *Music for Solo Performer* I simply positioned the loudspeakers so that they touched or almost touched the percussion instruments. The vibrations of my brainwaves were amplified enough to be able to move the cones of the speakers, which in turn played the instruments. A large tam tam or a gong needs a large amount of energy to get it to sound; tympani are easier. Snare drums are the world champions of resonance. The instruments I chose had different degrees of effectiveness of resonance. *Solo Performer* is really more about resonance than it is about brainwaves. Does that make sense?

BK: Absolutely. A feature of many of the sine tone pieces is that they teach the listener to pay attention to very small artifacts in sound. The person who can't figure out what's interesting about *In Memoriam Jon Higgins* is going to be terribly bored, until they're able to attune themselves to the features that you want.

It has been said that aesthetics is about making oneself sensitive. Does this describe your music?

AL: I think so. When I'm doing *I Am Sitting in a Room*, for example, I love to see someone in the audience getting it. They are listening intently; then all of a sudden you can see, oh, they figured out what's happening. In more conventional music a composer takes the listener from point A to point B and designs the work to climax at a certain point. *I am sitting in a room* has no such goal. There's no climax unless it might be the point at which the speech goes from intelligibility to unintelligibility. You think you hear it and then you don't. People arrive at that point at different times. So instead of building the climax into the music, I let the listener decide where the climax is. Actually, it's not a climax as such; it's the point at which a listener loses understanding of the words and the speech has turned into music.

In Memoriam Jon Higgins [1985] presents a different situation. You might not understand the phenomenon, but since it's so physical—the wave is moving by itself in the space, and the player is sustaining tones—you get it eventually. The interaction between the clarinet tones and the glissing [glissando] wave creates physical bumps of sound. They are not happening on the page. My work is not on a flat two-dimensional surface—it's in the sound in the room.

People have said that, when they hear my work, they try to figure out how they are hearing it. They refer to themselves, not to the work itself. The work stops being an object. They focus on listening rather than what they are listening to. I like it when people start going inward to examine themselves as they are listening. Somebody once said that my music is about revealing hidden or subliminal sounds—sounds that exist but are not audible or that you don't pay attention to, such as alpha waves, room resonances, echoes, even electromagnetic disturbances in the ionosphere. I simply make them audible.

BK: I'm curious about the intertwining, for lack of better words, of the objective and subjective in your music. Some interpretations of your work focus on the way it explores physical properties like room tone or beating. Others focus on the way that your music forces the listener to be attentive to their own processes of attention, as you say. And there are other strands in your work, like those that engage with questions of memory —*(Hartford) Memory Space* [1970] or *The Duke of York* [1971] for synthesizer. Memory is also called up by a work such as *Navigations for Strings* [1991], which deals with your own memory of hearing the Omega Navigation System. But one feature that your music is unconcerned with, as you've explicitly noted, is "musical language." This is a recurrent theme in your recent book, *Music 109: Notes on Experimental Music.*[5] What is experimental music? How would you characterize it?

AL: That's a tough question. "Experimental music" is not a perfect term. The terms "new music" and "contemporary music" are vague; they can mean any music that is recent. On the other hand some of my pieces are true experiments; I don't know what's going to happen. Many composers hate that idea. Edgard Varèse said that he made all his experiments beforehand, and then wrote his pieces. Bob Ashley hated the term, too. I guess I use it by default, to suggest works that don't have any connection with the past, that is, music for which there are no models. The term "avant-garde" describes music that forges ahead by taking from the past. I don't do that. *In Memoriam Jon Higgins* consists of a constantly rising sine wave and long clarinet tones. There's no music I can think of that does that. So the term "experimental" will have to do until we can think of a better term.

BK: Nowadays your work is highly esteemed in both the world of sound art and of contemporary music, which I think is wonderful. You once said the most interesting things were happening in art schools in the 1970s and not in music schools. Do you still feel that that's the case? Do you feel more connected to artists than composers?

AL: University music departments have changed a good deal since the '60s. Places such as Mills College and Wesleyan have championed experimental music for a long time. There were only a few places I could send students to for graduate study. Now there are several. *Sound art* is a useful term because when people ask "Is this music?" you can answer that if you don't like that term, you may call it something else.

BK: Is sound art a way of trying to unwork that conventional language of music?

AL: You know, I'm a very conservative composer. When I write for strings, for example, I don't use extended techniques, not even *col legno* or *sul ponticello*. I love the pure, grainy sound of each string. Change the pitch and it's a different timbre, a different sound. Rich timbres interfere with the acoustical phenomena I am trying to make vivid for the listener. I don't want to screw that up.

I never feel as though I explain anything well enough.

III. SOUNDING

BK: I think you explain things beautifully. All my revelatory experiences with your music have been in live performance. I feel like there's always something very important about being in the room with it, being immersed in these moving sound waves. Recordings can do some justice to it, but it's hard. So much of what's happening today involves convolution reverbs, models of reverberation, or music happening on the internet. It seems as if real space is constantly being pushed aside in the name of virtual space. Do you feel like there's a place for the kind of inquiries you want to make in that virtual world?

AL: I have in fact made a few works using Impulse Response. You simply make a sharp sound in a room and record it. There are programs that take the recorded sound and re-create the acoustical space in which it was made. It's an interesting idea. But I suppose I am addicted to the natural acoustics of a room, not a creation of one using electronic means. I've made a few pieces using this technique, but I don't know how much I like them.

Evan Ziporyn asked me if there was a theatrical element to something like *I Am Sitting in a Room*, whether it could be seen as a performance art piece. I answered that performance art enabled me to do a work like that. I didn't have to justify it as music.

5
Alvin Lucier, *Music 109: Notes on Experimental Music* (Middleton, CT: Wesleyan Press, 2012).

FIG. 1A

FIG. 1B

FEELING
Adam Frank

"I think we should start talking again about emotions in music." So begins a 57-minute conversation between American composers Robert Ashley and Alvin Lucier, part of Ashley's 1976 television series *Music with Roots in the Aether* (specifically, the episode titled "Landscape with Alvin Lucier").[1] A rich meditation on emotion in musical composition, performance, and reception, the conversation offers a set of complementary terms that speak directly to debates about the nature of emotion and its role in aesthetic experience. This essay brings "Landscape with Alvin Lucier" together with contemporaneous conceptions of affect in the work of psychologist Silvan Tomkins to unfold ideas about feeling in postwar America, and to begin thinking about the expressiveness of technology in experimental aesthetic forms.

Consider the mise-en-scène of Ashley's unusual and deeply enjoyable work of videotaped musical theater. Set in what looks like a warehouse or gymnasium, Ashley and Lucier's conversation (a duet, as Ashley calls it) is staged as an absurd fly-fishing expedition: both men stand around a canoe wearing dark sunglasses, while Ashley drinks a can of beer and Lucier, in full regalia (rod, hat, vest), casts his line across the concrete floor. (FIG. 1A) Two female dancers, Anne Koren and Susan Matheke, perform Lucier's *Outlines of Persons and Things* (1975), a work that explores audible diffraction patterns; one of the dancers scans the interior of the canoe with a directional microphone, while the other moves slowly across the back wall away from a stack of loudspeakers. In addition to the composers' distinctive voices (Lucier's stutter, Ashley's sinuous midwestern drawl), we hear quiet, subtly changing high-pitched electronics throughout, as the dancers create the diffracting sine waves of Lucier's composition. The visual image is flat and fairly bright, with shadows of the performers' bodies visible on the back wall. Philip Makanna's camera occasionally pans or zooms to provide dramatic energy, but there are no cuts or edits, here or in any of the episodes of *Music with Roots in the Aether*. According to Ashley, the series' visual style "comes from the need I felt to find a new way to show music being performed . . . to not editorialize on the time domain of the music through arbitrary space-time substitutions."[2]

Time is crucial to these composers' thoughts about emotion. Ashley's focus on "the time domain of the music," more specifically,

FIGURE 1
(A) Photograph taken on the set of the work "Landscape with Alvin Lucier," featuring a performance of *Outlines of Persons and Things*, from episode 5 of Robert Ashley's television production *Music with Roots in the Aether*, 1976. (B) Still image from a videotaped performance of Alvin Lucier's *Music for Solo Performer* (1965) at Wesleyan University, Middletown, CT, 1975, from episode 6 of Robert Ashley's television production *Music with Roots in the Aether*, 1976.

1
More accurately, so begins the transcription of this episode in Gisela Gronemeyer and Reinhard Oehlschlägel, eds., *Music with Roots in the Aether* (Edition MusikTexte, 2000), 79. The first words we hear in the television production itself are Lucier's: "When I see anybody doing anything there's an emotional feeling." In the transcription Lucier's words appear just after a brief exchange in which Ashley introduces the topic of emotions in music. This episode, and the entire 14-hour series (including portraits of and videotaped work by David Behrman, Philip Glass, Alvin Lucier, Gordon Mumma, Pauline Oliveros, Terry Riley, and Ashley himself), can be seen on the Penn Sound website: http://writing.upenn.edu/pennsound/x/Ashley.php.

2
Music with Roots in the Aether, Lovely Music. Online at www.lovely.com. For reviews of Ashley's television series, see Kenneth Goldsmith, "Robert Ashley: Music with Roots in the Aether," *The Brooklyn Rail* (February 1, 2004); Norbert Osterreich, (cont. on page 144)

"Music with Roots in the Aether," *Perspectives of New Music* 16, no. 1 (1977): 214–28; and Arthur J. Sabatini, "ReViewing Robert Ashley's *Music with Roots in the Aether*, the first opera for television," *MFJ* 42 (Fall 2004): 53–66.

3

Robert Ashley, "Variations on the 'Drone': A Non-Timeline Concept, in *Outside of Time: Ideas about Music,* ed. and trans. Ralf Dietrich (MusikTexte, 2009), 114–24.

4

See Michael Nyman's *Experimental Music: Cage and Beyond* (Cambridge: Cambridge University Press, 1999; first published 1974) for an early and influential account of this Anglo-American musical tradition. For an interesting revision of the category of experimental music, see Frank X. Mauceri, "From Experimental Music to Musical Experiment," *Perspectives of New Music* 35, no. 1 (Winter 1997): 187–204. Douglas Kahn's *Noise Water Meat: A History of Sound in the Arts* (Cambridge, MA: MIT Press, 1999) offers an important set of critical discussions of 20th-century sound.

5

Alvin Lucier and Douglas Simon, *Chambers: Scores by Alvin Lucier* (Middletown, CT: Wesleyan University Press, 2012), 69.

6

Ibid., 72–73.

7

Ashley, "All Music Can Be Understood," in *Outside of Time,* 216, 218.

8

Kahn, *Noise Water Meat,* 159–60.

9

Robert Ashley, "Landscape with Alvin Lucier," in Gronemeyer and Oehlschlägel, *Music with Roots in the Aether,* 79.

10

Ibid., 80.

11

Lucier and Simon, *Chambers,* 71.

12

Ashley, "Landscape with Alvin Lucier," 83.

13

Ibid.

his concern to represent continuous, uninterrupted duration—what he later calls the "drone"—is central for the work of all the composers portrayed in *Aether*.[3] Coming after John Cage and similarly attracted to the philosophical tradition of pragmatism that he helped popularize, these composers worked with sound very differently from the Continental serialist and post-serialist traditions (e.g., Schoenberg, Stockhausen, et al.), with their legacy of European expressionism.[4] For example, in Lucier's *Music for Solo Performer* (1965), which Ashley included as part of episode 6, electroencephalogram (EEG) scalp electrodes taped to regions of Lucier's head transmit alpha wave signals through a series of amplifiers, causing adjacent percussion instruments to vibrate. We see Lucier's eyelids flutter as he sits, formally dressed, in a grand hall; at the same time, we hear quiet, sporadic percussion sounds. (FIG. 1B) As the score puts it, "Control of the alpha consists simply of alteration of thought content—for example, a shifting back and forth from a state of visual imagery to one of relaxed resting."[5] Since alpha waves are produced in a wakeful, relaxed state with closed eyes, the sound is literally produced by means of a particular kind of *feeling*. An audience may become engrossed (or bored, or both) while watching and listening to Lucier's attempt to regulate the meditative state needed to produce alpha brainwaves. As one interviewer describes the work: "The performer is performing live but not only isn't he physically manipulating the sound-producing elements in the piece, he can't move. If he moves, he loses the alpha state and there is silence."[6]

While this piece is clearly informed by Cage's ideas (it vexes the opposition between intended and unintended sounds, is indeterminate, and has a score written as a set of technical instructions), Lucier takes those ideas in a different direction. In a lecture at Brooklyn College in 1979, Ashley observed that the music of the composers portrayed in *Aether* is almost always described as "static," and the experience of listening becomes a kind of watchful waiting: "The music creates a non-neutral self-consciousness in the listener. . . . Apparently, the 'static' quality increases the tendency to observe oneself."[7] If Cage's *4'33"* (1952) famously directs audience attention to the environment of the concert hall as the source of sounds, Ashley implies that works by the next generation of composers encouraged audiences and performers to attend to their own psychophysiological dynamics. This approach at once builds on and moves away from Cage's anti-expressivist aesthetics of silence—which, as Douglas Kahn has argued, depend on specific acts of silencing (of the performer in *4'33"*, for example), "a silencing of the social and ecological within an ever-expanding domain of music."[8] By contrast, the work of Ashley and his fellow composers sought to be open to social and political noise, and especially to "non-neutral" emotion.

In *Music for Solo Performer* audience members listen to the performer's psychophysiological dynamics—Lucier's amplified

brainwaves—and, in so doing, may attend to their own. Lucier's piece recontextualizes composition, performance, and technology itself: "When you do an EEG on somebody, you hide it. I mean it's in a hospital . . . but I'm interested in . . . what the human situation of that person who's having the EEG is."[9] He goes on to explain: "What I cared more about was the feeling of the person in that particular situation, okay? The person sitting there without having to make a single muscular motion, yet showing something that you cannot observe from the outside."[10] Lucier's colleagues at Brandeis encouraged him to create a more conventional tape collage using recordings of amplified brainwaves as source material, but he thought this idea less evocative than a live performance that explored technology's relation to the "human situation": "the poetic part of the piece was that at any given moment in time, some person, male or female, is sitting in a medical center with electrodes on his or her scalp, and an analysis is being done of his or her brainwaves to determine whether he or she is going to live or die."[11] By juxtaposing the anxiety associated with EEG technology with the calm, relaxed state of mind required by his technical setup, Lucier invites both performer and audience to engage in a kind of spiritual exercise, an encounter, at once intimate and estranging, with the brain as finite signal generator. In this way his composition explores and exploits the expressive capacities of the technology.

As a post-Romantic composer on the American scene, Lucier does not dismiss expression but seeks the expressive capacities of his 20th-century surround: "I don't think of technology as technology," Lucier says to Ashley, "I think of it as landscape. We're born and brought up in a landscape and there's not much I can do about the fact that there are EEG amplifiers."[12] Feeling is crucial for connecting with this landscape: "it's touching: a composer in the 19th century or in another century is talking about the landscape that he's in; the trees and the poetry—and I'm just doing that."[13] Ashley, too, is fascinated by and committed to the technological artifacts that create the landscape of North American daily life in the 1960s and '70s, especially radio and television.[14] Despite their similarities, however, the two composers characterize emotion in music differently. For Ashley, emotion is "so obviously there, whether I put it in or whether I do it on purpose, and I'm wondering how it gets in," and he uses the idea of projection to understand this: "Every piece has a particular feeling. I thought it would be interesting if you could identify the point where you project that particular thing into your actions."[15] But Lucier denies that he intentionally engages in emotional projection, insisting "It's not true for me to do that, okay? Now what I do instead is to make pieces about natural acoustic phenomena. The way sounds act; the way sounds are."[16] At some point in their conversation Lucier steps away from the word *feelings* ("I don't know if it's feelings, but qualities that I find I like . . . I try to distill these ideas and present them in their purest form").[17] He avoids Ashley's

14
There is much more to say about Ashley's commitment to television, as well as the role and genealogy of the idea of landscape, than I have space for in this essay. Elsewhere I have begun to explore Gertrude Stein's landscape theater poetics in relation to postwar American experimental theater and music. In her lecture "Plays" (1934), Stein explains that she wrote plays like landscapes to address the problem of "nervousness," or emotional syncopation, between the audience and the events on the stage, that is, the inordinate claim that narrative makes on a listener's attention. She writes, "If a play was exactly like a landscape then there would be no difficulty about the emotion of the person looking on at the play being behind or ahead of the play because the landscape does not have to make acquaintance"; or again, "A landscape does not move nothing really moves in a landscape but things are there, and I put into the play the things that were there" (Gertrude Stein, *Lectures in America* [Boston: Beacon Press, 1985], 122, 129). Compare this with Ashley's writing on the drone: "Non-timeline music makes no attempts to keep the attention of the listener. It exists as if apart from the attention of the listener. The listener is free to come and go. When the listener attends to the music, there is only the 'sound.' The sound is everything. When the listener is away, the music exists anyway" (*Outside of Time*, 120). For a reading of Stein's landscape poetics in relation to theories of emotion and technologies of graphic reproduction, see Adam Frank, "Loose Coordinations: Theater and Thinking in Gertrude Stein," *Transferential Poetics, from Poe to Warhol* (New York: Fordham University Press, 2015).

15
Ashley, "Landscape with Alvin Lucier," 79, 81.

16
Ibid., 79.

17
Ibid., 81.

18 Ibid., 81.

19 Ibid., 83.

20 See Melissa Gregg and Gregory J. Seigworth, eds., *The Affect Theory Reader* (Durham, NC: Duke University Press, 2010) for a sample of approaches to affect that subscribe to one or another of these oppositions. For an excellent review of this reader, see Russ Leo, "An Archive for Affect Theory," *Reviews in Cultural Theory* 2, no. 2 (2011): 1–9.

21 For an introduction to Tomkins and his relevance to the theoretical humanities, see Eve Kosofsky Sedgwick and Adam Frank, eds., *Shame and Its Sisters: A Silvan Tomkins Reader* (Durham, NC: Duke University Press, 1995).

explicitly emotional terms, but he also avoids a scientizing modernism that would cast his work as experiments in perception, emphasizing instead the aesthetic dimensions of his music: "It's putting people in a beautiful relationship to those phenomena."[18] When Ashley, less embarrassed by subjectivized terms and ideas, asserts, "I feel very strongly that you're trying to do something that makes people feel good. Don't you think of it as being sort of new?" Lucier translates this into a sociopolitical register: "I suppose when you make a piece, you imagine it as a visionary model of how society could be."[19]

Subjective feelings versus objective natural phenomena, projection versus purification, emotions versus ethics and aesthetics: readers familiar with the field of affect studies will recognize that these opposed terms continue to structure many of its current discussions.[20] Thinking about affect is usefully informed by the work of Silvan Tomkins, whose four-volume *Affect Imagery Consciousness* (1962–63, 1991–92) offers an empirically based and conceptually sophisticated theory of affect that remains a promising resource for criticism precisely because it can accommodate these seemingly contradictory terms. Tomkins (1911–1991), whose lifespan is almost identical with that of Cage (1912–1992), also emerged from the context of American pragmatism. He received his PhD in philosophy from the University of Pennsylvania working with (among others) Edgar Singer Jr., a student of William James's, and then pursued postdoctoral work with W. V. O. Quine at Harvard in the 1930s. There he joined Henry Murray's group at the Harvard Psychological Clinic, where projective tests were a major focus; he wrote a book on the Thematic Apperception Test, developed the Tomkins-Horn Picture Arrangement Test, and participated in Murray's attempt to integrate European psychoanalytic theories of development and personality with the empirical methods of American academic psychology. In the 1950s Tomkins encountered the writing of Norbert Wiener on cybernetics, an approach that had already influenced behaviorism, but in Tomkins's case led (perhaps surprisingly) to his development of a systematic, innovative, and challenging theory of affect, which was not always well received in the increasingly narrow, data-oriented discipline of academic psychology.[21]

For the purposes of this short essay, I will emphasize only those aspects of Tomkins's theory of affect that can frame the discussion of feeling I have been exploring thus far. For Lucier and Ashley, feelings are central to musical composition, performance, and reception; for example, we have seen how in *Music for Solo Performer* Lucier maintains a meditative state in order to produce sounds. For Tomkins, the affects—joy, anger, distress, excitement, etc.—constitute the primary motivational system in humans. Feelings literally make things happen. While he contrasted his theory with the psychoanalytic emphasis on instincts or drives, Tomkins proposed that affects (like instincts, in Freud's understanding) are both psychical and physiological: they are biological events (evolutionary programs activated by specific neural profiles) experienced as punishing or rewarding aesthetic

responses. Tomkins found empirical evidence for the positive affects of interest-excitement and enjoyment-joy, for the negative affects of distress-grief, anger-rage, fear-terror, shame-humiliation, and contempt-disgust, and for the resetting affect of surprise-startle (these hyphenated names represent ranges of intensity in his theory). While never committing to a detailed neural account of emotion—in spite of his very general "neural density model" of affect activation—Tomkins's research supports the view that processes in the thalamus (just above the brainstem) produce both bodily changes and emotional experience almost simultaneously.[22] What starts the thalamus off can be internal, external, or a mix of both: a memory, a heard melody, or the "non-neutral self-consciousness" of the listener waiting for Lucier's brainwaves to provoke a percussive event.

For Tomkins, the affects are fundamentally aesthetic responses that are accompanied by distinct *qualia*: distress feels different than anger, which in turn feels different than excitement. These core affects are not usually experienced in isolation; they are coassembled with (and either amplify or inhibit) drive states, cognitive states, and other affective states to result in complex feelings and emotions. Indeed, if affects are like basic elements in Tomkins's periodic table, then emotions are complex molecules formed by combining affects with other psychic elements.[23] Such chemical metaphors occur in Tomkins's writing with some regularity, as they do in "Landscape with Alvin Lucier." For example, Lucier describes his music this way: "It's like distilling, making pure those things that happen anyway, but that you don't perceive because they're too complicated."[24] Similarly, Tomkins proposes that "Because affects are phenomenologically so soluble in every kind of psychic solution we must expect that the distillation of purified components will be rarely achieved by the individual who experiences the totality."[25] But Tomkins does not consider such distillation of components always possible or even desirable. Consider this call for more integrative experimental protocols in psychology:

> We have a great craft union tendency to polarize and to debate things which nature has put together, and to pull them asunder for analytic experimental purposes. That is fine for many aspects of science. But if we want to understand feeling, we had better understand all the things that are conjoined and that have evolved to be conjoined. We can tease them apart, we can factor them, we can centrifuge them, but they remain a unitary phenomenon, which exhibits many diverse characteristics at once. Now that is not fashionable in science. It is called contamination. Unfortunately, we are deeply contaminated creatures.[26]

For Tomkins, acknowledging the fundamentally contaminated nature of feeling does not obviate the need to explain it scientifically. Rather,

22
Tomkins differed from the James-Lange theory of emotion in his suggestion that the primary organ of affect is the face rather than the viscera (although he linked the face to visceral and other bodily responses through feedback), and argued strongly against the Schachter-Singer model of emotion (the two-factor theory), in which a general physiological arousal is followed by a process of cognitive labeling. The Cannon-Bard theory comes closest. See William James, "What Is an Emotion?" *Mind* 9, 34 (1884): 188–205; Stanley Schachter and Jerome Singer, "Cognitive, Social, and Physiological Determinants of Emotional State," *Psychological Review* 69 (1962): 379–99; and W. B. Cannon, "The James-Lange theory of emotion: A critical examination and an alternative theory," *American Journal of Psychology*, 39 (1927): 106–124.

23
Eve Sedgwick makes this point in *Touching Feeling: Affect, Pedagogy, Performativity* (Durham, NC: Duke University Press, 2003), xi.

24
Ashley, "Landscape with Alvin Lucier," 81.

25
Silvan Tomkins, *Affect Imagery Consciousness*, Vol. 1 (New York: Springer Publishing, 1962), 175.

26
Silvan Tomkins, "Inverse Archaeology," in *Exploring Affect: The Selected Writings of Silvan S. Tomkins,* ed. Virginia Demos (Cambridge: Cambridge University Press, 1995), 285.

[27] Tomkins, *Affect Imagery Consciousness 1*, 133–34.
[28] Ibid., 134–35.
[29] Ashley, "Landscape with Alvin Lucier," 86.

this acknowledgment should lead to an examination of what makes feeling difficult to study using ordinary empiricist methods. For example, in conceptualizing what he calls the freedom of object of the affect system (the fact that any affect may take any object), Tomkins defines what he calls "affect-object reciprocity": "If an imputed characteristic of an object is capable of evoking a particular affect, the evocation of that affect is also capable of producing a subjective restructuring of the object so that it possesses the imputed characteristic which is capable of evoking that affect. Thus, if I think that someone acts like a cad I may become angry at him, but if I am irritable today then I may think him a cad though I usually think better of him."[27] These are the dynamics of (what psychoanalysis calls) projection and introjection. While a strictly empiricist science must avoid these dynamics insofar as they "contaminate" the object of knowledge, for Tomkins, such dynamics are exactly what affect theory needs to take into account: "There is a real question whether anyone may fully grasp the nature of any object when that object has not been perceived, wished for, missed, and thought about in love and in hate, in excitement and in apathy, in distress and in joy. This is as true of our relationship with nature, as with the artifacts created by man, as with other human beings and with the collectivities which he both inherits and transforms."[28]

Both Ashley's description of how emotions may be projected into compositions and Lucier's aim to purify acoustic experience can be accommodated in Tomkins's understanding of affect. As a scientist and theorist, Tomkins is clearly committed to analyzing core affects as separate and distinct from other psychical and physiological elements. At the same time, he recognizes that it is in the nature of affect to become reciprocally confused with their objects *in experience*, a confusion precisely described by the term *feeling* (the haptic sense best captures the interdependence of affects and objects). Both composers accept this fundamental complexity of feeling in experience. But where Lucier, with some ambivalence, wants to separate acoustic forms from feelings, Ashley accepts projection as an inevitable feature of performance and reception, composing in a manner that invites the listener to attend carefully (as the camera in *Aether* does) to affective dynamics and wait for surprising self-relations to come into awareness. But even Lucier's commitment to purification may be an affective one: "If I'm dealing with acoustical things, I try to get the most elegant meaning, the simplest way of execution. And when I've done that, there's a feeling of simplification and there's a kind of purifying quality about that feeling."[29] It is entirely unclear from these sentences whether Lucier's "feeling of simplification" is a consequence or a reciprocal cause of his approach to acoustic phenomena. The feeling, which initially seems to follow the "simplest way of execution," itself has the effect of "purifying" Lucier's sense of his own composition—feeling is at once cause and effect.

For Tomkins, there is no choice to be made between the subjectivizing and desubjectivizing aspects of affect: "The logic of the heart

would appear not to be strictly Boolean in form, but this is not to say that it has no structure."[30] Structure is crucial for Tomkins, both the structure of the affect system itself and the relations between the affects and other psychical or cognitive systems. Indeed, the structural independence of the affect system from the purposive or goal-seeking aspects of what he calls "the human feedback system" lets Tomkins begin to account for the seemingly contradictory aspects of affect. At the same time that affects and emotions constitute our sense of self or subjectivity, in his view they also act like "primitive gods within the individual," motivating actions that we do not intend and that can seem entirely other to our selves.[31]

This aspect of Tomkins's theory—that affects are at once proximate and strange—permits us to understand subjectivity as fundamentally multiple, without foregoing either the sense of agency that characterizes much of our ordinary minute-to-minute, task-oriented activities, or the sense (available with just the slightest shift of perspective) that we are buffeted by forces from within and without that are beyond our control. "Man is neither as free as he feels nor as bound as he fears," asserts Tomkins at the beginning of a chapter titled "Freedom of the Will and the Structure of the Affect System."[32] His writing usefully moves us toward a space that does not require the all-or-nothing attitudes of so much theory of the last several decades, and encourages us to think the continuities between our daily lives and our headier cognitive encounters (what so much aesthetics purports to be).

"Landscape with Alvin Lucier" ends with an exchange that emphasizes exactly these kinds of continuities. Ashley asks Lucier to describe what it feels like "when you've decided you've just made something apart from yourself," and observes, "You feel less and less well until you start feeling well."[33] Lucier agrees: "I'm sure it's anxiety and doubt and all those things and just not having gotten there yet. And then when you do, you feel good when you've made something. . . . It's like an activity without a purpose—with and without a purpose." When Ashley mishears, Lucier repeats himself and goes on, "I think it's to clarify and to improve your everyday life. You know, you improve your everyday life and you hope you improve other people's everyday life."[34] This ordinary, basic statement of purpose for composition (to improve life) does not replace what has come before, the composers' agreement about those nonpurposive feelings (doubt, anxiety, feeling well) that accompany making something. It is precisely the role of feeling in composition that permits it to be an activity "with and without a purpose": because affects are motives and not (primarily) goals, according to Tomkins, they can motivate those judgments of value that can establish goals. To put this another way, the experiences of feeling good and doing good, while certainly not identical, have something to do with each other, and something to do with *poesis*. The works of Ashley, Lucier, and Tomkins invite us to keep these continuities of feeling in experience in mind.

[30] Tomkins, *Affect Imagery Consciousness 1*, 134.
[31] Ibid., 144.
[32] Ibid., 108.
[33] Ashley, "Landscape with Alvin Lucier," 87.
[34] Ibid.

FIG. 1A

FIG. 1B

MODULATION

Mara Mills

FIGURE 1
Theresa Dudley's Lesson Book (Notebook kept by Alexander Graham Bell, September 7, 1871, to February 15, 1872). (A) Practicing articulation with the Visible Speech symbols, and pitch control with sketched speech curves. (B) Visual and Tactile instructions for "Articulation" and "Modulation." (C) A speech curve illustrating changes in pitch and loudness—the *signs of the voice* that indicate emotion.

> 1. The action of singing or making music; a tune, a melody; . . .
> 3. Musical inflection of the voice; variation of the quality of one's voice . . . with respect to tone, pitch, and intensity; . . .
> 7. Chiefly *Physics* and *Engin*. The process of modulating an electromagnetic wave . . . esp. in order to impress a signal on it;
> — Entries for "modulation," *Oxford English Dictionary*

Is there a direct route from modulation in speech and music, to modulation in electronics? How was *voice* extrapolated to *signal*? This capsule history of modulation begins with phonetics and deaf education in the 19th century and ends with pulse code modulation, an early form of digital signal processing. The telephone proves to be the hinge in this sequence, the relay that carries the voice into new systems; it makes electronics a domain for applied phonetics and casts electrical signals in the terms of speech.[1] Modulation is not merely a loanword, *from* music and phonetics *to* engineering, but a keyword, as specified by cultural theorist Raymond Williams. Keywords are "the vocabulary we share with others, often imperfectly, when we wish to discuss many of the central processes of our common life."[2] Technologies for speech transmission—beginning with the vocal tract, and its sound-shaping resonances—introduced *modulation* into the broad discourse of electrical communication. The speech sciences, especially as applied to deaf oral education, augured the future of modulation: control over the behavior of sound and the transmission of messages; the employment of techniques such as filtering and channeling; the enforcement of communication; the attachment of "defects" to sound along with the aim of eliminating them.

Theresa Dudley began a six-month course in speech training with Alexander Graham Bell in September 1871, in Boston. She was 17; he was 24. She was his first student in the United States to have been born deaf. Her father, Lewis Dudley, was a member of the governor's council of Massachusetts. Before her encounter with Bell, Dudley communicated through numerous means. She studied lip-reading and articulation at the Clarke School in Northampton, Massachusetts—an oral school that her father helped to found. Her mother taught her the manual alphabet and how to read and write in English. She had

[1] John Durham Peters proposes that we think of media as "applied physiology," borrowing this phrase from Friedrich Nietzsche's discussion of aesthetics. See John Durham Peters, "Helmholtz, Edison, and Sound History," in *Memory Bytes: History, Technology, and Digital Culture*, ed. Lauren Rabinovitz and Abraham Geil (Durham, NC: Duke University Press, 2004), 179.

[2] Raymond Williams, *Keywords: A Vocabulary of Culture and Society, Revised Edition* (New York: Oxford University Press, 1983), 14.

previously been a star pupil at the American Asylum in Hartford, where she learned sign language over the course of two years.[3]

With Bell, her education focused exclusively on speech. In a series of lessons on *articulation* and *culture of the voice*, he coached Dudley to gain "command over the movements of the vocal organs."[4] *Articulation* was a term from phonetics, a field dedicated to the investigation of speech sounds, newly established through the work of Bell's father, Alexander Melville Bell, among others. Articulation referred to the production of speech—the meaningful elements of sound in a given language, which seemed to be buried within individual voices.

Speech was studied from all sides in the 19th century. Tools and theories were exchanged between the new medical specialties of otology and laryngology; acoustical research in physics (informed by calculus); and the emerging academic discipline of linguistics—especially the subfield of phonetics, with its focus on "living sounds" over philology's "dead letters."[5] Physics contributed to the understanding of sound as a vibratory phenomenon, like heat and light.[6] It was medium-dependent, thus its media—air, water, solids—also came under scrutiny. In the late 19th century, a new "experimental" (or "instrumental") phonetics yielded tools for visualizing, recording, transmitting, dissecting, and synthesizing speech. According to linguist John E. Joseph, "experimental phonetics, the detailed measurement of speech sounds, offered the first truly positivistic approach to language."[7] Speech began to be mechanized in this period, continuing—with the telephone—into phases of electrification and automation.

In the absence of auditory feedback, Dudley worked with visual, tactile, and gestural translations or signs of speech. She might watch Bell pronounce "ff," then, while looking in a hand mirror, imitate the motions of his teeth and lips. Bell made comparative sketches of their mouths and throats, pointing out the hidden organs in their vocal tracts. As an aid to articulation training, he employed the "Visible Speech" symbols designed by his father. This iconic alphabet depicted the positions of the tongue, lips, and throat—what Melville Bell called "the speaking machine"—for each speech sound. Melville Bell had described the Visible Speech characters as "phonograms" or "fac-simile writing," but they portrayed the mechanism of sound production and not the resulting acoustic wave.[8] He, too, offered private lessons for "all cases of impediment or defect of speech" and for "oratorical ineffectiveness."[9] He refined his physiological alphabet through years of pedagogy; his students furnished "a constant variety of examples for study and corroboration."[10] He predicted, in 1863, that the science of phonetics held the key to the design of new sound technologies:

> Scientific men . . . have elaborated theories of optics—and look at the result? Wonderful mechanical adaptations of

[3] For more on Dudley, see the *First Annual Report of the Clarke Institution for Deaf Mutes* (Springfield, MA: Samuel Bowles and Co., 1868). See also volumes 2–4 of these annual reports, as well as Fred DeLand, *Dumb No Longer: Romance of the Telephone* (Washington, DC: Volta Bureau, 1908), 33, 59–60. Harlan Lane discusses Theresa and Lewis Dudley in *When the Mind Hears: A History of the Deaf* (New York: Random House, 1985), especially chapters 10 and 11.

[4] Alexander Graham Bell and Theresa Dudley, *Notebook by Alexander Graham Bell from September 7, 1871, to February 15, 1872*, unpaginated third page; MSS51268: folder: "The Deaf, Dudley, Theresa, 1871–1872," Alexander Graham Bell family papers, 1834–1974, Library of Congress, Washington, DC.

[5] For a more thorough survey of the histories of acoustics and linguistics, see Robert T. Beyer, *Sounds of Our Times: Two Hundred Years of Acoustics* (New York: Springer-Verlag, 1999); Dayton Clarence Miller, *Anecdotal History of the Science of Sound to the Beginning of the 20th Century* (New York: Macmillan, 1935); E. F. K. Koerner and R. E. Asher, eds., *Concise History of the Language Sciences: From the Sumerians to the Cognitivists* (Oxford: Pergamon, 1995).

[6] Beyer credits the insight that sound is a vibratory phenomenon to the German physicist and musician Ernst Chladni (1756–1826). Beyer, *Sounds of Our Times*, 3.

[7] John E. Joseph, "Trends in Twentieth-Century Linguistics: An Overview," in *Concise History of the Language Sciences*, 222.

[8] Alexander Melville Bell, *Visible Speech: The Science of Universal Alphabetics, Or, Self-Interpreting Physiological Letters for the Writing of All Languages in One Alphabet* (London: Simpkin, Marshall, 1867), 81.

[9] His professional card is reproduced in Melville Bell, *Visible Speech*, 102.

optical principles, before undreamt of, and which, otherwise, would never have been discovered. Might not an analogous result attend the philosophical investigation of the faculty of speech; and acoustic and articulative principles be developed, which would lead to mechanical inventions no less wonderful and useful than those in optics?"[11]

Working with Alexander Graham Bell, Dudley performed "oral gymnastics" to become familiar with different configurations of the vocal tract: blowing out a candle, blowing on a feather through the nostrils, voicing while holding an ivory plug or a pencil between the teeth (as with the students in FIG. 2A). Pitch, duration, loudness, and rhythm were different aspects of culturing the voice, which Bell increasingly termed *modulation*. (FIG. 1B) Articulation conveyed words, while modulation conveyed emotion. The Latin word for modulation, *modulātiō*, referred to "inflection of tone." When modulation entered English in the 14th century, it designated "the action of singing or making music."[12] It has often been associated with pitch—intonation of the voice, or change in musical key.[13] Yet modulation came to encompass other means of variation, in disparate materials, as is evident from its dictionary entry.

To explain pitch to deaf students, Bell sometimes used musical notation. He searched for a technique that would prompt Dudley to "inward self-correction."[14] Dudley held one hand to his throat and another to her own, attempting to match pitch and duration (as with the students in FIG. 2B). Bell asked her to "follow the motion" of his pencil while she was inflecting a speech sound: the length of the line indicated duration; its thickness corresponded to force, or loudness; upward or downward motion indicated pitch. One time, he drew the dotted line of a speech curve and asked her to make the corresponding sound. He then penciled in her vocalization, the pitch rising off the page. (FIG. 1A) If it was obvious that the same words could be differently inflected, together Bell and Dudley also investigated the manifold forms in which words could be represented, and how they could be conveyed to different sense organs, all the while prioritizing speech.

Bell soon began to tutor Alice Jennings, a twenty-one-year-old student at the Boston School for Deaf-Mutes (now the Horace Mann School). She had been deafened at age eight after a bout of scarlet fever. Bell explored the anatomy and physiology of speech through his work with Jennings, although certain details remained incommunicable. At one point, he wrote in his lesson-book, "I want to know what you feel. . . . Where do you feel the pitches? In your ears? In your head, or throat, or chest? . . . Do you have a different feeling for do mi sol? Try and think what the difference is." Her reply is also preserved, owing to the written nature of their exchange: "I cannot explain it, because I do not know how. If you were deaf, perhaps you might find it difficult to explain it when a teacher asked you. I think any one would find more or less difficulty in explaining the feelings

10
Ibid., 14.

11
Alexander Melville Bell, *A New Elucidation of the Principles of Speech and Elocution: A Full Theoretical Development, with Numerous Practical Exercises, for the Correction of Imperfect, Or the Relief of Impeded Utterance, and for the General Improvement of Reading and Speaking; the Whole Forming a Complete Directory for Articulation, and Expressive, Oral Delivery* (Edinburgh: W. P. Kennedy, 1849), 58.

12
According to the *Oxford English Dictionary*, online edition, 2015.

13
In 1867, Melville Bell described modulation as simply change in pitch, whereas timbral and rhythmic modulation are later forms. Melville Bell, *Visible Speech*, 82.

14
Bell used this phrase in 1885, in a letter to a friend. He described the ways his students copied his father's Visible Speech word-pictures with their mouths. They would "memorize the picture of the pronunciation of the words and sentences they understand when written and spoken," Bell explained, "and we will substitute a power of inward self-correction for correction constantly applied only by pressure from without." Alexander Graham Bell to Mrs. Bingham, [month illegible] 8, 1885, Alexander Graham Bell Papers Series, box 1, folder 3, Alexander Graham Bell Association for the Deaf and Hard of Hearing Collection, The History Factory, Chantilly, VA.

FIGURE 2
The Detroit Day School for the Deaf, 1902: (A) Exercises in breath control; (B) Tactile feedback while speaking. Courtesy of Harriet (Green) Kopp.

15
This exchange between Bell and Jennings was written in the notebook otherwise used for Theresa Dudley's lessons. Alexander Graham Bell and Theresa Dudley, *Notebook by Alexander Graham Bell from September 7, 1871, to February 15, 1872*, folder: "The Deaf, Dudley, Theresa, 1871–1872," Alexander Graham Bell Family Papers, 1834–1974, Library of Congress, Washington, DC, 119. Underlining in original.

16
Alice C. Jennings, *Heart-Echoes* (Boston: Franklin Press, 1880), n.p.. Copy held at Houghton Library, Harvard University, Cambridge, MA.

17
Julia Kursell details the application of the phonograph to understand the nature of the vowels in "A Gray Box: The Phonograph in Laboratory Experiments and Fieldwork, 1900–1920," in *The Oxford Handbook of Sound Studies*, ed. Trevor Pinch and Karin Bijsterveld (New York: Oxford University Press, 2011), 176–97.

18
Timbre remains a little-understood category, defined as what remains after pitch, loudness, and duration are accounted for. In the 19th century, "timbre," "quality," and "color" were used to compare speech sounds; today's speech scientists make finer-grained distinctions.

FIG. 2A

given them by musical intervals."[15] Yet Jennings attempted to convey her deep attention to sound and its uses in a book of poems, *Heart-Echoes*, published in 1880. The poems rhymed. Some employed acoustic metaphors, others the theme of acoustic exclusion. One titled "Influence" was especially thoughtful about the uncanny material-semiotics of the spoken word:

> The viewless air, that every tone
> In swift vibrations onward sends,
> Is emblem of that power unknown,
> Unseen, that every word attends.[16]

Scientists of the day struggled to understand how the molding of speech sounds occurred. Vowels served as the primary test case.[17] Produced by the free passage of air through the vocal tract (unlike most consonants), all the vowels could be spoken in the same pitch and yet distinguished by timbre.[18] Charles Wheatstone surmised that articulation was the result of resonance in the vocal tract. As the oral cavities changed position during speech, different frequencies were reinforced—and different vowels produced. Working in Germany, Hermann von Helmholtz applied Joseph Fourier's analytic theory of heat to acoustic vibration: a complex wave could be broken down into a series of simple waves. Conversely, sine waves could be summed to create a complex sound. Helmholtz synthesized vowel tones by coupling a sequence of tuning forks to resonators (metal flasks or cylinders) with apertures adjusted in size to control amplification. He theorized that the vocal cords passed a complex set of airborne vibrations through the throat and mouth. Two to three overtones, reinforced, determined the timbre. The vocal

FIG. 2B

tract thus worked something like a filter, amplifying certain wave components and not others. According to Alexander Ellis, who translated Helmholtz's *On the Sensations of Tone* into English, if Melville Bell mapped the shapes and positions of the vocal tract, Helmholtz dissociated the filtering process from any particular form or material.[19]

By the winter of 1873, Alexander Graham Bell became interested in the possibilities for "voice-writing"—visualizing sound vibrations—as he searched for a new technical aid to enable his deaf students to both read lips and "correct their own speech."[20] In a story that has been remembered, recorded by AT&T, and recited (in almost identical terms) by media theorists ever since, Alexander Graham Bell assembled an "ear phonautograph" in 1874 from the tympanum and bones of a corpse. A proposed aid for his deaf students—a second-generation "visible speech"—the phonautograph inscribed sound waves on sooted glass. Collectively forgotten, though also recorded, are the impressions of the students who participated in Bell's speech research.

Bell quickly decided not to employ the ear phonautograph for deaf education. Its plates represented only brief cuts from a speech stream, and Bell admitted that he himself "found it impossible to recognize the various vowel sounds by their tracings."[21] Although the phonautograph was a pedagogical failure, Bell later claimed that it led him to conceive of the "membrane speaking telephone," which employed a diaphragm to vary an electrical current in response to sound waves.[22] Bell's students followed his burgeoning electrical experiments with interest, even as he neglected their lessons. Jeanie Lippitt, who began to work with Bell in the fall of 1872, and whose mother founded Rhode Island School for the Deaf, recollected:

19
Melville Bell had tried to estimate the resonant frequencies of vowels, by whispering the sounds to remove the fundamental frequency. Remarks on Melville Bell and Helmholtz are from Ellis's additional "Notes," appended to Hermann von Helmholtz, *On the Sensations of Tone as a Physiological Basis for the Study of Music*. Translated with the author's sanction from the third German edition by Alexander J. Ellis (London: Longman, Greens, and Co., 1875), 740.

20
A summary of Bell's lecture "Methods of Visualizing Speech," discussed in these paragraphs, can be found in Fred DeLand, "An Ever-Continuing Memorial," *The Volta Review* 24, no. 10 (October 1922): 358–59.

21
Alexander Graham Bell, *The Mechanism of Speech* (New York and London: Funk & Wagnalls, 1907), 124. Bernhard Siegert notes that, in Germany, Werner von Siemens subsequently used the eardrum as the model for his own telephone transmitter. Bernhard Siegert, *Relays: On Literature as an Epoch of the Postal System*, trans. Kevin Repp (Stanford, CA: Stanford University Press, 1999), 198.

22
Fred DeLand, "An Ever-Continuing Memorial," 360.

It was not long after I began my course of training with Professor Bell in Boston, that he began to tell me about his wonderful new invention. He did not call it a "Telephone," but a "Talking Machine" or something of that kind. He brought it under his arm in a black box, long and narrow, possibly two feet long by nine inches wide and six inches deep. It roused my curiosity from the first, as he kept it so carefully by his side while teaching me. Afterward I found he did not dare to let it out of his sight a moment fearing some one would steal his precious machinery. He became so absorbed in the invention he could think and talk of nothing else. I soon knew all the details of the "Talking Machine," but it was not perfect, something was lacking, and it was while training my voice, as well as the voices of his other deaf pupils, that the vibration of our voices gave Professor Bell the idea, the missing link, and then his machine really talked.[23]

With his assistant, Thomas A. Watson, Bell promoted the first telephones at fairs and expositions, and on a lecture circuit. Lippitt took part in stage demonstrations of the telephone in Rhode Island. Bell promised her that he would build a "Reflector" attachment for the telephone, so "deaf people could talk over it, and see the person at the other end answer it."[24] Such attachments were repeatedly attempted, without success, as the telephone system evolved in the 20th century.

The telephone spurred what physicist Frederick Hunt calls "the transducing 1870s," a period of burgeoning invention in the field that came to be known as electroacoustics.[25] Historian Roland Wittje remarks, "As a transducer, the telephone connected the otherwise still separate electrical and acoustic worlds."[26] Many scholars in sound studies now use the term *transduction* to mean simply transmission or propagation, however its core meaning, energy conversion, indicates more precisely how new forms of communication were made possible by Bell's machine. Telephones converted mechanical sound waves to electrical form—often, manipulated them—and then converted the waves back to audible sound. As the telephone system expanded, early mechanical-electrical analogies were joined by distinctly electrical techniques: more precise or more powerful filtering and amplification, new procedures for coding and compression, and new sounds and new impediments to communication.

Transduction was also key to a new understanding of "the signal." For centuries, the term had been used synonymously with symbol; it eventually meant a cue, a warning, or instruction. In the field of electrical telegraphy, signal came to refer to the conveyance of a message rather than the message itself—specifically, a pattern of variation in an electrical current.[27] Early telegraph signals were

[23] Jeanie Lippitt Weeden, "My Recollections of Professor A. Graham Bell" [typescript], AT&T Archives and History Center, Warren, NJ.

[24] Jeanie Lippitt Weeden to William Chauncy Langdon, October 5, 1923, AT&T Archives and History Center, Warren, NJ. The sound spectrograph would later be applied to "visual telephony," as described in Mara Mills, "Deaf Jam: From Inscription to Reproduction to Information," *Social Text* 102 (Spring 2010): 35–58.

[25] Prior to this time, thunderstorms and the discharges of Leyden jars had provided anecdotal interest in electroacoustic transduction. Frederick V. Hunt, *Electroacoustics: The Analysis of Transduction, and Its Historical Background* (Cambridge, MA: Harvard University Press, 1954), 37.

[26] Roland Wittje, "The Electrical Imagination: Sound Analogies, Equivalent Circuits, and the Rise of Electroacoustics, 1863–1939," *Osiris* 28, no. 1 (January 2013): 52. Wittje discusses the founding of electroacoustics as a field in Germany around 1900, as well as the rise of the electromagnetic paradigm.

[27] Following the "sense" section of the definition for this term in the *Oxford English Dictionary*.

[28] In his lectures on communication theory delivered at MIT in 1951, Dennis Gabor elaborated, "The problems of signal analysis fall naturally into two classes. In the first class, the signal is 'dead'; it has happened before the analysis starts, and all its data can be assumed to be known. This is the case, for example, if the message is handed to us in the form of a telegram. In the second class the signal is 'alive'; it is known only up to the present instant, as in telephony." Dennis Gabor, "Lectures on Communication Theory," from *Lectures, Research Laboratory of Electronics, Massachusetts Institute of Technology*, Fall 1951 (published as *Technical Report* No. 238, April 1952), 7.

[29] Wittje, "The Electrical Imagination," 46–47.

[30] As one example of an article by Fessenden, see "Recent Progress in Wireless Telephony," *Scientific American*, January 19, 1907, 68–69. See also (cont. on facing page)

translations of text, coded by hand and carried by signals over communications systems. Transducers such as the telephone automatically converted sounds—and later sights—into electrical energy. Telegrams were described as "dead" signals, telephony as "live" because the voice and its message changed rapidly and continuously over time.[28] Wittje explains:

> Telegraph signals were understood as pulses, or electric shocks . . . and not as electric waves, which could be translated into equivalent acoustic waves by means of transducers. Physicists' understanding of electric oscillations rapidly changed with the advance of electrodynamic theory, the design of electric circuits, and the development of the telephone as the first reversible electric sound transducer.[29]

As signals became more complex, their measurement and manipulation became an increasing concern. How many different ways could a signal be designed and yet carry the same message? With analog signals, the waveform and its frequency components were of particular interest.

The term modulation entered the field of electroacoustics around 1907 when it appeared in the publications of Reginald Fessenden concerning his early experiments with wireless telephony—the forerunner to radio and mobile phones.[30] Transmitting a call via electromagnetic waves offered a solution to the problem of overseas communication. Telephoning would be faster than wireless telegraphy, which required the coding and decoding of messages by expert telegraphers. Another wireless researcher, William Eccles, described modulation as "the process of molding the oscillatory currents by means of the voice."[31]

Fessenden's work would later be understood as a type of amplitude modulation, whereby a voice signal is superimposed on an electrical wave of higher frequency (such as a radio wave), modifying its envelope or pattern of amplitudes. (FIG. 3) And this type of modulation was made possible, initially, through the exploitation of resonance. In the late 1800s, Heinrich Hertz and other physicists began to investigate electrical waves and, in turn, the phenomenon of *electrical resonance*—drawing analogies to acoustics. In the 1890s, several French, British, and American experimenters developed "tuned circuits" for "carrier" telephony, in which a set of lower-frequency speech signals modulated a series of high-frequency waves, then demodulated by resonance at the receiver.[32] This technique allowed "multiplexing"—sending multiple signals simultaneously over the same medium—which accommodated an influx of callers on a limited number of lines as the telephone network expanded. Modulation had come to denote both *inflect* and *mold* (filter through resonance), taking on some of the meanings previously associated with "articulation."[33]

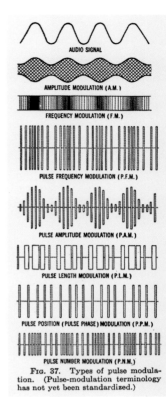

FIG. 37. Types of pulse modulation. (Pulse-modulation terminology has not yet been standardized.)

FIGURE 3
Types of Electrical Modulation, frontispiece for Stanford Goldman, *Frequency Analysis, Modulation, and Noise* (New York: McGraw-Hill, 1948).

Members of the Technical Staff, *Transmission Systems for Communications, Volume I* (New York: Bell Telephone Laboratories, 1959), 4–1. This book has unusual pagination, with the chapter number (or P for Preface) preceding the page number within that chapter.
31
W. H. Eccles, "Wireless Telephony," *Nature* 105 (June 1920), 519.
32
Inventor Oliver Lodge had used the term *syntony* instead of resonance. Julian Blanchard, "The History of Electrical Resonance," *Bell System Technical Journal* 20 (October 1941): 415–33.
33
A recent handbook of communication engineering offers the following broad definition: "To convey information, the shaping of a signal is termed modulation." M. N. Bandyopadhyay, *Communication Engineering* (New Delhi: PHI Learning, 2010), 2.

FIGURE 4
Patent illustration for Pulse Code Modulation: "The duration of the pulse being proportional to the instantaneous amplitude of the signal wave form." From Alec Reeves, "Electric Signaling System" (US Patent 2,272,070, filed November 22, 1939, granted February 3, 1942).

34
Blanchard, "The History of Electrical Resonance," 415.
35
On electrical and mechanical filters, and their relationship to resonance, see W. P. Mason, "Electrical and Mechanical Analogies," *Bell System Technical Journal* 20, no. 4 (October 1941): 405–14, published electronically July 2013; Karl Willy Wagner, "Spulen- und Kondensatorleitungen," *Archiv für Elektrotechnik* 3 (1915): 315–22; John Pierce, *Signals: The Telephone and Beyond* (San Francisco: W. H. Freeman, 1981), 73–75; *Transmission Systems for Communications, Volume I*, P–3.
36
Transmission Systems for Communications, Volume I, 5–22.
37
Ibid., 5–22, 3–33.
38
David Robertson, "The Radical Who Shaped the Future," *IEEE Review* 48 (May 2002): 31–32.

Tuned circuits were incorporated into wireless transmission and, eventually, into radio dials. They enabled "tuning in."[34] With the invention of the electric wave filter—also based on resonance—in 1922 by AT&T's George Campbell (and, in Germany, by Karl Willy Wagner) bands of frequencies could be selected more precisely, and with less distortion, from an electrical current.[35] Wave filters could be used to suppress noise or, for instance, to transmit particular segments of speech. Filtering continues to be a central procedure in audio and video engineering, although it is under-theorized in the field of media studies. It was an old impulse, newly realized—with massive consequences for representation. In the influential book *Reason and Resonance,* music theorist Veit Erlmann posits a decline in the resonance model of hearing and subjectivity around 1928 (New York: Zone Books, 2010). Yet as a tool and inspiration for filtering—an essential cultural technique for shaping sounds and other signals—resonance remained consequential in theories of hearing and practices of telecommunication.

In both radio and multiplexed telephone systems, engineers began to weigh modulation strategies based on their susceptibility to noise, distortion, and other "impairments." According to *Transmission Systems for Communications*, an AT&T handbook first published in 1959, amplitude modulation (AM) was prone to "a number of types of impairment . . . noise, crosstalk, modulation distortion, and overload."[36] Unintelligible interference between AM channels was known as "monkey chatter"; crosstalk was the interference of other callers' speech.[37] Impairment had become the umbrella term for noise, distortion, and attenuation—it was one of many concepts borrowed from deaf pedagogy for audio engineering. The category of impairment expanded considerably as the very process of engineering generated new impairments at each stage of transmission, and with each new mode of communication.

To transmit messages without impairment or distortion under noisy conditions, experimenters worked out techniques for pulse code modulation (PCM). Although forays into PCM date to the first two decades of the 20th century, it was successfully developed by Alec Reeves for the French telephone system only in 1937, as a means of sampling signals and transmitting pulsatile representations of the amplitudes at those moments. (FIG. 4) As historian David Robertson observes in an article about Reeves, PCM created a radical shift in the representation of speech:

> Reeves formulated the principles of pulse-code modulation—laying the foundations for all of today's digital and multimedia technologies. Rather than the analogue "voice-shaped current" used to represent speech since Bell's invention of the telephone in 1876, Reeves proposed that sound be sampled at regular intervals, with the values of these samples represented by binary numbers and transmitted as unequivocal on-off pulses.[38]

Because PCM signals were "unequivocal"—either on, or off—they were more resilient to noise and easier to "regenerate." In the United States, PCM was not commercialized until 1962, when AT&T launched T-1—the first digital voice transmission system. This early means of digitizing began with speech and moved into visual applications, dominating digital coding by the 1970s. With PCM, "encoding" began to be used as a synonym for modulation.[39]

After computer automation, in the 1960s the manipulation of signals became increasingly complex—and was increasingly described as *processing*, a category broader than modulation. Signals could be processed, and then used to modulate carrier waves. Alternately, certain types of modulation were subsumed under the term processing. The verb form of the word *process*, meaning "to operate on mechanically, according to a set procedure," came into use in the late 19th century in the arena of food processing. In electroacoustics, the term processing was at first mostly applied to pulse code modulation and the analog compression of signals with tools such as the vocoder.[40] Frederik Nebeker of the IEEE History Center, who has written a brief but indispensable history on this topic, explains that today signal processing refers broadly to any "changes made to signals so as to improve [their] transmission or use."[41] By 1993, the Signal Processing Society—launched by the IEEE Audio and Electroacoustics Group—would state its mission as "the theory and application of filtering, coding, transmitting, estimating, detecting, analyzing, recognizing, synthesizing, recording, and reproducing signals by digital or analog devices or techniques. The term *signal* includes audio, video, speech, image, communication, geophysical, sonar, radar, medical, musical, and other signals."[42]

Phenomena seemingly further afield also came to be understood as acts of (tele)communication. The language of "signals" and "circuits" had emerged concurrently in 19th-century biology and telegraphy, as demonstrated by Laura Otis, when researchers such as Helmholtz approached each subject with the same equipment and metaphors.[43] In 1937, modulation entered biology in an article by William Bloom, professor at the University of Chicago, who credited a personal communication with Paul Weiss, a biologist originally trained in mechanical engineering.[44] For these life scientists, modulation became an explanation for unprogrammed cellular changes—those that don't fall under the category of differentiation. ("Reversible variation in the activity or form of a cell in response to a changing environment," according to the *Oxford English Dictionary*.)

Philosopher Gilles Deleuze singled out modulation as a cultural keyword in his brief article "Postscript on the Societies of Control." Writing in 1992, he proposed that the so-called disciplinary societies of the 18th through 20th centuries were being replaced by this new social form. If disciplinary societies were marked by institutions—the prison, the factory, the hospital, the school—societies of control were marked by individualized and continuous regulation. Perpetual

[39] Members of the Technical Staff, *Transmission Systems for Communications, Vol. II* (New York: Bell Telephone Laboratories, 1959), 25-2, 25-11.

[40] Using the imprecise tool of Google Ngram Viewer, it seems that the term *modulation* became more ubiquitous in the mid-1920s, peaking once in 1949, and then again in the 1980s. These peaks align with the advent of amplitude modulation, key publications by Claude Shannon on information theory and pulse code modulation (PCM), and the widespread commercialization of PCM.

[41] Frederik Nebeker, online lecture notes for the course *Signal Processing: The Emergence of a Discipline, 1948 to 1998* (New Brunswick, NJ: IEEE History Center, 1998), 2-3. Similarly, Paolo Prandoni and Martin Vetterli define signal processing as "any manual or 'mechanical' operation which modifies, analyzes, or otherwise manipulates the information contained in a signal." *Signal Processing for Communications*, http://www.sp4comm.org/webversion.html.

[42] As quoted in Frederik Nebeker, *The IEEE Signal Processing Society: Fifty Years of Service, 1948–1998* (New Brunswick, NJ: IEEE History Center, 1998), 73.

[43] Laura Otis, *Networking: Communicating with Bodies and Machines in the Nineteenth Century* (Ann Arbor: University of Michigan Press, 2011). On signals at the intersection of telegraphy and physics, see Jimena Cañales, "Einstein's Discourse Networks," *Zeitschrift für Medien- und Kulturforschung* 5, no. 1 (2014): 11–39.

[44] William Bloom, "Cellular Differentiation and Tissue Culture," *Physiological Reviews* 17, no. 4 (1937): 592.

training replaces the school; pharmaceuticals and genetic engineering replace hospital confinement. Drawing on the work of Gilbert Simondon, Deleuze argued that the central operation of disciplinary society is molding, and that of control society, modulation. For Simondon, "to mold is to modulate in a definitive manner, to modulate is to mold in a continuous and perpetually variable manner."[45]

Under closer examination, the discourse of modulation can be seen to cut across the eras of discipline and control. Significant shifts and reversals occurred in the aesthetics of modulation as it left the bodies of Bell's deaf students, informed telephony, and entered the industrial era: from modulation as inflection—the uniqueness of the individual voice—to modulation as a mode of training and normalization, to modulation as an automated procedure for handling signals in an efficient way. These are shifts in purpose rather than definition. Each case relies on the same confidence in vocal, anatomical, or signal malleability—understood alternately as supple or governable. Modulation in the form of signal processing can exert a rigidly molding effect, moreover discipline-era modulation—as in the case of oral pedagogy—was hardly definitive.

Bell's star pupils, for instance, never fully entered the hearing world.[46] Dudley eventually married a deaf man, Wallace Krause, who was a well-known metal engraver, educated at the New York Institution. They became active members of the Boston Deaf and Dumb Library and Lyceum, which had been founded to "provide a pleasant home to all Deaf-Mutes, where they can meet their mates, read the papers and books, enjoy the pictures, and talk as much as they please, for it is a blessed boon so to do, after being deprived all day of the chance of making themselves understood."[47]

After four years at the Boston School, Alice Jennings applied to Gallaudet College, which was all male at the time; she was denied admission. In 1906, she published an article in *The Silent Worker* titled "Is it Beneficial to the Deaf Oralist to Learn the Sign Language."[48] She answered, "unhesitatingly," yes. The confidence of her school years soon flagged, as she found that hearing people did not accept her. She joined a meeting group—the ABB society—that brought deaf oralists and signers together. "Oralists occupy a peculiarly trying position," she noted, "They are 'neither pigs or puppies'—neither hearing-people nor sign-people . . . for many years I have keenly felt the awkwardness of such a position, and only within the last twelve months have I become fully identified with the deaf." She studied sign language, which broadened her social sphere. She added, "The study of signs has, I think, increased my own mental power. I have written more vividly, more pictorially, through having these 'pictured words' constantly before my mind."[49] In turn, her increased awareness of gesture improved her lip-reading ability.

The subfield of "communication engineering" was founded in the same decade that Jennings published her article; it aimed for

45
Gilbert Simondon, quoted in Gilles Deleuze, *Francis Bacon* (London: Continuum, 2005), 140. See also Gilles Deleuze, "Postscript on the Societies of Control," *October* 59 (Winter 1992): 3–7.

46
Similarly, his student George Sanders studied at the National College for Deaf Mutes (now Gallaudet) and married a deaf woman, Lucy Swett, who was a member of a prominent deaf family. Her father was one of the publishers of *Deaf–Mute's Friend*. See Robert V. Bruce, *Bell: Alexander Graham Bell and the Conquest of Solitude* (Boston: Little, Brown & Co., 1973), 399. For more on Lucy Swett, see Joseph John Murray, "'One Touch of Nature Makes the Whole World Kin': The Transnational Lives of Deaf Americans, 1870–1924," PhD diss., University of Iowa, December 2007, http://ir.uiowa.edu/etd/132/.

47
"Organization of the Boston Deaf and Dumb Library and Lyceum Association," *The Deaf-Mutes' Journal*, November 14, 1872, 1.

48
Alice Jennings, "Is it Beneficial to the Deaf Oralist to Learn the Sign Language," *The Silent Worker* 19, no. 1 (October 1906): 3–4.

49
Ibid.

greater control over telegraph, telephone, and wireless networks, which were rapidly multiplying in scale and density. If modulation is an old term that spans many fields, its senses of transmission, communication, and control start with phonetics.[50] Speech, always a learned skill—and hence a technology in the broad sense—began to be systematically technified in the 19th century. From 19th-century phonetics and deaf education, modulation migrated into electroacoustics via radio-telephony, and then into digital signal processing.[51] As designs for electroacoustic technology proliferated in the 20th century, so did a particular set of communications ideals: the efficient, the universal, the instantaneous.

[50] The terms modulation and articulation were similarly applied in the neighboring field of elocution. See, for instance, John Forsyth's *The Practical Elocutionist* (London and Glasgow: Blackie & Son, Ltd., 1895).

[51] On the importance of modulation to the emergence of radio-telephony, see R. A. Heising, "Modulation in Radio Telephony," *Proceedings of the IRE* 9 (August 1921): 305–52. The term modulation was subsequently applied to telegraphy, especially in the case of "carrier" telegraphy.

Locus inſtrumenti nõ in libero aere, ſed in loco clauſo eſſe debet, ita tamen vt vtrinque aer liberum abitum aditumque habeat. Ventus autem varijs modis cõſtringi poteſt, primò per canales conicos & cochleatos, quibus vocem ſupra intra domũ collegimus, deinde per valuas: Sint duæ valuæ ex ligno EF, & BVCD in F & VD ita cõiuncta, vt tamẽ vẽto aditũ præbeãt ad ſpaciũ intra FV & K & FE tabulas parallelas cõprehẽſũ.

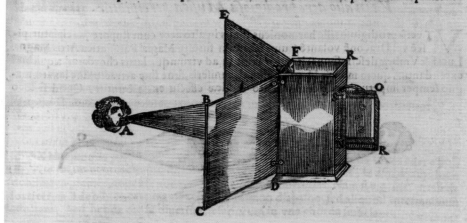

FIG. 1

TRANSDUCING

Stefan Helmreich

What is sound? What is sounding?

An ample, adjustable definition for both terms is *resonance*, precisely because resonance *is* and *is not* sound. Stretching beyond the acoustic, auditory, and audible to reach the zone of the vibratory, resonance transduces energies across various media. Therefore, it can enlist not only the sonic but also the tactile and haptic, as well as that which oscillates just beyond the sensible, in the domain of what dubstep artist Kode9 calls *unsound*.[1] Resonance—transductive and synchronous vibration—operates, too, in the register of the associative imagination, which turns out to be, with some frequency, at the very center of its imagined opposite: scientific rationality. In *Reason and Resonance*, historian of sound Veit Erlmann suggests that there is a minor-key Western tradition that has hearing, listening, and feeling resonance as a path to reason.[2] If the dominant visual idiom of *reflection* has posited that the mind is a mirror of the world—an entity detached, apart, objective—then *resonance* suggests participating in the world, moving in sympathy, working in an empirically attuned embodiment. Resonance allows us to understand how energy must always be translated, through a relay of associations, in order for it to be received at a point distant from its source.

Within this alternative Western tradition of resonant rationality, the human has been envisaged as an Aeolian harp, an instrument named for the ancient Greek ruler of the winds, Aeolus. The Aeolian harp (FIG. 1) resonates with the wind, animated by the world around it, air brought to a dynamic instability so that it might oscillate strings and transduce energies that are thereby moved to sing. Such a harp, made by humans, becomes an eerie nonhuman agent, famously celebrated in the poems of Samuel Coleridge, the music of Frédéric Chopin, and the works and philosophies of other Romantics. The Victorians considered the harp a *sensitive*, an attuned being, imagined in that age as essentially feminine (whether Bruno Latour's "Sensitizing" invites an ungendering or transgendering of the sensitive is open to question).[3] When Henry David Thoreau listened to wind traveling through telegraphy wires—those 19th-century modern skeins of cables carrying significant signals—the Aeolian harp of the Romantics went electric. (FIG. 2)

FIGURE 1
Aeolus blowing forth at point A, in Athanasius Kircher's "Machinamentum X" from *Musurgia Universalis* (1650), page 353.

1
Steve Goodman, *Sonic Warfare: Sound, Affect, and the Ecology of Fear*. (Cambridge, MA: MIT Press, 2010).
2
Veit Erlmann, *Reason and Resonance: A History of Modern Aurality* (New York: Zone Books, 2010).
3
See Bruno Latour, "Sensitizing," in this volume.

FIGURE 2
Illustration for Karl von Schlözer, "The Romance of a Telegraph Wire," *The Strand Magazine* 3 (January–June 1892), page 202.

Sifting wind through their wiry strings, telegraph cables also oscillated in another, more interior, realm. Resonating in the audible range of human hearing, they simultaneously transduced via their inner channels the resonance of electromagnetic energy from the earth's ionosphere. The off-duty machinist Thomas A. Watson, listening in on this static sizzle, was more fascinated by such "clicks and tweeks" than his boss Alexander Graham Bell, hearing it as a kind of unearthly 20th-century music of the spheres. Here, human sensing moved into the domain of what media scholar Douglas Kahn calls the *aelectrosonic*.[4] Strings and wires, resonance without and within, the transduction of celestial energies into accessible form—the aelectrosonic became a model for what modern human hearing could aspire to be. For Hermann von Helmholtz, of course, hearing had already become explicable through an analogy with the telegraph; the ear was "a tuning fork interrupter with attached resonators," transducing sound for the listening mind.[5] Fast-forward to information theory at mid-20th century, at which moment the MIT-based founder of cybernetics, Norbert Wiener, turned hearing into a function that might be imitated and installed in cyborgs, looping acoustic capacities between organisms and machines. Such cyborgian sounds have been with us ever since. They weave through modern music, as Christina Dunbar-Hester suggests—from the work of John Cage to Bebe Barron to Wendy Carlos to Brian Eno to Afrika Bambaataa to Jessica Rylan to Janelle Monáe.[6] Cyborg sounds find themselves instantiated in technologies such as the cochlear implant, or the "eyeborg" that allows color-blind Neil Harbisson to "hear" color.[7]

That cybernetic story reverberates in the work of Alvin Lucier, known for compositions that investigate sound as resonance, as transduction, as amplification, or as perceptual effect. Lucier, too,

has tapped the aelectrosonic, setting up antennae to pick up the energies of lightning whistling through the ionosphere (codified in his 1981 piece *Sferics*), an activity featured in Robert Ashley's television program about him, *Music with Roots in the Aether* (1976). With Lucier's 1969 *I Am Sitting in a Room*, "composition" is given over to the resonant frequencies of a room in which a speaking and listening performer sits, an enclosed space that begins to hum with reverberations set off by the simple probe of a voice, recorded, and recursively replayed into the same space, then recorded again, both testing the sonic affordances of specific spaces and making them ring like resonant bells and lapping baths of sound. In the 1965 *Music for Solo Performer*, Lucier scaled resonance down from the atmospheric and even down from the architectural-acoustic, to the realm of the internal bodily milieu, amplifying brainwaves of the alpha state in order to produce impulses that would activate percussion instruments—a practice of cyborg resonance that blurs boundaries between the intentional, agentive human author and the inhuman electromagnetic materials of which fleshy bodies are made. This piece is, in the vernacular, "mind-blowing." It forms what I want to call an "audiodelic" exploration of the insides and outsides of human experience akin to what Tauba Auerbach theorizes for the psychedelia of color. Lucier's performative range complicates a simplistic notion of signal transmission-reception. (See Tauba Auerbach, "Amphibian," and Alvin Lucier with Brian Kane, "Resonance," in this volume.) Resonance and transduction are both active, ensuring that while the listening subject is specifically situated, she is also filtered, calibrated, and tuned to pick up signals amid noise, sometimes switching the cultural valuation of one for the other (turning noise into signal, nonsense into sense). Listeners become the sound engineers of their own spatial-temporal experience.

There may be resonance in the forest without animals to hear it, but there is no life of sound as such without an animate apparatus of sensing. My own interest in the anthropology of sound led me to join a submarine dive in the Woods Hole Oceanographic Institution's three-person research submersible named *Alvin*. (FIG. 3) (One might hope this was in homage to Lucier, but in fact the namesake was Allyn Vine, a scientist at Woods Hole.) Sinking to the bottom of the sea in order to explore underwater volcano fields in the eastern Pacific Ocean, the submarine surrounded its human inhabitants with the sounds of sonar pings, of cyborgian robotic subroutines, of the MP3 player of the pilot. These auditory emanations all contributed to my sense of immersion: in sound, in water, in the culture of oceanographers. But that immersion was hard won—the result of an assembly of technologies working well, working in sync, working *in harmony*. The components of this sonic envelope formed by the ocean itself, sloshing around us, were thoroughly mediated and structured in this situation. The water had to stay outside the sub; so what were we hearing in our small pod of displaced and submerged air? Put

4
Douglas Kahn, *Earth Sound Earth Signal: Energies and Earth Magnitude in the Arts* (Berkeley: University of California Press, 2013). For "clicks and tweeks," see the discussion of the words used by early telegraphers in their descriptions of what were eventually revealed as ionospheric sounds; see Stanford Very Low Frequency Group webpage.

5
Hermann von Helmholtz, *Die Lehre von den Tonempfindungen als physiologie Grundlage für die Theorie der Musik*, 5th ed. (Brunswic: Vieweg & Sohn, 1896), 633. This source is cited in Timothy Lenoir, "Helmholtz & the Materialities of Communication," *Osiris* 9 (1994): 185–207.

6
Christina Dunbar-Hester, "Listening to Cybernetics: Music, Machines, and Nervous Systems, 1950–1980," *Science, Technology, and Human Values* 35, no. 1 (2010): 113–39.

7
Neil Harbisson demonstrates his "eyeborg" in his July 2012 TED talk, "I Listen to Color," https://www.ted.com/speakers/neil_harbisson.

8

In a related text titled "Transduction," I argue for a "transductive anthropology" that listens for the distortions and resistances that might reveal the fault lines beneath any self-evident "presence." This text can be found in *Keywords in Sound Studies: Towards A Conceptual Lexicon*, ed. David Novak and Matt Sakakeeny (Durham, NC: Duke University Press, 2015), 222–31.

9

Seth Kim-Cohen, *In the Blink of an Ear: Toward a Non-Cochlear Sound Art* (New York: Continuum, 2009), 137.

10

Michel Chion, "Un langage pour décrire les sons," *Programm-Bulletin du G.R.M* 16:39-75, at 65. Translation in Jean-Jacques Nattiez, *Music and Discourse: Toward a Semiology of Music*, trans. from the French by Carolyn Abbate (Princeton, NJ: Princeton University Press, 1990), 100.

11

Tara Rodgers, "'What, For Me, Constitutes Life in a Sound?': Electronic Sounds as Lively and Differentiated Individuals," *American Quarterly* 63, no. 3 (2011): 509–30. On "big blooming buzzing confusion," see William James, *The Principles of Psychology* (New York: Henry Holt, 1890).

simply, in order for us submariners to feel immersed in sea sound, this energy had to be seamlessly *transduced*, translated from the watery surround into our interior sphere. There is no self-evident immersion, no self-evident presence, without the work of signal transduction, which can glitch at any time, drowning us in sound unwound. No self-evident "presence," because that merely labels the experience of immersion without acknowledging the transducing processes that always already need to be there. There is no *life* of sound without an apparatus of sensing, and this transducing apparatus frames and forms effects typically associated with subjective experience. In this sense, presence might be understood to be a particularly convincing illusion formed as various processes unfold— the registration of sound waves on eardrums, the transduction of mechanical vibration into neuronal impulses, the reading of same as identifiable sources of sound—each of which require multiple acts of transduction before presence can be felt.[8]

But presence implies co-presence (being "in the presence of"). Being present to sonic energy can give humans the feeling of something preexisting their sensing. Back in 1960, minimalist composer La Monte Young proposed, according to musician and critical theorist Seth Kim-Cohen, "sound as an organism with its own reason for being."[9] And in 1975, French critic and composer Michel Chion

FIG. 3

pronounced that sound "*unscrolls itself*, manifests itself within time, and is a living process, energy in action."[10] These are tropes of presence as *self-evident*: sound is there, living and acting, *Being*. But, as electronic music critic Tara Rodgers has shown, such statements emerge from an audio-technical tradition, dating back to Helmholtz, that gives to sounds the status of discrete individuals whose lifetimes can be graphed, whose energies can be isolated from the "big blooming buzzing" world, whose properties can be purified (as with the sine wave), and whose essences can be known through the shape of the waveform.[11] Rodgers argues that the waveform, rather than simply a preexisting thing in the world, should rather be seen as an artifact of the technological apparatuses designed to capture and represent it—exemplified by the 1943 Triumph Wobbulator. (FIG. 4) Once pictured in this way, the waveform's technological origins are often erased, its debts to transducing operations forgotten. The waveform is present in sound. In a term borrowed from Bruno Latour and Steve Woolgar's *Laboratory Life*, the waveform becomes *an inscription*, one that resonates with its conditions of production, but then effaces these in an autotelic fantasy of disclosing a pure reality.[12]

Resonance has a history, a language, and an infrastructure. It is indebted to transduction, all the way up, down, and across. In the contemporary moment, we and our machines have come to specialize in transducing operations in order to produce what we can then call *experience*.

FIG. 4

FIGURE 3 (FACING)
The three-person submersible vehicle "Alvin" was built for the Woods Hole Oceanographic Institution (Woods Hole, MA) in 1964 and has been overhauled several times, with none of its original parts still operational; it is designed to take scientists more than 12,000 feet below the surface of the ocean for up to nine hours per dive. The submarine continues to be transported around the world by support vessels in order to undertake dives, and has made over 4,800 dives in more than four decades of activity.

FIGURE 4
The Triumph 830 Wobbulator, an oscillograph machine manufactured in the United States, 1943.

12
See Robert Brain, *The Pulse of Modernism: Physiological Aesthetics in Fin-de-Siècle Europe* (Seattle: University of Washington Press, 2015) for a history of how inscriptions came to be imagined as indexical traces of preexisting phenomena, rather than as representations of events (e.g., pulse rates, speech) already isolated and conceptualized through abstraction.

IV.

SENSING

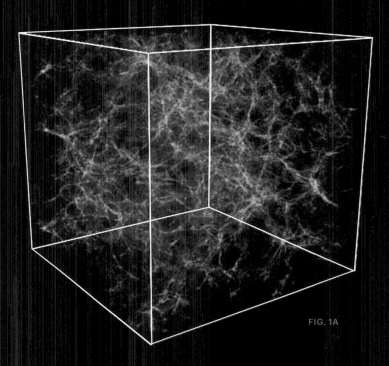

FIG. 1A

ACTIONS

Tomás Saraceno

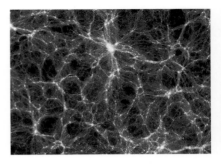

FIG. 1B

When scientists talk about what happened after the Big Bang, they often refer to a cosmic web. And the analogy everyone makes is to a three-dimensional spider web. Three-dimensional webs can be woven by solitary spiders like the black widow, or by social spiders who live together in a single web. In the millennium simulation (FIG. 1B), this is how scientists model the formation of the universe, and how they imagine galaxies started to condense and get together, along with a social spider web.[1] (FIG. 1A) You can understand the analogy between these very large and very small webs: the places where spiders cluster have the same kind of nodes as the places in the universe around which galaxies condense and social beings emerge.

But what's funny is that while everybody *talks* about the analogy of the three-dimensional spider web, no one has ever measured or studied an actual three-dimensional spider web. Until we did.[2] There are lots of studies of the orb weavers, even ones in which the scientists gave the poor spiders different kinds of psychedelic drugs, to see what would happen with their webs.[3] The orb weaver is the type of spider that everybody knows. And you can examine its type of web in a flat dimension, as arachnologists do. It might have a little bit of a variation in three-dimensional space, but basically it is horizontal and easy to study. But there are other types of spiders, and to me the most fascinating are those that spin three-dimensional webs. Until I began to examine their geometry, there was no published analysis of the actual three-dimensional structure of this entire class of spider webs.[4]

Well before I began the project *On Space Time Foam* for HangarBicocca in Milan, we were embroiled in this problem of three-dimensional structures suspended in space. The spider web research itself had continued earlier work on tensile networks, where the cosmic analogy was already expressed.[5] (FIG. 2) With collaborators in technical image laboratories, I was now trying to scan these actual three-dimensional spider webs, something we discovered that no existing machine can really do. The filament is very, very thin—it's on the order of a thousandth of a millimeter, below the resolution of most standard optical scanning devices. This means it is very difficult to understand the emerging properties or patterns or geometries of how these spiders' webs are built, over time, and in space.

FIGURE 1
(A) Tomás Saraceno, a three-dimensional spider web as revealed by a tomographic method with subsequent analysis of photogrammetric pictures, resembling a simulation of dark matter clusters. (B) Simulation of dark matter distribution in the universe as of 2008, based on the Millennium Simulation, a dynamic N-body simulation of over 10^{10} particles. Created by Volker Springel and colleagues for the Max Planck Institute for Astrophysics in Garching, Germany.

This text is based on the presentation made by Tomás Saraceno on Saturday, September 27, 2014, as part of the "Sensing/Actions" session of the public symposium "Seeing/Sounding/Sensing," presented by the Center for Art, Science & Technology (CAST) at MIT. This transcript has also been informed by a panel discussion including Tomás Saraceno and Markus J. Buehler, MIT Professor of Civil and Environmental Engineering, conducted on September 25, 2014, for the MIT Museum, titled "Reverberations: Spiders and Musical Webs." For both, see: http://arts.mit.edu/saraceno

1
"In nature spiders earn our respect by constructing fascinating, well-organized webs in all shapes and sizes. But their beauty masks a cruel, fatal trap. Analogously, the NASA/ESA Hubble Space Telescope has found a large galaxy 10.6 million light years away from Earth that is stuffing itself with smaller galaxies caught like flies in a web of gravity." The ACS Science Team and Davide de Martin, *Astrophysical Journal Letters*, October 2006, posted online by the European (cont. on page 172)

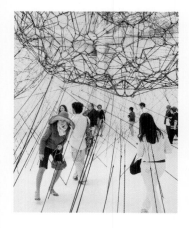

FIGURE 2
Installation view of Tomás Saraceno, *Galaxies Forming along Filaments, like Droplets along the Strands of a Spider's Web*, 2009. Elastic cords, dimensions variable. Italian Pavillion, 53rd Venice Biennale.

FIGURE 3 (FACING)
Detail of Tomás Saraceno, 110 pairs of stereoscopic-photogrammetric images converted to 3D data, 2010. Conceptualized by Tomás Saraceno, the applied method was further developed in a collaboration between Studio Saraceno, Peter Jäger, and Samuel Zschokke, with scanning realized by and at IPK, TU-Darmstadt.

(NEXT PAGES)
Tomás Saraceno. *Social Strings*, 2015. Black nylon strings and scans of "spider map" prints.

Space Agency, http://www.esa. int/Our_Activities/Space_Science/ Flies_in_a_spider_s_web_galaxy_ caught_in_the_making/. See also Tomás Saraceno and Sara Arrhenius, eds., *14 Billions (Working Title)* (Milan and Stockholm: Skira Editore and Bonniers Konsthall, 2011).

2
See Peter Jäger and Tomás Saraceno, 'Unser Kosmos ist (fast) wie ein Spinnennetz', *Natur Forschung Museum* 142, no. 5/6 (2012): 220–27; Gilles Clement et al., "Let's Move To Space: 3D Spider Web in Microgravity," in Saraceno and Arrhenius, *14 Billions*, 109–10; Tomás Saraceno et al., "Spider Webs in Science and Space—An Interdisciplinary Project On 3D-Visualization," paper presented at the 18th (cont. on facing page)

It was very difficult to solve this problem—to determine how to scan such a complex, microfilamentary assembly. I came up with a very simple method, and collaborated with the Photogrammetry Institute at the Technical University in Darmstadt to achieve it. (Photogrammetry can be simply two cameras focusing on the same thing at the same time.) So we set the spiders up in clear, comfortable boxes, where they wove their webs, allowing us to clearly see where and how they usually live. A black widow is a three-dimensional web weaver, and in the clear box you could see where she made a kind of a tunnel web in the corner, allowing her a place of retreat. But what was the exact structure? How was the tunnel supported and produced? Once we had a completed three-dimensional web in this clear box, then we could use a simple laser to illuminate the web one slice at a time, moving from top to bottom or from bottom to top in a single plane. (FIG. 3) Using two cameras, you take pictures perpendicular to that plane and parallel to it, at the exact moment of the laser slice. Then you have two data sources clearly indicating the intersection of the laser with those particular strands of spider silk that are in that plane. Proceeding to illuminate slices in this manner, systematically, we produced thousands of data points for the junctures between these threads, and their extensions in space.

When we finished, we had all these sections of the web that we then had to connect. This was a huge challenge. Our sampling took a sectional image every two or three millimeters for that first three-dimensional model, but we had to identify all the threads to understand their continuities. The camera images allowed us to observe precisely that there were many different types of threads, so that helped. But we could not find an existing computer script that could interpolate between images to extend and make this three-dimensional model automatically, as a simulation. We had to try to reconstruct it in three-dimensional space.

When I say "reconstruct it," I mean physically as well as computationally. (FIG. 4) We produced an installation that would enlarge the three-dimensional black widow's web and produce it on a human scale. This process began with a map where we projected all the junction points on the bottom and on the ceiling; then we connected each thread exactly according to the model. We were taking care, because when a thread bifurcates—two, then in three, then in four—it makes something that is quite difficult to model, both geometrically and in tensile properties. For example, the black widow has seven different types of threads with different qualities of elasticity and strength. We needed to confirm which thread was doing what as we built our human-scale model.

This exercise enabled us to recognize that the spider's job is quite complicated, and making a three-dimensional web is a great challenge. To keep the tension of the construction, you have to connect to every single precise thread. We were connecting point to point without cutting, putting everything in tension. This became a

bit of a nightmare. When we were finally finished, however, we had a construction of a single black widow web; it's upside down, because it was much easier to work the lines that way. I've acknowledged this orientation, and people actually complained that it was upside down, but usually the spider is also hanging upside down. From that perspective, the orientation might not be such a mistake, since humans entering this web have the same orientation to it as the spider does. I attended the International Space Studies Program at NASA Ames Center, and colleagues there said, "Why don't we send spiders to the International Space Station to try to see how spiders might weave differently between a micro-gravity environment and here on Earth?"[6] But I think first we have to understand the spider webs here on Earth, and then we can compare how different they are when they've been to space and come back.

With other collaborators, I have also explored the sonic properties of the webs: their capacity as resonating instruments.[7] Spiders have no ears; they cannot "hear." But spiders are very, very sensitive, even if they are deaf. The entire exoskeleton vibrates. With the hairs that they have connected to their bodies—they can perceive very, very thin vibrations. We are using very tiny sensors to study and listen in on how the spiders learn to play their webs and attend to those vibrations. This research would also clarify how this, let's call it an instrument, how this web-instrument is built.[8] William Eberhard, the famous entomologist specializing in arachnology, said that if you want to imagine yourself building a web the way a spider does, you will be blind, because web-building spiders are mostly blind. They don't really see. You would have to be under the water, because this is the density that they feel in their space on Earth. When they move into the air it is like a human under the water—and spiders built the web backward, since the spinnerets come from the backside. You have to imagine standing up under resistance, blind and

International Congress Of Arachnology, Siedlce, Poland, 2010. For a technical analysis of the first 3D spider web scan that I commissioned from TU-Darmstadt and, for an acknowledgement of this contribution to the field of close-range photogrammetry, see Thomas Luhmann, *Nahbereichsphotogrammetrie: Grundlagen—Methoden— Anwendungen* (Berlin: Wichmann Verlag, 2010).

3

Eds.: In 1948, German zoologist H. M. Peters and Swiss pharmacologist Peter N. Witt experimented on orb spiders at the University of Tübingen (Germany). They dosed the arachnids with marijuana, mescaline (peyote), morphine, scopolomine, Benzedrine, and later, LSD and caffeine. See Peter Nikolaus Witt, *Die Wirkung von Substanzen auf den Netzbau der Spinne als biologischer Test* (Berlin: Springer Verlag, 1956). NASA continued such experiments through the 1980s, and more recently, biologists have pursued these studies in the wild. For example, William Eberhard, an entomologist working in Costa Rica for the Smithsonian's Tropical Research Institute, has studied the effect of a parasitic wasp whose maturing larvae inject a specific chemical into the local orb-weaving spider, which then weaves erratic, dysfunctional webs that don't function for catching prey, but are suitable for the wasp larva to hook onto and pupate. See John Barrat, "Drugged Spiders' Web-Spinning May Hold Keys to Understanding Animal Behavior," Zoology, *Smithsonian Science News* (January 11, 2010), online at http://smithsonianscience.si.edu/2010/01/drugged-spiders.

4

Peter Jäger, "Crazy Threads or How Art and Science Worked Together," in Saraceno and Arrhenius, *14 Billions*.

5

See my installation *Galaxies Forming along Filaments, like Droplets along the Strands of a Spider's Web* (presented at the Palazzo delle Esposizioni, Giardini, Venice Biennale, 2009). Installation, elastic ropes.

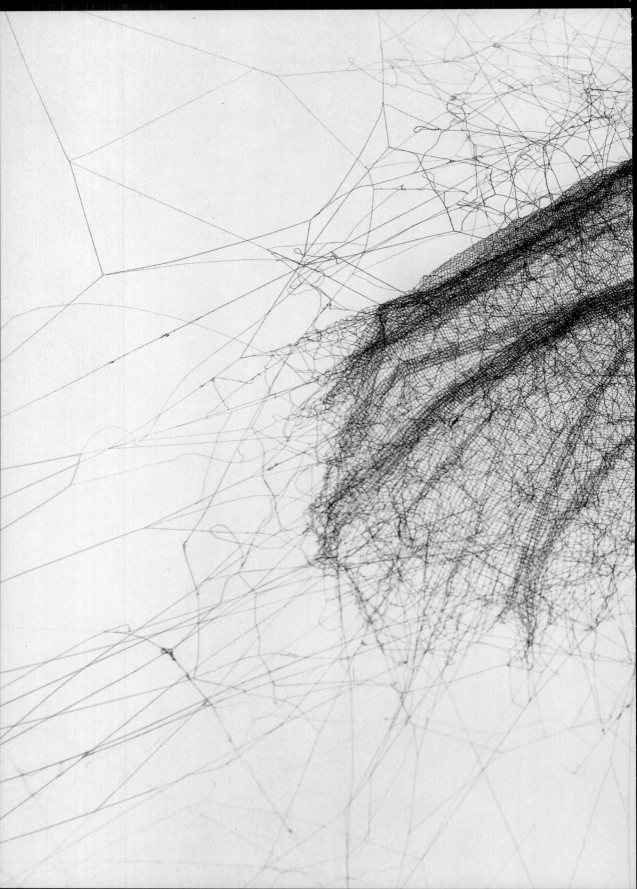

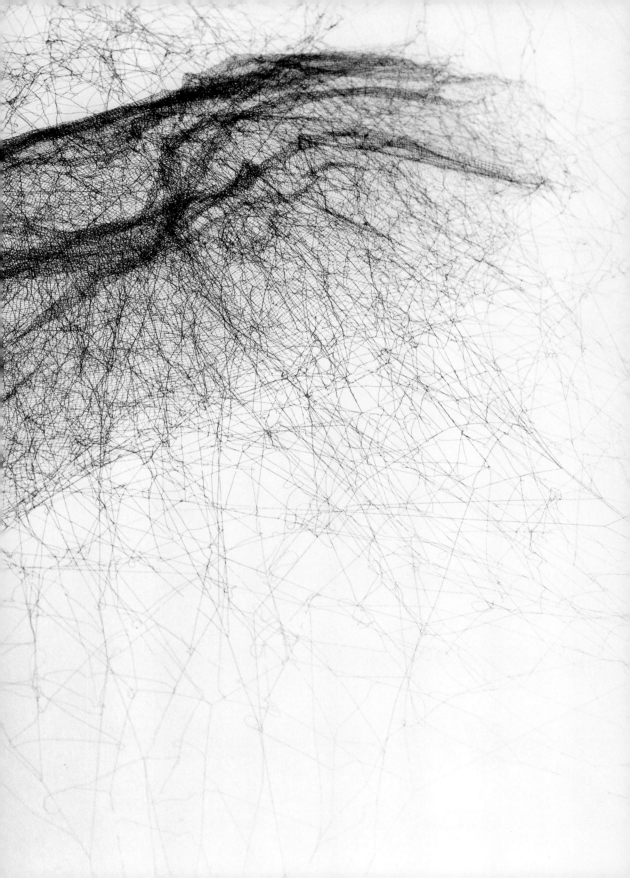

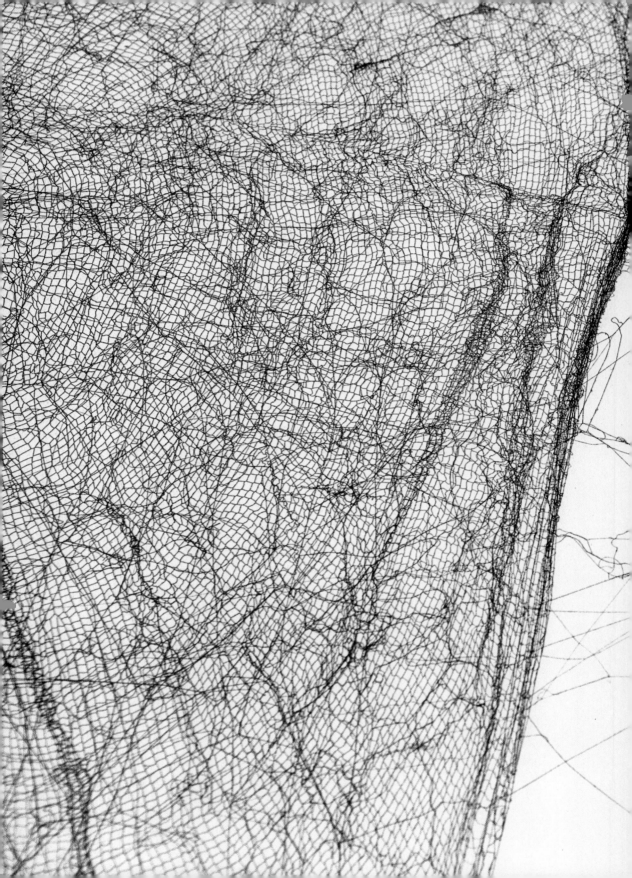

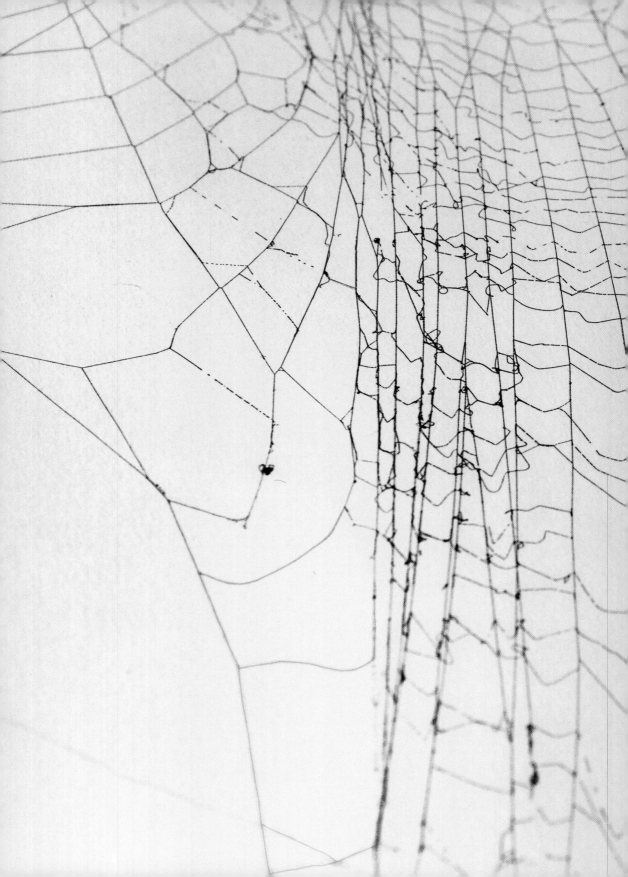

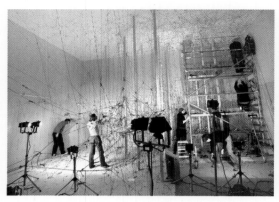 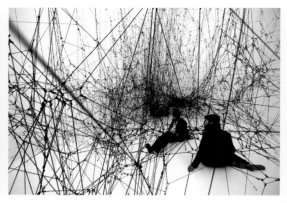

FIG. 4A FIG. 4B

FIGURE 4
(A) Assembly of Tomás Saraceno, *14 Billions (working title)*, 2010. Black cords, elastic rope, hooks, 1:16 scale, modeling *Latrodectus mactans* (spider) three-dimensional web.
(B) Installation of *14 Billions (working title)*, 2010. Commissioned by and installed at Bonniers Konsthall, Stockholm, 2010.

6
Eds.: Experiments with spiders in micro-gravity were already being conducted in Peter Witt's time, and they were periodically revived through the 1980s. It seems that few, if any, involved three-dimensional weavers. In 2009, Tomás Saraceno, along with Gilles Clement, Peter Jäger and Samuel Zschokke, submitted a research proposal entitled "3D Spider Web in Microgravity" for the International Space Station.

7
The collaborators on the arachnid bioacoustics research include Roland Mühlethaler (Research Scientist, Museum für Naturkunde, Humboldt University, Berlin), Hannelore Hoch (Professor, Museum für Naturkunde, Humboldt University, Berlin), Yael Lubin (President of the International Society of Arachnology and Professor, The Jacob Blaustein Institutes for Desert Research, Negev, Israel), Iara Sandomirsky (Department of Biological Sciences, Midreshet Ben-Gurion, Israel), Molly Nesbit (Professor, Department of Art, Vassar College, Poughkeepsie, NY), Odysseus (cont. on page 182)

deaf, and then you start to release a thread. You reel it out from your backside. You don't see anyway, but also you are backward. You are in the middle of a dense soup. You release thread, thread, and more thread—and then the wind starts to blow. You're kind of going fishing but in the middle of the air. Then possibly you feel something. Your thread gets caught, your fishing worked, because you feel tension at the end of the line. Your thread was designed to have some glue at the end, and so somehow it stuck somewhere. And by sticking there, you can pull it back, and when the tension is taut you can start to pluck it, once, twice, three times—this is what gives me the idea of the music that webs must be generating all the time, spiders sensing with every hair.

The goal of these research projects, and what I'm trying to say in my installations, is that perhaps there's a way we can become a little bit more aware of each other. The social spiders come in here as another kind of analogy—not just to the cosmic web, but also to the humans deep inside that web. It's a challenge to communicate this analogy. When I do a presentation, I might have 500 slides, and I'm changing them until the last minute, so it's always an improvisation. But if I don't do it, I stop learning. Ideally, it becomes an exercise, confronting me with something that is a little beyond comfortable, something I'm a little afraid of. In many of the installations that I do, I hope that something like this happens. I think an individual might feel a bit afraid or certainly not comfortable, but by being together and socializing with others in that experience, somehow you stop being afraid of it, hopefully. You are all vibrating in the same web.

On Space Time Foam (November 2012) was certainly the biggest of these social experiments. To describe it technically, the installation was basically a pressurized space divided into several sections by thick membranes of tough, transparent plastic. Rather than on webs, visitors are suspended on these skins held aloft by great piles of pressurized air. But those membranes are pliable; they shift as people move on them. So the space moves as we move through it,

Actions

maybe vibrating as we might imagine a web. But unlike the webs, it's a kind of space that is always in transit. It is never fixed. In fact, it opens only as one moves in it—and then action happens. Maybe the situation was to plunge people into a verb—*acting*—a kind of invented language, a kinesthetic or intuitive language for action. I was thinking: How will this space react to such a conversation? It is a dialogue, between the space and the people in it. Space here somehow follows you; it's kind of a science fiction because it has its own agency. And it very much depends on the amount of people inside. If you move alone, you might open up a certain amount of space. If you are with two or three people, you open more. You see how complicated it is for me to try to explain with still images. Over the many weeks of the installation, I began to understand the language myself, this invented language of space and the social, this language that is spoken only by actions.

I found the group dynamic even more interesting. The layers in the installation produce a space that is very, very hard to experience alone; experiencing *On Space Time Foam* is contingent on codependency or relationship. In anthropologist Edward T. Hall's *The Hidden Dimension* he talks about the idea of "proxemics."[9] (FIG. 5) By this he means how the perception of space is inflected by culture, by the spatial baggage that you internalize as part of a specific national group. Two Argentinian people, we speak face to face about five centimeters apart. Between Germans, you have a little more distance, and so on. Hall explains that this is also true with smelling and hearing. It comes up in all kinds of intercultural relationships, but

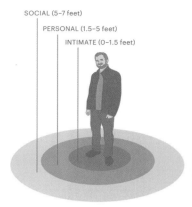

FIGURE 5
Anthropologist Edward Hall's theory of "proxemics" (1966), examining the distances humans from different cultures find comfortable for intimate, personal, and social interactions.

FIGURE 6
Installation view of Tomás Saraceno, *On Space Time Foam*, 2012–13, pressurized air, plastic films stretched over 400 square meters at a height of 20 meters on three layers, for a total of 1,200 square meters. HangarBicocca, Milan.

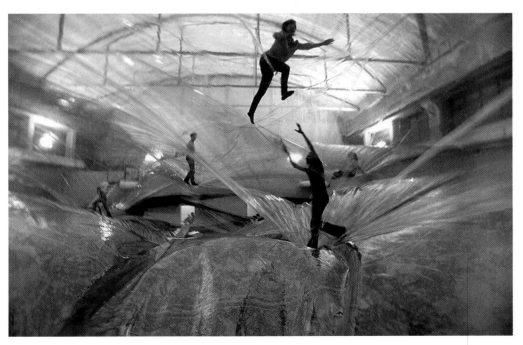

FIG. 6

181

Klissouras (sound artist), Leila W. Kinney (Executive Director of Arts Initiatives, MIT Center for Art, Science & Technology, Cambridge, MA), Markus J. Buehler (Professor and Department Head, Department of Civil and Environmental Engineering, MIT, Cambridge, MA), Zhao Qin (Research Scientist, Department of Civil and Environmental Engineering, MIT, Cambridge, MA), Daiqin Li (Associate Professor, Department of Biological Sciences, National University of Singapore), Joseph Koh (Research Scientist, Lee Kong Chian Natural History Museum, National University of Singapore), Evan Ziporyn (Musician and Kenan Sahin Distinguished Professor, Department of Music, MIT, Cambridge, MA).

[8] This passage builds on a conversation between the author, Roland Mühlethaler, and Ute Meta Bauer at Saraceno's studio on July 29, 2015; it was also inspired by William G. Eberhard, "Effects of Orb-Web Geometry on Prey Interception and Retention," in William A. Shear, ed., *Spiders: Webs, Behavior, and Evolution* (Stanford, CA: Stanford University Press, 1986). For information on the nonvisual senses of web-spinning spiders, see "Spiders.us: An international spider community with a focus on North America," see the website for Spiders.us: An International Spider Community with a Focus on North America, http://www.spiders.us/faq/how-many-eyes-do-spiders-have/.

[9] Edward T. Hall, *The Hidden Dimension* (Garden City, NY: Doubleday, 1966).

[10] Eds.: See Bruno Latour, "Sensitizing," in this volume, as well as Bruno Latour, "Air," in Caroline A. Jones, ed., *Sensorium: Embodied Experience, Technology, and Contemporary Art* (Cambridge, MA: MIT Press and List Visual Art Center, 2006), 104–108.

it is most dynamic and mappable in space. He provides an exercise or thought experiment: let's say, we name someone the president of Argentina. And then suddenly, if she's the president, and I know that she became the president, there is a kind of aura between me and her, because now I know that she became something else. This circumstance pertains to the distance with which we relate one to each other—she now is in my "public" proxemia, even beyond a social distance. This spatial relation reflects lived culture, perception, recent history, and our experience of all these things. And it affects our actions.

Now, what happened in the space of the installation? (FIG. 6) People brought their cultural baggage with them, but in some way *On Space Time Foam* seemed to strip that away. Usually there was a lot of solidarity right from the beginning. Those who came in at the opening moment were together, even if they were strangers. You knew that when you entered this space, somehow, you were afraid, and you didn't know what the hell was going to happen. You didn't know how the space would change and react as you yourself entered, much less as others entered. This meant that when other people entered, those who were already in there always kept an eye on the new person. And when an older person was that new person, I noticed people kind of slowed down a little bit and gave time and space for that slower person to enter.

What happened in the experience of *On Space Time Foam* was that actions had a rhythm that you could learn. At the beginning, always, you start to fall. Two people are heavier than one person. Intuitively you begin to realize you need to distribute weight, even the weight of your own body. One of the things that is very, very important to the construction of the space is that people should not get too close to one another. If everybody gets too close, we all start to fall. A kind of social black hole, I call it. Because everybody falls into the same place, they are sucked into that gravitational hot spot. But at the same time, you are constantly sustained by this breathable air, by a medium that you didn't even sense at the beginning, that you took for granted. This is part of what Bruno Latour means by "sensitizing"—because nobody understood until they came into these malleable spaces, that people are supported by this "something" that allows us to live on Earth, this full substance that we ignore, that we call air.[10] (FIG. 7) Atmosphere in the installation became a type of presence, even though it was obviously technological, mediated by the giant noisy fans producing the pressurized space you depended on to move.

On Space Time Foam became the ideal kind of social web I had been studying with the spiders, even though it wasn't a "web" at all. It became really something much bigger than this rather large space with a bunch of fans and plastic. It came to be about our interrelationship, about the way we understand space, or how I move in relation to how another moves, and how you move, and how we move. The

proxemics expanded in all of this; there was something much, much wider in our relationship with others and with the world, even as our actions were responsive to each other in new and intimately connected ways.

This expansion in nonverbal communication connects back to the spider web geometry model that we are still working on, now using the new software developed by researchers in Markus Buehler's lab at MIT.[11] *After* we built the web physically, it became possible to take the laser image data and simulate this single web computationally. The manipulable virtual model looked very simple, but it was actually very complex and took forever to build; in fact they are still working on the program. When I work with it I feel as if I were in the virtual space, connecting thread by thread. (I remember some of those threads!) Putting it back into the computer in order to manipulate and model the forces—well, in my imagination, when I see this, we are pulling up galaxies. (FIG.8) That's the experience I have with this model. This research is not just about planning better ways to hang bridges, but also about understanding the expansiveness and structure of the whole universe. Likewise, to experience these webs down here on Earth might lead to something out there, something that might be interconnected in ways we might not otherwise understand.

The spiders have another lesson for us, regarding that resonance I mentioned earlier. The social ones can often take abandoned webs and build on them to live, many of them at a time, in cooperative

FIGURE 7
Installation view of Tomás Saraceno, *In Orbit*, 2013, 2500 m² of steel wire meshwork, PVC spheres with diameters up to 8.5 meters. Kunstsammlung Nordrhein-Westfalen, K21 Ständehaus, Düsseldorf.

11
Eds.: The simulation was produced by a thesis student working under the supervision of Prof. Markus J. Buehler and Dr. Zhao Qin, using coordinate data collected by the artist Tomás Saraceno by capturing the 3D web spun by a black widow spider, for which see Bogdan A. Demian, "Structural and Mechanical Analysis of the Black Widow Spider Web Subjected to Stretching, Expansion and Wind" (master's thesis, Department of Civil and Environmental Engineering, MIT, 2014). Markus Buehler leads the Laboratory for Atomistic and Molecular Mechanics, Department of Civil and Environmental Engineering at MIT. Zhao Qin works in the Buehler lab on deformation and fracture mechanics of proteins and bio-inspired materials.

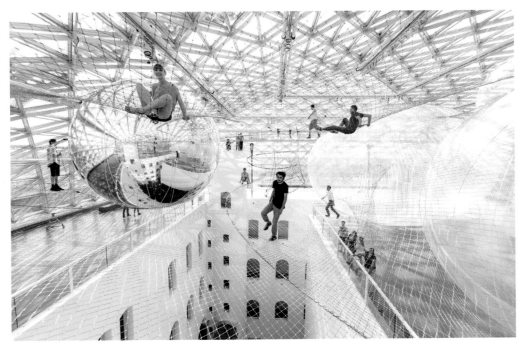

FIG. 7

[12] Stephen Webb, *If the Universe Is Teeming with Aliens . . . Where Is Everybody?: Seventy-Five Solutions to the Fermi Paradox and the Problem of Extraterrestrial Life,* second ed. (Cham: Springer International Publishing, 2015).

[13] Eds.: The Arecibo broadcast in 1974 was one such organized broadcast, but SETI (Search for Extra-terrestrial Intelligence) has only debated, without implementing, an "Active SETI" program of electromagnetic signals that would be crafted into a coherent broadcast. The engraved records sent out with the *Voyager* spacecrafts in 1977 are considered only semi-active, as the odds of their being picked up are small.

[14] Eds.: The "butterfly effect" is a well-known metaphor in chaos theory devised by Edward Lorenz to assert the idea that, within a deterministic nonlinear system, a small change in initial conditions could result in a large difference in a subsequent state, such that perhaps even a flapping butterfly wing could eventually cause a tornado.

colonies. They are deaf, but they can sense space with techniques that are very, very refined. Their bodies vibrate with the movements on the web—not just an ear or two, but each spider's entire body. This means that spider communication can go faster than the speed of sound as it is conventionally measured (in air). This is true because vibrations have different speeds depending on whether they are traveling through gaseous or solid materials. Sound as a vibrational wave travels faster over the solid materials of spider silk, than in the loose molecules of the air. And if we can make an instrument on that model, there will be something there to change how we communicate.

Stephen Webb's book *If the Universe Is Teeming with Aliens . . . Where Is Everybody?* explores different answers to the Fermi Paradox—why we've never managed to communicate with other intelligent creatures beyond our own planet.[12] If you go to the Moon, Mars, or far away, and you start to hear planet Earth, it's just noise. It's like static. You won't understand anything, even if you speak all of those languages in the blast of our electromagnetic signal. So one of the hypotheses resolving this Fermi Paradox is that because we all speak different languages and we cannot somehow agree on sending a coherent message out to space, there can be no response to that message.[13] This means there could be a very simple way to solve this—maybe we have to build an instrument that more than one person can play together, to send one coherent answerable message.

To some extent, this is the kind of instrument that spiders—both social and nonsocial—build. Spiders' complex webs have many different types of filaments, only some of which are there to trap. Others are there just to vibrate, maybe for mating signals or other kinds of communication we can't even imagine. Maybe with a human version of this group vibration instrument we can start to tune ourselves to communicate with the universe—at least we could try it, as an exercise in engaging such a cosmic communication capability. Human experience is very limited so far. We know that if you play one single instrument yourself, and if it's an instrument that is affected by the way somebody else is playing an instrument, then there needs to be a conductor, a score, a lot of cultural effort put into "harmony." And when you go to a concert, if every musician there has been given his own kind of drum, there couldn't be a "concerted" effort or message. But what if you had one single instrument—a big drum, say 10 meters across—that everyone could play at once? If everybody was hitting the same instrument, that would make sound together, from one source.

Many of the installations I make are along these lines. They are models for a larger question. *On Space Time Foam* required a lot of study, and it was important that the three membranes were transparent, and people could see other people entering above their heads, or below their bodies. In the end, the installation relied on a huge trust in the human capacity for socialized synchronicity,

responsibility, behavior, solidarity. And it magnified very small actions, which resonated throughout the entire structure. I'm fascinated by the complexity scientists call the butterfly effect.[14] But this was, by contrast, very simple. Even if somebody far back in the cube of air were to move, it would immediately affect my position in the space. This is an experience that is not so common. I think Earth, or the ground we have been walking on since we have been children, is something that does not perform in this way every day. So the art experience here was imagining something, somehow, about learning to coexist.

FIGURE 8
Digital model of a black widow spider web, manipulable in three dimensions, from Bogdan A. Demian, "Structural and Mechanical Analysis of the Black Widow Spider Web Subjected to Stretching, Expansion and Wind," 2014 (see note 11), in collaboration with Tomás Saraceno, sponsored by MIT Center for Art, Science & Technology (CAST).

FIG. 1A

FIG. 1B

INTUITING

Josh Tenenbaum

One way to approach cognition is through reverse engineering—working backward from function to determine how the brain might be operating. The technologies that we call "Artificial Intelligence" (AI) have often been accomplished in this way, mimicking human capacities, whether they be pedestrian detectors or self-driving cars. Such AI would be seen as a remarkable achievement, even by the field's founders—Alan Turing or, before him, Gottfried Leibniz. Yet we all know that none of these systems is truly intelligent. What's missing? Common sense is an undervalued piece of human intelligence. My work aims to reverse engineer the common-sense core, and I argue for *intuiting* as a key component of this remarkable cognitive achievement.

The common-sense core is not a new idea. It emerged from a number of different scientists in the last few decades. They were cognitive scientists broadly construed, including linguists, philosophers, developmental psychologists, vision scientists, and computer scientists of many different stripes. These various domains generated the central idea that, from early infancy, human thought and action is organized through key concepts generated in relation to the world: concepts emerging from physical objects, intentional agents, and their causal interactions. These concepts can be clustered into what might be called "intuitive theories of physics and psychology." Intuitive theories are robust systems of concepts and abstractions that operate much like scientific theories, because they are not just a collection of facts but rather function as principles that can be applied to an endless number of new situations.

Certain specific sensing problems illuminate this claim for an intuitive physics operating in seeing, understanding, and acting, as well as interpretations of agency that we can call "intuitive psychology." Current engineering systems can grasp an image of a scene and detect the people or detect the objects. But as humans, we are not just interested in what is where. For our agency in the world, it's a matter of understanding what is likely to happen next, and what can be done in a given interval of time. What are the possibilities for action, prediction, and counterfactual reasoning? We seek to know what could have been done differently once the action has passed.

In the workshop scene (FIG. 1A), you see more than a crowded world of objects. Your intuitive physics knows the table is supporting

FIGURE 1
(A) Workshop scene cluttered with objects. (B) Street scene with crossing guard, Ridgewood Avenue School, Glen Ridge, NJ.

Josh Tenenbaum

[1] These quotes by Google car engineers are from the National Public Radio program *All Tech Considered*, October 3, 2012, and from a related feature by Henry Fountain, "Yes, Driverless Cars Know the Way to San Jose," published in the *New York Times*, October 26, 2012.

the objects. If you were to remove the table, the objects would fall. If you were to bump the table, some of the objects might fall off. Maybe if it's just a gentle bump, then the empty peanut jar or glue bottle might fall off, but the other objects would be stable. If you are shown an image of a house being constructed with the wood from this table, you won't see any of the nails. Those small things are attaching the pieces of wood together, and you know they're there, because otherwise that house would be falling over. How do you perceive the invisible nails? Or, look at that street and crossing guard scene. (FIG. 1B) When you look at that, you are capable of thinking, "What's going on inside that crossing guard's head?" You know where she's looking, what she's expecting to see, what she might be worried about seeing, what she's thinking about the people on the other side of her (even though she can't see them). You can even imagine what somebody else, such as the driver of that car, might be able to see or not see. It's this kind of understanding of agents in the world around us—their mental states and likely movements—that are at the heart of common sense. On the technology side, this understanding constitutes a key frontier of what machine learning might someday accomplish.

To paraphrase some of the tech leads in Google's self-driving car project: "The thing we've got covered is the sensors. We're not missing better lasers or scanners or images. We're missing the common sense." As they say, "We do a good job of detecting pedestrians at the side of the road. But we don't yet have a way to build in the kind of intuition for what a pedestrian might do."[1] As stressful and anxiety producing as it might be to be a teenager learning to drive (or even more stressful, to be the parent of a teenager learning to drive), that aspect of anticipating pedestrian behavior is not something you're worried about. That knowledge comes automatically from being a human being. But how can we understand this?

Developmental psychology is tremendously helpful in approaching such a question. We are not born knowing how to anticipate pedestrian behavior. But we do have some structures that predetermine how we build intuitive physics and intuitive psychology. You can see this most clearly in young children playing with blocks and playing with each other. When you study a child learning about certain unusual kinds of physical objects for the first time, like magnets or Silly Putty or a touch-screen device, this human learning can be strongly contrasted with the state-of-the-art machine learning using megabytes of data. A child is going to learn much more from just one encounter than any machine system will learn from hundreds of thousands of data points.

The first time you encountered a touch screen designed for human use, you needed to become sensitive to the spatiotemporal coordinates linking how, where, and when you touch the screen, and to what then happens on that screen. It's the coincidence of your touch and those results in relation to your sensitivities. The first

IV. SENSING

time the coincidence takes you by surprise, but then you understand what's going on, and very rapidly you have some idea of this new causal mechanism in the world. But how does it work?

Experiments that test such situational learning often deploy minimal sensing examples, yet they fully engage your common sense. Take the work of developmental psychologists such as Victoria Southgate and Gergely Csibra. (FIG. 2) In various experiments together and with other scientists, these psychologists aim to study common sense in early childhood.[2] They did so initially with a short animation in which you can see a blue ball and a red ball rolling on a green background, which is structured with boundaries punctured with openings. The smaller red ball moves through the openings smoothly, while a larger blue ball follows it, but seems to have some difficulty navigating the same space. If we adults watch the same film, we don't just perceive a blue and a red ball rolling. We perceive the blue ball as chasing the red ball—it's an organized activity, and apparently very goal directed. We perceive that the red ball is smarter than the blue ball as it squeezes through spaces that the blue ball has trouble navigating. That's a judgment about a certain kind of mental character or mental state, inferred solely by the actions of these abstract shapes. To understand how we could see the balls as having goals such as "chasing" or "fleeing," we need to understand something about mental states and the beliefs within mental states. The blue ball has some correct beliefs: it seems to know where the red ball is. But it also has some false beliefs. It thinks it can fit through those holes, but it can't fit through, and it persistently holds those false beliefs even with lots of evidence to the contrary. That failure to learn registers on us as not being very smart.

Behind this kind of intuitive psychological analysis is also the kind of intuitive physics I referred to earlier. We can make our intuitive judgments about beliefs only because the balls seem to have physical constraints; the balls can't pass through physical boundaries, and they "know" that. When those physical constraints are removed, the perception shifts. In that condition, the same kinds of movement are perceived as being like dancing, which is a different kind of activity. Intuitive psychology has an intuitive physics wrapped up in it.

The famous Heider-Simmel film from 1943 set up the same conditions that Southgate and Csibra elaborated. (See Caroline A. Jones, "Modeling," in this volume.) One of the most famous and most important films in psychology, Fritz Heider and Marianne Simmel produced a very low-quality stop-action animation, yet when you look at the two triangles and the circle, you see characters in a story. Almost all of the college students they tested saw a competitive interaction in this little animation, judging that the big triangle bullies the smaller one, backing him up against the wall. Small triangle gets scared and runs away. The circle was watching but then hides. Then the big triangle goes to try to find the little circle. There's no

[2] Victoria Southgate and Gergely Csibra, "Inferring the Outcome of an Ongoing Novel Action at 13 Months," *Developmental Psychology* 45, no. 6 (November 2009), 1794–1798. See also Mikołaj Hernik, Pasco Fearon, and Gergely Csibra, "Action Anticipation in Human Infants Reveals Assumptions about Anteroposterior Body-Structure and Action," *Proceedings of the Royal Society B* 281, no. 1781 (February 26, 2014); Mikołaj Hernik and Victoria Southgate, "Nine-Month-Old Infants Do Not Need to Know What the Agent Prefers in Order to Reason about Its Goals: On the Role of Preference and Persistence in Infants' Goal-Attribution," *Developmental Science* 15, no. 5 (2012): 714–22.

Josh Tenenbaum

FIGURE 2 (ABOVE)
Still image from a video animation by Victoria Southgate and Gergely Csibra, used as an experimental prompt. (See note 2.)

FIGURE 3 (BELOW)
Charles Darwin, evolutionary "tree" sketch from 1837, envisioning the logical hierarchy of species and genera and evoking the idea of the Bayesian network. (See note 3.)

FIGURE 4 (FACING)
Intuitive physics: various views of a 3D tower simulation from Peter Battaglia, Jessica Hammrick, and Joshua Tenenbaum. (See note 4.)

FIG. 3

soundtrack, but you can imagine scary music. It ends happily, at least for two of the three characters.

Again, intuitive physics is nested within intuitive psychology. There are shapes being filmed from above and moved around from one frame to the next on a board, but you see them in terms of forces. Along with those forces, you see all these psychological states that then build intuitive social sciences, such as intuitive sociology or morality or ethics. How do we get so much from so little? They are very simple images of a few shapes, and, if you were to characterize them with a mathematical description, in a time series of positions, it takes only 9 or 10 numbers to describe these shapes over time, 9 or 10 numbers to describe the horizontal and vertical position and the orientation of each of these shapes. Yet, from just those 9 or 10 dimensions over time, you get so much. How is that possible?

Enter *reverse engineering*, a term that refers, in this context, to the computational approach for building an intelligent machine's software and hardware. How do complex intuitive systems of inference build in the infant mind, in some combination of nature and nurture? What is innate, and what can be learned only from experience? How can we fix intuitive systems when they seem to be going wrong in developmental disorders such as autism? Reverse engineering the common sense would have significance for the fields of education, policy making, and the arts, as well as for machines.

The computational approach posits Bayesian networks at the core of these intuitive systems. A Bayesian network can be depicted as a directed graph, using circles and arrows to represent causal structures in the world. The key idea is that your mind is making probabilistic inferences—good, plausible guesses—based on intuitive theories of relations between coincident events, theories reinforced through experience but based on innate structures of the brain. A diagram of the Bayesian type would form a branching network to represent the mental models of causal processes out in the world. For example, Charles Darwin's "tree of life" sketch of branching species (FIG. 3) emerging hierarchically from a single trunk forms an inference about the likelihood that species close or distant in this hierarchy would "require extinction" for the logic to work.[3] At another scale, we can have a graph that is meant to capture very roughly the process of generating a medical diagnosis, or predicting an appropriate course of treatment. The doctor observes a pattern of symptoms, and attempts to reason backward to the pattern of diseases most likely to have caused those symptoms; by reasoning forward, the treatment is planned. The doctor can't be sure from sparse observations of only a few symptoms, but she can make a good guess with the right causal models and the right probabilities. When scientists talk about doing Bayesian inference on a causal model, or just Bayesian inference, they are taking a probabilistic model and running it in reverse to make good guesses as to the inputs that best explain a pattern of observed outputs.

Intuiting

3 The text accompanying Darwin's diagram says this: "I think [the] case must be that one generation should have as many living as now. To do this and to have as many species in [the] same genus (as is) requires extinction. Thus between A + B the immense gap of relation. C + B the finest gradation. B + D rather greater distinction. Thus genera would be formed. Bearing relation to ancient types with several extinct forms." Transcription available on the en.wikipedia page for "Darwin's tree of life."

In more sophisticated probabilistic programs aimed at capturing common-sense physics and psychology, the results also look like directed graphs. But we put words on the arrows, because the arrows are not just stand-ins for tables of numbers. They represent entire computer programs that simulate the interesting causal processes that our mind uses to represent the physical and psychological processes going on in the world of objects and agents. Computer graphics and robotics are fields in which programs have to capture how the physical world unfolds and how it looks in images. Computer graphics people try to do this in ways that make very efficient approximations very fast, particularly the kind of computer graphics used in video games. In order to create those kinds of immersive experiences, you have to capture approximately in your computer programs the things that go on in the world. You don't actually have to capture all the things that are going on inside a soccer player's head, or all of the detailed physics of how a soccer ball bounces off the field—but you do have to make it realistic enough to stimulate the game player's response.

We are working from the hypothesis that the reason these games work with such minimal stimulus is that, in some sense, your brain is doing the same thing. Your brain has similar kinds of models of how objects move, how light bounces off things, and how agents have goals and pursue them. If this hypothesis is correct, then it is reasonable to assume that our brains can take these Bayesian frameworks and run them backward. We observe the outputs of these programs, and we can make guesses—or inferences—about the inputs that

FIG. 4

Peter W. Battaglia, Jessica B. Hamrick, and Josh Tenenbaum, "Simulation as an Engine of Physical Scene Understanding," *Proceedings of the National Academy of Sciences* 110, no. 45 (2013): 18327–18332; James J. DiCarlo, Davide Zoccolan, and Nicole C. Rust, "How Does the Brain Solve Visual Object Recognition?" *Neuron* 73, no. 3 (2012): 415–34; Nuo Li and James J. DiCarlo, "Unsupervised Natural Experience Rapidly Alters Invariant Object Representation in Visual Cortex," *Science* 321, no. 5895 (2008): 1502–1507.

must have caused them. In other words, when you are "having an experience" it's not just observation, but also interaction. You receive the data related to your experience—let's call it the video game of your life—and your brain is making guesses about inputs such as the mental states of other agents or the physics of objects.

How can we test this hypothesis? To test humans' intuitive physics engine, we show them stimuli in a simulated world of Newtonian physics. (FIG. 4) And they make a simple judgment in response to a question such as, "On a scale of one to seven, how likely do you think it is that a given stack of blocks will fall under the influence of gravity?" Then we devise machine models for plotting the same predictions. The machine looks at an image, makes a guess at the three-dimensional positions of these blocks, and then runs a simple sort of Newtonian physics simulator a few steps forward in time to plot a few different guesses, because there are uncertainties as to where the blocks are. In such experiments, the machine does a pretty good job of predicting people's common-sense judgments.[4]

The same kinds of intuitive physics can be studied in infants; they can be shown representations of a few objects bouncing around. After a moment that image will be occluded. And then one of the objects will reappear. With respect to infants' intuitive physics, you can only map preverbal responses, asking: How surprising is that? Within such constraints, the experimenter can vary different factors, such as whether the reappeared object is the blue or yellow one, or whether it's the one that's close to the door or far from the door, or how long the delay is between when it's occluded and when the object reappears. An infant's looking time is the standard measure of surprise: when infants see something surprising, they look longer. This looking-time can be quantitatively predicted using one of the probabilistic intuitive physics measures. This is one of the first times quantitative predictive models have been used to gauge infant behavior, taking us all the way down to the "core of common sense" even in very young babies.

We're working on trying to reverse engineer how this kind of physical knowledge grows with experience, with the supposition that the same kind of model can be applied to intuitive psychology. In this case, however, we need to add planning programs. Familiar to any user of a GPS-enabled device, the planning program knows where you are now, takes a map of the city that it has stored, and plans a route for you. These programs formalize a very classic set of concepts in intuitive psychology where belief, desire, and action form within a rational agent model. (Belief includes your general model of the world, desire is where you want to go, and planning becomes an efficient sequence of actions that allow you to achieve your desires, given your beliefs.)

From the context of Bayesian inference buttressed by probabilistic programs such as these, we can argue that the common-sense core in a human is observing the actions of others, assuming they

are the result of a rational planning program, and then working backward from the observed effects to their probable causes. "Causes" here are the hidden mental states, the beliefs, and the desires inferred to be in the other person's head. Standard computer vision algorithms will see an agent or a person reaching for something and will try to analyze the visual motion. Inferential Bayesian programs may be able to take that gesture and reverse engineer the person's mental representation of something wanted or hoped for that might not actually be there. In fact, the Bayesian model can make that inference to learn what that person was likely to have believed when he or she started off, because otherwise their movements wouldn't have made any sense.

Developmental psychologists in cognitive science have been very interested in these kinds of activities. Theories of mind that imagine the other agent as *having* common sense are developed into moral judgments about right actions. We can debate "neuroeconomics" and whether expected utilities are a good way to think about the actual ways our brains work.[5] But economic utility theories seem to be a good way to think about how our brains *think* about how our brains work. This approach allows us to add one more type of program, formalizing a specific desire as a kind of utility function. A helpful desire then emerges as one that recursively has its utility function depend on another agent's utility function—intersecting to form a kind of a golden rule, if you like. These kinds of common-sense physics and psychology, the scientists in my lab and other collaborators contend, are the result of deep structures in the brain that respond actively to engaged experience with the world.

How did looking at finches in the Galapagos Islands move Darwin toward his theory of natural selection? How did studying pea pods nudge Gregor Mendel toward his theory of genetics? What intuitive physics did Isaac Newton use to consider orbiting planets and dropping apples, and thereby construct his theory of gravitation? Understanding such leaps in intuition might help us think about the challenges facing the human species on a societal and global scale. Our society's inability to grapple with issues like climate change is clearly linked to common-sense intuitive theories, which barely grasp Newton's concept of angular momentum, much less catastrophic and cascading events on a planetary scale. Understanding why people fail to grapple with what's really at stake in climate change may also give us some insight into what we can do to modify the limits of our understanding. To conclude, I return to the Heider-Simmel film, which suggests what art does that science can't. That film, constructed by hand by two very artful psychologists, has artistic subtleties that we aren't yet able to handle scientifically. Even with something so simple, our models are just scratching the surface of the richness of human experience.

[5] The field of neuroeconomics is often attributed to the work of psychologist Daniel Kahneman, whose theories of cognitive bias in economic choice-making have sufficiently informed economics that he was awarded the Nobel Prize for Economics in 2002.

FIG. 1

TRACKING
Natasha Schüll

> In this short Life
> That only lasts an hour
> How much — how little —
> Is Within our power
> — Emily Dickinson

In 1990, just as digital information and communication technologies were coming into widespread use, the French philosopher Gilles Deleuze suggested that the architectural enclosures, institutional arrangements, and postural rules of disciplinary societies were giving way to the networked technologies of "control societies," involving continuous coding, assessment, and modulation.[1] The latter scenario bears an uncanny resemblance to the tracking-intensive world of today, in which the bodies, movements, and choices of citizens and consumers are ever more seamlessly monitored and mined by governments and corporations. Heated public debate has arisen over how such tracking might undermine personal identity, liberty, and privacy.

Yet even as this discussion on surveillant monitoring unfolds, the public has embraced practices and products of *self*-tracking, applying sensor-laden patches, wristbands, and pendants to their bodies. The contemporary world is characterized by "an intimacy of surveillance encompassing patterns of data generation we impose on ourselves," writes anthropologist Joshua Berson.[2] As prescient as Deleuze's vision of the future was, Berson notes that the philosopher did not anticipate the degree to which the tracking and coding of bodies and acts would be drawn into the ethical project of self-formation and self-care. What Michel Foucault called *technologies of the self*—means through which individuals perform "operations on their own bodies and souls, thoughts, conduct, and way of being, so as to transform themselves in order to attain a certain state of happiness, purity, wisdom, perfection, or immortality"[3]—take an actual technological shape in the assemblages of wire, chips, and batteries that constitute contemporary self-tracking devices.

While people have long used simple, analog devices to record, reflect upon, and regulate their bodily processes, use of time, moods, and even moral states (here we can list mirrors, diaries, scales, wristwatches, thermometers, or the lowly mood ring), the

FIGURE 1
Mette Dyhrberg, "2.5 Years of My Weight," image posted in the visualization gallery of quantifiedself.com, September 2014. "I gained a lot of insights from this heat map," writes Dyhrberg.

This text draws material from Natasha Schüll, "Data for Life: Wearable Technology and the Design of Self-Care," *BioSocieties* 11, no. 1 (March 2016).
 1
Gilles Deleuze, "Postscript on the Societies of Control," *October* 59 (1992): 3–7.
 2
Joshua Berson, *Computable Bodies: Instrumented Life and the Human Somatic Niche* (London: Bloomsbury, 2015), 40.
 3
Michel Foucault, "Technologies of the Self," in *Technologies of the Self: A Seminar with Michel Foucault*, ed. Luther H. Martin, Huck Gutman, and Patrick H. Hutton (Amherst: University of Massachusetts Press, 1988), 18.

[4] Gary Wolf, "QS15: What Happened?" http://quantifiedself.com/2015/06/qs15-what-happened/.

[5] Gary Wolf, "The Data-Driven Life," *New York Times Sunday Magazine*, April 28, 2010, online at www.nytimes.com.

[6] Ibid.

[7] Ibid.

past five years have seen a dramatic efflorescence in the use of digital technology for self-tracking. As mobile technology spreads, as electronic sensors become more accurate, portable, and affordable, and as analytical software becomes more powerful and nuanced, consumers are offered an ever-expanding array of gadgets equipped to gather real-time information from their bodies and lives, convert this information into electrical signals, and run it through algorithms programmed to reveal insights and inform interventions into future behavior.

The recent rise of self-tracking is epitomized by the practices of the Quantified Self (QS) community, an international collective of individuals—as of summer 2015, there were more than 45,000 members in 40 countries—who ascribe to the quest for "self-knowledge through numbers."[4] In online forums and in meetings around the world, quantified selfers share their attempts to experiment with diet and meditation, monitor drug side effects, correlate hormone levels with mood fluctuations and relationship dynamics, or even evaluate semantic content in daily email correspondence for clues to stress and unhappiness. In large volumes of numerical self-data, rendered in spreadsheets, pie charts, graphs, and other visual media, they seek to detect patterns and uncover habit pathways. (FIG. 1)

Started in 2009 by Gary Wolf and Kevin Kelly, two former editors at *Wired* magazine, QS made its public debut when "The Data-Driven Life," authored by Wolf, appeared on the cover of April's *New York Times Sunday Magazine* in 2010.[5] In the piece, Wolf proposes that data can serve not only as a means of inspecting others' lives (as an actuary, policy maker, or welfare officer might) but as a tool for introspection—a kind of digital mirror in which to see and learn new things about ourselves. "Humans have blind spots in our field of vision and gaps in our stream of attention," writes Wolf; "We are forced to steer by guesswork. We go with our gut. That is, some of us do. Others use data."[6] In heart rate spikes or mood dips charted over time, he argues, we can grasp how we are affected by seemingly trivial habits or circumstances. "If you want to replace the vagaries of intuition with something more reliable, you first need to gather data. Once you know the facts, you can live by them." Automated sensors and statistical correlation become tools for the good life.

"The idea that our mental life is affected by hidden causes is a mainstay of psychology," notes Wolf. And yet, "the contrast to the traditional therapeutic notion of personal development is striking." He explains:

> When we quantify ourselves, there isn't the imperative to see through our daily existence into a truth buried at a deeper level. Instead, the self of our most trivial thoughts and actions, the self that, without technical help, we might barely notice or recall, is understood as the self we ought to get to know.[7]

Longtime self-tracker Eric Boyd, a mechanical engineer who runs Toronto's Quantified Self meetup, believes that the tools and practices of self-quantification are less about numbers than self-discovery. "The reason you begin tracking your data is that you have some uncertainty about yourself that you believe the data can illuminate," he said in 2013. "It's about introspection, reflection, seeing patterns, and arriving at realizations about who you are and how you might change." And yet this intimate journey commences not with a turn inward but with a move outward to the streaming data of a device: an extraction of information, a quantification, a visualization. Self-tracking, following Boyd, renders "an *exoself*, or a digital mirror; it lets you look at things you otherwise couldn't see using just your own eyes, and see yourself more honestly."[8]

For his company Sensebridge, Boyd designs a variety of devices intended to produce these digital mirrors of the self. The Heart Spark pendant, for instance, flashes in time with one's heartbeat, externalizing the body's affective rhythms. (FIG. 2) Sound Spark flashes along with the cadence of one's voice; a compass anklet vibrates to augment one's sense of direction. As experience feeds into data streams, so data streams feed back into experience, becoming a vital aspect of sentience and self-knowledge.

Like Wolf, Boyd distinguishes data-driven modes of self-discovery from those of talk-based therapy: "Quantified self is not a linguistic exploration like psychoanalysis—it's more of a digital exploration, and the stuff you're exploring is made up of many little bits and moments." One arrives at insights not through language unfolding in time, he elaborates, but through tracking these bits and moments *over* time. "You may not gain any knowledge in a week or even a month, but maybe with a year of data you might see something significant about yourself; you need a view that's longer than whatever moment you're in." In the interview prompting this verbal rumination on the "exoself," Boyd shifted the plane of existential significance and the possibility of self-knowing from the fleeting temporality of single events to the longitudinal temporality of accretion:

> In our physical world we're actually quite small creatures—our powers only extend a few meters. But in the *temporal* dimension we're actually extremely effective. The trouble for us is that it's difficult for us to see the amount of power we have in time because our sense of time is so limited. We go through life one minute a time—but we're actually going to live a billion moments or something like that.

Digital tracking and time-series analysis allow us to take stock of these billion moments; "they give a longer view of our power in time" by showing how our habits—"the things we're doing over and over"—add up to affect our lives in positive and negative ways. "Without good time calibration," notes Wolf, "it is much harder to

FIGURE 2
The Heart Spark pendant flashes in time with wearers' heartbeats, broadcasting their emotions.

8
Eric Boyd, interview with the author, July 2013, Toronto, spoken emphasis. (All subsequent quotations from Boyd in this text are taken from this interview.)

see the consequences of your actions." Thus tracking tools become ethical tools, technologies of the self; in self-tracking Boyd finds a pathway from self-knowledge to self-transformation. Tracking has allowed him to regard himself as a "time-series self," which he finds both liberating and empowering.

Over the last five years, the practice, ethos, and technology of self-tracking has migrated out of the "geeky," rarefied domain of QS and hacker conventions to capture the attention of venture capitalists, technology startups, established electronics companies, and mass-market consumers. The aisles of Best Buy and Walmart are abundantly stocked with gadgets designed to record personal metrics, the Internet rife with downloadable smartphone apps that can monitor behavior, and suggest, as Boyd commented, "how you might change." Data-tracking gadgetry includes earbuds that adjust their musical output to keep wearers' heart rates at certain levels of calm or energy, electronic skin patches that monitor blood flow, smart toothbrushes that help people brush their teeth correctly and long enough, and an impressive collection of wristbands packed with sensors that log footsteps, heart rate, sleep phases, and more.

Fitbit, currently the best known of these devices, is the undisputed market leader in wearable fitness. The company makes a wearable movement-tracker that syncs with users' personal computers, mobile phones, and now smart watches to continuously monitor steps taken, hours slept, and other data they might choose to track. The stated purpose is to bring about "a healthier you." In a video advertisement, close-up shots of different body parts in motion elaborate on this aspiration, as the voiceover celebrates the arrival of a sensor that keeps track of routine activities. "Every step you take, every goal you set, every choice you make to be active" will be recorded—either by the band slipped over the wrist or the pendant clipped to the waist. A male runner strides in slow motion with concentric circles radiating out from his feet as they strike the pavement, illustrating the technical achievement of accurate, consumer-grade signal processing and prompting potential users to attend to the rippling consequences of their every movement. Next a woman plays with her family in their backyard, segueing to her home office where crisp imaginary lines extend from her blurry form in the window to the smartphone and laptop on her desk. The sequence suggests to prospective users that they can trust the device to capture any and all information, even when they are absorbed in quality time with family. Data generated as they move through their days—calories burned, distance covered, duration of activity, fluctuation in weight—will be synchronized in real time, across all screens, creating exo-selves they can tap into on any device.

Partway through the Fitbit video advertisement, a man pauses at the turnstile of a subway entrance, then slowly turns to face the camera as a digital overlay indicates the choice before him: Monorail versus WALK. With a smile he rejects the train and sets off on an

illuminated footpath to realize the "potential 2,000 steps" he would thereby add to his daily count. At the press of a button on his mobile smartphone, he broadcasts his choice to a group of friends, his new step-count advancing him on the leaderboard of life. From running to childrearing to commuting—every quotidian activity has potential for transformation, via Fitbit. The advertisement closes on the figure of a woman sleeping, an expression of contentment on her face, her exposed arm revealing the band that promises to optimize "even inactivity" as she slumbers.

Fitbit competitor Jawbone's "idle alert" also addresses inactivity, vibrating when wearers are still for too long. Some wearables focus entirely on bodily stillness—tracking it, preventing it, helping users maintain proper posture during it. A simple gadget called the Rise sits in one's pocket and records time sat throughout the day. The Lumo Lift posture device fastens upon one's lapel or brassiere strap, whence it records and corrects posture with subtle (or not-so-subtle) vibration. "Through the app, you can control when you're buzzed, how you're buzzed, and even how intensely it buzzes," informs the product literature. While the technology performs standard activity tracking, its primary purpose is to monitor and regulate the stationary states of sitting or standing. A promotional ad for the Lift closes with images of a corporate meeting in which the wearer briefly pauses to lift her head and bring her shoulders back, seemingly unprovoked, and allows a triumphal smile to play across her face. "Small changes can be empowering," the ad exults. As Boyd confirmed, power in time lies with the plasticity of habit; small changes mark the site where the exoself is molded.

Few habits are more intimate and entrenched than those involving food, and it is no surprise that designers of digital tracking technology have created products that focus exclusively on eating. Recalling the dystopian feeding machine in Charlie Chaplin's film *Modern Times,* the HAPIfork is a smart utensil designed to help people eat more mindfully—and eat less. The fork intervenes in the habit of feeding by monitoring and recording the length of each meal, the number of fork-servings per meal, and the time between each of these servings; if shorter than ten seconds, the fork will oscillate so that the eater knows to slow down—an effect achieved via proprietary "slow control" technology. "You are advised to take about 10–20 chews," reads the user manual. "If you trigger the HAPIfork's alarm [by eating too fast], don't panic. Set the fork down at the side of the plate and wait until the light turns green again, signaling that it is safe to take another bite." The device, which turns something as routine as a single bite of food into a matter of potential danger, is presented as an "everyday technology" that helps users "take control" of their consumption. The company recommends keeping smartphones in view so users can see their data as it is collected in real time; as they feed themselves, their data is "fed" back to them. "Every bite is a potential teaching experience," noted

a user in a *TechCrunch* review.[9] Like all technologies of the self, the HAPIfork is an instrument of entrainment, serving to bring one's daily habits into alignment with the conduct to which one aspires.

The habit of hydration, another mundane yet vital human action, is the focus of the H20-Pal monitoring device, a small wireless scale that one attaches to the bottom of any water bottle where it keeps track (using built-in flash memory and a weight measuring sensor and accelerometer) of how much liquid is consumed from it, conveying this information to users' smartphones where a corresponding application is programmed to alert those who have not hydrated enough. Similarly, BluFit's "passive hydration tracking" bottle uses built-in sensors to measure how much has been drunk, automatically adjusting daily goals based on temperature and humidity, and providing feedback in the form of flashing lights. Yet another smart water bottle, the Ilumi, changes color from red, to yellow, to green throughout the day to signal users' proximity or distance to their preset hydration goals. As with the HAPIfork, these devices transfer the burden of vigilance—and even, to a degree, behavior change—from selves to the sensors and computational algorithms of wearable technology.

Wearable vigilance extends from the outward-in acts of eating and hydration to the intimate, self-generated act of breathing—arguably the most elemental and vital unit of existence in and through time. The measure of breath, coupled to heartbeat, is the metric that constitutes seconds, accumulating into minutes, aggregating into hours—much as data itself aggregates into the time-series self. A small wearable device called the Spire helps people to regulate their breath—and, by extension, their stress levels—by alerting them when their respiration becomes shallow or erratic. The product website suggests that users review graphs of their breathing during activities such as meditating, reading, and working on a computer as a way to enhance their self-awareness. (FIG. 3) The idea is that by wearing the Spire, receiving its prompts, and reflecting on its data, users will be able to cultivate better breathing habits. Another device concerned with entraining new patterns of breath and focus is the Muse, a seven-sensor, mobile EEG headset designed to give users a window into—and, over time, a handle on—the intimate signals of their brain data via real-time audio feedback and dynamic onscreen visualizations. The ad speaks with the voice of a personal coach: "See and hear your brain activity. Test how well you can manage stress. Learn how to calm your busy mind." Giving a cyborgian twist to centuries of analog meditation devices of the visual (mandalas) and acoustic (chants) sort, the Muse tunes into internal brainwaves to offer an external read-out; it is a real-time informatic instrument designed to help individuals achieve mindfulness as they move through their days. "I'm really interested in figuring out what is actually possible in terms of mental augmentation with this new digital mirror that we have," comments Boyd of this and other

[9] Ryan Lawler, "In Defense of the HAPIfork," *TechCrunch* (January 12, 2013), online at www.techcrunch.com.

[10] Clynes and Kline coined the term *cyborg* while writing in 1960 about how to equip astronauts for space. "For the exogenously extended organizational complex functioning as an integrated homeostatic system unconsciously," they wrote, "we propose the term *cyborg*." Manfred E. Clynes and Nathan S. Kline, "Cyborgs and Space," *Astronautics* (September 1960): 27. See also Auguste Villiers de L'Isle-Adam, *L'Eve Future* (Paris: M. De Brunhoff, 1886); Terry Castle, *The Female Thermometer: Eighteenth-Century Culture and the Invention of the Uncanny* (New York: Oxford University Press, 1995); Donna Haraway, "A Cyborg Manifesto: Science, Technology, and Socialist-Feminism in the Late 20th Century" (1985), reprinted in *Simians, Cyborgs, and Women: The Reinvention of Nature* (New York: Routledge, 1991), 149–81.

[11] Anthony Giddens, *Modernity and Self-Identity: Self and Society in the Late Modern Age* (Stanford, CA: Stanford University Press, 1991); Nikolas Rose, *The Politics of Life Itself: Biomedicine, Power, and Subjectivity in the Twenty-First Century* (Princeton, NJ: Princeton University Press, 2007); Alan Hunt, "Risk and Moralization in Everyday Life," in *Risk and Morality*, ed. Aaron Doyle and Richard V. Ericson (Toronto: University of Toronto Press, 2003), 165–92.

FIGURE 3
Breathing during information work is more erratic and less deep than breathing during meditation or reading, according to the commercial website for the Spire feedback device, in a blog posting from August 4, 2014.

emerging "brainware" devices. "In a sense you could call it a cyborg, because it lets you look at things you couldn't look at using just your own eyes."

Fantasies of the body measured by thermometers and controlled by feedback devices exist from the European Enlightenment to mid-20th-century cyborg imaginaries in which human self-regulatory controls would be enhanced and extended via feedback loops with machinic controls, creating powerful "artifact-organism systems."[10] Although such systems were fueled by a desire to enhance human capacities beyond animal limits, they also heightened anxiety over these limits, introducing a new pressure for technological supplementation.

The wearable tech industry plays on this anxiety and pressure, addressing a market of consumers who "fly blind" through their daily routines, unsure whether to trust their own senses, desires, and intuitions as they make mundane yet vital choices—when, what, and how much to eat, drink, move, or rest. Denizens of so-called risk society are expected to shape their lives through choice in the manner of savvy, vigilant entrepreneurs—and yet, more often than not, they lack the knowledge, foresight, or resources to navigate the abundance of potential choices they face.[11] When equipped with devices that transcend the myopic vantage of real-time experience, these subjects are released from the burden of vigilance; they don't have to look at the water bottle or check their thirst because digital tracking products and applications do it for them. The technology promises to fill in the blind spots and take the guesswork out of everyday living, supplementing users' shortsighted perspective with a continuous, informatic gaze—a big data gaze—able to compute how small choices become consequential through repetition. Personal sensor technologies are offered by their producers as digital compasses to help people make, as Fitbit puts it, the "small daily decisions" that can add up to "BIG RESULTS." (FIG. 4) This is an epistemological mode in which correlation holds sway over causation, cumulative data over immediate experience, and future over present.

"You can build a profile or picture of what it is you're doing, and this lets you see and understand the choices you're making

FIGURE 4
Still image from a promotional video for the Fitbit Zip from 2012.

on a daily basis," said Scott Kozicki, a representative of Verizon's Health Care Management group in praise of self-tracking technology, "which is really who you *are:* the choices that you make all day long, whether to take the stairs or the elevator, what you will eat or not eat."[12] It is important, Kozicki continued, that one remain in constant touch with one's data profile—one's *exoself*, to use Boyd's term—in order "to see how your choices are impacting you *now*—see how the gauges are moving *as* you make choices." The novel insight into one's habits that sensor data affords, he suggested, could function as a sort of "sixth sense." Traditionally a phrase to describe uncanny insights that seem to come from some ethereal, "extra-sensory" domain, the sixth sense is, in the case of tracking devices, a cyborgian affordance that supplements human sentience with electromechanical sensors and data-processing software sensitive enough to detect otherwise imperceptible patterns of being.[13]

The science and technology pundit Melanie Swan uses a similar metaphor to describe this supplemental insight into being, suggesting that the transposition of big-data epistemologies to the scale of the individual affords "a sort of fourth-person perspective" on the self and, ultimately, a new kind of truth—one that is "not possible with ordinary senses" in that it does not correspond to a phenomenological self (temporally and spatially located) but to a self whose truth lies in scattered points, associations, and dynamic accretions.[14] Wearable sensor technology invites us to view ourselves as longitudinal databases constantly accruing new content: "You are your data" is the frequent refrain.

The fourth-person self thus joins the exoself and the time-series self as a new entity complicating the presumed unified subject, the biological human. The "body" here is a data-generating device that must be coupled to data-monitoring systems; together they inform a new episteme that devotees find empowering. As the electronics company Samsung asks in a recent video promoting its health and fitness system, *"What if you could ask your body questions and listen to the answers, every minute of every day? You could adjust your habits according to your body's advice. Imagine the insights gained, the mysteries unlocked; it would change your life."*[15] In this scenario, sensing happens not only in or through the body, but also in and through sensor technology; one's own "data exhaust" (contemporary parlance for the traces given off by citizens of the networked world), tracked and filtered through analytic algorithms, becomes a trustworthy guide through the uncertainty of human experience and perception.

Countering the cheerful boosterism of digital tracking pundits, some worry that the rhetoric of "you are your data" introduces a gap between the "you" of the dataset and the epistemologies by which that dataset is amassed, studied, and made meaningful. "This is a body that is continually emitting signs, albeit in forms inaccessible to the self that might act to maintain it," note anthropologists

Ana Viseu and Lucy Suchman.[16] These scholars are troubled by the potential disempowerment that the discourse of wearable computing produces, in which technology is the only way to bridge the "epistemological lacuna" that divides "the modern body and the knowing and acting self" and the sole means of bringing "physiological fact into the grasp of the experiencing subject."[17]

Whether or not technology serves to empower or disempower "the knowing and acting self" is a point of debate among tracking enthusiasts. This debate came to the fore during a panel on self-tracking held at the 2012 Consumer Electronics Show in Las Vegas, when an audience member raised his hand and asked:

> I'd like to be able to create an avatar of myself who drinks regular [not diet] coke and takes the elevator [not the stairs] and eats no vegetables, and then drag that avatar across a timeline into the future and show myself how I'm getting fatter, getting older, getting diabetes, and by age 65 my tombstone rises up? I want something that can communicate to me what the decisions I make *now* mean over time.[18]

Panelists responded that tracking technology could do more than give people self-knowledge and perspective on choices—it could help *guide* those choices, "in the fashion of a thermostat." Such technology would not only track wearers—it would keep them "on track," interrupting the flow of experience to prompt them to eat, drink, meditate, or rest as needed (or even, in the case of the app RunPee, meant for moviegoers, TV watchers, and computer users, to get up and go urinate). "We're on the brink of really exciting things—devices that monitor things and then give you actionable updates before you even need to ask," said panelist Leslie Zeliger, a technology designer and longtime self-tracker who welcomes the opportunity to outsource the labor of self-regulation.

Yet technology that entrains as it tracks, acting as a kind of advanced human cattle prod, is where Wolf, Boyd, and other QS protagonists draw the line. Across it, the quantified self becomes the infantilized self and the ethical project recedes. These self-trackers insist on the core humanism of their enterprise: rather than compromising or degrading human subjectivity and free will, technology such as Boyd's suite of Sensebridge electronics or longitudinal graphs of automatically tracked data can enhance it by enabling new awareness of one's being in the world and in time, and lending new tools to the project of self-care and the good life. The novel ethical mandate of the digitally self-tracking subject is not simply to "know thyself" but to let digital sensors and big-data analytics share in the knowing.[19] Tracking, on this account, reveals new truths about who we are—and who we might become.

12
Scott Kozicki of Verizon's Health Care Management Markets group, speaker on the panel "Is Mobile Making Us Healthier?" Consumer Electronics Show in Las Vegas on February 5, 2012.

13
Jerry Kang and Dana Cuff argue that microcomputational sensing amounts to a new sense organ: "It is as if human beings are granted an additional 'sense' in addition to sight, hearing, taste, smell, and touch—a sort of sixth sense, a datasense." See Jerry Kang and Dana Cuff, "Pervasive Computing: Embedding the Public Square," *Washington and Lee Law Review* 62, no. 1 (2005): 110. These microsensors are not simply prosthetic, writes Mark Hansen, for they alter the very conditions of human sensing and perception, allowing us to "forge connections with microtemporal processes, that, despite evading the grasp of our conscious reflection and sense perception," we can "feed forward" into our future actions. See Mark Hansen, *Feed-Forward: On the Future of Twenty-First-Century Media* (Chicago: University Of Chicago Press, 2014), 38.

14
Melanie Swan, "The Quantified Self: Fundamental Disruption in Big Data Science and Biological Discovery," *Big Data* 1, no. 2 (2013): 85–99.

15
The Samsung video can be found online at: https://vimeo.com/96135620.

16
Ana Viseu and Lucy Suchman, "Wearable Augmentations: Imaginaries of the Informed Body," in *Technologized Images, Technologized Bodies*, ed. Jeanette Edwards, Penelope Harvey, and Peter Wade (New York: Berghahn Books, 2010), 161–84. Quote from page 175.

17
Ibid., 175.

18
Audience member comment during the panel "Is Mobile Making Us Healthier?" Consumer Electronics Show in Las Vegas on February 5, 2012, https://www.youtube.com/watch?v=vF8tPruZqOw.

19
Along these lines, Hansen (2014) argues that we should view humans, in their relationship with sensing and tracking technology, as *modulators* of their experience rather than transcendent agents.

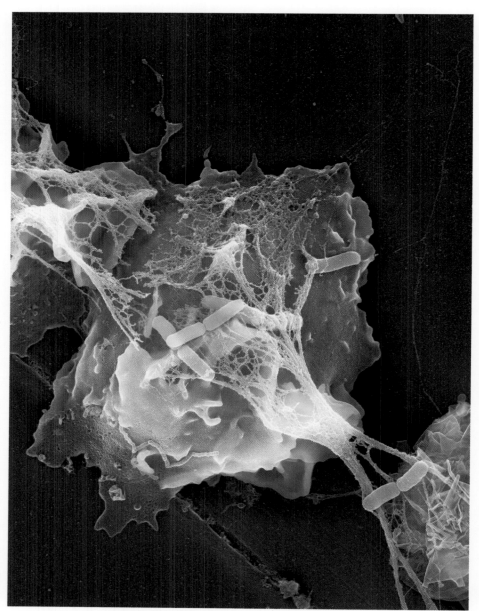

FIG. 1

SELF OF SENSE

Leah Kelly

The brain has taken precedence as the organ of perception, interpretation, learning, memory, emotion, decision-making, and initiation of action, and neurons as the units of cognitive processing. But these processes occur in *all* cells. By recognizing that these processes are epiphenomena of life, belonging to all cells, we may come to view ourselves as not merely a reflection of brain activity, but as the ongoing product of states that are continually in flux, in which numerous interconnected dynamic relationships exist at all scales and across all systems, not limited to a particular location.

We all began as only one cell, both evolutionarily (bacteria) and developmentally (zygote). At this fundamental level, a cell must be able to sense changes in its environments (in pH, metabolism, osmotic pressure, mechanical pressure, etc.) and respond appropriately via homeostatic feedback loops to maintain a stable internal milieu.[1] When cells are multiple, organizing into tissues, organs, and bodies, similar feedback loops exist at each level to maintain optimal temperature and metabolic and osmotic conditions without conscious effort. Such regulation may only require the closing of an ion channel or a molecularly induced change in gene expression at the single cell level, while the whole body requires highly differentiated organs to communicate via molecules traveling across large distances to achieve the same end. As well as maintaining consistency in dynamic environments, cells must also be able to adapt. When a bacterial population reaches a particular density, for example, the change in concentration of signaling molecules triggers a process called quorum sensing, in which the bacteria's behavior shifts from individual to social, allowing the population as a whole to enjoy maximal metabolic efficiency.[2] Genetic mutations allow adaptation to changes in environmental conditions by conferring resistance to antibiotics for some members of that bacterial colony, enabling a small number of that population to survive and replicate, returning the colony to its original growth rate.[3] Is this ability to sense the environment, to respond and perpetuate traits, not intelligence, learning, and memory?

In 1953, mathematician Alan Turing turned his attention to the problem of how one cell can develop into a differentiated being.[4] We now know the answer: through polarity and asymmetry.[5] The symmetry of the blastocyst of some organisms is disrupted by the

FIGURE 1
Scanning electron micrograph of stimulated neutrophil (a type of white blood cell), with NETs— neutrophil extracellular traps — and some trapped, rod-shaped Shigella bacteria.

1
Grahame W. Gould and John C. Measures, "Water Relations in Single Cells," *Philosophical Transactions Royal Society Series B* 278, no. 959 (March 1977): 151–66.
2
Melissa B. Miller and Bonnie L. Bassler, "Quorum Sensing in Bacteria," *Annual Review of Microbiology* 55 (2001): 165–99.
3
Dan I. Andersson and Diarmaid Hughes, "Evolution of Antibiotic Resistance at Non-Lethal Drug Concentrations," *Drug Resistance Updates* 15, no. 3 (2012): 162–72; Dan I. Andersson and Diarmaid Hughes, "Persistence of Antibiotic Resistance in Bacterial Populations," *FEMS Microbiology Reviews* 35, no. 5 (2011): 901–11.
4
Alan Turing, "The Chemical Basis of Morphogenesis. 1953," *Bulletin of Mathemathical Biology* 52, no. 1–2 (1990): 153–97; discussion on pages 119–52.
5
Robert O. Stephenson, Janet Rossant, and Patrick P. L. Tam, "Intercellular Interactions, Position, and Polarity in Establishing Blastocyst Cell Lineages and Embryonic Axes," *Cold Spring Harbor Perspectives in Biology* 4, no. 11 (2012).

concentration gradient of maternal proteins. As with bacterial quorum sensing, asymmetric concentrations of molecules trigger cascades of changes in gene expression, leading to cell division, differentiation, and specialization.[6] Cells guided by their orientation in space and/or chemical cues, migrate to and develop into various points of genetic and/or anatomical no return. Like often attracts like to form tissue structures, and cells continue to migrate in search of their destination until they have found it. Cell migration and differentiation translate time into space, and therefore the position and identity of every cell is a record of time and of fate.[7] Even when development is complete, tissue structures must be maintained by cells responding to global and local signals, so that structure emerges from complex, swarm-like behavior.[8] These cells sometimes make decisions about what to become and where to go based on the information available to them. Is tissue repair in response to injury and apoptosis also not a form of intelligence? Cellular decisions may not rise to the threshold of awareness, but neither do many of the macro choices that we make as subjects: various experiments show that despite our self-confidence in conscious decision-making, we are in fact deeply influenced by salient information that is not consciously perceived.[9]

While bacteria adapt to defend themselves against us, we, in turn, reciprocate. We are exposed to millions of potential pathogens every day in the form of viruses, bacteria, fungi, parasites, etc. Our immune system protects us by detecting, recognizing, and remembering agents it determines as non-self. (FIG. 1) Pathogens are first detected by the innate immune system, which is immediate and non-specific. Germ-line genetically encoded pattern recognition receptors recognize molecules that have been conserved in microbes throughout evolution.[10] This innate immune response leads to activation of the younger (less than 500 million years old) adaptive immune system, which is less immediate but is highly specific. Just as genetic variation allows bacteria to adapt, the genes of adaptive immune cells rearrange randomly during cell maturation to produce different combinations of receptor subcomponents, generating a receptor repertoire that could recognize a near-infinite number of foreign molecules called "antigens."[11] Upon presentation of an antigen, cells of the adaptive immune system rapidly mutate and divide further by a process known as somatic hypermutation, through which nucleotide substitutions, and occasional insertions and deletions are made at a rate of approximately 10^3 per base pair, per generation, roughly one million times the rate of spontaneous mutations in other cells.[12] Daughter cells are selected under intense selection pressure, such that each subsequent generation produces antibodies that better fit or "sense" the antigen.[13] The ultimate survivors are stored in the body as memory cells, lasting for many years,[14] so that "the same man was never attacked twice."[15]

The immune system has been described as our sixth sense.[16] The innate immune system's representation of what is non-self,

[6] Ibid.; Jérôme Artus and Claire Chazaud, "A Close Look at the Mammalian Blastocyst: Epiblast and Primitive Endoderm Formation," *Cellular and Molecular Life Sciences* 71, no. 17 (2014): 3327–3338.

[7] Eva Posfai, Oliver. H. Tam, and Janet Rossant, "Mechanisms of Pluripotency in Vivo and in Vitro," *Current Topics in Developmental Biology* 107 (2014): 1–37.

[8] Nicolas A. Dumont, Yu Xin Wang, and Michael A. Rudnicki, "Intrinsic and Extrinsic Mechanisms Regulating Satellite Cell Function," *Development* 142, no. 9 (2015): 1572–1581; Phil Salmon, "Non-Linear Pattern Formation in Bone Growth and Architecture," *Frontiers in Endocrinology (Lausanne)* 5 (2014): 239.

[9] Brenda Ocampo, "Unconscious Manipulation of Free Choice by Novel Primes," *Consciousness and Cognition* 34 (2015): 4–9; Oliver H. Turnbull et al., "Emotion-Based Learning: Insights from the Iowa Gambling Task," *Frontiers in Psychology* 5 (2014): 162.

[10] Charles A. Janeway Jr., "Approaching the Asymptote? Evolution and Revolution in Immunology," *Cold Spring Harbor Symposia on Quantitative Biology* 54 (1989): 1–13; Christina J. Thomas and Kate Schroder, "Pattern Recognition Receptor Function in Neutrophils," *Trends in Immunology* 34, no. 7 (2013): 317–28.

[11] Melvin Cohn, "The Evolutionary Context for a Self-Nonself Discrimination," *Cellular and Molecular Life Sciences* 67, no. 17 (2010): 2851–2862.

[12] Valerie H. Odegard and David G. Schatz, "Targeting of Somatic Hypermutation," *Nature Reviews Immunology* 6, no. 8 (2006): 573–83.

[13] Andrea González-Muñoz et al., "Tailored Amino Acid Diversity for the Evolution of Antibody Affinity," *MAbs* 4, no. 6 (2012): 664–72.

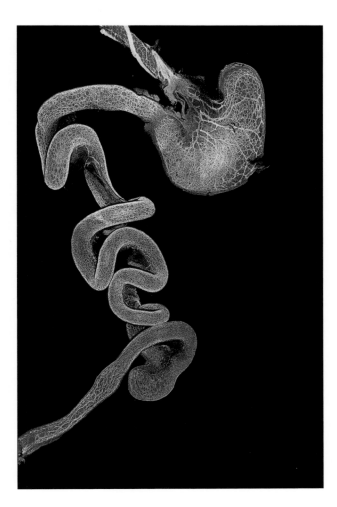

FIGURE 2
Maturing enteric nervous system (orange) reaches from the stomach at the top followed by the intestine in the middle to the colon at the bottom in a laboratory mouse. These neural crest cells are successfully colonizing the digestive system. Courtesy of Naomi Tjaden and Paul Trainor, Stowers Institute for Medical Research, Kansas City, MO.

14 Nan-ping Weng, Yasuto Araki, and Kalpana Subedi, "The Molecular Basis of the Memory T Cell Response: Differential Gene Expression and Its Epigenetic Regulation," *Nature Reviews Immunology* 12, no. 4 (2012): 306–15.

15 Stuart G. Tangye, "Staying Alive: Regulation of Plasma Cell Survival," *Trends in Immunology* 32, no. 12 (2011): 595–602.

16 J. Edwin Blalock, "The Immune System as the Sixth Sense," *Journal of Internal Medicine* 257, no. 2 (2005): 126–38.

17 Leandro N. De Castro and J. Timmis, eds., *Artificial Immune Systems: A New Computational Intelligence Approach* (London and New York: Springer, 2002), xviii, 357.

18 Xiang Zhao et al., "AITSO: A Tool for Spatial Optimization Based on Artificial Immune Systems," *Computational Intelligence and Neuroscience* 2015 (2015): 549832.

learned over millions of years, could be seen as a form of transgenerational memory about selfhood. While the memory of the adaptive immune system exploits the creation of vast genetic variability pressured by selection to learn and recognize antigens over the relatively short timecourse of one person's lifetime. Because of these systems' ability to learn and remember it is tempting to draw analogies between the Central Nervous System (CNS) and the immune system as "cognitive systems formed by large networks of interconnected elements presenting several degrees of world perception."[17] Indeed, a branch of Artificial Intelligence, "artificial immune systems," has developed to solve real world problems like spatial optimization and computer virus detection.[18] However, we should remember that "no historical account or philosophical perspective or analysis by analogy with the nervous system can change the immune system's definition of self. The selection pressure defining self is that an attack on the self is debilitating and what must not be attacked is somatically

learned."[19] It is also fallible. Mistaken identity acts against us in the form of the immune system and autoimmune disease. The accident of history that has led science to concentrate the study of cognition in neuronal networks rather than other systems is revealed by the fact that when we observe intelligence elsewhere, we still make analogies with the brain, where in fact, numerous examples of bodily intelligence exist in their own distributed functionality.

The immune system and nervous system are intimately linked. Immune cells called microglia reside in the CNS, and T immune cells from the periphery circulate in the cerebral spinal fluid (CSF).[20] Neurons innervate immune organs and relevant areas such as bone marrow, skin, lungs and gut. Both systems are described as "speaking the same language chemically" because neurons can communicate with cytokines and chemokines (small signaling proteins released by immune cells), and immune cells are able to synthesize neurotransmitters and express their respective receptors.[21] Stimulation or ablation of specific neurons can enhance or inhibit immune responses; reciprocally, immune responses can alter neuronal generation, degeneration, activity, and plasticity.[22]

Neuro-immune communication must serve us in many ways, largely without our noticing. As is often the case, it is only when things go wrong that we begin to appreciate and attend to what is always there when systems are functioning correctly. Currently, the neuro-immune discourse hangs on a framework constructed from the intersection of research into inflammation, stress, mood, and cognition. The main struts are cytokines (signaling proteins secreted by cells), the hypothalamic pituitary axis (HPA), and CNS, respectively.[23] Cytokines become elevated during inflammation and act on the CNS via afferent nerves and/or humorally (via circulatory systems) to affect synaptic transmission, neuronal growth, and degradation; they also affect neuronal activity within the HPA.[24] Depressed patients show increased levels of chemokines (a type of cytokine) and correspondingly, depression can be induced or reduced by increasing or decreasing cytokines.[25] Paradoxically, although stress (typically indicated by the presence of the glucocorticoid cortisol) is thought to suppress immune responses, depression caused by chronic stress may in fact be mediated by them. Increased levels of immune-cell subtypes are found in Alzheimer patients, and levels of certain cytokines affect the cellular mechanisms thought to underpin learning and memory.[26] The immune system can also activate and sensitize nociceptors (pain receptors) and vice versa. Bidirectional communication between the immune and nervous systems is clearly evident. What is more fundamental and subtle to consider is how these interactions may inform us constantly, nonconsciously, and homeostatically—before pathology makes them blatantly apparent.

The signals that determine the development from one cell to an entire organism also reveal the intimate interaction between neuronal and immune systems. During embryogenesis, neural crest

[19] Cohn, "The Evolutionary Context for a Self-Nonself Discrimination."

[20] Manuel B. Graeber, "Changing Face of Microglia," *Science* 330, no. 6005 (2010): 783–88; Florent Ginhoux et al., "Fate Mapping Analysis Reveals that Adult Microglia Derive from Primitive Macrophages," *Science* 330, no. 6005 (2010): 841–45; Catherine Toben and Bernhard T. Baune, "An Act of Balance between Adaptive and Maladaptive Immunity in Depression: A Role for T Lymphocytes," *Journal of Neuroimmune Pharmacology* (2015).

[21] Mark Horowitz and Patricia A. Zunszain, "Neuroimmune and Neuroendocrine Abnormalities in Depression: Two Sides of the Same Coin," *Annals of the New York Academy of Science 1351* (2015): 68–79; Aletta D. Kraneveld et al., "The Neuro-Immune Axis: Prospect for Novel Treatments for Mental Disorders," *Basic and Clinical Pharmacology and Toxicology* 114, no. 1 (2013/2014): 128–36.

[22] Ruth M. Barrientos et al., "Neuroinflammation in the Normal Aging Hippocampus," *Neuroscience* 309 (November 2015): 84–99; Francesca Calabrese et al., "Brain-Derived Neurotrophic Factor: A Bridge between Inflammation and Neuroplasticity," *Frontiers in Cellular Neuroscience* 8 (2014): 430; Yong-Ku Kim et al., "The Role of Pro-Inflammatory Cytokines in Neuroinflammation, Neurogenesis and the Neuroendocrine System in Major Depression," *Progress in Neuro-Psychopharmacology and Biological Psychiatry* 64 (2015): 277–84; Gianvito Martino et al., "Brain Regeneration in Physiology and Pathology: The Immune Signature Driving Therapeutic Plasticity of Neural Stem Cells," *Physiological Reviews* 91, no. 4 (2011): 1281–1304.

[23] Barrientos et. al, "Neuroinflammation"; Premysl Bercik and Stephen M. Collins, "The Effects of Inflammation, Infection and Antibiotics on the Microbiota-Gut-Brain Axis," *Advances in Experimental Medicine and Biology* 817 (2014): 279–89.

[24] Michela Deleidi, Madeline Jäggle, and Graziella Rubino, "Immune Aging, Dysmetabolism, and Inflammation in Neurological Diseases," *Frontiers in Neuroscience* 9 (2015): 172.

cells not only give rise to the CNS but also the autonomic nervous system (ANS), which includes the enteric nervous system (ENS), the large network of neurons that controls the gastrointestinal system.[27] Prenatally, ENS development is determined chemically by the sensing of intrinsic neural-crest cell factors, as well as chemical cues coming from the developing gut. These cues guide the sequential rostral to caudal migration of enteric neural crest cells as the embryo forms. However, from the moment we swallow the amniotic fluid, it is the foreign (non-self) contents of our digestive tract that further guide development of both the CNS and ENS, by priming our immune system and producing the necessary chemical cues.[28] It is only by experiencing the outside, on the inside, that we can acquire the knowledge to become ourselves.

Like the immune system, the brain is inextricably linked to our digestive function, itself mediated by neuronal, endocrine, and humoral connections.[29] Afferent signals from the gut are transmitted via enteric, spinal, and vagal pathways of the autonomic nervous system to the CNS, and efferent signals in the opposite direction from the CNS to the intestinal wall. (FIG. 2) The ENS contains at least as many neurons as the spinal cord and the same diversity of neurotransmitters as the CNS.[30] The bidirectional interaction between them, known as the gut-brain axis (GBA), has also recently become a focus of research with regard to certain pathologies that encompass neuro-gut-immune interactions, the HPA axis, and more recently the microbiota (those non-selves, which we once were, which we needed to consume to tell us how to be).[31] The human gastrointestinal tract is inhabited by 10^{13} to 10^{14} microorganisms from 500 to 1,000 species. The metabolism of these microbes complement the host metabolism and alterations in microbiota have been linked to changes in mood, analgesia, and even autism, all of which are effects thought to be mediated mainly by the immune system.[32] From our conception, every moment is a delicate (and possibly violent) exchange of information with the other, a necessary environment that forms and informs the self.

If the immune system is an internal interface that defines the self, how does our external experience define us? We have an internal representation of the body (i.e., body schema); this is not fixed and is continuously updated based on experience. Likewise, our internal models of the world perpetually morph in order to make sense of the sensory input we receive. Both body schema and world model are thought to be constructed using a predictive coding model where the discrepancy between observed and predicted sensory input (called a prediction error) is used to recalibrate the self.[33] In this model, cortical areas of the brain are no longer thought to merely react to stimulation, but are instead in *active anticipation* of it. Information detected by our exteroceptive sense organs (visual, auditory, tactile, olfactory, and gustatory) is compared to and integrated with interior error predictions generated by internal senses

[25] Kim et al., "The Role of Pro-Inflammatory Cytokines"; Gerald D. Griffin, Dominique Charron, and Rheem Al-Daccak, "Post-Traumatic Stress Disorder: Revisiting Adrenergics, Glucocorticoids, Immune System Effects and Homeostasis," *Clinical and Translational Immunology* 3, no. 11 (2014): e27.

[26] Leslie C. Freeman and Jenny P.-Y. Ting, "The Pathogenic Role of the Inflammasome in Neurodegenerative Diseases," *Journal of Neurochemistry* 136, S1 (January 2016): 29–38.

[27] Marina Avetisyan, Ellen Merrick Schill, and Robert O. Heuckeroth, "Building a Second Brain in the Bowel," *The Journal of Clinical Investigation* 125, no. 3 (2015): 899–907.

[28] Avetisyan, Schill, and Heuckeroth, "Building a Second Brain"; Toshihiro Uesaka, Mayumi Nagashimada, and Hideki Enomoto, "Neuronal Differentiation in Schwann Cell Lineage Underlies Postnatal Neurogenesis in the Enteric Nervous System," *The Journal of Neuroscience* 35, no. 27 (2015): 9879–9888.

[29] Emeran A. Mayer, Kirsten Tillisch, and Arpana Gupta, "Gut/Brain Axis and the Microbiota," *The Journal of Clinical Investigation* 125, no. 3 (2015): 926–38.

[30] Arianna Psichas, Frank Reimann, and Fiona M. Gribble, "Gut Chemosensing Mechanisms," *The Journal of Clinical Investigation* 125, no. 3 (2015): 908–17.

[31] Bercik and Collins, "Effects of Inflammation," 279–89; Mayer, Tillisch, and Gupta, "Gut/Brain Axis," 926–38; Yuliya E. Borre et al., "The Impact of Microbiota on Brain and Behavior: Mechanisms and Therapeutic Potential," in *Microbial Endrocrinology: The Microbiota-Gut-Brain Axis in Health and Disease*, Advances in Experimental Medicine and Biology, vol. 817, ed. Mark Lyte and John F. Cryan (New York: Springer, 2014), 373–403.

[32] Bercik and Collins, "Effects of Inflammation," 279–89; Mayer, Tillisch, and Gupta, "Gut/Brain Axis," 926–38; Borre et al., "Impact of Microbiota," 373–403.

such as interoceptive, proprioceptive, and vestibular input. "Our own bodily position, attitude, condition is one of the things of which some awareness, however inattentive, invariably accompanies the knowledge of whatever else we know."[34] Again, it is in the act of comparing, the relationship between different sensations, both exterior and interior, that multiple, coexisting representations and variations of the self are formed.

Interoception, the sensing of internal states, is seen as information carried by the afferent fibers coming from and innervating all areas of the body, regarding metabolism, immune function, heart rate, digestion, and other functions that are then re-represented in the anterior insular cortex of the brain. For example, internal perception of heart rate is correlated with insular activity in the brain, as is an increase in cytokines as a result of peripheral inflammation.[35] Proprioception senses how our body is positioned in space whether at rest or during movement, and is mediated by muscle spindles, Golgi tendons, and stretch-sensitive receptors in the skin. These parts of us combine with efference copies generated by the musculoskeletal system that allow the brain to track itself during initiated movements, again by comparing those movements to visual and proprioceptive input or predicted states. The vestibular system encodes information about head position in relation to space and gravity, via the vestibular organs in the inner ear. Associated with whole body balance, this system is also important for gaze stabilization, another phenomenon we take for granted.[36] All these multisensory signals are integrated with those from the external world to form a coherent representation of self. "Not only has your past viscerosensory experience reached forward to create your present experience, but how your body feels now will again project forward to influence what you will feel in the future. It is an elegantly orchestrated self-fulfilling prophecy, embodied within the architecture of the nervous system."[37] Here, the authors are describing proprioception, but the same could be said for all the sensory systems and experiences described above.

Body-world schema is critical for homeostasis (as in the single cell) and makes coordinated movement possible. We would not survive very long if low blood sugar levels did not motivate us to find food. What is less obvious is that our sensory-motor interactions with the world, and various perceptions of internal states, are also integral to the experience of emotion, social cognition, a sense of embodied self, and even memory.[38] The James–Lange theory of emotion was the first to propose that it is the afferent feedback from muscles and viscera that provide the brain with a sensory image, or "feeling."[39] Current theories such as the "somatic marker hypothesis" state that the re-representation of interoceptive information in the insula cortex serves as a limbic sensory substrate for subjective feelings.[40] Impaired interoception has been linked to depression, anxiety, and addiction.[41] Manipulating facial feedback can affect

[33] Hiroaki Ishida, Keisuke Suzuki, and Laura Clara Grandi, "Predictive Coding Accounts of Shared Representations in Parieto-Insular Networks," *Neuropsychologia* 70 (2015): 442–54; Lisa Feldman Barrett and W. Kyle Simmons, "Interoceptive Predictions in the Brain," *Nature Reviews Neuroscience* 16, no. 7 (2015): 419–29.

[34] William James, *The Principles of Psychology* (New York: Henry Holt, 1890).

[35] Hideki Ohira "Functions of the Insula and Sense of Self," *Brain Nerve* 66, no. 4 (2014): 417–27; Martin P. Paulus and Murry B. Stein, "Interoception in Anxiety and Depression," *Brain Structure & Function* 214, no. 5–6 (2010): 451–63; Diane Sliz and Shawn Hayley, "Major Depressive Disorder and Alterations in Insular Cortical Activity: A Review of Current Functional Magnetic Imaging Research," *Frontiers in Human Neuroscience* 6 (2012): 323.

[36] Katinka van der Kooij et al., "Visuomotor Adaptation: How Forgetting Keeps Us Conservative," *PLOS One* 10, no. 2 (2015): e0117901.

[37] Barrett and Simmons, "Interoceptive Predictions," 419–29.

[38] Paulus and Stein, "Interoception in Anxiety," 451–63; Peter Brugger and Bigna Lenggenhager, "The Bodily Self and Its Disorders: Neurological, Psychological and Social Aspects," *Current Opinion in Neurology* 27, no. 6 (2014): 644–52.

[39] William James, "The Physical Basis of Emotion," *Psychological Review* 1 (1894), 516–29; Carl Georg Lange, "Om sindsbevaegelser et psyko-fysiologisk studie" (Copenhagen: Jacob Lunds, 1885), reprinted in *The Emotions*, ed. Carl Georg Lange and William James, trans. Istar A. Haupt (Baltimore, MD: Williams & Wilkins, 1922).

[40] Antonio R. Damasio, "The Somatic Marker Hypothesis and the Possible Functions of the Prefrontal Cortex," *Philosophical Transactions of the Royal Society of London Series B, Biological Sciences* 351, no. 1346 (1996): 1413–1420.

[41] Brugger and Lenggenhager, "The Bodily Self," 644–52.

emotional evaluation, heart rate, and skin conductance; it can also speed recovery from stress. Conversely, Botox injections that restrict facial movements reduce the experience of fear in response to fearful stimuli.[42] Experiencing emotion, and recognizing emotion in others, requires that you enact the emotion.[43] Emotionally salient stimuli such as angry or smiling faces, or faces of loved ones, are processed and remembered despite not being consciously perceived, informing our decisions and behavior nonconsciously.[44] Similarly, our emotional states and bodily positions affect the way we attend to the world and recall memories.[45] How we feel affects the way we interpret internal and external signals, and our interpretations affect the way we feel. Subjective experience is far more complex than stimulus and response, and it is not unidirectional but emerges from a complex relationship between stimuli and state.

To move one's own body and to feel it behave in a certain way are important aspects of determining agency (the sense that one's voluntary actions produce external sensory events).[46] Self-touch allows somatosensory input from one part to build up perceptual information contributing to somato-representation of another body part.[47] Representation of body parts can be easily manipulated by altering afferent signals (e.g., the anaesthetized body part usually feels bigger) and can generate feelings of body ownership over external objects, as in the "rubber hand illusion," affecting the autonomic control of a limb that has been put out of sight and temporarily disowned in favor of a visible but manifestly synthetic substitute.[48] This finding highlights the influence that external, top-down perception can have on internal states. Looking at a painful body part reduces the intensity of acute pain; correspondingly, the misidentification and confabulation of body parts (somatoparaphrenia) can occur due to cortical lesions.[49] Voluntary actions produce stronger motor signals and sense of agency than involuntary actions, as do actions that have been repeated. A recent publication shows that one's sense of agency can also be manipulated artificially, and is enhanced in goal-directed behavior when performance is improved with a computer. The authors write: "The present study offers inspiration, that if automation technology could improve task performance (without the operator's awareness), it would probably enhance the sense of agency."[50] Note the irony in their finding. Could it not be that our sensory system, evolving over millions of years, *is* such a "technology" that internally generates the self's sense of agency?

Sensing, learning, and memory are inherent to life; vital properties occur at all levels of an organism's existence. Every aspect of ourselves that we have been or will be, from the single cell to the integrated organism, from five seconds ago to now, exists by detecting and comparing self to non-self, predicted to observed, interior to exterior. This ongoing flux of negotiations generates the fluid, often-fallible self of sense. We cannot attend to everything

[42] Mathieu Arminjon et al., "Embodied Memory: Unconscious Smiling Modulates Emotional Evaluation of Episodic Memories," *Frontiers in Psychology* 6 (2015): 650; M. Justin Kim et al., "Botulinum Toxin-Induced Facial Muscle Paralysis Affects Amygdala Responses to the Perception of Emotional Expressions: Preliminary Findings from an A-B-A Design," *Biology of Mood and Anxiety Disorders* 4 (2014): 11.

[43] Ulf Dimberg, "Facial Reactions to Facial Expressions," *Psychophysiology* 19, no. 6 (1982): 643–47; Ulf Dimberg, Monika Thunberg, and Kurt Elmehed, "Unconscious Facial Reactions to Emotional Facial Expressions," *Psychological Science* 11, no. 1 (2000): 86–89.

[44] Turnbull et al., "Emotion-Based Learning," 162; Marco Tamietto et al., "Unseen Facial and Bodily Expressions Trigger Fast Emotional Reactions," *Proceedings of the National Academy of Sciences of the United States of America* 106, no. 42 (2009): 17661–17666.

[45] Arminjon et al., "Embodied Memory," 650.

[46] James W. Moore, Daniel M. Wegner, and Patrick Haggard, "Modulating the Sense of Agency with External Cues," *Consciousness and Cognition* 18, no. 4 (2009): 1056–1064.

[47] Haike E. van Stralen, Marc van Zandvoort, and H. C. Dijkerman, "The Role of Self-Touch in Somatosensory and Body Representation Disorders After Stroke," *Philosophical Transactions of the Royal Society of London Series B, Biological Sciences* 366, no. 1581 (2011): 3142–3152.

[48] Marta Siedlecka et al., "Rubber Hand Illusion Reduces Discomfort Caused by Cold Stimulus," *PLOS One* 9, no. 10 (2014): e109909.

[49] Martin Diers et al., "Site-Specific Visual Feedback Reduces Pain Perception," *Pain* 154, no. 6 (2013): 890–96.

[50] Hannah Limerick, David Coyle, and James W. Moore, "The Experience of Agency in Human-Computer Interactions: A Review," *Frontiers in Human Neuroscience* 8 (2014): 643.

we perceive. Many processes occurring simultaneously in differentiated but communicating systems nonconsciously inform our decision-making and our behavior such that our internal states affect the way we interpret the world and vice versa. Maps of our body and of the world are how we navigate; they are formed dynamically in the relationships between the microbial world and the immune system, the immune system and the nervous system, extero- and interoception. It is through this complex, simultaneous body-world mapping that we exist. Self and sense are not limited to the neurons, and extend well beyond the brain.

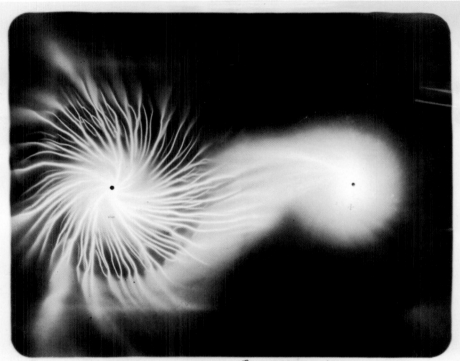

Turn over for data

FIG. 1

LIGHTNING

Douglas Kahn

> The preface could be called "the lightning rod."
> —Georg Christoph Lichtenberg

Georg Christoph Lichtenberg etched his name onto lightning once he froze it. In the spring of 1877, the physics professor crafted an *electrophorus*, a device for studying electricity that included a large disk of resin. Shaving and sanding a smooth surface onto the disk created dust that settled into every nook and cranny of the room. Even after Lichtenberg cleaned up, drafts of wind would stir up the remaining dust, which left a fine layer upon his experimental equipment.

After an electrical discharge, the scientist noticed that the laboratory dust bore distinctive patterns:

> Much to my great joy, [the dust] gathered to form little stars, dim and pale at first, but as the dust was more abundantly and energetically scattered, there were very beautiful and definite figures, not unlike an engraved design. Sometimes there appeared almost innumerable stars, milky ways and great suns. There were arcs, unclear on their concave side, but radiant on their convex side. Very glittering little twigs were formed, similar to those which frozen moisture produces on glass windowpanes.[1]

Although stars, galaxies, and radiating arcs were invoked, it was the glittering twigs on a frosted window pane (the antithesis of power and heat) that seemed to mimic branches of lightning in miniature. These dendritic patterns, which became widely known as *Lichtenberg figures* (FIG. 1), were not merely an exercise in analogy; Lichtenberg claimed that it was "lightning itself which is being observed."[2] In the present day, medical doctors examining victims of lightning, or pathologists performing autopsies on those killed in lightning strikes, commonly refer to Lichtenberg figures—not in resin but branching through capillaries in the skin. Others know these deadly tattoos as *lightning flowers*.

Lichtenberg was amazed by his fellow physicists' ability to observe a "path of lightning that has flashed from the top of the chimney into the kitchen and which lasted scarcely a single moment" and then "fill up notebooks for which to read through

FIGURE 1
Lichtenberg figures in photographic film. Positive and negative figures together, "Sparking Process studied with Lichtenberg Figures," cover of *Science Newsletter* (April 22, 1933).

[1] Georg Christoph Lichtenberg, *De nova methodo naturam ac motum fluidi electrici investigandi* (*Concerning a New Method of Investigating the Motion and the Nature of the Electrical Fluid*) (Göttingen, 1778–79). Translated from the Latin by Joseph Blain. English title as cited in *The Monthly Review* 67 (July 1782): 483.

[2] Ibid.

scarcely an hour is sufficient."[3] His own achievement, therefore, was to open a library on lightning. Yet whatever may be read into lightning, only so much can be experienced. Lightning "flowers" faster than we can think or feel; it is swift judgment and striking thought incarnate in light, sudden death, and the birth of knowledge within which experience is suspended. What one experiences with actual lightning must exist in this rich, indeterminate mix of genesis and negation and not, of course, as it concentrates its formidable energies upon one's vital signs. So it is best to experience lightning where one can, at a critical distance, looking back at its inscriptive moment, where it can be read like figures frozen on a page.

People who see Lichtenberg as a scientist may not know him as the likes of Friedrich Nietzsche and Walter Benjamin knew him, as a formidable satirist, polemicist, and aphorist. André Breton included Lichtenberg in his *Anthology of Black Humor*, and, in fact, used Lichtenberg's epigram "The preface could be called 'the lightning rod,'" as an epigraph to the *Anthology's* preface, "Lightning Rod."[4] This lightning rod on the lightning rod led to a third Lichtenberg lightning image in the section of the *Anthology* devoted to him: "Gallows with lightning rod."[5] Gallows humor as a precursor for black humor was particularly meaningful for Breton, since the book, published in 1940, had a punch line delivered by the German blitzkrieg (lightning-war). Comic timing is a matter of execution.

The novelist Raymond Roussel was also included in the *Anthology*, but not for his most famous work. That elaborate vision—*Impressions of Africa*—includes a gallows with lightning rod. (FIG. 2) Midway through the book thunder is heard and everyone knows Djizmé "is about to die." She will be the next in line in Emperor Talu's processional of strange rites, punishments, and executions.[6] Heralded by thunder, the lightning flicker soon frames the movement of a contraption being placed in the path of the storm: a chaise on four wooden legs, with a head combining an iron skull cap connected to a lightning rod, and two metal shoes at the other end grounded to the earth by a wire. Cryptic images cover the scene, an elaborate subtext to the salient purpose of this cruel furniture. Djizmé, released from her immediate imprisonment, obediently secures herself for the inevitable as "the lightning was becoming frequent enough to give the illusion of artificial daylight."[7]

The image of a *lightning-filled night* could not be more central to André Breton's 1924 *Manifesto of Surrealism*. He solicits this dramatic environmental event to describe how dreaming and the unconscious are wellsprings for a poetics structured by electricity. Following the writing of poet Pierre Reverdy, Breton argued that poetic images are not generated by comparisons, but "from a juxtaposition of two more or less distant realities. The more the relationship between the two juxtaposed realities is distant and true, the stronger the image will be—the greater its emotional power and poetic reality."[8] Think of the distance as a gap, and the relationship

[3] Ibid.

[4] Andre Breton, *Anthology of Black Humor* (1940) trans. Mark Polizzotti (San Francisco: City Lights Books, 1997), xiii.

[5] Georg Christoph Lichtenberg, from *Aphorisms*, collected in ibid., 37.

[6] Raymond Roussel, *Impressions of Africa*, trans. Lindy Foord and Rayner Heppenstall (London: Calder & Boyars, 1966), 77–78.

[7] Ibid.

[8] André Breton, "Manifesto of Surrealism" (1924), in *Manifestoes of Surrealism*, trans. Richard Seaver and Helen R. Lane (Ann Arbor: University of Michigan Press, 1972), 21. Breton cites Pierre Reverdy, "L-Image," *Nord-Sud 13* (March 1918).

that forms across that distance as a spark. If the gap is small, there will be a steady stream of unremarkable sparks. Move further out and there will be fewer but larger sparks; too distant and no spark will ever occur. Breton celebrated the spot just before the distance of a spark gap becomes too great, where a self-illuminating poetics is most powerful:

> From the fortuitous juxtaposition of the two terms . . . a particular light has sprung, *the light of the image,* to which we are infinitely sensitive. The value of the image depends upon the beauty of the spark obtained; it is, consequently, a function of the difference of potential between the two conductors.[9]

Where day and night roll into one another, where waking and dreaming, consciousness and the unconscious trade places, Breton seeks a site capable of generating the poetic light from unlikely (distant) juxtapositions, whose sparks project a "dizzying race of images." He, too, like Lichtenberg, moves from sparks to lightning when he says, "This is the most beautiful night of all, the *lightning-filled night*: day, compared to it, is night."[10]

Breton imported experiences of an electrical storm into the head and froze its flashes onto the poetics of a page, whereas for Walter Benjamin lightning converted insight into knowledge in the mind: "In the fields with which we are concerned, knowledge comes only in lightning flashes. The text is the long roll of thunder that follows."[11] Benjamin's aphorism was an isolated fragment from the unfinished *Arcades Project* (1927–40); is it lightning or thunder, and where is the storm? Aphorisms by their nature leave limited room for text to roll out, so his preferred form (the aphorism) must be lightning—on the front end of the *Erlebnis/Erfahrung* divide.[12] But thunder need not be reduced to the mild sussurus of pages turning. James Joyce demonstrated in *Finnegans Wake* (1939) that the sound of thunder alone, ungrounded, could quake its own knowledge:

> Bothallchoractorschumminaroundgansumuminarumdrumstrumtruminahumptadumpwaultopoofoolooderamaunsturnup![13]

That one is the Seventh Thunderclap; there are nine more scattered throughout the book, each one a micro-maelstrom of internal phonemic overlays and co-articulations as each thunderclap interacts with its own exceedingly rich, churning contexts, fields that enable knowledge of an exegetical sort to roll on and on anon.

Benjamin's isolated aphorism lacks the embrace of immediate context. It is lightning without a storm, without a field to rumble over or clouds to inhabit—although given his fondness for modernist

[9] Ibid., 37. Emphasis in the original.

[10] Ibid., 38. Emphasis in the original. Breton: "I believe in the future resolution of these two states, dream and reality, which are seemingly so contradictory, into a kind of absolute reality, a *surreality,* if one may so speak." Ibid., 14.

[11] Walter Benjamin, *The Arcades Project*, ed. Rolf Tiedemann, trans. Howard Eiland and Kevin McLaughlin (Cambridge, MA: The Belknap Press of Harvard University Press, 1999), 456.

[12] On Benjamin and *Erlebnis/Erfahrung*, see Miriam Bratu Hansen, "Benjamin's Aura," *Critical Inquiry* 34, no. 2 (Winter 2008): 336–75; and chapter 8 of Martin Jay, *Songs of Experience: Modern American and European Variations on a Universal Theme* (Berkeley: University of California Press, 2005), 312–60.

[13] See chapter 10, "The Seventh Thunderclap: Radio," in Eric McLuhan, *The Role of Thunder in Finnegans Wake* (Toronto: University of Toronto Press, 1997), 152–71.

FIGURE 2
Poster for the theatrical production of Raymond Roussel's *Impressions d'Afrique*, Théâtre Antoine, Paris, May 1912. At the upper right, the caption reads: "DJIZMÉ voluntarily electrocuted by lightning." Courtesy of John Ashbery. See detail on facing page.

shock and illumination and flash-bulb-photography, it is not entirely a bolt from the blue.

Bolts from the blue are not entirely from the blue. One man who had stopped his bike to watch a rugby game in Vail, Colorado, was struck in the head by lightning from what seemed to be a clear sky, burning a hole in his helmet and causing serious long-term injury.[14] It was determined that a stray bolt from more than 16 kilometers away found him and him alone: a horror of individuated weather when there was no sign of weather. There was no thunder, and mountain ridges masked the culprit cloudbank—only the National Lightning Detection Network could later pinpoint its source. The bolt of extreme energy caught everyone at the game by surprise and, it is probably safe to say, the cyclist was the only one there who did not experience lightning. Even those who cared for him while he was in a coma could be said to have experienced an aspect of the lightning. The effects of the specific bolt were characterized by the patterns Lichtenberg had begun to intuit a century before: a strong start, with diminishing experiential potential over time, rolling far from the point of contact. The person for whom the lightning was most meaningful was one of the last to experience it, a tender shoot in the dendritic field, and we can only speculate about when that experience began. The moment would be sought in a theory of moments along the coma scale, where waking and dreaming regain their autonomy, where sense and semantics charge a sustained consciousness coming back into being, connecting the lightning-struck with the cause of his condition.

Our speculations about the experience of lightning are as unbounded as electrostatic energy itself. In 1838 three soldiers at Vic-sur-Aisne took shelter from a storm under a tree. "They all three remained standing in their original positions as though they had not been touched by the electric fluid: their clothes were intact! After the storm some passers-by noticed them, spoke to them without receiving an answer, and went up to touch them, when they fell pulverized into a heap of ashes."[15] Georges Bataille tested the limits of experience in figures and practices of excess and death, but electrostatic dissipation can abruptly preempt ecstatic dissolution of the self and cut to the quick. There simply is no graceful gradient of voltages between the synaptic firings that produce a good idea, poetic structure, or negotiated selfhood, on the one hand, and the earth and atmosphere reconciling their differences, on the other. The unknown soldiers become monuments, but not in stone—their monument commemorates not knowing experience, by crumbling to the touch—leaving ashes and anecdote like thunder in the wake of lightning's strike.

People have historically imported things into their heads to model the operations of the mind, as with telegraph networks in the 19th century or computers in the second half of the 20th. In 1924, the same year he wrote the *Manifesto of Surrealism*, André Breton performed

such induction. He wrote about importing a large-scale energetic phenomenon into his skull: "Wireless telegraphy, wireless telephony, wireless imagination, as it has been called. An easy induction to make, but also an appropriate one as I see it."[16] This marks the moment when the last of the spark-gap transmitters were being decommissioned. They had embodied Pierre Reverdy's poetic structure in the power of the signal to signify between distant poles—but the greater the emotional power, seemingly the noisier the interference with other communications systems. Spark-gap had to go. Vacuum tubes were the new wireless things; they sapped the strength of the sparking image, but there were still confected pictures of Tesla in his electrostatic lair and eventually Van de Graaff generators to fill the void, new figures following Lichtenberg's path. But of all the things that one may import into human spaces, lightning runs the greatest risk of literalization. It is one thing to lure lightning into a rhetoric of knowledge in "the fields with which we are concerned," another altogether in an open field. Importing lightning for emphasis should be accompanied by insulating one's head and body integument from becoming the most expedient pathway to the ground.

Georg Richmann, Saint Petersburg physicist and student of atmospheric electricity, stands as the historical monument to the scientific import of lightning. He stands there because he bent over one day in 1753 to inspect his detection apparatus, and lightning found him attractive. The lightning was imported into his forehead and exited his left foot, where it blew off his shoe. He died instantly, leaving no log of his experience—if he had time to have one. Joseph Priestley was moved to observe a number of years later, "But it is

[14] Michael Cherington et al., "A Bolt from the Blue: Lightning Strike to the Head," *Neurology* 48 (1997): 683–86.

[15] Camille Flammarion, *Thunder and Lightning* (London: Chatto and Windus, 1905), 97.

[16] André Breton, "Introduction to the Discourse on the Paucity of Reality" (1924), *October* 69, no. 102 (Summer 1994): 133–44.

FIGURE 3
Textbook case of "lightning flowers" on the skin of a lightning strike survivor, ca. 1950.

FIGURE 4 (FACING)
Walter Benjamin (right) with Jean Selz (left) and Guyet Selz (center) in Ibiza, 1932.

not given to every electrician to die in so glorious a manner."[17] One person was there—a skilled engraver who might have been able to provide detail about the event—but he missed what happened because the lightning concussed him into a daze. He did not hear or remember the loud accompanying crack, an acoustical havoc heard in other rooms of Richmann's building and in the surrounding neighborhood. Differing experiences of lightning greeted those who rushed upon the scene to assist, those who later investigated the site, and those who conducted the autopsy.

The wound on Richmann's forehead was the size of a ruble, whereas the burn on a seamstress's forehead in France was the size of a half-franc coin. Whatever the denomination, there is still a short distance to be reckoned with from the surface of the skin to where consciousness might be hovering to snap a glimpse of the experience. (FIG. 3) The physicist John Tyndall was not convinced that any such experience could be had. Death by lightning "would be simply the sudden negation of life."[18] Referring to Hermann von Helmholtz's work on the speed of signal transmission along the nerves, he first calculated that a pinprick on the tail of a 40-foot whale would take one and one-tenth (1.1) seconds to reach the whale's consciousness. Likewise, a rifle bullet required but one one-thousandth (0.001) of a second to pass through a person's brain, and thus no one talks about its initial pinprick. As Tyndall knew, lightning is much faster than a bullet, appearing and disappearing "in less than a hundred-thousandth (0.00001) of a second, and the velocity of electricity is such as would carry it in a single second over a distance almost equal to that which separates the earth and moon."[19] Yet Tyndall was the wrong type of physicist to fully understand lightning. If he had practiced the poetic physics that, as Georg Lichtenberg observed, "explains the northern lights as the phosphorescence of herrings," or the pataphysics of Roussel, he could have taken his calculations further, given that certain whales eat herring.[20] What fraction of a whale would it take to traverse the space between a coin on the forehead to wherever experience would be eradicated?

Like the sublime, an experience of actual lightning is enaction best conducted at a distance. Walter Benjamin's encounter with a lightning-filled night in Ibiza brought him closer to experience (as Erlebnis) but not the knowledge he found among internal flashes of insight (closer to Erfahrung). (FIG. 4) Different forms of illumination occur all over Benjamin's writings. "Linked to the flashes of memory, the suddenness of the perception of similarity, the irruption of events or images, and even the passage into night, Benjamin's vocabulary of lightning helps register what comes to pass in the opening and closing of vision. It tells us what brings sight to writing," as literary theorist Eduardo Cadava puts it.[21] Illumination will be different, however, depending upon what drug you are on. In Ibiza, it was opium. The experience would have been funnier and more illuminating on hashish.

FIG. 4

All things being equal, Benjamin distinguished between identity and his neologism for sameness (*identié* and *mêmité*) where the latter, "same-ity," denoted the possibility "that two different things were actually one and the same," a possibility he entertained more readily while on hashish, and more readily still in *thinking* about being on hashish.[22] Different things being the same gave Benjamin happiness through the propensity of our brain-on-cannabis to drift toward "a wonderful, beatific humor," rather than a black one.[23] Opium, instead, polarized the user between serenity and terror. In Ibiza the effects of opium were overtaking Benjamin and his friend Jean Selz as the thunderstorm hit. The window onto the night had been open "but closing the window would have required far more effort than we could muster, and we preferred to remain in the grip of terror—a state quite familiar to opium smokers."[24] Terror—of proximity to lightning's strike—was linked to a paralysis that prevented changing that distance. Similarly, the other pole of a serene laughter "would require an outlay of energy far too costly"—so distance could not be achieved.[25]

Uncontrollable, proximate lightning demanded respect, and courtesy. Benjamin thought that the lightning bolts had "'something to tell us,' and in fact were telling us, though we couldn't understand them, every time they *went white*. It was in their dazzling whiteness (had they been yellow before?) that they seemed to achieve their purpose."[26] Knowledge that might have been generated from a fusion of similarity was instead held in an abeyance of confusion. So Selz and Benjamin pulled away from actual lightning to dwell on the poetry of Paul Valéry (*Monsieur Teste*): "There are certain flashes that are exactly like ideas."[27] Benjamin was again in a comfort zone of "letting the mind participate in that measure of time in which similarities flash up fleetingly out of the stream of things only in order to become immediately engulfed again."[28]

17
Joseph Priestley, *The History and Present State of Electricity with Original Experiments* (London: J. Dodsley, J. Johnson and T. Cadell, 1767), 108.
18
John Tyndall, "Death by Lightning," *Fragments of Science: A Series of Detached Essays, Addresses and Reviews* (New York: A. L. Burt, 1890), 334.
19
Ibid.
20
Lichtenberg, *Aphorisms*, 36.
21
Eduardo Cadava, *Words of Light: Theses on the Photography of History* (Princeton, NJ: Princeton University Press, 1997), 22.
22
Jean Selz, "An Experiment by Walter Benjamin" (1959), in Walter Benjamin, *On Hashish* (Cambridge, MA: Harvard University Press, 2006), 148.
23
Ibid., 149.
24
Ibid., 153.
25
Ibid., 149.
26
Ibid., 154.
27
Paul Valéry, quoted in ibid.
28
Walter Benjamin, "Doctrine of the Similar" (1933), *New German Critique* 17 (Spring 1979): 65–69.

FIGURE 5
A. Shimko, "Alexander Popov demonstrating his invention at the Russian Physico-Chemistry Society in Saint Petersburg," 1895, lithograph. During the demonstration, Popov inserted a lightning rod into a radio set in place of an antenna to detect distant bursts of electromagnetic discharge in the atmosphere.

What is there to know in an experience of lightning, beyond the tropes configured in the head? Lightning strikes somewhere around the world about 200 times per second: over millennia, the spotlight has fallen upon innumerable characters in this nonlinear cinema. Some who have experienced lightning strike closely, but not so close as to be left with no experience, will speak of a lingering smell—ozone, or trioxygen. It derives its name from the Greek word *ozein,* to smell; some track it to the Hebrew for *breath of God*, which would mean that God's breath can be deadly. This is the reason He so rarely speaks to people directly, benevolently choosing instead a burning bush as a plasma speaker, leaving a wafted bouquet of smoldering brambles rather than the acrid perfume of a lightning flower.

Ozone is like thunder; it can follow or precede lightning, alerting those at a distance that a storm is approaching. The electrical chemistry unleashed by lightning transforms breathable O2 into the toxic O3, which is then blown out ahead of the weather front. People then feel "it is about to rain." *Feeling* is an atmospheric knowing located in the environment; people say it *feels* like it is going to rain, although the ground-hugging ozone produced by internal combustion engines blunts such sensitivity. Now, due to the ignition of fossil fuels, there is even less feeling for the weather that approaches, since electrical storms too have undergone accelerated anthropogenic modification. Lightning has increasing amounts of the human in every strike.

Even in the thickest smog you can still tune an AM radio between stations to hear the static bursts of electrical storms coming and going over vast distances. An improvement on many of the programs on offer, static transforms a means of communication into a means of commune. Since their inception, telecommunications technologies have functioned simultaneously as instruments of science, aesthetics, and communications. Long lines and coils of metal wire—telegraph, telephone, submarine cables—acted as unwitting antennas. Once Alexander Graham Bell and Thomas A. Watson attached a

telephone to their long lines of wire in 1876, lightning and other naturally occurring phenomena in the energetic environment could be heard—a looping between electromagnetism and acoustics I have called the *Aelectrosonic*.[29] By 1886 antennas were being consciously deployed, but substitute receivers could still be revelatory. In 1895 Alexander Popov (FIG. 5) used a lightning rod where an antenna might be and was able to track lightning, the ancestor of the National Lightning Detection Network that located the 16km stray bolt in Vail.[30]

Lightning static is merely a storm's local and regional radio transmission; there is also an international broadcast. Electromagnetic bursts from lightning ricochet in that precious layer between the ionosphere and the earth, traveling hundreds and hundreds of kilometers to be teased out into the little sliding tones of composer Alvin Lucier's *Sferics* (1981). Under proper conditions, the ricochets get caught up in magneto-ionic flux lines that loop up into the magnetosphere, tightly spiraling out into the vacuum of outer space for a while and then descending back down to earth longitudinally into the opposite hemisphere, where they are tonally stretched out farther still into glissandi called whistlers. With fairly simple radio gear tuned to long-wave signals or by clicking on live antenna feeds on the Internet one can experience in real time an electrical storm at earth magnitude, whistling and sliding like whales, instead of thunder's crack and rumble.

There must be a way to import the earth's electro-energetic, olfactory, and radiophonic environments (there are others) into the head, where they could join the audiovisuals already there. Smells, glissandi, and space-traveling whistles could then contribute to the poetic structure of images, knowledgeable aphorisms, and miniature emulations on the page, lab bench, or exhibition space. It would be a way to carry on a tradition that Michel Foucault attributed to André Breton:

> What we really owe to him alone is the discovery of a space that is not that of philosophy, nor of literature, nor of art, but that of experience. We are now in a time when experience—and the thought that is inseparable from it—are developing with an extraordinary richness, in both a unity and a dispersion that wipe out the boundaries and provinces that were once well established.[31]

Safety measures must be put securely in place to allow experience to bloom while, at the same time, normative pressures that might damage the eccentric impulses of lightning itself are surely to be avoided. Allow all its branches to grow, like the strike that sapped the sap from a 25-meter oak, leaving "the concentric layers . . . as detached from one another as the tubes of an opera-glass," or the one that wove the leaves of an oak into the needles of a pine, and vice versa, forming an "unusual spectacle of a pine-oak and an oak-pine."[32] Lightning must be permitted to discharge all its metaphorical duties.

[29] Douglas Kahn, *Earth Sound Earth Signal: Energies and Earth Magnitude in the Arts* (Berkeley: University of California Press, 2013).

[30] W. H. Eccles and H. Morris Airey, "Note on the Electrical Waves Occurring in Nature," *Proceedings of the Royal Society of London. Series A, Containing Papers of a Mathematical and Physical Character* 85, no. 576 (April 11, 1911): 145–50.

[31] Michel Foucault, from a 1966 interview anthologized in translation in Michel Foucault, *Aesthetics, Method, and Epistemology*, ed. James D. Faubion (New York: The New Press, 1998), 174.

[32] Flammarion, *Thunder and Lightning*, 175–77.

UNDERSTANDING

Alva Noë

According to an old and tired idea, the scope of experience is fixed by what projects to our eyes, or to the sensory periphery of our bodies. Experience, then, is something that happens inside us as a result of our being so affected by the world around us. I reject this way of thinking about experience and its scope. We see much more than projects to the eyes. We experience what is hidden or occluded (the tomato's back, for example); we experience the nature of things (what they are—telephones, say, or other people); we perceive emotion and meaning (the intensity of a person's concentration; what she is saying).

Of course, there are constraints on what shows up for us in experience, and these constraints have to do with our physical, embodied, spatial relations to things. But it is impossible even to begin to make sense of what shows up in terms of a one-way causal influence of the things around us on our nervous system, as I have argued in *Out of Our Heads* (2010).

Instead of thinking of what we experience as fixed by the way the world projects to us, giving rise to events of consciousness inside of us, we should think of what is experienced as what is *available* to a person, as what is available to a person *from a place*. The seeing does not happen in the head. Rather, the experience is achieved or enacted by the person. We do it *in the world*. The scope of experience is a matter of what is available to us. And what is available to us depends on not only what there is, but also, crucially, on what we can do. What we can do depends in turn on understanding, know-how, but also on tools and technology (pictures, language, the telephone, the pencil), and on where we find ourselves and what environmental or social resources are available to us. What is available is that to which we have access, and the ground of access is knowledge, understanding, and skill. Mere sensory projection is neither necessary nor sufficient. It is understanding that brings the world into focus for perceptual consciousness. One reason why art matters to us, I think, is that it provides opportunities for us to recapitulate this basic fact about ourselves: understanding and skill enable us to bring the world into focus for perceptual consciousness.

Consider what sometimes happens when you encounter an unfamiliar artwork. Every song on the new record (for example) may

Used by kind permission of the author, this text is excerpted from chapter 6, "On Over-Intellectualizing the Intellect," in Alva Noë, *Varieties of Presence* (Cambridge, MA: Harvard University Press, 2012), 114–29, in which the author notes his debt to Stanley Cavell, "On Aesthetic Problems of Modern Philosophy," in Cavell, *Must We Mean What We Say?*, updated edition (Cambridge: Cambridge University Press, 2002), 73–96.

sound more or less the same, each coming across flat, or unengaging. Every painting in the gallery presents its face to you, but only as a face in a crowd, with no discernable features. Sometimes we encounter the work, but it is as if we don't see it, or can't see it, or don't see any meaning in what we see.

But suppose you don't give up. You listen to the record again and again; you begin to notice different qualities in the different songs. As you familiarize yourself with them, they begin to engage your attention, and offer you comfort, or excitement, or stimulation, or pleasure. Perhaps you discuss the music, or the paintings in the gallery, with a friend, and she draws your attention to patterns or devices or lyrics. Whereas before the works—the songs, the paintings—were flat, opaque, undifferentiated, now they reveal themselves to you as structured and meaningful, as deep and involving. Each song, or each painting, now shows you its very own distinctive face. You make its acquaintance.

If you have spent time around art, you have probably had this experience. To a child all "classical music" sounds the same, just as every white-haired figure presented in 18th-century garb "looks like" George Washington. We don't differentiate well among the unfamiliar; this partly explains why the rural Nigerian border guards thought my girlfriend and I looked so much alike that we must be brother and sister. Or consider the case of literacy: to an illiterate person, the text might as well be invisible. The consciousness of the person who can read, in contrast, is captured by the text and by all that it affords.

We gain knowledge, and familiarity, and skill, and so we are able to bring the world into focus for perceptual consciousness.

At the outset I called attention to the way in which aesthetic experience—the experience of the work of art—is an achievement of the understanding. The bare perceptual exposure to the song, or to the painting there on the wall in the gallery, is not yet the aesthetic experience. Aesthetic experience is achieved by interrogating what is there before you. To bring the work into focus, we need to acquire the skills needed to do this. And this we do on the fly, in situ, with the resources the world (the artwork) provides. Through looking, handling, describing, conversing, noticing, comparing, keeping track, we achieve contact with the work/world. We achieve an appreciation of the way the piece hangs together—what the work is—through activities I will refer to collectively as aesthetic discourse, or better, criticism. We achieve the sort of understanding that consists in seeing connections, what [Ludwig] Wittgenstein characterized as a perspicuous overview of the whole.[1]

We learn our way around in a space of possibilities that the piece opens up.

Aesthetic criticism is thus a necessary accompaniment of the kind of perceptual achievement in which aesthetic experience consists. Criticism is the way we make the adjustments needed to

[1] Ludwig Wittgenstein, *Philosophical Investigations*, trans. G. E. M. Anscombe (Oxford: Blackwell, 1953), §122.

make sense of what is before us. Aesthetic experience happens against the background of criticism.[2] This was [Immanuel] Kant's conception. Aesthetic experience—for example, the sort of experience he characterized as that of the beautiful—has intersubjectively valid content. Our aesthetic experience of the work of art reflects our sense of what the work demands, not only of us, but of anyone. Our response thus reflects our sense of how one ought to respond to the work. Aesthetic experience happens only where there is the possibility of substantive disagreement, and so also the need for justification, explanation, and persuasion. The work of art is only experienced when it is experienced as making claims on us, claims we need to adjudicate.

Kant was also clear that despite the fact that aesthetic experience is a thoughtful recognition of what the work demands—we must regard the experience as a cognitive achievement—it is nevertheless the case that aesthetic response is always also and fundamentally a matter of feeling, of responsiveness, rather than a matter of judgment. We don't engage in explicit deliberative reasoning to decide whether something is beautiful. There is literally no possibility of such reasoning. We can't convince ourselves or others of the beauty of a work. Rules, algorithms, criteria, have no place here.

And yet—crucially—we can try. We have to try, if we are to take our own aesthetic responses (our own aesthetic *judgments*) seriously. What we need to see is that there is a deployment of our cognitive faculties that is at once rigorous, and rational, but that does not require that it eventuate in a QED. We aim at persuasion, at clarification, at motivation, and indeed justification. I can't prove to you that something is beautiful, but I can teach you to see its beauty, and I can fault you for being unable or unwilling to do so.

Whether or not this is exactly Kant's view, it seems that Kant, like Wittgenstein, offers a picture of the way the intellect enlivens aesthetic experience, which shows us how, to use John McDowell's Sellarsian phrasing, aesthetic experience is in the space of reason, even though, at one and the same time, there is no sense in which it is attached to explicit deliberative judgment. Crucially, as I would put it, the critical inquiry that the artwork occasions and requires is the very means by which we exercise the understanding that brings the work of art into focus and so allows us to feel it, to be sensitive to it.

The pleasure of aesthetic experience, in my approach, is the pleasure of "getting it." It is the pleasure of understanding, of seeing connections, of comfortably knowing one's way about. It is the pleasure that comes from recognizing the purposiveness (*Zweckmässigkeit*,[3] as Kant would have it), or integrity (as [John] Dewey put it), or meaning, of the work. This meaning or purposiveness was there all along, but hidden in plain sight.

And so there can be no charge here of over-intellectualizing. What we need to admit, finally, is that there is a nonjudgmental use

[2] This point is important. The existence of critical conversation about art is not a mere accidental byproduct of art practices themselves, but an essential constituent of those practices.

[3] Eds.: The term *Zweckmässigkeit*, often translated into English as purposiveness, means a general quality of having or evoking purpose, which can entail, but does not require, specification in a concrete or practical manner.

Eds.: The German term *Begriff* translates into English as concept or idea.

of concepts, a deployment of concepts in, as I put it earlier, a perceptual or experiential mode. We can say more about this here. Building on the idea that understanding is akin to an ability, I propose that we think of concepts as tools for picking up features of the world around us, or techniques for grasping things, features, aspects, qualities. To learn a concept is to learn to grasp something (it is to acquire a *Begriff*;[4] it is to learn to handle something, *etwas befgreifen*). What criticism affords is the cultivation of the understanding, the development and so the procurement of the conceptual tools that enable us to pick up what is there before us. Concepts are ways of achieving access to the world around us.

Art and philosophy are one; this is our surprising upshot. Philosophy aims at the kind of understanding that lets us find our way about and make contact with the world. Philosophy aims at the sort of understanding that an artwork occasions and that aesthetic criticism produces. Philosophical discussion and argument is a modality of aesthetic discourse; it is a species of criticism. Philosophical arguments, no less than aesthetic ones, never end with a QED, pretensions of philosophers to the contrary notwithstanding. This troubled Plato in the *Meno* and it has continued to puzzle philosophy all along. Philosophy—and again, the same is true of art—is always troubled by itself, always seeking better to understand its project. We can see our way clear of this by recognizing that the value of philosophical conversation, like aesthetic conversation about a work of art, consists not in arrival at a settled conclusion, but rather in the achievement of the sort of understanding that enables one to bring the world, or the artwork, or one's puzzles, into focus. This is the transformation we seek, in philosophy and in art.

We also see that the conception of aesthetic experience I am articulating here—incorporating as it does elements from Kant and Wittgenstein—is really a conception of perceptual experience *tout court*. All perceptual experience is a matter of bringing the world into focus by achieving the right kind of skillful access to it, the right kind of understanding. Art matters because art recapitulates this basic fact about perceptual consciousness. Art is human experience, in the small, and so it is, in a way, a model or guide to our basic situation. Art is philosophy. And all perceptual experience, viewed correctly, is a kind of aesthetic experience.

And so, the encounter with the world, like the encounter with a work of art, unfolds against the background of aesthetic conversation. Perception is not a matter of sensation; it is never a matter of mere feeling. Perceiving is an activity of securing access to the world by cultivating the right critical stance, that is, by cultivating the right understanding.

It is easy to lose track of the thoughtful and rhetorical structure of human experience. For example, it is sometimes noticed that contents of experience do not enter into logical relations with other contentful states. Perception does not entail belief, and belief does

not rule out countervailing perceptual experience. This is sometimes taken to show that experience and belief have different kinds of content, that the content of the former cannot be conceptual in the way that the latter is. Examples like the Müller-Lyer illusion have been adduced to demonstrate this.[5] The fact that the lines can look different in length even when I know they are the same is thought to show that the content of the perceptual experience cannot be logically structured in the way that the corresponding belief is structured.

But this is a gross mistake. Nothing requires us to say that concepts are brought into play in the one case, but not the other; all that we are compelled to say, rather, is that there are different ways for them to be brought into play. To suppose that the contents are truly incommensurable, rather than that they are in conflict, say, is not to offer an explanation of the phenomenon of conflict between what we see and what we know. It is to explain it away, or really, to deny the phenomenon itself.

The big mistake is the overlooking of the aesthetic, or critical, character and context of all experience. There is *no such thing* as how things look independently of this larger context of thought, feeling, and interest. What we know and what we see push and pull against each other, and they move each other and guide each other and tutor each other. This is plain and obvious when we think of the experience of art.

[5] For a thorough explanation of the Müller-Lyer illusion, see Gareth Evans, *Varieties of Reference* (New York: Oxford University Press, 1982), 123–25.

V.

EXPERIENCING

ON EXPERIENCE

Tino Sehgal with Arno Raffeiner

ARNO RAFFEINER: Mr. Sehgal, we are thrilled about this meeting. You almost never publicly speak about your art.

TINO SEHGAL: I do speak with journalists, but never in the form of an interview. But since I've known *Spex* for a long time and since it is not an art publication, I thought: Why not? In general, however, I think that if one already has the privilege of having a reception, it is better to let it evolve by itself. I don't believe that the artist's own intentions are necessarily the right interpretation of his or her work. And I've also observed with other artists that if one can utter reasonably sensible sentences that those thoughts quickly come to dominate the texts about one's work.

AR: And you don't want that?

TS: The interesting thing about art is that someone [an artist] puts something forward and people make something out of it. And not that someone says: that is my intention, and that intention is expressed in the work one-to-one. It is always of interest to me when someone really works with a format or a given ontology. Just like a few years ago the band Gorillaz, for example. One had the feeling that the notion of how a band would be conceived or even perform had been slightly shifted.

AR: The band invented high-profile characters for the public, while at the same time the actual members could be erased as real people behind those characters. In your art it can happen that your name is not even mentioned in its context: there is nothing signed. While in the Guidebook for *Documenta 13* your name could indeed be read in the table of contents, the corresponding pages were nevertheless missing from the book.[1] Are you interested in this disappearance behind the work of art?

TS: There are different things at play. The Documenta catalogue, for example, is a very specific case: people walk with this book in their hands through Kassel; it becomes an experiential part of the work, so to speak. I worked on *This Variation*, my work that could be seen there, for six years, therefore it really should speak for itself. I don't need half a page of text on top of that, which is both too long and too short. That is a relatively practical reason. Another reason is that the printed word and objecthood simply are not the realms in which I operate. I operate with situations, in four dimensions, if you will. And then I restrain myself from engaging with other realms. My work is out there, after all; it's not that one can't find it.

AR: In the specific case of *This Variation*, however, it could be found only through a backdoor. And at first one doesn't even see it: you stumble into a totally dark room, simultaneously thrown and drawn into these situations and you want to know, "what is actually going on here?"

TS: That you don't see anything is not a problem, from a musical perspective [laughs]. It is a dark room, in which people are beat-boxing and dancing. When you tune out one of the senses, namely the dominant sense of our time, *the visual*, it enables you to boost the sensitivity of the other senses.

This text is adapted from the interview "Erfahrung—das ist die Materie, aus der Leben besteht," published in *Spex: Magazin für Popkultur* 357 (November/December 2014): 94–99; translated from the original German for this volume by Rebecca Uchill and Anna-Maria Meister, in consultation with the authors.

1
Das Begleitbuch/The Guidebook: Katalog/Catalog 3/3 (Ostfildern: Hatje Cantz Verlag, 2012).

On the one hand, one could say that we are an *Erfahrungsgesellschaft* [Experience Society]—in the '90s it was called an *Erlebnisgesellschaft* [Experiencing Society]—a society that is oriented to experience and the economizing of experience.[2] On the other hand, we come from a bureaucratic or corporate culture, and that often blends in unpleasant ways. Corporate culture always seeks to give instructions for an experience, to take you by the hand. But I don't want to be taken by the hand in every situation. I am not a child. Yet especially in museum culture this practice is deeply ingrained.

AR: Could one also say that we live in a Recording Society? Everyone records everything all the time and hence is unable to consume it. Consumption essentially exists already in the knowledge that my smart phone has everything recorded in its memory storage.

TS: What you call a Recording Society might rather be a subtype of the Experience Society. Technological possibilities allow the focus on experience to materialize. We are an experience-oriented society, but we are not really trained to live experience *as* experience [*Erfahrung*]. We have a strong relationship to objects, to acquiring something through consumption. I have nothing against someone recording something with their mobile phone. I experience it more from the other side, when my works are photographed. In recent years I haven't interfered with people recording my work, because I understand it can act as a kind of third eye. But if I ask myself: With which third eye would I want to engage more, with my own actual one or with a mobile one? Then I would say: the actual one is probably the richer option. This act of recording—it often makes me feel sorry for people. It is a little bit like someone who gets poured a good wine and then dilutes it with apple juice. Why would you need the apple juice? Take it as it is . . .

AR: You mean that the recording changes the experience.

TS: Yes, of course. Michel Foucault spoke of the "technologies of the self." I would say it is also a technology to be really present in a situation. It is one of the hardest things of all.

AR: Are you fascinated by volatility, by transience?

TS: Those are not the terms in which I think. What exists first of all, also in the metaphysical sense, is experience [*Erfahrung*]. It is the material of which life consists; one must deal with it in both the private and artistic realm. Whether one calls that volatile or transient—I don't know. Ideas are after all often the most powerful and, as in Plato, the most durable matter. If you apply that to my work, you could say: in comparison to a classical work of visual art, my work is in some ways even more durable. You can go to a painting, you could give it a punch once, and that would be it. If you do the same to my work and you hit the guy in the face, the work still exists. Because it is really a system of rules, and in some way that is more durable. It is just a juvenile superstition of our time that there are things that are fixed. It was certainly a cultural achievement to tell oneself in a collective "autosuggestion:" there are things that are really substantial, that are absolutely permanent. But we know through quantum physics that permanence does not exist at all. Everything is procedural. Even the table at which we sit now is constantly changing. It just changes at a rate that is not really relevant to humans.

2
For comparison, see Gerhard Schulze, *Die Erlebnisgesellschaft: Kultursoziologie der Gegenwart* (Frankfurt: Campus, 1992).

FIG. 1

BODILY FRAMING

Vittorio Gallese

> What we call "aesthetic experience" (*ästhetisches Erleben*) always provides us with certain feelings of intensity we cannot find in the historically and culturally specific everyday worlds that we inhabit.
>
> — Hans Gumbrecht, *Production of Presence: What Meaning Cannot Convey*, 2003

The production and reception of images are unique to the human species. Why do humans produce images in the first place? What are the distinctive features of human-made images? What is the relationship between image-making and the use of images, their fruition and purpose? Is there any privileged perspective from which to address these issues? These and other related issues show the complexity of our relation to images; questions about the "problem of images" have accompanied human beings since we started asking ourselves what it means to be human.

Different approaches and answers have been proposed to address the problem of human-made images, primarily within the humanities.[1] More recently, the biological and cognitive sciences have begun to offer empirical investigations of art and aesthetics.[2] These approaches have mainly focused on the receptive aspects, by concentrating on how our brains process artistic images as distinct from other kinds of objects in the world.

Following the coinage of vision scientist Semir Zeki, much of the recent neuroscientific work on art and aesthetics has been referred to as *neuroaesthetics*.[3] Zeki's research contributed greatly to what we currently know about vision and the brain, establishing particular locations in the human brain that become active when processing specific visual stimuli.[4] Following Zeki, many other neuroscientists started addressing different problems related to aesthetics: some used art to better understand brain functioning by employing paintings or movie shots as mere stimuli to investigate the neurobiological bases of cognitive functions that are not art-specific. Others, among whom Zeki is still one of the leading figures, have employed brain-imaging techniques such as functional magnetic resonance imaging (fMRI), to study areas that become active when "aesthetic pleasure" or "the sublime and beauty" are experienced by the human subject of the experiment.[5]

FIGURE 1
Still from *L'intrus* (*The Intruder*), 2004, a film directed by Claire Denis. Based on a text by philosopher Jean-Luc Nancy, the film chronicles a man's black market heart transplant, implicating his estranged son Sidney (pictured). Denis's imagery explores both empathy and emotional distance.

Author's note: Some of the ideas discussed in this chapter have been published elsewhere in slightly different form. See Vittorio Gallese and Cinzia Di Dio, "Neuroesthetics: The Body in Esthetic Experience," in *The Encyclopedia of Human Behavior*, Vol. 2, ed. V. S. Ramachandran (Waltham MA: Elsevier Academic Press, 2012), 687–93; V. Gallese, "Aby Warburg and the Dialogue Among Aesthetics, Biology and Physiology," *Ph* 2 (July–December, 2012), 48–62; V. Gallese, "Bodily Selves in Relation: Embodied Simulation as Second-Person Perspective on Intersubjectivity," *Philosophical Transactions Royal Society Series B* 369, no. 1644 (April 28, 2014); V. Gallese, "The Empathic Body in Aesthetic Experience: Embodied Simulation and Experimental Aesthetics," in *Empathy: A Neurobiologically Based Capacity and Its Cultural and Conceptual History*, ed. S. Weigel and V. Lux (London and New York: Pallgrave McMillan, in press). I gratefully acknowledge the Chiesi Foundation, Italy, for their generous support of this work.

1
For more on these complex issues, see: David Freedberg, *The Power of Images: Studies in the History and Theory of Response* (Chicago: University of (cont. on page 238)

Chicago Press, 1991); Hans Belting, *Bild-Anthropologie: Entwürfe für eine Bildwissenschaft* (Munich: W. Fink, 2001), trans. Thomas Dunlap as *An Anthropology of Images: Picture, Medium, Body* (Princeton, NJ: Princeton University Press, 2011); H. Bredekamp, *Theorie des Bildakts* (Berlin: Suhrkamp Verlag, 2010).

2
The long history of science-based interrogations of visual perception is not discussed here; rather this essay attends primarily to the revival of such studies in the past two decades.

3
Semir Zeki, "Art and the Brain," *Journal of Consciousness Studies* 6, no. 6/7 (June/July 1999): 76–96.

4
Semir Zeki, *A Vision of the Brain* (London: Blackwell Scientific Publications, 1993).

5
Tomohiro Ishizu and Semir Zeki, "The Brain's Specialized Systems for Aesthetic and Perceptual Judgment," *European Journal of Neuroscience* 37, no. 9 (May 2013): 1413–1420; Tomohiro Ishizu and Semir Zeki, "Toward a Brain-Based Theory of Beauty," *PLoS One* 6, no. 7 (July 6, 2011). See also Ishizu and Zeki, "A Neurobiological Enquiry into the Origins of our Experience of the Sublime and Beautiful," *Frontiers in Human Neuroscience* 8 (2014): 891.

6
See L. E. Shiner, *The Invention of Art: A Cultural History* (Chicago: University of Chicago Press, 2001).

7
See David Freedberg and Vittorio Gallese, "Motion, Emotion and Empathy in Esthetic Experience," *Trends in Cognitive Sciences* 11, no. 5 (May 2007): 197–203.

8
Eds.: For an accessible summary of this neuroscience research see Anjan Chatterjee, *The Aesthetic Brain: How We Evolved to Desire Beauty and Enjoy Art* (Oxford: Oxford University Press, 2014).

The "neuroaesthetics" approach is committed to investigating the neural mechanisms underpinning humans' perceptual analysis of the formal visual features of artworks and the explicit aesthetic judgment they report.

This essay departs from neuroaesthetics to offer a different model of perception and reception. In the following sections, I will illustrate how recent discoveries of cognitive neuroscience have revolutionized ideas about perception, action, and cognition as well as the relationships among them, allowing a fresher look at the problem of images, with the explicit aim of collaborating more closely with the humanist approach. My purpose is not to reduce aesthetics to the mere working of neural cells, but rather to use what I call *experimental aesthetics* to widen and enrich our perspective on the human condition.

How should cognitive neuroscience go about investigating our relationship with art and aesthetics, and why? Framing this empirical approach as an experimental aesthetics is intentionally polemical. An experimental aesthetics addresses the problem of human-made images by extending the neuronal and brain-specific focus of neuro-aesthetics to investigate the brain-body physiological correlates of the aesthetic experience. Here, correlates are determined in conjunction with those particular outcomes of human creative expression that we call "artworks." I begin with the presumption that anything humans designate a work of art must by definition occupy the realm of the aesthetic. But importantly, the notion of aesthetics is used here according to its etymology from *aesthesis*—a bodily sensing. Although aesthetics exists as a category in cultural discourse, *aesthesis* starts from a multimodal notion of vision. Aesthetics can thus be empirically investigated by privileging the *sensorimotor and affective* features of our experience of perceptual objects.

Of course, these components of aesthetic experience are just one instantiation of the many levels at which images and artworks can be perceived and understood. Experimental aesthetics additionally aims to shed new light on the ways we receive images through *bodily framing*, by empirically investigating the embodied cognitive processes that connect image-making to image-reception.

An important caveat: neuroscience by itself is not sufficient to provide a full account of art and artistic images, as they are both strongly culturally and historically determined and situated.[6] My experimental aesthetic proposal is further distinguished by framing the problem of art and the so-called artistic image as, first, a particular case subsumed in the broader and more inclusive problem of images *qua* images.[7] In other words, a digital image on a computer screen will be experienced differently, and will be processed by different brain centers, if the experimental subject is told it is "from an art museum."[8]

Experimental aesthetics contributes a novel approach. By means of cognitive neuroscience (used as a sort of *cognitive archeology*),

one can empirically address the problem of human-made images by investigating the neurophysiological brain mechanisms that make our interactions with the world possible. The approach begins by searching for possible functional antecedents of our cognitive skills and by measuring the sociocultural influence exerted by human cultural evolution onto those very same cognitive skills. In this speculative vein—constrained by existing affordances and current findings on how they came to be part of human equipment—we can analyze some of the concepts we normally use when referring to intersubjectivity, aesthetics, and art, as well as to the experience we make of them. Ideally, we will be able to revise these concepts with a new sub-personal level of description.

The experimental aesthetics approach requires a new model of perception and cognition I call *embodied simulation*.[9] This model reveals the constitutive relationship between body and creative expression, by suggesting that the human experience of images, broadly speaking, should first be understood as a form of active bodily relational experience. As the novelist Siri Hustvedt wrote: "Visual art exists only to be seen. It is the silent encounter between the viewer, 'I,' and the object, 'it.' That 'it,' however, is the material trace of another human consciousness. . . . The painting carries within it the residue of an 'I' or a 'you.' In art, the meeting between viewer and thing implies intersubjectivity. . . . The intersubjectivity inherent in looking at art means that it is a personal, not impersonal act."[10] We live in relation to other people, objects, and landscapes that are present in our real world, but we live as well in relation to people, objects, and landscapes that are part of the imagined worlds produced by the arts. Both kinds of relationships are rooted in our brain-body system. If we aim to grasp the basis of the complex multi-modality these relationships imply, we will have to get back to the brain in its own body.

The first important contribution of experimental aesthetics to the problem of images is to construct, from cognitive neuroscience, a novel notion of visual perception. Importantly, this complicates vision as more than a relay of cerebral visual cues. Vision, too, is embodied simulation.

CHALLENGING VISUAL IMPERIALISM: MULTIMODALITY AND VISION

Our vision of the world is far more complex than the mere activation of the visual part of the brain. Vision is multimodal: it encompasses somatosensory, emotion-related, and motor brain networks, and this activation plays out in endocrine systems and more. (Images can make you sweat.)

The observation of touch triggers the somatosensory cortex. (FIG. 1) The observation of the expression of emotions and feelings activates limbic and emotion-related brain regions. Motor neurons not only cause movements and actions but they also respond to body-related visual, tactile, and auditory stimuli, mapping the space

9
For more on embodied simulation, see Vittorio Gallese, "The Manifold Nature of Interpersonal Relations: The Quest for a Common Mechanism," *Philosophical Transactions of the Royal Society B* 358, no. 1431 (March 2003): 517–28; V. Gallese, "Embodied Simulation: From Neurons to Phenomenal Experience," *Phenomenology and the Cognitive Sciences* 4 (2005): 23–48; V. Gallese and S. Ebisch, "Embodied Simulation and Touch: The Sense of Touch in Social Cognition," *Phenomenology & Mind*, 4 (2013): 269–291; V. Gallese, "Mirror Neurons and the Perception-Action Link," in *Oxford Handbook of Cognitive Neuroscience, Vol. 2*, ed. S. Kosslyn and K. Ochsner (Oxford: Oxford University Press, 2013): 244–56; V. Gallese, "Bodily Selves in Relation (2014): 1–10; V. Gallese and C. Sinigaglia, "What Is So Special about Embodied Simulation?" *Trends in Cognitive Sciences* 15, no. 11 (November 2011): 512–19; V. Gallese and V. Cuccio, "The Paradigmatic Body: Embodied Simulation, Intersubjectivity and the Bodily Self," in *Open MIND*, ed. T. Metzinger and J. M. Windt (Frankfurt: MIND Group, 2015), 1–23.

10
Siri Hustvedt, *Mysteries of the Rectangle: Essays on Painting* (New York: Princeton Architectural Press, 2005), xix.

Vittorio Gallese

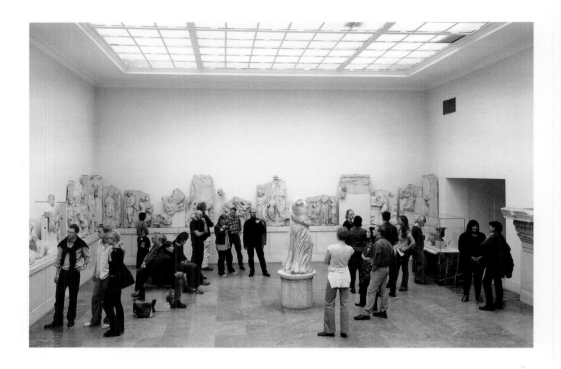

FIGURE 2
Thomas Struth, *Pergamon Museum 4*, Berlin, 2001, chromogenic print mounted on Plexiglas, 60⅜ × 90 in. (153.4 × 228.8 cm) framed.

[11] Leonardo Fogassi et al., "Coding of Peripersonal Space in Inferior Premotor Cortex (Area F4)," *Journal of Neurophysiology* 76, no. 1 (July 1996): 141–57; Giacomo Rizzolatti et al., "The Space Around Us," *Science* 277, no. 5323 (July 11, 1997): 190–91.

[12] Akira Murata et al., "Object Representation in the Ventral Premotor Cortex (Area F5) of the Monkey," *Journal of Neurophysiology* 78, no. 4 (October 1997): 2226–2230; Vassilis Raos et al., "Functional Properties of Grasping-Related Neurons in the Ventral Premotor Area F5 of the Macaque Monkey," *Journal of Neurophysiology* 95, no. 2 (2006): 709–29.

around us, the objects at hand in that very same space, and the actions of others. Cortical motor networks thus define in motor terms the representational content of space, objects, and actions. But how do they do this?

The space surrounding our body—peripersonal space—whose limits are the working limits of our arms' reach, is defined by the motor potentialities of our body. Premotor neurons controlling the movements of the upper arm also respond to tactile stimuli applied to it, to visual stimuli from objects brought into the arm's peripersonal space, or to auditory stimuli emanating from the same body-centered peripersonal space.[11] Manipulable objects when observed activate our motor brain as potential targets of the interactions we might entertain with them. Premotor and parietal "canonical neurons" controlling the grasping and manipulation of objects also respond to their mere observation.[12] Finally, mirror neurons located in a macaque monkey's brain—those motor neurons that become activated during the animal's execution of an action and during observation of the same action performed by another (even a human other)—provide suggestive evidence of the ways in which representations of actions might trigger the observers' motor representation of that action.[13]

Human brains are endowed with analogous mechanisms, integrating body-related multimodal sensory inputs into their motor schemata. The brain circuits displaying the "mirror mechanism"[14] connect frontal and posterior parietal multimodal motor neurons,

sharing many properties with macaques' mirror neurons. These brain circuits are activated by given motor contents we can semantically label, such as "reach out," "grasp," "hold," "smile," "frown," etc., not only when controlling their performance, but also when visually perceiving such acts being performed by others, when imitating them, or when imagining performing these motor contents in spite of being perfectly still. Indeed, empirical evidence shows that motor imagery and real action both trigger a common network of brain motor centers such as the primary motor cortex, the premotor cortex, the supplementary motor area (SMA), the basal ganglia, and the cerebellum.[15] A typical human cognitive activity such as motor mental imagery, far from being exclusively symbolic and propositional, relies upon the activation of sensory-motor brain regions. Mental motor imagery is somehow equivalent to simulating an actual motor experience. Thus, motor imagery does qualify as a further form of embodied simulation, since it implies reusing our motor apparatus to imagine actions that are not actual, and to simulate situations that are not real. Even the observation of the static image of someone else's action can awaken beholders' internal motor representations of the same actions.

Here it is important to introduce a powerful difference between humans and macaques. The mirror mechanism in humans can be evoked not only by the execution/observation of *goal-directed* motor acts, but also by simple, apparently random movements with no object as a goal—movements such as raising one's arm, jumping, or flexing one's finger. This wider motor palette likely plays a role in the distinctively wide-ranging mimetic actions found in the human species.

The functional architecture of the cortical motor system not only structures and controls our actions, but also plays a crucial role in the way we perceive, imitate, and imagine the movements and actions of others. When we initiate action, or when we imitate the actions of another, our cortico-spinal pathway becomes active, triggering the excitation of muscles and prompting our ensuing movements. When instead we only observe or imagine movements and actions, such execution is inhibited. The motor system is activated, but not in all components and not with the same intensity as when we actively move our bodies. It is this condition I am defining as embodied simulation: *action is not produced but only simulated*. The cortical motor system is not merely a muscle controller, but also an integral part of our cognitive system.[16] It is actively engaged with the processing of visual images: spaces and environments, objects and actions, minute gestures and static scenes.

Further research demonstrates that analogous embodied simulation mechanisms also apply to emotions and sensations. Observing someone else expressing a given emotion or undergoing a given sensation, such as touch or pain, recruits some of the same viscero-motor (e.g., anterior insula) and sensori-motor (e.g., SII, ventral premotor cortex)

[13] On "mirror neurons," see Vittorio Gallese et al., "Action Recognition in the Premotor Cortex," *Brain* 119 (1996), 593–609. For a review, see Giacomo Rizzolatti, Leonardo Fogassi, and V. Gallese, "Neurophysiological Mechanisms Underlying the Understanding and Imitation of Action," *Nature Reviews Neuroscience* 2, no. 9 (September 2001): 661–70; Gallese, "Mirror Neurons."

[14] For various overviews of the "mirror mechanism," see Vittorio Gallese, Christian Keysers, and Giacomo Rizzolatti, "A Unifying View of the Basis of Social Cognition," *Trends in Cognitive Science* 8, no. 9 (September 2004), 396–403; Gallese, "Mirror Neurons"; Gallese, "Bodily Selves"; Massimo Ammaniti and V. Gallese, *The Birth of Intersubjectivity: Psychodynamics, Neurobiology and the Self* (New York: W. W. Norton, 2014), 236; Gallese and Cuccio, "The Paradigmatic Body."

[15] For an overview, see Hannah Chapelle Wojciehowski and Vittorio Gallese, "How Stories Make Us Feel: Toward an Embodied Narratology," *California Italian Studies* 2, no. 1 (2011), 3–37.

[16] Vittorio Gallese et al., "Motor Cognition and Its Role in the Phylogeny and Ontogeny of Intentional Understanding," *Developmental Psychology* 45, no. 1 (2009): 103–13.

brain areas activated when one experiences that emotion or sensation, respectively. Other cortical regions, though, are exclusively recruited for one's own and not for others' emotions; still others are activated for one's own tactile sensation, but are actually deactivated when observing someone else being touched. Embodied simulation thus enables us to experience others as experiencing emotions or sensations we know from the inside, as it were.

Our capacity for the embodied simulation of action likely provides us with the conditions for differentiating the phenomenal quality of experience between actions that are real, imagined, our own, or observed. Embodied simulation thus allows a direct apprehension of the relational quality linking space, objects, and the actions of others to our body. In a beautiful passage from philosopher Henri Lefebvre: "In the beginning was the *Topos*. Before—long before—the advent of the *Logos*, in the chiaroscuro realm of primitive life, lived experience already possessed its internal rationality; this experience was *producing* long before *thought* space, and spatial thought, began *reproducing* the projection, explosion, image, and orientation of the body."[17] The primordial capacities that allow us to turn space, objects, and behavior into intentional forms result from their constitution as the targets of the "motor intentionality" already potential in our human bodies.[18] In sum, embodied simulation by means of neural reuse of established pathways enables us to map space, objects, actions, emotions, and sensations from within. Embodied simulation serves as a physiological ground for the fundamental role of empathy in aesthetic experience.

EMBODIED SIMULATION AND EXPERIMENTAL AESTHETICS

Experimental aesthetics emphasizes the experiential and social nature of human creative expressions. The very same forms of sociality that propel artistic expression are at their basis a further exemplification of an intersubjectivity that is clearly conceived of as *intercorporeality*. By addressing human forms of creative expression in terms of the thinking body's social performativity, experimental aesthetics can fully exploit the heuristic value of embodied simulation.

Among the different approaches aimed at grounding art and aesthetics in empirical science, the bio-cultural one appears to be particularly relevant to the project of experimental aesthetics advocated here. This approach, heavily influenced by cultural anthropology, argues for the performative character of human creativity. In his book *The Perception of the Environment*, Tim Ingold takes a long historical view in keeping with the "cognitive archaeology" I am advocating here: "Hunters and gatherers of the past were painting and carving, but they were not 'producing art.' ... We must cease thinking of painting and carving as modalities of the production of art, and view art instead as one rather peculiar, and historically very specific objectification of the activities of painting and carving."[19] In a similar vein, art historically trained ethologist Ellen Dissanayake wrote:

17 Emphasis in the original. Henri Lefebvre, *La production de l'espace* (Paris: Anthropos, 1974), trans. Donald Nicholson-Smith as *The Production of Space* (London: Blackwell, 1992), 174.

18 Vittorio Gallese, "The Inner Sense of Action: Agency and Motor Representations," *Journal of Consciousness Studies* 7 (2000): 23–40; Gallese and Sinigaglia, "What Is So Special with Embodied Simulation?"; Gallese, "Mirror Neurons"; Gallese, "Bodily Selves in Relation."

19 Tim Ingold, *The Perception of the Environment: Essays on Livelihood, Dwelling and Skill* (London and New York: Routledge, 2000), 131.

20 Dissanayake, an independent scholar, has pioneered the field of "evolutionary aesthetics." Ellen Dissanayake, *Homo Aestheticus: Where Art Comes From and Why* (Seattle: University of Washington Press, 1992), 224.

21 Eds.: "Seeing as" is an important philosophical category, generally traced in the Anglo-American tradition to Ludwig Wittgenstein. See Richard Wollheim, *Art and Its Objects* (Cambridge: Cambridge University Press, 1980).

22 Freedberg and Gallese, "Motion, Emotion and Empathy." See also V. Gallese and Cinzia Di Dio, "Neuroesthetics: The Body in Esthetic Experience," in *The Encyclopedia of Human Behavior* Vol. 2, ed. V. S. Ramachandran (Amsterdam: Elsevier Academic Press, 2012); 687–93; V. Gallese, "Aby Warburg and the Dialogue Among Aesthetics, Biology and Physiology," *Ph* 2 (July–December 2012): 48–62; Gallese, "Mirror Neurons"; V. Gallese and Alessandro Gattara, "Embodied Simulation, Aesthetics and Architecture: An Experimental Aesthetic Approach," in *Mind in Architecture: Neuroscience, Embodiment and the Future of Design*, ed. Sarah Robinson and Juhani Pallasmaa (Cambridge, MA: MIT Press, 2015), 161–79.

"Artistic behavior and response, which Western society treats as an ornamental and dispensable luxury, are really essential parts of our nature."[20] For art to be considered ethologically, according to Dissanayake, it should be considered an inherent behavioral tendency.

Indeed, embodied simulation as a key ingredient of experimental aesthetics is fully congruent with this approach. Embodied simulation can be relevant to aesthetic experience in at least two ways: First, because of the feeling of the body triggered by artworks, by means of embodied simulations. Parallel to the detached third-person reception of images, then, embodied simulation generates non-linguistic, internal "first-person representations" of the body-states associated with spatiality, objects, actions, emotions, and sensations. In such a way, embodied simulation generates the peculiar "seeing as" that characterizes our aesthetic experience of the images we look at.[21] Second, there is an intimate relationship between the creative gesture and its visual consequences for those who behold it. By virtue of embodied simulation, the motor representation that first produced the image activates its simulation by the viewer observing the traces and graphic signs left by the artist's hand, thus enabling an intersubjective bodily experience.[22]

This experience can be related to the many theories of indexicality that can be found in humanist scholarship.[23] According to neuroscientific revisions of this hypothesis, when looking at a graphic sign we unconsciously simulate the gesture that has produced it, and this "unconscious" response includes bodily framing and sensorimotor activation of the simulating kind.[24] Our scientific investigation of this phenomenon was applied to visual arts in three distinct experiments, which investigated the link between the expressive gesture of the hand and the images those gestures produced by means of high-density electroencephalography (EEG). We recorded beholders' brain responses to graphic signs like letters, ideograms, and scribbles, and then to abstract artworks by Lucio Fontana and Franz Kline.

The results of the first study showed that the observation of handwritten letters of the Roman alphabet, Chinese ideograms, or meaningless scribbles all activated beholders' motor representation of their hands.[25] In two other studies we demonstrated that looking at a cut on canvas by Lucio Fontana, or at the dynamic brushstrokes on canvas by Franz Kline, evoked motor simulations of the related hand gestures.[26]

Images' visible traces of hand gestures activate in the observers' brains the specific motor areas controlling the execution of those gestures. By means of embodied simulation, beholders' eyes trigger empathetic activations in their own sensorimotor areas; viewers are grasping the actual motor expressions of the artist creating the artwork. The sensory-motor components of our perceptions of images, together with the jointly evoked emotional reactions, allow beholders to feel the artwork in an embodied manner, from within.

23
Eds.: Philosopher Charles Sanders Peirce brought the term *index* into his theories of the visual sign; Rosalind Krauss theorized the index for art history. See R. Krauss, "Notes on the Index: Seventies Art in America," *October* 3 (Spring 1977): 68–81, and her "Notes on the Index: Seventies Art in America Part 2," *October* 4 (Autumn 1977): 58–67. For one example of Peirce, see Charles Sanders Peirce, "Logic as Semiotic: The Theory of Signs," in *Philosophical Writings of Peirce*, ed. Justus Buchler (New York: Dover Publications, 1955): 98–115.

24
This use of the term *unconscious* sets aside the substantial Freudian literature on this aspect of brain functioning to another discussion.

25
Katrin Heiman et al., "How the Motor-Cortex Distinguishes Among Letters, Unknown Symbols and Scribbles: A High Density EEG Study," *Neuropsychologia* 51 (2013), 2833–2840. Note that the observation of symbolic signs evoked stronger and longer lasting activation of beholders' motor system than that of meaningless scribbles.

26
Maria Alessandra Umiltà et al., "Abstract Art and Cortical Motor Activation: An EEG Study," *Frontiers in Human Neuroscience* 6 (2012): 311; Beatrice Sbriscia-Fioretti et al., "ERP Modulation During Observation of Abstract Paintings by Franz Kline," *PloS ONE* 8, no. 10 (2013): e75241.

[27] As cited above, for recent reviews, see Gallese, "Mirror Neurons"; Gallese, "Bodily Selves"; Ammaniti and Gallese, *The Birth of Intersubjectivity*, 236.

[28] Alfonso M. Iacono, "Gli universi di significato e i mondi intermedi," in Aldo G. Gargani and Alfonso M. Iacono, *Mondi intermedi e complessità* (Pisa: Edizioni, 2005): 5–39; Alfonso Iacono, *L'illusione e il sostituto: Riprodurre, imitare, rappresentare* (Milan: Bruno Mondadori Editore, 2010).

[29] Eds.: Also see Jacques Derrida on the Parergon, in Derrida, *The Truth in Painting*, trans. Geoff Bennington and Ian McLeod (Chicago: University of Chicago Press, 1987), 31.

[30] Iacono, *L'illusione e il sostituto*, 84.

There is ample proof that contingent and idiosyncratic factors dynamically modulate embodied simulation, framing what is perceived. Indeed, several studies have shown that one's previous experiences, memories, and expertise deeply affect the intensity of activation of mirror mechanisms and the ensuing perceptual contents.[27] Embodied simulation, through its plasticity and modulation, might also be the vehicle for projective qualities in aesthetic experience—conditions under which individual personality, cultural identity, and social context, as well as fleeting mood or general disposition, shape the way a given viewer will relate to a perceptual object. Embodied simulation, if capaciously conceived, will include these dynamic instantiations of experiential memories and their historically and culturally determined qualities. This projective quality of embodied simulation complements its receptive features.

LIBERATED EMBODIED SIMULATION AND AESTHETIC INSULARITY

Our relationship with human-made images and fictional worlds is double-edged: on the one hand we pretend that they are true, while, on the other, we are fully aware that they are not. When we behold a painting at an art museum, several powerful framing effects take place. First, we find ourselves in a context where the images hanging on the wall are supposedly all artworks. Second, once we let the image capture our attention, the frame surrounding it almost disappears, as we enter the cultural practice of being fully absorbed by the image. As the Italian philosopher Alfonso Iacono put it, we experience a sort of "tail of the eye" vision (the outer edge of vision, a peripheral region of fuzzy attributions and slipping glances). This intentionally peripheral view, he argues, characterizes all of our relationships with the "intermediate worlds" of fiction.[28] Our appreciation of human-made images implies inhabiting such intermediate worlds, where the territory of the world and our internal maps do overlap. As Iacono notes, one enters the picture through the frame, only by forgetting about having entered it.[29] This process, which takes place while being in an emotional state prompted by strong cultural rituals, is a process of "naturalization"—that is, it is an embodied framing process by which artificial, historical, and changeable objects come to appear "natural," eternal, and unalterable works of art.[30] (FIG. 2)

This explanation situates the body at the core of our perceptions, our understanding, and our imagination. Yet our relationship with fictional worlds is still usually explained in Romantic terms—following the poet Samuel Coleridge, we understand this process as a "suspension of disbelief"—the result of a purely cognitive concept. This explanation, however, is partial at best, and still provokes the question of *why* we would so consistently perform this purely mental operation.

Such a question brings us to the *why* of embodied simulation. We have proposed that embodied simulation evokes, by means of the mirroring mechanisms stimulated by images and fictional worlds,

the strong feelings associated with, and activated within, the sensorimotor cortex.[31] In such a way, embodied simulation generates the peculiar embodied emotions informing human aesthetic experience. Furthermore, the bodily memories and imaginative associations that fictional content can awaken in our minds provide the idiosyncratic character of its appreciation.

Our experience of fictional images, besides being a form of suspension of disbelief, can also be interpreted as a *liberated embodied simulation*. Such liberated simulations come about in a context-dependent way, since our relationship to human-made images is always mediated by distancing devices culturally intended to remain at the periphery of our attentional focus (such as the frame of the image). When we adopt an aesthetic attitude, our embodied simulation becomes liberated; that is, it is freed from the burden of modeling our actual psychophysical presence in daily life; new simulative energies are liberated.[32] Through the pleasurable immersive state in which our attention is focused on the virtual world we behold, we can fully deploy our simulative resources, and can allow our defensive guard against daily reality to relax.

Finally, when engaged with fictional images, our contextual bodily framing—our being still, our cessation of external activity—additionally boosts our embodied simulation. Being still enables us to fully deploy our simulative resources at the service of the immersive relationship with the image, thus generating an even greater feeling of embodiment. Being forced into contemplative inaction, we are more open to feelings and emotions. Beholding an art image can generate a specific and particularly moving experience, one likely driven by this sense of safe intimacy with a world we not only imagine, but also embody in our full sensori-motor and viscero-motor systems. Only *action* is stilled.

CONCLUSIONS

As human beings we are not satisfied with the prosaic relation we daily entertain with the world. We are constantly projecting ourselves toward the Other, toward what is missing, what is elsewhere in space and time. Such dissatisfaction induces humans to re-create the world by representing it, transfiguring it, or by creating a new world with the power of imagination. We imagine hunting wild game, representing it pictorially on the walls of a cave, or fusing its features with those of the human body by creating chimerical figures with supernatural powers. Thanks to the body, concepts of internal and external, subject and object, are nothing but verbal placeholders for a dynamic relation that could just as easily be described as openness to the world, or desire. These two latter words allude in different ways to our intrinsic and constitutive search for a constitutively missing other(ness).

In contemporary times our relation with the world is characterized by an unprecedented ontological instability that takes form

[31] Wojciehowski and Gallese, "How Stories Make Us Feel."

[32] Vittorio Gallese, "Mirror Neurons and Art" in *Art and the Senses*, ed. Francesca Bacci and David Melcher (Oxford: Oxford University Press, 2010), 441–49; Wojciehowski and Gallese, "How Stories Make us Feel."

as an *aesthetic disturbance*. Traditional constructions of images and their cultural distancing devices are in active transformation. By means of technology—mobile phones, tablets, computers, and the like—we constantly cycle through the very same media through which we experience the reality of data, representations of reality, and fictional narratives within the media flow. Our sense of what is real and what happened is increasingly nourished by the fetishized digital fragments of a shared public artificial reality, which often turns out to be counterfeited and manipulated. The growing autonomy of the digital world colonizes our imagination and externalizes our memories, while coding digital simulations to tap our internal embodied ones.

Are we then moving away from a bodily account of our relation to images? Not if we can help it. In some influential humanist accounts, contemporary digital technologies are self-consciously putting the body back into the center of the mediations through which we appreciate reality. As Mark Hansen has written about Walter Benjamin's thesis concerning the impact of technology on contemporary societies, "Just as technological modernization produces a shift in the *mode* of experience, from *Erfahrung* to *Erlebnis*, it also brokers a shift in the *medium* of experience, from non-sensuous linguistic correspondences to embodied and practical mimetic activity."[33] New digital technologies dethrone language from its leading role in building our reality, installing a new form of nonlinguistic and embodied visuality at the center of our lives. Our world experience becomes less language-centered and more haptic, less text-driven and more image-based. This shift offers a significant place of entry for theories of embodied simulation, based in the human nervous system and extending well beyond the brain.

Cognitive neuroscience by means of experimental aesthetics is well equipped to provide a new approach to the contemporary problem of images, by investigating, among other things, the bodily impact of new digital communication technologies and by shedding new light on the postmodern technological mechanosphere. Embodied simulation theory specifically addresses various modalities that our bodies use to interface with reality and its digital representations, and it provides new means for their comprehension. By means of embodied simulation, the recent emphasis put on "haptic vision" when discussing the new digital interfaces to images can now be empirically addressed from the vantage point of the brain-body system.[34]

Cognitive neuroscience can also deliver us from forced choices between the paralyzing relativism of social constructivism, which leaves no room for the constitutive role of the body in cognition, and the deterministic scientism found in some quarters of evolutionary psychology, which explains art exclusively in terms of adaptation and modularity in hardwired structures of the brain. We can now look at the aesthetic and symbolic dimensions of human existence

[33] Mark Hansen, *Embodying Technesis: Technology Beyond Writing* (Ann Arbor: University of Michigan Press, 2000), 236; emphasis in the original. See also Mark Hansen, *New Philosophy for New Media* (Cambridge, MA: MIT Press, 2004); Mark Hansen, *Bodies in Code: Interfaces with Digital Media* (New York: Routledge, 2006).

[34] On "haptic vision," see Laura Marks, *Touch: Sensuous Theory and Multisensory Media* (Minneapolis: University of Minnesota Press, 2002); Vivian Sobchack, *The Address of the Eye: A Phenomenology of Film Experience* (Princeton, NJ: Princeton University Press, 1992); Vivian Sobchack, *Carnal Thoughts: Embodiment and Moving Image Culture* (Berkeley: University of California Press, 2004); Jennifer Barker, *The Tactile Eye: Touch and the Cinematic Experience* (Oakland: University of California Press, 2009); Giuliana Bruno, *Public Intimacy: Architecture and the Visual Arts* (Cambridge, MA: MIT Press, 2007).

not only from a semiotic-hermeneutic perspective, but also starting from the experience of bodily presence. With the aid of neuroscience we can empirically test the supposed universality of human creative expression and, most importantly, challenge the hypothesis of its uniquely logocentric origin. As the anthropologist Thomas Csordas wrote: "The body is to be considered as the subject of culture, or in other words as the existential [as opposed to the cognitive] ground of culture."[35]

Finally, by locating embodied sites of aesthetic experience we can interpret the outcomes of human creative expression in ways much less conditioned by the contemporary Western cultural and aesthetic canon; such influences can be specifically studied, allowing a new understanding of their role and influence. Experimental aesthetics can shed new light on the human creative inclination. In so doing it will help us reframe the problem of why and how images are among the most fundamental expressions of our species.

[35] Thomas J. Csordas, "Embodiment as a Paradigm for Anthropology," *Ethos* 18, no. 1 (March 1990): 5.

"CONSCIOUSNESS"
William James

"Thoughts" and "things" are names for two sorts of object, which common sense will always find contrasted and will always practically oppose to each other. Philosophy, reflecting on the contrast, has varied in the past in her expectations of it, and may be expected to vary in the future. At first, "spirit and matter," "soul and body," stood for a pair of equipollent substances quite on a par in weight and interest. But one day [Immanuel] Kant undermined the soul and brought in the transcendental ego, and ever since then the bipolar relation has been very much off its balance. The transcendental ego seems nowadays in rationalist quarters to stand for everything, in empiricist quarters for almost nothing. In the hands of such writers as [Wilhelm] Schuppe, [Johannes] Rehmke, [Paul] Natorp, [Hugo] Münsterberg—at any rate in his earlier writings, [Richard von] Schubert-Soldern and others, the spiritual principle attenuates itself to a thoroughly ghostly condition, being only a name for the fact that the "content" of experience *is known*. It loses personal form and activity—these passing over to the content—and becomes a bare *Bewusstheit* or *Bewusstsein überhaupt*, of which in its own right absolutely nothing can be said.

I believe that "consciousness," when once it has evaporated to this estate of pure diaphaneity, is on the point of disappearing altogether. It is the name of a nonentity, and has no right to a place among first principles. Those who still cling to it are clinging to a mere echo, the faint rumor left behind by the disappearing "soul" upon the air of philosophy. During the past year, I have read a number of articles whose authors seemed just on the point of abandoning the notion of consciousness,[1] and substituting for it that of an absolute experience not due to two factors. But they were not quite radical enough, not daring enough in their negations. For twenty years past I have mistrusted "consciousness" as an entity: for seven or eight years past I have suggested its nonexistence to my students, and tried to give them its pragmatic equivalent in realities of experience. It seems to me that the hour is ripe for it to be openly and universally discarded.

To deny plumply that "consciousness" exists seems so absurd on the face of it—for undeniably "thoughts" do exist—that I fear some readers will follow me no further. Let me then immediately explain that I mean only to deny that the word stands for an entity,

This text was published previously as William James, "Does 'Consciousness' Exist?" *The Journal of Philosophy Psychology and Scientific Methods* 1, no. 18. (September 1, 1904): 477–91.

1 Articles by Baldwin, Ward, Bawden, King, Alexander, and others. Dr. Perry is frankly over the border.

> In my [*Principles of*] *Psychology* I have tried to show that we need no knower other than the "passing thought."

but to insist most emphatically that it does stand for a function. There is, I mean, no aboriginal stuff or quality of being, contrasted with that of which material objects are made, out of which our thoughts of them are made, but there is a function in experience which thoughts perform, and for the performance of which this quality of being is invoked. That function is *knowing*. "Consciousness" is supposed necessary to explain the fact that things not only are, but get reported, are known. Whoever blots out the notion of consciousness from his list of first principles must still provide in some way for that function's being carried on.

I.

My thesis is that if we start with the supposition that there is only one primal stuff or material in the world, a stuff of which everything is composed, and if we call that stuff "pure experience," then knowing can easily be explained as a particular sort of relation toward one another into which portions of pure experience may enter. The relation itself is a part of pure experience; one of its "terms" becomes the subject or bearer of the knowledge, the knower;[2] the other becomes the object known. This will need much explanation before it can be understood. The best way to get it understood is to contrast it with the alternative view, and for that we may take the recentest alternative, that in which the evaporation of the definite soul-substance has proceeded as far as it can go without being yet complete. If neo-Kantism has expelled earlier forms of dualism, we shall have expelled all forms if we are able to expel neo-Kantism in its turn.

For the thinkers I call neo-Kantian, the word consciousness today does no more than signalize the fact that experience is indefeasibly dualistic in structure. It means that not subject, not object, but object-plus-subject is the minimum that can actually be. The subject-object distinction meanwhile is entirely different from that between mind and matter, from that between body and soul. Souls were detachable, had separate destinies; things could happen to them. To consciousness as such nothing can happen, for, timeless itself, it is only a witness of happenings in time, in which it plays no part. It is, in a word, but the logical correlative of "content" in an Experience of which the peculiarity is that *fact comes to light* in it, that *awareness of content* takes place. Consciousness as such is entirely impersonal—"self" and its activities belong to the content. To say that I am self-conscious, or conscious of putting forth volition, means only that certain contents, for which "self" and "effort of will" are the names, are not without witness as they occur.

Thus, for these belated drinkers at the Kantian spring, we should have to admit consciousness as an "epistemological" necessity, even if we had no direct evidence of its being there.

But in addition to this, we are supposed by almost every one to have an immediate consciousness of consciousness itself. When the

world of outer fact ceases to be materially present, and we merely recall it in memory, or fancy it, the consciousness is believed to stand out and to be felt as a kind of impalpable inner flowing, which, once known in this sort of experience, may equally be detected in presentations of the outer world. "The moment we try to fix our attention upon consciousness and to see *what*, distinctly, it is," says a recent writer, "it seems to vanish. It seems as if we had before us a mere emptiness. When we try to introspect the sensation of blue, all we can see is the blue; the other element is as if it were diaphanous. Yet it *can* be distinguished, if we look attentively enough, and know that there is something to look for."[3] "Consciousness" (*Bewusstheit*), says another philosopher, "is inexplicable and hardly describable, yet all conscious experiences have this in common that what we call their content has this peculiar reference to a centre for which 'self' is the name, in virtue of which reference alone the content is subjectively given, or appears. . . . While in this way consciousness, or reference to a self, is the only thing which distinguishes a conscious content from any sort of being that might be there with no one conscious of it, yet this only ground of the distinction defies all closer explanations. The existence of consciousness, although it is the fundamental fact of psychology, can indeed be laid down as certain, can be brought out by analysis, but can neither be defined nor deduced from anything but itself."[4]

"Can be brought out by analysis," this author says. This supposes that the consciousness is one element, moment, factor—call it what you like—of an experience of essentially dualistic inner constitution, from which, if you abstract the content, the consciousness will remain revealed to its own eye. Experience, at this rate, would be much like a paint of which the world pictures were made. Paint has a dual constitution, involving, as it does, a menstruum[5] (oil, size, or what not) and a mass of content in the form of pigment suspended therein. We can get the pure menstruum by letting the pigment settle, and the pure pigment by pouring off the size or oil. We operate here by physical subtraction, and the usual view is, that by mental subtraction we can separate the two factors of experience in an analogous way—not isolating them entirely, but distinguishing them enough to know that they are two.

II.

Now my contention is exactly the reverse of this. *Experience, I believe, has no such inner duplicity; and the separation of it into consciousness and content comes, not by way of subtraction, but by way of addition*—the addition, to a given concrete piece of it, of other sets of experiences, in connection with which severally its use or function may be of two different kinds. The paint will also serve here as an illustration. In a pot in a paint-shop, along with other paints, it serves in its entirety as so much saleable matter. Spread on a canvas, with other paints around it, it represents, on the contrary,

[3] G. E. Moore, *Mind: [A Quarterly Review of Psychology and Philosophy*, vol. XII (1887)], N. S., 450.

[4] Paul Natorp, *Einleitung in die Psychologie* [nach kritischer Methode] [(Freiburg: J.C.B. Mohr, 1888)], 14, 112.

[5] "Figuratively speaking, consciousness may be said to be the one universal solvent, or menstruum, in which the different concrete kinds of psychic acts and facts are contained, whether in concealed or in obvious form." [George Trumball] Ladd, *Psychology, Descriptive and Explanatory: [A Treatise of the Phenomena, Laws, and Development of Human Mental Life* (New York: Charles Scribners, 1909 (first edition, 1894)], 30.

a feature in a picture and performs a spiritual function. Just so, I maintain, does a given undivided portion of experience, taken in one context of associates, play the part of a knower, of a state of mind, of "consciousness"; while in a different context the same undivided bit of experience plays the part of a thing known, of an objective "content." In a word, in one group it figures as a thought, in another group as a thing. And, since it can figure in both groups simultaneously we have every right to speak of it as subjective and objective both at once. The dualism connoted by such double-barreled terms as "experience," "phenomenon," "datum," *"Vorfindung"*—terms which, in philosophy at any rate, tend more and more to replace the single-barreled terms of "thought" and "thing"—that dualism, I say, is still preserved in this account, but reinterpreted, so that, instead of being mysterious and elusive, it becomes verifiable and concrete. It is an affair of relations; it falls outside, not inside, the single experience considered, and can always be particularized and defined.

The entering wedge for this more concrete way of understanding the dualism was fashioned by [John] Locke when he made the word "idea" stand indifferently for thing and thought, and by [George] Berkeley when he said that what common sense means by realities is exactly what the philosopher means by ideas. Neither Locke nor Berkeley thought his truth out into perfect clearness, but it seems to me that the conception I am defending does little more than consistently carry out the "pragmatic" method, which they were the first to use.

If the reader will take his own experiences, he will see what I mean. Let him begin with a perceptual experience, the "presentation," so-called, of a physical object, his actual field of vision, the room he sits in, with the book he is reading as its center; and let him for the present treat this complex object in the common-sense way as being "really" what it seems to be, namely, a collection of physical things cut out from an environing world of other physical things with which these physical things have actual or potential relations. Now at the same time it is just *those self-same things* which his mind, as we say, perceives, and the whole philosophy of perception from Democritus's time downward has been just one long wrangle over the paradox that what is evidently one reality should be in two places at once, both in outer space and in a person's mind. "Representative" theories of perception avoid the logical paradox, but on the other hand they violate the reader's sense of life, which knows no intervening mental image but seems to see the room and the book immediately just as they physically exist.

The puzzle of how the one identical room can be in two places is at bottom just the puzzle of how one identical point can be on two lines. It can, if it be situated at their intersection; and similarly, if the "pure experience" of the room were a place of intersection of two processes, which connected it with different groups of associates respectively, it could be counted twice over, as belonging to either group, and spoken of loosely as existing in two places,

although it would remain all the time a numerically single thing. Well, the experience is a member of diverse processes that can be followed away from it along entirely different lines. The one self-identical thing has so many relations to the rest of experience that you can take it in disparate systems of association, and treat it as belonging with opposite contexts. In one of these contexts it is your "field of consciousness"; in another, it is "the room in which you sit," and it enters both contexts in its wholeness, giving no pretext for being said to attach itself to consciousness by one of its parts or aspects, and to outer reality by another. What are the two processes, now, into which the room-experience simultaneously enters in this way?

One of them is the reader's personal biography, the other is the history of the house of which the room is part. The presentation, the experience, the *that* in short (for until we have decided *what* it is it must be a mere *that*) is the last term of a train of sensations, emotions, decisions, movements, classifications, expectations, etc., ending in the present, and the first term of a series of similar "inner" operations extending into the future, on the reader's part. On the other hand, the very same *that* is the *terminus ad quem* of a lot of previous physical operations, carpentering, papering, furnishing, warming, etc., and the *terminus a quo* of a lot of future ones, in which it will be concerned when undergoing the destiny of a physical room. The physical and the mental operations form curiously incompatible groups. As a room, the experience has occupied that spot and had that environment for 30 years. As your field of consciousness it may never have existed until now. As a room, attention will go on to discover endless new details in it. As your mental state merely, few new ones will emerge under attention's eye. As a room, it will take an earthquake, or a gang of men, and in any case a certain amount of time, to destroy it. As your subjective state, the closing of your eyes, or any instantaneous play of your fancy will suffice. In the real world, fire will consume it. In your mind, you can let fire play over it without effect. As an outer object, you must pay so much a month to inhabit it. As an inner content, you may occupy it for any length of time rent-free. If, in short, you follow it in the mental direction, taking it along with events of personal biography solely, all sorts of things are true of it which are false, and false of it which are true if you treat it as a real thing experienced, follow it in the physical direction, and relate it to associates in the outer world.

III.

So far, all seems plain sailing, but my thesis will probably grow less plausible to the reader when I pass from percepts to concepts, or from the case of things presented to that of things remote. I believe, nevertheless, that here also the same law holds good. If we take conceptual manifolds, or memories, or fancies, they also are in their first intention mere bits of pure experience, and, as such, are single

[6] Here as elsewhere the relations are of course *experienced* relations, members of the same originally chaotic manifold of non-perceptual experience of which the related terms themselves are parts.

[7] Of the representative function of non-perceptual experience as a whole, I will say a word in a subsequent article: it leads too far into the general theory of knowledge for much to be said about it in a short paper like this.

thats which act in one context as objects, and in another context figure as mental states. By taking them in their first intention, I mean ignoring their relation to possible perceptual experiences with which they may be connected, which they may lead to and terminate in, and which then they may be supposed to "represent." Taking them in this way first, we confine the problem to a world merely "thought of" and not directly felt or seen. This world, just like the world of percepts, comes to us at first as a chaos of experiences, but lines of order soon get traced. We find that any bit of it which we may cut out as an example is connected with distinct groups of associates, just as our perceptual experiences are, that these associates link themselves with it by different relations,[6] and that one forms the inner history of a person, while the other acts as an impersonal "objective" world, either spatial and temporal, or else merely logical or mathematical, or otherwise "ideal."

The first obstacle on the part of the reader to seeing that these non-perceptual experiences have objectivity as well as subjectivity will probably be due to the intrusion into his mind of *percepts*, that third group of associates with which the non-perceptual experiences have relations, and which, as a whole, they "represent," standing to them as thoughts to things. This important function of the non-perceptual experiences complicates the question and confuses it; for, so used are we to treat percepts as the sole genuine realities that, unless we keep them out of the discussion, we tend altogether to overlook the objectivity that lies in non-perceptual experiences by themselves. We treat them, "knowing" percepts as they do, as through and through subjective, and say that they are wholly constituted of the stuff called consciousness, using this term now for a kind of entity, after the fashion which I am seeking to refute.[7]

Abstracting, then, from percepts altogether, what I maintain is, that any single non-perceptual experience tends to get counted twice over, just as a perceptual experience does, figuring in one context as an object or field of objects, in another as a state of mind: and all this without the least internal self-diremption on its own part into consciousness and content. It is all consciousness in one taking, and, in the other, all content.

I find this objectivity of non-perceptual experiences, this complete parallelism in point of reality between the presently felt and the remotely thought, so well set forth in a page of Münsterberg's *Grundzüge*, that I will quote it as it stands.

"I may only think of my objects," says Professor Münsterberg, "yet, in my living thought they stand before me exactly as perceived objects would do, no matter how different the two ways of apprehending them may be in their genesis. The book here lying on the table before me, and the book in the next room of which I think and which I mean to get, are both in the same sense given realities for me, realities which I acknowledge and of which I take account. If you agree that the perceptual object is not an idea within me, but that

percept and thing, as indistinguishably one, are really experienced *there*, *outside*, you ought not to believe that the merely thought-of object is hid away inside of the thinking subject. The object of which I think, and of whose existence I take cognizance without letting it now work upon my senses, occupies its definite place in the outer world as much as does the object which I directly see."

"What is true of the here and the there, is also true of the now and the then. I know of the thing which is present and perceived, but I know also of the thing which yesterday was but is no more, and which I only remember. Both can determine my present conduct, both are parts of the reality of which I keep account. It is true that of much of the past I am uncertain, just as I am uncertain of much of what is present if it be but dimly perceived. But the interval of time does not in principle alter my relation to the object, does not transform it from an object known into a mental state. . . . The things in the room here which I survey, and those in my distant home of which I think, the things of this minute and those of my long-vanished boyhood, influence and decide me alike, with a reality which my experience of them directly feels. They both make up my real world, they make it directly, they do not have first to be introduced to me and mediated by ideas which now and here arise within me. . . . This not-me character of my recollections and expectations does not imply that the external objects of which I am aware in those experiences should necessarily be there also for others. The objects of dreamers and hallucinated persons are wholly without general validity. But even were they centaurs and golden mountains, they still would be 'off there,' in fairy land, and not 'inside' of ourselves."[8]

This certainly is the immediate, primary, naïf, or practical way of taking our thought-of world. Were there no perceptual world to serve as its "reductive," in [Hippolyte] Taine's sense, by being "stronger" and more genuinely "outer" (so that the whole merely thought-of world seems weak and inner in comparison), our world of thought would be the only world, and would enjoy complete reality in our belief. This actually happens in our dreams, and in our day dreams so long as percepts do not interrupt them.

And yet, just as the seen room (to go back to our late example) is *also* a field of consciousness, so the conceived or recollected room is *also* a state of mind, and the doubling-up of the experience has in both cases similar grounds.

The room thought-of, namely, has many thought-of couplings with many thought-of things. Some of these couplings are inconstant, others are stable. In the reader's personal history the room occupies a single date—he saw it only once perhaps, a year ago. Of the house's history, on the other hand, it forms a permanent ingredient. Some couplings have the curious stubbornness, to borrow [Josiah] Royce's term, of fact; others show the fluidity of fancy—we let them come and go as we please. Grouped with the rest of its house, with the name of its town, of its owner, builder, value, decorative plan, the room

[8] [Hugo Münsterberg,] *Grundzüge der Psychologie,* vol. I (Leipzig: J.A. Barth, 1900), 48.

[9] [Alfred] Hodder, *The Adversaries of the Sceptic* [(New York: Macmillan, 1901)], 94–99.

[10] For simplicity's sake I confine my exposition to "external" reality. But there is also the system of ideal reality in which the room plays its part. Relations of comparison, of classification, serial order, value, also are stubborn, assign a definite place to the room, unlike the incoherence of its places in the mere rhapsody of our successive thoughts.

[11] Note the ambiguity of this term, which is taken sometimes objectively and sometimes subjectively.

[12] In the *Psychological Review* for July [1904], Dr. R. B. Perry has published a view of Consciousness which comes nearer mine than any other with which I am acquainted. At present, Dr. Perry thinks, every field of experience is so much "fact." It becomes "opinion" or "thought" only in retrospection, when a fresh experience, thinking the same object, alters and corrects it. But the corrective experience becomes itself in turn corrected, and thus experience as a whole is a process in which what is objective originally forever turns subjective, turns into our apprehension of the object. I strongly recommend Dr. Perry's admirable article to my readers.

maintains a definite foothold, to which, if we try to loosen it, it tends to return, and to reassert itself with force.[9] With these associates, in a word, it coheres, while to other houses, other towns, other owners, etc., it shows no tendency to cohere at all. The two collections, first of its cohesive, and, second, of its loose associates, inevitably come to be contrasted. We call the first collection the system of external realities, in the midst of which the room, as "real," exists; the other we call the stream of our internal thinking, in which, as a "mental image," it for a moment floats.[10] The room thus again gets counted twice over. It plays two different roles, being *Gedanke* and *Gedachtes*, the thought-of-an-object, and the object-thought-of, both in one; and all this without paradox or mystery, just as the same material thing may be both low and high, or small and great, or bad and good, because of its relations to opposite parts of an environing world.

As "subjective" we say that the experience represents; as "objective" it is represented. What represents and what is represented is here numerically the same; but we must remember that no dualism of being represented and representing resides in the experience *per se*. In its pure state, or when isolated, there is no self-splitting of it into consciousness and what the consciousness is "of." Its subjectivity and objectivity are functional attributes solely, realized only when the experience is "taken," *i.e.*, talked-of, twice, considered along with its two differing contexts respectively, by a new retrospective experience, of which that whole past complication now forms the fresh content.

The instant field of the present is at all times what I call the "pure" experience. It is only virtually or potentially either object or subject as yet. For the time being, it is plain, unqualified actuality or existence, a simple *that*. In this *naïf* immediacy it is of course *valid*; it is *there*, we *act* upon it; and the doubling of it in retrospection into a state of mind and a reality intended thereby, is just one of the acts. The "state of mind," first treated explicitly as such in retrospection, will stand corrected or confirmed, and the retrospective experience in its turn will get a similar treatment, but the immediate experience in its passing is always "truth,"[11] practical truth, *something to act on*, at its own movement. If the world were then and there to go out like a candle, it would remain truth absolute and objective, for it would be "the last word," would have no critic, and no one would ever oppose the thought in it to the reality intended.[12]

I think I may now claim to have made my thesis clear. Consciousness connotes a kind of external relation, and does not denote a special stuff or way of being. *The peculiarity of our experiences, that they not only are, but are known, which their "conscious" quality is invoked to explain, is better explained by their relations—these relations themselves being experiences—to one another.*

IV.

Were I now to go on to treat of the knowing of perceptual by conceptual experiences, it would again prove to be an affair of external relations. One experience would be the knower, the other the reality known, and I could perfectly well define, without the notion of "consciousness," what the knowing actually and practically amounts to—leading-toward, namely, and terminating-in percepts, through a series of transitional experiences which the world supplies. But I will not treat of this, space being insufficient.[13] I will rather consider a few objections that are sure to be urged against the entire theory as it stands.

[13] I have given a partial account of the matter in *Mind*, vol. X, page 27, 1885, and in the *Psychological Review*, Vol. II, page 105, 1895 [partly reprinted in *The Meaning of Truth*, 43–50]. See also C. A. Strong's article in the *Journal of Philosophy, Psychology and Scientific Methods*, Vol. I, page 253, May 12, 1904. I hope myself very soon to recur to the matter....

V.

First of all, this will be asked: "If experience has not 'conscious' existence, if it be not partly made of 'consciousness,' of what then is it made? Matter we know, and thought we know, and conscious content we know, but neutral and simple 'pure experience' is something we know not at all. Say *what* it consists of—for it must consist of something—or be willing to give it up!"

To this challenge the reply is easy. Although for fluency's sake I myself spoke early in this article of a stuff of pure experience, I have now to say that there is no *general* stuff of which experience at large is made. There are as many stuffs as there are "natures" in the things experienced. If you ask what any one bit of pure experience is made of, the answer is always the same: "It is made of *that*, of just what appears, of space, of intensity, of flatness, brownness, heaviness, or what not." Shadworth Hodgson's analysis here leaves nothing to be desired. Experience is only a collective name for all these sensible natures, and save for time and space (and, if you like, for "being") there appears no universal element of which all things are made.

VI.

The next objection is more formidable, in fact it sounds quite crushing when one hears it first.

"If it be the self-same piece of pure experience, taken twice over, that serves now as thought and now as thing"—so the objection runs— "how comes it that its attributes should differ so fundamentally in the two takings. As thing, the experience is extended; as thought, it occupies no space or place. As thing, it is red, hard, heavy, but who ever heard of a red, hard, or heavy thought? Yet even now you said that an experience is made of just what appears, and what appears is just such adjectives. How can the one experience in its thing-function be made of them, consist of them, carry them as its own attributes, while in its thought-function it disowns them and attributes them elsewhere? There is a self-contradiction here from which the radical dualism of thought and thing is the only truth that can save us. Only if the thought is one kind of being can the adjectives exist

in it *intentionally* (to use the scholastic term); only if the thing is another kind, can they exist in it constitutively and energetically. No simple subject can take the same adjectives and at one time be qualified by it, and at another time be merely 'of' it, as of something only meant or known."

The solution insisted on by this objector, like many other common-sense solutions, grows the less satisfactory the more one turns it in one's mind. To begin with, *are* thought and thing as heterogenous as is commonly said?

No one denies that they have some categories in common. Their relations to time are identical. Both, moreover, may have parts (for psychologists in general treat thoughts as having them), and both may be complex or simple. Both are of kinds, can be compared, added and subtracted and arranged in serial orders. All sorts of adjectives qualify our thoughts which appear incompatible with consciousness, being as such a bare diaphaneity. For instance, they are natural and easy, or laborious. They are beautiful, happy, intense, interesting, wise, idiotic, focal, marginal, insipid, confused, vague, precise, rational, casual, general, particular, and many things besides. Moreover, the chapters on "Perception" in the [*Principles of*] *Psychology* books are full of facts that make for the essential homogeneity of thought with thing. How, if "subject" and "object" were separated "by the whole diameter of being," and had no attributes in common, could it be so hard to tell, in a presented and recognized material object, what part comes in through the sense-organs, and what part comes "out of one's own head"? Sensations and apperceptive ideas fuse here so intimately that you can no more tell where one begins and the other ends, than you can tell, in those cunning circular panoramas that have lately been exhibited, where the real foreground and the painted canvas join together.[14]

[René] Descartes for the first time defined thought as the absolutely unextended, and later philosophers have accepted the description as correct. But what possible meaning has it to say that, when we think of a foot-rule or a square yard, extension is not attributable to our thought? Of every extended object the *adequate* mental picture must have all the extension of the object itself. The difference between objective and subjective extension is one of relation to a context solely. In the mind the various extents maintain no necessarily stubborn order relatively to each other, while in the physical world they bound each other stably, and, added together, make the great enveloping Unit which we believe in and call real Space. As "outer," they carry themselves adversely, so to speak, to one another, exclude one another and maintain their distances; while, as "inner," their order is loose, and they form a *Durcheinander* in which unity is lost.[15]

But to argue from this that inner experience is absolutely inextensive seems to me little short of absurd. The two worlds differ, not by the presence or absence of extension, but by the relations of the extensions which in both worlds exist.

14
Spencer's proof of his "Transfigured Realism" (his doctrine that there is an absolutely non-mental reality) comes to mind as a splendid instance of the impossibility of establishing radical heterogeneity between thought and thing. All his painfully accumulated points of difference run gradually into their opposites, and are full of exceptions.

15
I speak here of the complete inner life in which the mind plays freely with its materials. Of course the mind's free play is restricted when it seeks to copy real things in real space. [Eds.: The word *durcheinander* (jumble) is lower-case in the original; it has been corrected here.]

Does not this case of extension now put us on the track of truth in the case of other qualities? It does, and I am surprised that the facts should not have been noticed long ago. Why, for example, do we call a fire hot, and water, wet, and yet refuse to say that our mental state, when it is "of" these objects, is either wet or hot? "Intentionally," at any rate, and when the mental state is a vivid image, hotness and wetness are in it just as much as they are in the physical experience. The reason is this, that, as the general chaos of all our experiences gets sifted, we find that there are some fires that will always burn sticks and always warm our bodies, and that there are some waters that will always put out fires, while there are other fires and waters that will not act at all. The general group of experiences that *act*, that do not only possess their natures intrinsically, but wear them adjectively and energetically, turning them against one another, comes inevitably to be contrasted with the group whose members, having identically the same natures, fail to manifest them in the "energetic" way. I make for myself now an experience of blazing fire; I place it near my body, but it does not warm me in the least. I lay a stick upon it, and the stick either burns or remains green, as I please. I call up water, and pour it on the fire, and absolutely no difference ensues. I account for all such facts by calling this whole train of experiences unreal, a mental train. Mental fire is what won't burn real sticks; mental water is what won't necessarily (though of course it may) put out even a mental fire. Mental knives may be sharp, but they won't cut real wood. Mental triangles are pointed, but their points won't wound. With "real" objects, on the contrary, consequences always accrue; and thus the real experiences get sifted from the mental ones, the things from our thoughts of them, fanciful or true, and precipitated together as the stable part of the whole experience-chaos, under the name of the physical world. Of this our perceptual experiences are the nucleus, they being the originally *strong* experiences. We add a lot of conceptual experiences to them, making these strong also in imagination, and building out the remoter parts of the physical world by their means; and around this core of reality the world of laxly connected fancies and mere rhapsodical objects floats like a bank of clouds. In the clouds, all sorts of rules are violated which in the core are kept. Extensions there can be indefinitely located; motion there obeys no Newton's laws.

VII.

There is a peculiar class of experiences to which, whether we take them as subjective or as objective, we *assign* their several natures as attributes, because in both contexts they affect their associates actively, though in neither quite as "strongly" or as sharply as things affect one another by their physical energies. I refer here to *appreciations*, which form an ambiguous sphere of being, belonging with emotion on the one hand, and having objective "value" on the other,

Eds.: The author's original spelling "esthetic" has been changed here and in other reprinted historical texts (e.g., Dewey); these and other minor changes in spelling and punctuation have been made for the purposes of consistency across this volume and in accordance with contemporary usage.

yet seeming not quite inner nor quite outer, as if a diremption had begun but had not made itself complete.

Experiences of painful objects, for example, are usually also painful experiences; perceptions of loveliness, of ugliness, tend to pass muster as lovely or as ugly perceptions; intuitions of the morally lofty are lofty intuitions. Sometimes the adjective wanders as if uncertain where to fix itself. Shall we speak of seductive visions or of visions of seductive things? Of wicked desires or of desires for wickedness? Of healthy thoughts or of thoughts of healthy objects? Of good impulses, or of impulses toward the good? Of feelings of anger, or of angry feelings? Both in the mind and in the thing, these natures modify their context, exclude certain associates and determine others, have their mates and incompatibles. Yet not as stubbornly as in the case of physical qualities, for beauty and ugliness, love and hatred, pleasant and painful can, in certain complex experiences, coexist.

If one were to make an evolutionary construction of how a lot of originally chaotic pure experiences became gradually differentiated into an orderly inner and outer world, the whole theory would turn upon one's success in explaining how or why the quality of an experience, once active, could become less so, and, from being an energetic attribute in some cases, elsewhere lapse into the status of an inert or merely internal "nature." This would be the "evolution" of the psychical from the bosom of the physical, in which the aesthetic, moral, and otherwise emotional experiences would represent a halfway stage.[16]

VIII.

But a last cry of *non possumus* will probably go up from many readers. "All very pretty as a piece of ingenuity," they will say, "but our consciousness itself intuitively contradicts you. We, for our part, *know* that we are conscious. We *feel* our thought, flowing as a life within us, in absolute contrast with the objects which it so unremittingly escorts. We can not be faithless to this immediate intuition. The dualism is a fundamental *datum*: Let no man join what God has put asunder."

My reply to this is my last word, and I greatly grieve that to many it will sound materialistic. I can not help that, however, for I, too, have my intuitions and I must obey them. Let the ease be what it may in others; I am as confident as I am of anything that, in myself, the stream of thinking (which I recognize emphatically as a phenomenon) is only a careless name for what, when scrutinized, reveals itself to consist chiefly of the stream of my breathing. The "I think" which Kant said must be able to accompany all my objects, is the "I breathe" which actually does accompany them. There are other internal facts besides breathing (intracephalic muscular adjustments, etc., of which I have said a word in my larger [*The Principles of*] *Psychology*), and these increase the assets of

"consciousness," so far as the latter, is subject to immediate perception, but breath, which was ever the original of "spirit," breath moving outward, between the glottis and the nostrils, is, I am persuaded, the essence out of which philosophers have constructed the entity known to them as consciousness. *That entity is fictitious, while thoughts in the concrete are fully real. But thoughts in the concrete are made of the same stuff as things are.*

I wish I might believe myself to have made that plausible in this article. In another article I shall try to make the general notion of a world composed of pure experiences still more clear.[17]

[17] Eds.: William James, "A World of Pure Experience," *The Journal of Philosophy Psychology and Scientific Methods* 1, nos. 20 and 21 (September 29 and October 13, 1904): 533–43 and 561–70.

VISUAL AND TACTUAL

Edmund Husserl

We find now a striking difference between the sphere of the visual and that of the tactual. In the tactual realm we have the *external Object*, tactually constituted, and a second Object, the *Body*, likewise tactually constituted, e.g., the touching finger, and, in addition, there are fingers touching fingers. So here we have that double apprehension: the same touch-sensation is apprehended as a feature of the "external" Object and is apprehended as a sensation of the Body as Object. And in the case in which a part of the Body becomes equally an external Object of an other part, we have the double sensation (each part has its own sensations) and the double apprehension as feature of the one or of the other Bodily part as a physical object. But in the case of an *Object constituted purely visually* we have *nothing* comparable. To be sure, sometimes it is said that the eye is, as it were, in touch with the Object by casting its glance over it. But we immediately sense the difference. An eye does not appear to one's own vision, and it is not the case that the colors which would appear visually on the eye as localized sensations (and indeed visually localized corresponding to the various parts of its visual appearance) would be the same as those attributed to the object in the apprehension of the seen external thing and Objectified in it as features. And similarly, we do not have a kind of extended occularity such that, by moving, one eye could rub past the other and produce the phenomenon of double sensation. Neither can we see the seen thing as gliding over the seeing eye, continually in contact with it, as we can, in the case of a real organ of touch, e.g., the palm of the hand, glide over the object or have the object slip past the hand. I do not see myself, my Body, the way I touch myself. What I call the seen Body is not something seeing which is seen, the way my Body as touched Body is something touching which is touched.[1] A visual appearance of an object that sees, i.e., one in which the sensation of light could be intuited just as it is in it—that is denied us. Thus what we are denied is an analogon to the touch sensation, which is actually grasped along with the touching hand. The role of the visual sensations in the correlative constitution of the Body and external things is thus different from that of the sensations of touch. All that we can say here is that if no eye is open there are no visual appearances, etc. If, ultimately, the eye as organ and, along with it, the visual sensations are in fact attributed to the Body, then that happens indirectly by means of the properly localized sensations.

Originally titled "Differences Between the Visual and Tactual Realms," this text is excerpted from Edmund Husserl, *Ideas Pertaining to a Pure Phenomenology and to a Phenomenological Philosophy, Second Book: Studies in the Phenomenology of Constitution*, translated by Richard Rojcewicz and André Schuwer (Dordrecht, The Netherlands: Kluwer Academic, 1989), 155–59; used by kind permission of Kluwer Academic Publishers. Husserl's *Second Book* cannot be securely dated to before the 1930s; while initially drafted around 1912, it was subsequently revised over many years by the author and his administrative assistant until his death in 1938, and it did not appear in print until the 1950s.

1

Obviously, it cannot be said that I see my eye in the mirror, for my eye, that which sees *qua* seeing, I do not perceive. I see something, of which I judge indirectly, by way of "empathy," that it is identical with my eye as a thing (the one constituted by touch, for example) in the same way that I see the eye of an other.

Actually, the eye, *too*, is a field of localization but *only for touch sensations*, and, like every organ "freely moved" by the subject, it is a field of localized muscle sensations. It is an Object of touch for the hand; it belongs originally to the merely touched, and not seen, Objects. "Originally" is not used here in a temporal-causal sense; it has to do with a primal group of Objects constituted directly in intuition. The eye can be touched, and it itself provides touch and kinetic sensations; that is why it is necessarily apperceived as belonging to the Body. All this is said from the standpoint of straightforward empirical intuition. The relation of the seen color of the thing to the seeing eye, the eye "with which" we see, the "being directed" of the open eye onto the seen thing, the reference back to this direction of the eye, which is part of having visual appearances, and, furthermore, growing out of this, the relation of the color sensations to the eye—all that will not be confused with the givenness of these sensations in the manner of localized "sensings."

The same applies to *hearing*. The ear is "involved," but the sensed tone is not localized in the ear. (I would not even say that the case of the "buzzing" in the ears and similar tones subjectively sensed in the ear are exceptions. They are in the ear just as tones of a violin are outside in space, but, for all that, they do not yet have the proper character of sensings and the localization proper to them.[2]) It would be an important task to thoroughly examine in this regard the groups of sensations of the various senses. However important that would be for a completely elaborated theory of the phenomenological constitution of material thinghood, on the one hand, and of the Body, on the other hand, for us now the broad distinctions will suffice. To make ourselves sure of them, we must be perfectly clear on the fact that *localization of sensings* is in fact something *in principle different from the extension of all material determinations of a thing*. The sensings do indeed spread out in space, cover, in their way, spatial surfaces, run through them, etc. But this *spreading out* and spreading into are precisely something that differs essentially from *extension* in the sense of all the determinations that characterize the *res extensa*. The sensing which spreads over the surface of the hand and extends into it is not a real quality of a thing (speaking always within the frame of intuitions and their givenness) such as, for example, the roughness of the hand, its color, etc. These real properties of a thing are constituted through a sensuous schema and manifolds of adumbrations. To speak in a similar way of sensings would be quite absurd. If I turn my hand, bring it closer or take it away, then, for one, the unchanged color of the hand is given to me as constantly different. Yet the color itself presents itself, and the color constituted first (that of the sensuous schema) manifests a real optical property of the hand. Roughness, too, presents itself and does so tactually in manifolds of touch sensations which constantly flow into one another and to each of which a spreading-out belongs. The touch-sensings, however, the sensations which, constantly varying, lie on the surface

[2] See [Edmund Husserl,] supplement III ["The localization of ear noise in the ear," *Ideas, Second Book*], 324.

of the touching finger, are, such as they are lying there spread out over the surface, nothing given through adumbration and schematization. They have nothing at all to do with the sensuous schema. The touch-sensing is not a *state* of the material thing, hand, but is precisely the *hand itself*, which for us is more than a material thing, and the way in which it is mine entails that I, the "subject of the Body," can say that what belongs to the material thing is its, not mine. All sensings pertain to my soul; everything extended to the material thing. *On* this surface of the hand I sense the sensations of touch, etc. And it is precisely thereby that this surface manifests itself immediately as my Body. One can add here as well: if I convince myself that a perceived thing does not exist, that I am subject to an illusion, then, along with the thing, everything extended in its extension is stricken out too. But the sensings do not disappear. Only what is *real* vanishes from being.

Connected to the privilege of the localization of the touch sensations are differences in the complexion of the visual-tactual apprehensions. Each thing that we see is touchable and, as such, points to an immediate relation to the Body, though it does not do so in virtue of its visibility. *A subject whose only sense was the sense of vision could not at all have an appearing Body*; in the play of kinesthetic motivations (which he could not apprehend Bodily) this subject would have appearances of things; he would see real things. It cannot be said that this subject who only sees his Body, for its specific distinctive feature as Body would be lacking him, and even the free movement of this "Body," which goes hand in hand with the freedom of the kinesthetic processes, would not make it a Body. In that case, it would only be as if the Ego, in unity with this freedom in the kinesthetic, could immediately and freely move the material *thing, Body.*

The Body as such can be constituted originarily only in tactuality and in everything that is localized with the sensations of touch: for example, warmth, coldness, pain, etc. Furthermore, the kinetic sensations play an important role. I see how my hand moves, and without it touching anything while moving, I sense kinetic sensations, though as one with sensations of tension and sensations of touch, and I localize them in the moving hand. And the same holds for all the members of the Body. If, while moving, I do touch something, then the touch sensation immediately acquires localization in the touching surface of the hand. At bottom, it is owing only to their constant interlacing with these primarily localized sensations that the kinetic sensations receive localization. But because there obtains here no parallelism which is exactly stratified as there is between temperature sensations and touch sensations, so the kinesthetic sensations do not spread out in a stratified way over the appearing extension, and they receive only a rather indeterminate localization. Yet this is indeed not without significance; it makes the unity between the Body and the freely moveable thing more intimate.

Obviously, the Body is also to be seen just like any other thing, but it becomes a *Body* only by incorporating tactile sensations, pain sensations, etc.—in short, by the localization of the sensations as sensations. In that case the visual Body also participates in the localization, because it coincides with the tactual Body, just as other things (or phantoms) coincide, ones which are constituted both visually and tactually, and thus there arises the idea of a sensing thing which "has" and which can have, under certain circumstances, certain sensations (sensations of touch, pressure, warmth, coldness, pain, etc.) and, in particular, have them as localized in itself primarily and properly. This is then a precondition for the existence of all sensations (and appearances) whatsoever, the visual and acoustic included, though these do not have a primary localization in the Body.

FIG. 1

HAVING AN EXPERIENCE

John Dewey

Experience occurs continuously, because the interaction of live creature and environing conditions is involved in the very process of living. Under conditions of resistance and conflict, aspects and elements of the self and the world that are implicated in this interaction qualify experience with emotions and ideas so that conscious intent emerges. Oftentimes, however, the experience had is inchoate. Things are experienced but not in such a way that they are composed into *an* experience. There is distraction and dispersion; what we observe and what we think, what we desire and what we get, are at odds with each other. We put our hands to the plow and turn back; we start and then we stop, not because the experience has reached the end for the sake of which it was initiated but because of extraneous interruptions or of inner lethargy.

In contrast with such experience, we have *an* experience when the material experienced runs its course to fulfillment. Then and then only is it integrated within and demarcated in the general stream of experience from other experiences. A piece of work is finished in a way that is satisfactory; a problem receives its solution; a game is played through; a situation, whether that of eating a meal, playing a game of chess, carrying on a conversation, writing a book, or taking part in a political campaign, is so rounded out that its close is a consummation and not a cessation. Such an experience is a whole and carries with it its own individualizing quality and self-sufficiency. It is *an* experience.

Philosophers, even empirical philosophers, have spoken for the most part of experience at large. Idiomatic speech, however, refers to experiences each of which is singular, having its own beginning and end. For life is no uniform uninterrupted march or flow. It is a thing of histories, each with its own plot, its own inception and movement toward its close, each having its own particular rhythmic movement, each with its own unrepeated quality pervading it throughout. A flight of stairs, mechanical as it is, proceeds by individualized steps, not by undifferentiated progression, and an inclined plane is at least marked off from other things by abrupt discreteness.

Experience in this vital sense is defined by those situations and episodes that we spontaneously refer to as being "real experiences," those things of which we say in recalling them, "that *was*

FIGURE 1
According to John Dewey, "A generalized illustration may be had if we imagine a stone, which is rolling down hill, to have an experience." Pictured here is a stone sacred to the Incas, on a hillside near a site called Moray (approximately 50 kilometers northwest of Cuzco on a high plateau), probably brought to the site from far away to "charge" the landscape. The Inca word for stone was in fact "flesh," the flesh of a god, and they aimed this stone at a mountain that was itself deified. Its precise meaning can no longer be known, but this stone doubtless added "intensity" to the ritual significance of the site. Photo and caption courtesy of Mark Jarzombek.

This text is excerpted from John Dewey, *Art as Experience*, as included in *John Dewey: The Later Works, 1925–1953*, vol. 10, 1934, edited by Jo Ann Boydston (Carbondale: Southern Illinois University Press, 1987), 35–57; used by kind permission of Southern Illinois University Press.

an experience." It may have been something of tremendous importance—a quarrel with one who was once an intimate, a catastrophe finally averted by a hair's breadth. Or it may have been something that in comparison was slight—and which perhaps, because of its very slightness, illustrates all the better what is to be an experience. There is that meal in a Paris restaurant of which one says "that *was* an experience." It stands out as an enduring memorial of what food may be. Then there is that storm one went through in crossing the Atlantic—the storm that seemed in its fury, as it was experienced, to sum up in itself all that a storm can be, complete in itself, standing out because marked out from what went before and what came after.

In such experiences, every successive part flows freely, without seam and without unfilled blanks, into what ensues. At the same time there is no sacrifice of the self-identity of the parts. A river, as distinct from a pond, flows. But its flow gives a definiteness and interest to its successive portions greater than exist in the homogenous portions of a pond. In an experience, flow is from something to something. As one part leads into another and as one part carries on what went before, each gains distinctness in itself. The enduring whole is diversified by successive phases that are emphases of its varied colors.

Because of continuous merging, there are no holes, mechanical junctions, and dead centers when we have *an* experience. There are pauses, places of rest, but they punctuate and define the quality of movement. They sum up what has been undergone and prevent its dissipation and idle evaporation. Continued acceleration is breathless and prevents parts from gaining distinction. In a work of art, different acts, episodes, occurrences melt and fuse into unity, and yet do not disappear and lose their own character as they do so—just as in a genial conversation there is a continuous interchange and blending, and yet each speaker not only retains his own character but manifests it more clearly than is his wont.

An experience has a unity that gives it its name, *that* meal, that storm, that rupture of friendship. The existence of this unity is constituted by a single *quality* that pervades the entire experience in spite of the variation of its constituent parts. This unity is neither emotional, practical, nor intellectual, for these terms name distinctions that reflection can make within it. In discourse *about* an experience, we must make use of these adjectives of interpretation. In going over an experience in mind *after* its occurrence, we may find that one property rather than another was sufficiently dominant so that it characterizes the experience as a whole. There are absorbing inquiries and speculations which a scientific man and philosopher will recall as "experiences" in the emphatic sense. In final import they are intellectual. But in their actual occurrence they were emotional as well; they were purposive and volitional. Yet the experience was not a sum of these different characters; they

were lost in it as distinctive traits. No thinker can ply his occupation save as he is lured and rewarded by total integral experiences that are intrinsically worthwhile. Without them he would never know what it is really to think and would be completely at a loss in distinguishing real thought from the spurious article. Thinking goes on in trains of ideas, but the ideas form a train only because they are much more than what an analytic psychology calls ideas. They are phases, emotionally and practically distinguished, of a developing underlying quality; they are its moving variations, not separate and independent like [John] Locke's and [David] Hume's so-called ideas and impressions, but are subtle shadings of a pervading and developing hue.

We say of an experience of thinking that we reach or draw a conclusion. Theoretical formulation of the process is often made in such terms as to conceal effectually the similarity of "conclusion" to the consummating phase of every developing integral experience. These formulations apparently take their cue from the separate propositions that are premises and the proposition that is the conclusion as they appear on the printed page. The impression is derived that there are first two independent and ready-made entities that are then manipulated so as to give rise to a third. In fact, in an experience of thinking, premises emerge only as a conclusion becomes manifest. The experience, like that of watching a storm reach its height and gradually subside, is one of continuous movement of subject matters. Like the ocean in the storm, there are a series of waves; suggestions reaching out and being broken in a clash, or being carried onward by a cooperative wave. If a conclusion is reached, it is that of a movement of anticipation and cumulation, one that finally comes to completion. A "conclusion" is no separate and independent thing; it is the consummation of a movement.

Hence *an* experience of thinking has its own aesthetic quality. It differs from those experiences that are acknowledged to be aesthetic, but only in its materials. The material of the fine arts consists of qualities; that of experience having intellectual conclusion are signs or symbols having no intrinsic quality of their own, but standing for things that may in another experience be qualitatively experienced. The difference is enormous. It is one reason why the strictly intellectual art will never be popular as music is popular. Nevertheless, the experience itself has a satisfying emotional quality because it possesses internal integration and fulfillment reached through ordered and organized movement. This artistic structure may be immediately felt. In so far, it is aesthetic. What is even more important is that not only is this quality a significant motive in undertaking intellectual inquiry and in keeping it honest, but that no intellectual activity is an integral event (is *an* experience), unless it is rounded out with this quality. Without it, thinking is inconclusive. In short, aesthetic cannot be sharply marked off from

intellectual experience since the latter must bear an aesthetic stamp to be itself complete.

The same statement holds good of a course of action that is dominantly practical, that is, one that consists of overt doings. It is possible to be efficient in action and yet not have a conscious experience. The activity is too automatic to permit a sense of what it is about and where it is going. It comes to an end but not to a close or consummation in consciousness. Obstacles are overcome by shrewd skill, but they do not feed experience. There are also those who are wavering in action, uncertain, and inconclusive like the shades in classic literature. Between the poles of aimlessness and mechanical efficiency, there lie those courses of action in which through successive deeds there runs a sense of growing meaning conserved and accumulating toward an end that is felt as accomplishment of a process. Successful politicians and generals who turn statesmen like Caesar and Napoleon have something of the showman about them. This of itself is not art, but it is, I think, a sign that interest is not exclusively, perhaps not mainly, held by the result taken by itself (as it is in the case of mere efficiency), but by it as the outcome of a process. There is interest in completing an experience. The experience may be one that is harmful to the world and its consummation undesirable. But it has aesthetic quality.

The Greek identification of good conduct with conduct having proportion, grace, and harmony, the *kalon-agathon,* is a more obvious example of distinctive aesthetic quality in moral action. One great defect in what passes as morality is its an-aesthetic quality. Instead of exemplifying wholehearted action, it takes the form of grudging piecemeal concessions to the demands of duty. But illustrations may only obscure the fact that any practical activity will, provided that it is integrated and moves by its own urge to fulfillment, have aesthetic quality.

A generalized illustration may be had if we imagine a stone, which is rolling down hill, to have an experience. The activity is surely sufficiently "practical." The stone starts from somewhere, and moves, as consistently as conditions permit, toward a place and state where it will be at rest—toward an end. Let us add, by imagination, to these external facts, the ideas that it looks forward with desire to the final outcome; that it is interested in the things it meets on its way, conditions that accelerate and retard its movement with respect to their hearing on the end; that it acts and feels toward them according to the hindering or helping function it attributes to them; and that the final coming to rest is related to all that went before as the culmination of a continuous movement. Then the stone would have an experience, and one with aesthetic quality.

If we turn from this imaginary case to our own experience, we shall find much of it is nearer to what happens to the actual stone than it is to anything that fulfills the conditions' fancy just laid down. For in much of our experience we are not concerned with

the connection of one incident with what went before and what comes after. There is no interest that controls attentive rejection or selection of what shall be organized into the developing experience. Things happen, but they are neither definitely included nor decisively excluded; we drift. We yield according to external pressure, or evade and compromise. There are beginnings and cessations, but no genuine initiations and concludings. One thing replaces another, but does not absorb it and carry it on. There is experience, but so slack and discursive that it is not *an* experience. Needless to say, such experiences are an-aesthetic.

Thus the non-aesthetic lies within two limits. At one pole is the loose succession that does not begin at any particular place and that ends—in the sense of ceasing—at no particular place. At the other pole is arrest, constriction, proceeding from parts having only a mechanical connection with one another. There exists so much of one and the other of these two kinds of experience that unconsciously they come to be taken as norms of all experience. Then, when the aesthetic appears, it so sharply contrasts with the picture that has been formed of experience that it is impossible to combine its special qualities with the features of the picture, and the aesthetic is given an outside place and status. The account that has been given of experience dominantly intellectual and practical is intended to show that there is no such contrast involved in having an experience; that, on the contrary, no experience of whatever sort is a unity unless it has aesthetic quality.

The enemies of the aesthetic are neither the practical nor the intellectual. They are the humdrum; slackness of loose ends; submission to convention in practice and intellectual procedure. Rigid abstinence, coerced submission, tightness on one side and dissipation, incoherence and aimless indulgence on the other, are deviations in opposite directions from the unity of an experience. Some such considerations perhaps induced Aristotle to invoke the "mean proportional" as the proper designation of what is distinctive of both virtue and the aesthetic. He was formally correct. "Mean" and "proportion" are, however, not self-explanatory, nor to be taken over in a prior mathematical sense, but are properties belonging to an experience that has a developing movement toward its own consummation.

I have emphasized the fact that every integral experience moves toward a close, an ending, since it ceases only when the energies active in it have done their proper work. This closure of a circuit of energy is the opposite of arrest, of *stasis*. Maturation and fixation are polar opposites. Struggle and conflict may be themselves enjoyed, although they are painful, when they are experienced as means of developing an experience; members in that they carry it forward, not just because they are there. There is, as will appear later, an element of undergoing, of suffering in its large sense, in every experience. Otherwise there would be no taking in of what preceded. For

"taking in" in any vital experience is something more than placing something on the top of consciousness over what was previously known. It involves reconstruction that may be painful. Whether the necessary undergoing phase is by itself pleasurable or painful is a matter of particular conditions. It is indifferent to the total aesthetic quality, save that there are few intense aesthetic experiences that are wholly gleeful. They are certainly not to be characterized as amusing, and as they bear down upon us they involve a suffering that is nonetheless consistent with, indeed a part of, the complete perception that is enjoyed.

I have spoken of the aesthetic quality that rounds out an experience into completeness and unity as emotional. The reference may cause difficulty. We are given to thinking of emotions as things as simple and compact as are the words by which we name them. Joy, sorrow, hope, fear, anger, curiosity, are treated as if each in itself were a sort of entity that enters full-made upon the scene, an entity that may last a long time or a short time, but whose duration, whose growth and career, is irrelevant to its nature. In fact emotions are qualities, when they are significant, of a complex experience that moves and changes. I say, when they are *significant,* for otherwise they are but the outbreaks and eruptions of a disturbed infant. All emotions are qualifications of a drama and they change as the drama develops. Persons are sometimes said to fall in love at first sight. But what they fall into is not a thing of that instant. What would love be were it compressed into a moment in which there is no room for cherishing and for solicitude? The intimate nature of emotion is manifested in the experience of one watching a play on the stage or reading a novel. It attends the development of a plot; and a plot requires a stage, a space, wherein to develop and time in which to unfold. Experience is emotional but there are no separate things called emotions in it.

By the same token, emotions are attached to events and objects in their movement. They are not, save in pathological instances, private. And even an "objectless" emotion demands something beyond itself to which to attach itself, and thus it soon generates a delusion in lack of something real. Emotion belongs of a certainty to the self. But it belongs to the self that is concerned in the movement of events toward an issue that is desired or disliked. We jump instantaneously when we are scared, as we blush on the instant when we are ashamed. But fright and shamed modesty are not in this case emotional states. Of themselves they are but automatic reflexes. In order to become emotional they must become parts of an inclusive and enduring situation that involves concern for objects and their issues. . . .

In every integral experience there is form because there is dynamic organization. I call the organization dynamic because it takes time to complete it, because it is a growth. There is inception, development, fulfillment. Material is ingested and digested through

interaction with that vital organization of the results of prior experience that constitutes the mind of the worker. Incubation goes on until what is conceived is brought forth and is rendered perceptible as part of the common world. An aesthetic experience can be crowded into a moment only in the sense that a climax of prior long enduring processes may arrive in an outstanding movement which so sweeps everything else into it that all else is forgotten. That which distinguishes an experience as aesthetic is conversion of resistance and tensions, of excitations that in themselves are temptations to diversion, into a movement toward an inclusive and fulfilling close.

Experiencing like breathing is a rhythm of intakings and outgivings. Their succession is punctuated and made a rhythm by the existence of intervals, periods in which one phase is ceasing and the other is inchoate and preparing. William James aptly compared the course of a conscious experience to the alternate flights and perchings of a bird. The flights and perchings are intimately connected with one another; they are not so many unrelated lightings succeeded by a number of equally unrelated hoppings. Each resting place in experience is an undergoing in which is absorbed and taken home the consequences of prior doing, and, unless the doing is that of utter caprice or sheer routine, each doing carries in itself meaning that has been extracted and conserved. As with the advance of an army, all gains from what has been already effected are periodically consolidated, and always with a view to what is to be done next. If we move too rapidly, we get away from the base of supplies—of accrued meanings—and the experience is flustered, thin, and confused. If we dawdle too long after having extracted a net value, experience perishes of inanition.

The *form* of the whole is therefore present in every member. Fulfilling, consummating, are continuous functions, not mere ends, located at one place only. An engraver, painter, or writer is in process of completing at every stage of his work. He must at each point retain and sum up what has gone before as a whole and with reference to a whole to come. Otherwise there is no consistency and no security in his successive acts. The series of doings in the rhythm of experience give variety and movement; they save the work from monotony and useless repetitions. The undergoings are the corresponding elements in the rhythm, and they supply unity; they save the work from the aimlessness of a mere succession of excitations. An object is peculiarly and dominantly aesthetic, yielding the enjoyment characteristic of aesthetic perception, when the factors that determine anything which can be called an experience are lifted high above the threshold of perception and are made manifest for their own sake.

EXPERIENCE PROCESS: SPACE POEMS

Renée Green

Welcoming the invitation to probe "experience" I thought about what I'd made and done. The invitation became a way to reflect. This led to a daily probe.

As probing experience is a facet of all of my work, I decided to focus on a particular aspect that continues to intrigue me, and one that I have felt compelled to make since 2007: the series *Space Poems*.[1]

Existing in a variety of spaces, *Space Poems* allow room for combining fragments of encounters, of diverse kinds. No claim is made for ownership regarding experience, as individuals can have their own encounters with a film, song, or book. The banners contain titles, names, words—all providing indications of what exists in the world at present. These hang in the air, people can circulate beneath and may look up to find these arrangements of words. If curiosity strikes it is possible to search online and elsewhere for a phrase or word to see what the search yields: a book, a song, or something else. Or these words can live on a page, in a graphic text or poem, where the reader may pore over or flip through them.

For my contribution to *Experience*, I selected and arranged images, texts, and an excerpt from my notes to indicate what the probe generated while I tested experiential possibilities over several months. The following pages help to capture some of the possibilities generated by this *Experience Process*.

Not knowing what is possible at present, or what can be known about particular things, is part of this encounter and the experience allowed by each of the *Space Poems*.

(FACING)
Installation view: *Space Poem #3 (Media Bicho)*, Museum of Modern Art, New York, 2013.

[1] At present, five Space Poems exist: *Space Poem #1* (2007: Galerie Christian Nagel, Berlin, Participant Inc., New York; 2010: Yerba Buena Center for the Arts, San Francisco); *Space Poem #2 (Laura's Words)* (2009: National Maritime Museum, Greenwich, U.K., Musée cantonal des Beaux-Arts, Lausanne; 2010: Yerba Buena Center for the Arts, San Francisco; 2015, Le Quartier, Centre d'Art Contemporaine de Quimper); *Space Poem #3 (Media Bicho)* (2012–2013: Museum of Modern Art, New York; 2015: Museum of Contemporary Art Chicago); *Space Poem #4* (2013: Palazzo delle Esposizioni, Rome, Galerie Thaddaeus Ropac, Paris); and *Space Poem #5 (Years & Afters)* (2015: MAK Center for Art + Architecture at the Schindler House, West Hollywood, CA).

I
AM
STILL
ALIVE

"I" AM STILL ALIVE

SPACE POEM #3 (MEDIA BICHO)

An island on the land
Which is of but not in
The experience of freedom
Which does and does not take place
Yes
Utopia and dissent
A power stronger than itself
For what is it to plan to believe
In the break
Grapefruit
Circles of confusion
Both insistent and unintelligible
The machinic unconscious
Under the skin
Haunted weather
The apperceiving mass
No island is an island
Blutopia
Prisoner of love
After the last sky
Terrible honesty
Symbiopsychotaxiplasm
Quincas Borba
Super Cannes
The varieties of religious experience
High Rise
Lanquidity
The motion of light in water
The curve of binding energy
The experimental exercise of liberty
Estruturação do self
The open work
Beyond a boundary
Nothing is

THE → experience
OF ↓
FREEDOM

PRISONER
OF
LOVE

AFTER
THE
LAST
SKY

TERRIBLE
HONEST
Y

Discovery but a fountain without source	Legend of mist and lost patience	The body swimming in itself
Matteo Ricci	*Georges Polti*	*Elvira Notari*
1887 1888 1889 1890 1891 1892 1893 1894 1895 1896	AFTER I AM DEAD DARLING	1897 1898 1899 1900 1901 1902 1903 1904 1905 1906

Is darling dissolution's	With dripping mouth it speaks a truth	That cannot lie, in words not born yet
Pier Paolo Pasolini	*Lina Bo Bardi*	*Félix Guattari*
AFTER MELVILLE	1907 1908 1909 1910 1911 1912 1913 1914 1915 1916	AFTER THEIR QUARREL

A CHRONICLe OF SOCIAL EXPERIMENTs

Experience Process: Space Poems

Page from Renée Green's notebook, March 23, 2015.

"Let me repeat once more that a man's vision is the great fact about him."
— William James, *A Pluralistic Universe*

"The doing may be energetic, and the undergoing may be acute and intense. But unless they are related to each other to form a whole perception, the thing is not fully aesthetic."
— John Dewey, *Art as Experience*

"If, however, experience is evidence, how can one ever study the experience of the other? For the experience of the other is not evident to me, as it is not and never can be an experience of mine."

"Experience is invisible to the other."
— R. D. Laing, *The Politics of Experience*

"A phenomenologically inclined cognitive scientist reflecting on the origins of cognition might reason thus: Minds awaken in a world. We did not design our world. We simply found ourselves with it; we awoke both to ourselves and to the world we inhabit. We come to reflect on that world as we grow and live. We reflect on a world that is not made, but found, and yet it is also our structure that enables us to reflect upon this world. Thus in reflection we find ourselves in a circle: we are in a world that seems to be there before reflection begins, but that world is not separate from us."
— Francisco J. Varela, Evan Thompson, and Eleanor Rosch, *The Embodied Mind: Cognitive Science and Human Experience*

EXPERIENCE BOOK

Michel Foucault
with Duccio Trombadori

DUCCIO TROMBADORI: From the exploration of fundamental forms of experience in *Madness and Civilization* to the most recent arguments put forward in the first volume of *The History of Sexuality*, it seems that you've proceeded by leaps, by shifts from one level of inquiry to another. If I wanted to draw up an account of the essential elements and points of continuity of your thought, I might begin by asking you what you see as superseded in your previous writings, in light of your recent studies on power and the will to know.

MICHEL FOUCAULT: Many things have been superseded, certainly. I'm perfectly aware of always being on the move in relation both to the things I'm interested in and to what I've already thought. What I think is never quite the same, because for me my books are experiences, in a sense, that I would like to be as full as possible. An experience is something that one comes out of transformed. If I had to write a book to communicate what I'm already thinking before I begin to write, I would never have the courage to begin. I write a book only because I still don't exactly know what to think about this thing I want so much to think about, so that the book transforms me and transforms what I think. Each book transforms what I was thinking when I was finishing the previous book. I am an experimenter and not a theorist. I call a theorist someone who constructs a general system, either deductive or analytical, and applies it to different fields in a uniform way. That isn't my case. I'm an experimenter in the sense that I write in order to change myself and in order not to think the same thing as before.

DT: In any case, the idea of a work as an experience should suggest a methodological reference point or at least offer the possibility of getting some ideas about method from the relation between the means you use and the results you arrive at in the research.

MF: When I begin a book, not only do I not know what I'll be thinking at the end, but it's not very clear to me what method I will employ. Each of my books is a way of carving out an object and of fabricating a method of analysis. Once my work is finished, through a kind of retrospective reflection on the experience I've just gone through, I can extrapolate the method the book ought to have followed—so that I write books I would call exploratory somewhat in alternation with books of method. Exploratory books: *Madness and Civilization, The Birth of the Clinic*, and so on. Method books: *The Archaeology of Knowledge*. Then I wrote things like *Discipline and Punish*, and the introduction to *The History of Sexuality*.

I also put forward some thoughts on method in articles and interviews. These tend to be reflections on a finished book that may help me to define another possible project. They are something like a scaffolding that serves as a link between a work that is coming to an end and another one that's about to begin. But this is not to state a general method that would be definitively valid for others or for myself. What I've written is never prescriptive either for me or for others—at most it's instrumental and tentative.

DT: What you're saying confirms the eccentric aspect of your position and, in a certain sense, explains the difficulties that critics, commentators, and exegetes have encountered in their

This text is adapted from "Interview with Michel Foucault," conducted by Duccio Trombadori in 1978 and first published in the Italian journal *Il Contributo* in 1980. This English translation is by Robert Hurley, courtesy of James D. Faubion, editor, and Paul Rabinow, series editor, *The Essential Works of Foucault*, vol. 3 (New York: The New Press, 2000), 238–46; used by kind permission of the New Press and Editions Gallimard.

attempts to systematize your work or to assign you a precise position in contemporary philosophical thought.

MF: I don't regard myself as a philosopher. What I do is neither a way of doing philosophy nor a way of discouraging others from doing philosophy. The most important authors who—I won't say shaped my thinking but enabled me to deviate from my university training—were people like Georges Bataille, Friedrich Nietzsche, Maurice Blanchot, and Pierre Klossowski, who were not philosophers in the institutional sense of the term. There were also a certain number of personal experiences, of course. What struck me and fascinated me about those authors, and what gave them their capital importance for me, was that their problem was not the construction of a system but the construction of a personal experience. At the university, by contrast, I had been trained, educated, driven to master those great philosophical machines called Hegelianism, phenomenology.

DT: You speak of phenomenology, but all phenomenological thought is centered on the problem of experience and depends on it for tracing its own theoretical horizon. What sets you apart from it, then?

MF: The phenomenologist's experience is basically a certain way of bringing a reflective gaze to bear on some object of "lived experience," on the everyday in its transitory form, in order to grasp its meanings. For Nietzsche, Bataille, Blanchot, on the other hand, experience is trying to reach a certain point in life that is as close as possible to the "unlivable," to that which can't be lived through. What is required is the maximum of intensity and the maximum of impossibility at the same time. By contrast, phenomenological work consists in unfolding the field of possibilities related to everyday experience.

Moreover, phenomenology attempts to recapture the meaning of everyday experience in order to rediscover the sense in which the subject that I am is indeed responsible, in its transcendental functions, for founding that experience together with its meanings. On the other hand, in Nietzsche, Bataille, and Blanchot, experience has the function of wrenching the subject from itself, of seeing to it that the subject is no longer itself, or that it is brought to its annihilation or its dissolution. This is a project of desubjectivation.

The idea of a limit-experience that wrenches the subject from itself is what was important to me in my reading of Nietzsche, Bataille, and Blanchot, and what explains the fact that however boring, however erudite my books may be, I've always conceived of them as direct experiences aimed at pulling myself free of myself, at preventing me from being the same.

DT: If I understand what you're saying, the three essential aspects of your intellectual attitude are: work as a constantly evolving experience, an extreme relativity of method, and a tension with regard to subjectivation. Given this set of factors, one wonders what would give credibility to the results of an inquiry, and what truth criterion might be consistent with the premises of your thinking.

MF: The problem of the truth of what I say is a very difficult one for me; in fact, it's the central problem. That's the question I still haven't answered. And yet I make use of the most conventional methods: demonstration or, at any rate, proof in historical matters, textual references, citation of authorities, drawing connections between texts and facts, suggesting schemes of intelligibility, offering different types of explanation. There is nothing original in what I do. From this standpoint, what I say in my books can be verified or invalidated in the same way as any other book of history.

In spite of that, the people who read me—particularly those who value what I do—often tell me with a laugh, "You know very well that what you say is really just fiction." I always reply, "Of course, there's no question of it being anything else but fiction."

If I had wanted, for example, to do the history of psychiatric institutions in Europe between the 17th and 18th centuries, obviously I wouldn't have written a book like *Madness and Civilization*. But my problem is not to satisfy professional

historians; my problem is to construct myself, and to invite others to share an experience of what we are, not only our past but also our present, an experience of our modernity in such a way that we might come out of it transformed. Which means that at the end of a book we would establish new relationships with the subject at issue: the I who wrote the book and those who have read it would have a different relationship with madness, with its contemporary status, and its history in the modern world.

DT: The efficacy of your discourse depends on the balance between the power of proof and the ability to connect us with an experience leading to a change of the cultural horizons against which we judge and live our present. I still don't understand what, in your view, this process has to do with the "truth criterion," as we called it earlier. That is, how are the transformations you speak of related to truth, how is it that they produce truth effects?

MF: There is a peculiar relationship between the things I've written and the effects they've produced. Look at what happened to *Madness and Civilization*: it was very well received by people such as Maurice Blanchot, Roland Barthes, and so on; it was received, in a first phase, with a bit of curiosity and a certain sympathy by psychiatrists, and completely ignored by historians, who had no interest in such things. Then, rather quickly, the psychiatrists' hostility grew to the extent that the book was judged as an attack on present-day psychiatry and a manifesto of antipsychiatry. But that was absolutely not my intention, for at least two reasons. When I wrote the book, in Poland in 1958, antipsychiatry didn't exist in Europe, and in any case it wasn't an attack on psychiatry for the very good reason that the book stops at the very start of the 19th century—I don't even fully examine the work of [Jean-]Étienne Esquirol. Despite all this, the book has continued to figure in the public mind as being an attack on contemporary psychiatry. Why? Because for me—and for those who read it and used it—the book constituted a transformation in the historical, theoretical, and moral or ethical relationship we have with madness, the mentally ill, the psychiatric institution, and the very truth of psychiatric discourse. So it's a book that functions as an experience, for its writer and reader alike, much more than as the establishment of a historical truth. For one to be able to have that experience through the book, what it says does need to be true in terms of academic, historically verifiable truth. It can't exactly be a novel. Yet the essential thing is not in the series of those true or historically verifiable findings but, rather, in the experience that the book makes possible. Now, the fact is, this experience is neither true nor false. An experience is always a fiction: it's something that one fabricates oneself, that doesn't exist before and will exist afterward. That is the difficult relationship with truth, the way in which the latter is bound up with an experience that is not bound to it and, in some degree, destroys it.

DT: Is this difficult relationship with truth a constant that accompanies your research and can be recognized also in the works after *Madness and Civilization*?

MF: The same thing could be said about *Discipline and Punish*. The investigation ends at the 1830s. Yet in this case as well, readers, critical or not, perceived it as a description of contemporary society as a society of confinement. I never wrote that, though it's true that its writing was connected with a certain experience of our modernity. The book makes use of true documents, but in such a way that through them it is possible not only to arrive at an establishment of truth but also to experience something that permits a change, a transformation of the relationship we have with ourselves and with the world where, up to then, we had seen ourselves as being without problems —in short, a transformation of the relationship we have with our knowledge.

So this game of truth and fiction—or if your prefer, of verification and fabrication—will bring to light something which connects us, sometimes in a completely unconscious way, with our modernity, while at the same time causing it to appear as changed. The experience through which we grasp the intelligibility of certain mechanisms (for example, imprisonment, punishment, and

so on) and the way in which we are enabled to detach ourselves from them by perceiving them differently will be, at best, one and the same thing. That is really the heart of what I do. What consequences or implications does that have? The first is that I don't depend on a continuous and systematic body of background data; the second is that I haven't written a single book that was not inspired, at least in part, by a direct personal experience. I've had a complex personal relationship with madness and with the psychiatric institution. I've also had a certain relationship with illness and death. I wrote about the birth of the clinic and the introduction of death into medical knowledge at a time when those things had a certain importance for me. The same is true of prison and sexuality, for different reasons.

A third implication: it's not at all a matter of transporting personal experiences into knowledge. In the book, the relationship with the experience should make possible a transformation, a metamorphosis, that is not just mine but can have a certain value, a certain accessibility for others, so that the experience is available for others to have.

Fourth and last: this experience must be capable of being linked in some measure to a collective practice, to a way of thinking. That's what happened, for example, with a movement like antipsychiatry, or with the prisoners' movement in France.

DT: When you show or, as you say, when you open the way to a "transformation" capable of being connected with a "collective practice," I already perceive the outline of a methodology or a particular type of teaching. . . .

MF: I don't accept the word "teaching." A systematic book employing a generalizable method or offering the demonstration of a theory would convey lessons. My books don't exactly have that particular value. They are more like invitations or public gestures.

DT: But shouldn't a collective practice be related to values, to criteria, to behaviors that would go beyond individual experience?

MF: An experience is something that one has completely alone but can fully have only to the extent that it escapes pure subjectivity and that others can also—I won't say repeat it exactly, but at least encounter it—and go through it themselves. Let's go back for a moment to the book on prisons. In a certain sense, it's a book of pure history. But the people who liked it or hated it felt that way because they had the impression that the book concerned them or concerned the purely contemporary world, or their relations with the contemporary world, in the forms in which it is accepted by everyone. They sensed that something in present-day reality was being called into question. And, as a matter of fact, I only began to write that book after having participated for several years in working groups that were thinking about and struggling against penal institutions. This was a complicated, difficult work carried out in association with prisoners, their families, prison staff, magistrates, and others.

When the book came out, different readers—in particular, correctional officers, social workers, and so on—delivered this peculiar judgment: "The book is paralyzing. It may contain some correct observations, but even so it has clear limits, because it impedes us; it prevents us from going on with our activity." My reply is that this very reaction proves that the work was successful, that it functioned just as I intended. It shows that people read it as an experience that changed them, that prevented them from always being the same or from having the same relation with things, with others, that they had before reading it. This shows that an experience is expressed in the book which is wider than mine alone. The readers have simply found themselves involved in a process that was under way we could say, in the transformation of contemporary man with respect to the idea he has of himself. And the book worked toward that transformation. To a small degree, it was even an agent in it. That is what I mean by an experience book, as opposed to a truth book or a demonstration book.

HISTORICIZING EXPERIENCE

Joan W. Scott

I.

The problem of writing the history of difference, the history, that is, of the designation of "other," of the attribution of characteristics that distinguish categories of people from some presumed (and usually unstated) norm, often involves metaphors of visibility. The history of difference is a history of multiplicity, of varieties of experience that may have been hitherto silenced or hidden from history. Visibility becomes a metaphor for literal transparency. Knowledge is gained through vision; vision is a direct apprehension of a world of transparent objects. In this conceptualization, the visible is privileged; writing is then put at its service.[1] Seeing is the origin of knowing. Writing is reproduction, transmission—the communication of knowledge gained through (visual, visceral) experience.

This kind of communication has long been the mission of historians documenting the lives of those omitted or overlooked in accounts of the past. It has produced a wealth of new evidence previously ignored about these others and has drawn attention to dimensions of human life and activity usually deemed unworthy of mention in conventional histories. It has also occasioned a crisis for orthodox history, by multiplying not only stories, but subjects, and by insisting that histories are written from fundamentally different—indeed irreconcilable—perspectives or standpoints, no one of which is complete or completely "true." Such histories have provided evidence for a world of alternative values and practices whose existence gives the lie to hegemonic constructions of social worlds, whether these constructions vaunt the political superiority of white men, the coherence and unity of selves, the naturalness of heterosexual monogamy, or the inevitability of scientific progress and economic development. The challenge to normative history has been described in terms of conventional historical understandings of evidence: as an enlargement of the picture, a corrective to oversights resulting from inaccurate or incomplete vision, and it has rested its claim to legitimacy on the authority of experience, the direct experience of others, as well as of the historian who learns to see and illuminate the lives of those others in his or her texts.

Documenting the experience of others in this way has been at once a highly successful and limiting strategy for historians of difference. It has been successful because it remains so comfortably

This text is adapted from Joan W. Scott, "The Evidence of Experience," *Critical Inquiry* 17, no. 4 (Summer 1991): 773–97; used by kind permission of the author.

[1] The publication of Samuel R. Delany's memoir, *The Motion of Light in Water: Sex and Science Fiction Writing in the East Village, 1957–1965* (New York: Open Road, 1988), was crucial to the development of these ideas on visibility. On the distinction between seeing and writing in formulations of identity, see Homi K. Bhabha, "Interrogating Identity," in *Identity: The Real Me*, ed. Lisa Appignanesi (London: ICA Document 6, 1987), 5–11.

within the disciplinary framework of history, working according to rules which permit calling old narratives into question when new evidence is discovered. The status of evidence is, of course, ambiguous for historians. On the one hand, they acknowledge that "evidence only counts as evidence and is only recognized as such in relation to a potential narrative, so that the narrative can be said to determine the evidence as much as the evidence determines the narrative."[2] On the other hand, their rhetorical treatment of evidence, and their use of it to falsify prevailing interpretations, depends on a referential notion of evidence which denies that it is anything but a reflection of the real.[3]

When the evidence offered is the evidence of "experience," the claim for referentiality is further buttressed—what could be truer after all, than a subject's own account of what he or she has lived through? It is precisely this kind of appeal to experience as uncontestable evidence and as an originary point of explanation—as a foundation upon which analysis is based—that weakens the critical thrust of histories of difference. By remaining within the epistemological frame of orthodox history, these studies lose the possibility of examining those assumptions and practices that excluded considerations of difference in the first place. They take as self-evident the identities of those whose experience is being documented and thus naturalize their difference. They locate resistance outside its discursive construction and reify agency as an inherent attribute of individuals, thus decontextualizing it. When experience is taken as the origin of knowledge, the vision of the individual subject (the person who had the experience or the historian who recounts it) becomes the bedrock of evidence on which explanation is built. Questions about the constructed nature of experience, about how subjects are constituted as different in the first place, about how one's vision is structured—about language (or discourse) and history—are left aside. The evidence of experience then becomes evidence for the fact of difference, rather than a way of exploring how difference is established, how it operates, how and in what ways it constitutes subjects who see and act in the world.[4]

To put it another way, the evidence of experience, whether conceived through a metaphor of visibility or in any other way that takes meaning as transparent, reproduces rather than contests given ideological systems—those that assume that the facts of history speak for themselves and those that rest on notions of a natural or established opposition between, say, sexual practices and social conventions, or between homosexuality and heterosexuality. Histories that document the "hidden" world of homosexuality, for example, show the impact of silence and repression on the lives of those affected by it and bring to light the history of their suppression and exploitation. But the project of making experience visible precludes critical examination of the workings of the ideological system itself, its categories of representation (homosexual/

[2] Lionel Gossman, *Towards a Rational Historiography; Transactions of the American Philosophical Society*, vol. 79, part 3 (Philadelphia: American Philosophical Society, 1989), 26.

[3] On the "documentary" or "objectivist" model used by historians, see Dominick LaCapra, "Rhetoric and History," *History and Criticism* (Ithaca, NY: Cornell University Press, 1985), 15–44.

[4] Vision, as Donna Haraway points out, is not passive reflection: "All eyes, including our own organic ones, are active perceptual systems, building in translations and specific ways of seeing—that is, ways of life." (Donna Haraway, "Situated Knowledges: The Science Question in Feminism and the Privilege of Partial Perspective," *Feminist Studies* 14 [Fall 1988]: 583). In another essay she pushes the optical metaphor further: "The rays from my optical device diffract rather than reflect. These diffracting rays compose interference patterns, not reflecting images.... A diffraction pattern does not map where differences appear, but rather where the effects of differences appear." (Donna Haraway, "The Promises of Monsters: A Regenerative Politics for Inappropriate/d Others," in *Cultural Studies*, ed. Lawrence Grossberg, Cary Nelson, and Paula A. Treichler (New York: Routledge, 1992), 295–337). In this connection, see also Minnie Bruce Pratt's discussion of her eye that "has only let in what I have been taught to see," in her "Identity: Skin Blood Heart," in Elly Bulkin, Minnie Bruce Pratt, and Barbara Smith, *Yours in Struggle: Three Feminist Perspectives on Anti-Semitism and Racism* (New York: Firebrand Books 1984), and the analysis of Pratt's autobiographical essay by Biddy Martin and Chandra Talpade Mohanty, "Feminist Politics: What's Home Got to Do with It?" in *Feminist Studies/Critical Studies*, ed. Teresa de Lauretis (Bloomington: Indiana University Press, 1986), 191–212.

[5] I am grateful to Judith Butler for discussions on this point.

heterosexual, man/woman, black/white as fixed immutable identities), its premises about what these categories mean and how they operate, and of its notions of subjects, origin, and cause.

The project of making experience visible precludes analysis of the workings of this system and of its historicity; instead, it reproduces its terms. We come to appreciate the consequences of the closeting of homosexuals, and we understand repression as an interested act of power or domination; alternative behaviors and institutions also become available to us. What we don't have is a way of placing those alternatives within the framework of (historically contingent) dominant patterns of sexuality and the ideology that supports them. We know they exist, but not how they have been constructed; we know their existence offers a critique of normative practices, but not the extent of the critique. Making visible the experience of a different group exposes the existence of repressive mechanisms, but not their inner workings or logics; we know that difference exists, but we don't understand it as relationally constituted. For that we need to attend to the historical processes that, through discourse, position subjects and produce their experiences. It is not individuals who have experience, but subjects who are constituted through experience. Experience in this definition then becomes not the origin of our explanation, not the authoritative (because seen or felt) evidence that grounds what is known, but rather that which we seek to explain, that about which knowledge is produced.

To think about experience in this way is to historicize it as well as to historicize the identities it produces. This kind of historicizing represents a reply to the many contemporary historians who have argued that an unproblematized "experience" is the foundation of their practice; it is a historicizing that implies critical scrutiny of all explanatory categories usually taken for granted, including the category of "experience."

II.

History has been largely a foundationalist discourse. By this I mean that its explanations seem to be unthinkable if they do not take for granted some primary premises, categories, or presumptions. These foundations (however varied, whatever they are at a particular moment) are unquestioned and unquestionable; they are considered permanent and transcendent. As such they create a common ground for historians and their objects of study in the past and so authorize and legitimize analysis; indeed, analysis seems not to be able to proceed without them.[5] In the minds of some foundationalists, in fact, nihilism, anarchy, and moral confusion are the sure alternatives to these givens, which have the status (if not the philosophical definition) of eternal truths. Historians have had recourse to many kinds of foundations, some more obviously empiricist than others. What is most striking these days is the determined embrace, the strident defense, of some reified, transcendent category of explanation by

historians who have used insights drawn from the sociology of knowledge, structural linguistics, feminist theory, or cultural anthropology to develop sharp critiques of empiricism. This turn to foundations even by antifoundationalists appears, in Fredric Jameson's characterization, as "some extreme form of the return of the repressed."[6]

"Experience" is one of the foundations that has been reintroduced into historical writing in the wake of the critique of empiricism; unlike "brute fact" or "simple reality," its connotations are more varied and elusive. It has recently emerged as a critical term in debates among historians about the limits of interpretation and especially about the uses and limits of poststructuralist theory for history. The evocation of "experience" appears to solve a problem of explanation for professed anti-empiricists even as it reinstates a foundational ground. For this reason it is interesting to examine the uses of "experience" by historians. Such an examination allows us to ask whether history can exist without foundations, and what it might look like if it did.

In *Keywords: A Vocabulary of Culture and Society*, Raymond Williams sketches the alternative senses in which the term experience has been employed in the Anglo-American tradition. These he summarizes as "(1) knowledge gathered from past events, whether by conscious observation or by consideration and reflection; and (2) a particular kind of consciousness, which can in some contexts be distinguished from 'reason' or 'knowledge.'"[7] Until the early 18th century, he says, experience and experiment were closely connected terms, designating how knowledge was arrived at through testing and observation (here the visual metaphor is important). In the 18th century, experience still contained this notion of consideration or reflection on observed events, of lessons gained from the past, but it also referred to a particular kind of consciousness. This consciousness, in the 20th century, has come to mean a "full and active 'awareness,'" including feeling as well as thought.[8] The notion of experience as subjective witness, writes Williams, is "offered not only as truth, but as the most authentic kind of truth," as "the ground for all (subsequent) reasoning and analysis."[9] According to Williams, experience has acquired another connotation in the 20th century different from these notions of subjective testimony as immediate, true, and authentic. In this usage it refers to influences external to individuals—social conditions, institutions, forms of belief or perception—"real" things outside them that they react to, and does not include their thought or consideration.[10]

In the various usages described by Williams, "experience," whether conceived as internal or external, subjective or objective, establishes the prior existence of individuals. When it is defined as internal, it is an expression of an individual's being or consciousness; when external, it is the material on which consciousness then acts. Talking about experience in these ways leads us to take the

[6] Fredric Jameson, "Immanence and Nominalism in Postmodern Theory," *Postmodernism, or, the Cultural Logic of Late Capitalism* (Durham, NC: Duke University Press, 1991), 199.

[7] Raymond Williams, *Keywords: A Vocabulary of Culture and Society*, rev. ed. (New York: Oxford University Press, 1985), 126.

[8] Ibid., 127.

[9] Ibid., 128.

[10] On the ways knowledge is conceived "as an assemblage of accurate representations," see Richard Rorty, *Philosophy and the Mirror of Nature* (Princeton, NJ: Princeton University Press, 1979), 163.

existence of individuals for granted (experience is something people have) rather than to ask how conceptions of selves (of subjects and their identities) are produced.[11] It operates within an ideological construction that not only makes individuals the starting point of knowledge, but that also naturalizes categories such as man, woman, black, white, heterosexual, and homosexual by treating them as given characteristics of individuals. Teresa de Lauretis's redefinition of experience exposes the workings of this ideology: Experience is "a *process* by which, for all social beings, subjectivity is constructed. Through that process one places oneself or is placed in social reality, and so perceives and comprehends as subjective (referring to, originating in, oneself) those relations—material, economic, and interpersonal—which are in fact social and, in a larger perspective, historical."[12] The process that de Lauretis describes operates crucially through differentiation; its effect is to constitute subjects as fixed and autonomous, and who are considered reliable sources of a knowledge that comes from access to the real by means of their experience.[13] When talking about historians and other students of the human sciences, it is important to note that this subject is both the object of inquiry—the person one studies in the present or the past—and the investigator him- or herself—the historian who produces knowledge of the past based on "experience" in the archives or the anthropologist who produces knowledge of other cultures based on "experience" as a participant observer.

The concepts of experience described by Williams preclude inquiry into processes of subject-construction, and they avoid examining the relationships between discourse, cognition, and reality, the relevance of the position or situatedness of subjects to the knowledge they produce, and the effects of difference on knowledge. Questions are not raised about, for example, whether it matters for the history they write that historians are men, women, white, black, straight, or gay; instead, as [Michael] de Certeau writes, "the authority of the 'subject of knowledge' [is measured] by the elimination of everything concerning the speaker."[14] His knowledge, reflecting as it does something apart from him, is legitimated and presented as universal, accessible to all. There is no power or politics in these notions of knowledge and experience.

An example of the way "experience" establishes the authority of an historian can be found in R. G. Collingwood's *The Idea of History*, the 1946 classic that has been required reading in historiography courses for several generations. For Collingwood, the ability of the historian to reenact past experience is tied to his autonomy, "where by autonomy I mean the condition of being one's own authority, making statements or taking action on one's own initiative and not because those statements or actions are authorized or prescribed by anyone else."[15] The question of where the historian is situated—who he is, how he is defined in relation to others, what the political effects of his history may be—never enters the discussion. Indeed, being free

[11] Bhabha puts it this way: "To see a missing person, or to look at Invisibleness, is to emphasize the subject's transitive demand for a direct object of self-reflection; a point of presence which would maintain its privileged enunciatory position *qua* subject" (Bhabha, "Interrogating Identity," 5).

[12] Teresa de Lauretis, *Alice Doesn't* (Bloomington: Indiana University Press, 1984), 159.

[13] Spivak describes this as "positing a metalepsis," or "the substitution of an effect for a cause." See Gayatri Chakravorty Spivak, *In Other Worlds: Essays in Cultural Politics* (New York: Routledge, 1987), 204.

[14] Michel de Certeau, "History: Science and Fiction," in *Heterologies: Discourse on the Other*, trans. Brian Massumi (Minneapolis: University of Minnesota Press, 1986), 218.

[15] R. G. Collingwood, *The Idea of History* (Oxford: Oxford University Press, 1946), 1961 edition, 274–75.

of these matters seems to be tied to Collingwood's definition of autonomy, an issue so critical for him that he launches into an uncharacteristic tirade about it. In his quest for certainty, the historian must not let others make up his mind for him, Collingwood insists, because to do that means

> giving up his autonomy as an historian and allowing someone else to do for him what, if he is a scientific thinker, he can only do for himself. There is no need for me to offer the reader any proof of this statement. If he knows anything of historical work, he already knows of his own experience that it is true. If he does not already know that it is true, he does not know enough about history to read this essay with any profit, and the best thing he can do is to stop here and now.[16]

For Collingwood it is axiomatic that experience is a reliable source of knowledge because it rests on direct contact between the historian's perception and reality (even if the passage of time makes it necessary for the historian to imaginatively reenact events of the past). Thinking on his own means owning his own thoughts, and this proprietary relationship guarantees an individual's independence, his ability to read the past correctly, and the authority of the knowledge he produces. The claim is not only for the historian's autonomy, but also for his originality. Here "experience" grounds the identity of the researcher as an historian.

Another, very different use of "experience" can be found in E. P. Thompson's *Making of the English Working Class*, the book that revolutionized social and labor history. Thompson specifically set out to free the concept of "class" from the ossified categories of Marxist structuralism. For this project "experience" was a key concept. His notion of experience joined ideas of external influence and subjective feeling, the structural and the psychological. This gave him a mediating influence between social structure and social consciousness. For him experience meant "social being"—the lived realities of social life, especially the affective domains of family and religion and the symbolic dimensions of expression. This definition separated the affective and the symbolic from the economic and the rational. "People do not only experience their own experience as ideas, within thought and its procedures," he maintained, "they also experience their own experience as *feeling*."[17] This statement grants importance to the psychological dimension of experience, and it allows Thompson to account for agency. Feeling, Thompson insists, is "handled" culturally as "norms, familial and kinship obligations and reciprocities, as values or (through more elaborated forms) within art and religious beliefs."[18] At the same time it somehow precedes these forms of expression and so provides an escape from a strong structural determination: "For any living generation, in any 'now,'" Thompson

[16] Ibid., 256.

[17] E. P. Thompson, "The Poverty of Theory or an Orrery of Errors," *The Poverty of Theory and Other Essays* (New York: New York University Press, 1978), 171.

[18] Ibid.

asserts, "the ways in which they 'handle' experience defies prediction and escapes from any narrow definition of determination."[19]

And yet in his use of it, experience, because it is ultimately shaped by relations of production, is a unifying phenomenon, overriding other kinds of diversity. Since these relations of production are common to workers of different ethnicities, religions, regions, and trades, they necessarily provide a common denominator and emerge as a more salient determinant of "experience" than anything else. In Thompson's use of the term, experience is the start of a process that culminates in the realization and articulation of social consciousness, in this case a common identity of class. It serves an integrating function, joining the individual and the structural and bringing together diverse people into that coherent (totalizing) whole which is a distinctive sense of class.

The unifying aspect of experience excludes whole realms of human activity by simply not counting them as experience, at least not with any consequences for social organization or politics. When class becomes an overriding identity, other subject-positions are subsumed by it, those of gender, for example (or, in other instances of this kind, of history, race, ethnicity, and sexuality). The positions of men and women and their different relationships to politics are taken as reflections of material and social arrangements rather than as products of class politics itself.

In Thompson's account class is finally an identity rooted in structural relations that preexist politics. What this obscures is the contradictory and contested process by which class itself was conceptualized and by which diverse kinds of subject-positions were assigned, felt, contested, or embraced. As a result, Thompson's brilliant history of the English working class, which set out to historicize the category of class, ends up essentializing it. The ground may seem to be displaced from structure to agency by insisting on the subjectively felt nature of experience, but the problem Thompson sought to address isn't really solved. Working-class "experience" is now the ontological foundation of working-class identity, politics, and history.[20]

This kind of use of experience has the same foundational status if we substitute women or African American or lesbian or homosexual for working class in the previous sentence. Among feminist historians, for example, "experience" has helped to legitimize a critique of the false claims to objectivity of traditional historical accounts. Part of the project of some feminist history has been to unmask all claims to objectivity as an ideological cover for masculine bias by pointing out the shortcomings, incompleteness, and exclusiveness of mainstream history. This has been achieved by providing documentation about women in the past that calls into question existing interpretations made without consideration of gender. But how do we authorize the new knowledge if the possibility of all historical objectivity has been questioned? By appealing

19 Ibid. Note that Williams's discussion of "structures of feeling" takes on some of these same issues in a more extended way. See Raymond Williams, *The Long Revolution* (London: Chatto and Windus, 1961), and the interview about it in his *Politics and Letters: Interviews with New Left Review* (London: Verso, 1981), originally published 1979, 133–74. I am grateful to Chun Lin for directing me to these texts.

20 For a different reading of Thompson on experience, see William H. Sewell Jr., "How Classes Are Made: Critical Reflections on E. P. Thompson's Theory of Working-class Formation," in *E. P. Thompson: Critical Perspectives*, ed. Harvey J. Kaye and Keith McClelland (Philadelphia: Temple University Press, 1990), 50–77. I also have benefitted from Sylvia Schafer's "Writing about 'Experience': Workers and Historians Tormented by Industrialization," unpublished manuscript.

to experience, which in this usage connotes both reality and its subjective apprehension—the experience of women in the past and of women historians who can recognize something of themselves in their foremothers.

Judith Newton, a literary historian, writing about the neglect of feminism by contemporary critical theorists, argues that women, too, arrived at the critique of objectivity usually associated with deconstruction or the new historicism. This feminist critique "seemed to come straight out of reflection on our own, that is, [on] women's experience, out of the contradictions we felt between the different ways we were represented even to ourselves, out of the inequities we had long experienced in our situations."[21] Newton's appeal to experience seems to bypass the issue of objectivity (by not raising the question of whether feminist work can be objective) but it rests firmly on a foundational ground (experience). In her work the relationship between thought and experience is represented as transparent (the visual metaphor combines with the visceral) and so is directly accessible, as it is in historian Christine Stansell's insistence that "social practices," in all their "immediacy and entirety," constitute a domain of "sensuous experience" (a prediscursive reality directly felt, seen, and known) that cannot be subsumed by "language."[22] The effect of these kinds of statements, which attribute an indisputable authenticity to women's experience, is to establish incontrovertibly women's identity as people with agency. It is also to universalize the identity of women and thus to ground claims for the legitimacy of women's history in the shared experience of historians of women and those women whose stories they tell. In addition, it literally equates the personal with the political, for the lived experience of women is seen as leading directly to resistance to oppression, that is, to feminism.[23] Indeed, the possibility of politics is said to rest on, to follow from, a preexisting women's experience.

"Because of its drive towards a political massing together of women," writes Denise Riley, "feminism can never wholeheartedly dismantle 'women's experience,' however much this category conflates the attributed, the imposed, and the lived, and then sanctifies the resulting mélange." The kind of argument for a women's history (and for a feminist politics) that Riley criticizes closes down inquiry into the ways in which female subjectivity is produced, the ways in which agency is made possible, the ways in which race and sexuality intersect with gender, the ways in which politics organize and interpret experience—in sum, the ways in which identity is a contested terrain, the site of multiple and conflicting claims. In Riley's words, "It masks the likelihood that . . . [experiences] have accrued to women not by virtue of their womanhood alone, but as traces of domination, whether natural or political."[24] I would add as well that it masks the necessarily discursive character of these experiences.

But it is precisely the discursive character of experience that is at issue for some historians because attributing experience to

[21] Judith Newton, "History as Usual? Feminism and the 'New Historicism,'" *Cultural Critique* 9 (Spring 1988): 93.

[22] Christine Stansell, "A Response to Joan Scott," *International Labor and Working Class History* 31 (Spring 1987): 28. Often this kind of invocation of experience leads back to the biological or physical "experience" of the body. See, for example, the arguments about rape and violence offered by Mary E. Hawkesworth, "Knowers, Knowing, Known: Feminist Theory and Claims of Truth," *Signs* 14 (Spring 1989): 533–57.

[23] This is one of the meanings of the slogan "the personal is the political." Personal knowledge, that is, the experience of oppression is the source of resistance to it. This is what Chandra Talpade Mohanty calls "the feminist osmosis thesis: females are feminists by association and identification with the experiences which constitute us as female" (Chandra Talpade Mohanty, "Feminist Encounters: Locating the Politics of Experience," *Copyright* 1 [Fall 1987]: 32). See also an important article by Katie King, "The Situation of Lesbianism as Feminism's Magical Sign: Contests for Meaning and the U.S. Women's Movement, 1968–1972," *Communication* 9 (1986): 65–91.

[24] Denise Riley, *"Am I That Name?" Feminism and the Category of Women in History* (Minneapolis: University of Minnesota Press 1988), 100, 99.

V. EXPERIENCING

discourse seems somehow to deny its status as an unquestionable ground of explanation. This seems to be the case for John Toews, who wrote a long article in the *American Historical Review* in 1987 called "Intellectual History after the Linguistic Turn: The Autonomy of Meaning and the Irreducibility of Experience."[25] The term "linguistic turn" is a comprehensive one used by Toews to refer to approaches to the study of meaning that draw on a number of disciplines, but especially on theories of language "since the primary medium of meaning was obviously language."[26] The question for Toews is how far linguistic analysis has gone and should go, especially in view of the poststructuralist challenge to foundationalism.

By definition, he argues, history is concerned with explanation; it is not a radical hermeneutics, but an attempt to account for the origin, persistence, and disappearance of certain meanings "at particular times and in specific sociocultural situations."[27] For him explanation requires a separation of experience and meaning: experience is that reality which demands meaningful response. "Experience," in Toews's usage, is taken to be so self-evident that he never defines the term. (This is telling in an article that insists on establishing the importance and independence—the irreducibility—of "experience." The absence of definition allows experience to resonate in many ways, but it also allows it to function as a universally understood category—the undefined word creates a sense of consensus by attributing to it an assumed, stable, and shared meaning.)

Toews protects the experience of historians, and the category of "experience" overall, from the relativism that historians are tasked to analyze in the different meanings produced in societies and over time. This has the effect (among others) of removing historians from critical scrutiny as active producers of knowledge. In Toews's article no disagreement about the meaning of the term experience can be entertained, since experience itself lies somehow outside its signification. For that reason, perhaps, Toews never defines it.

Even among those historians who do not share all of Toews's ideas about the objectivity or continuous quality of history writing, the defense of "experience" works in much the same way: it establishes a realm of reality outside of discourse and it authorizes the historian who has access to it. The evidence of experience works as a foundation providing both a starting point and a conclusive kind of explanation, beyond which few questions can or need to be asked. And yet it is precisely the questions precluded—questions about discourse, difference, and subjectivity, as well as about what counts as experience and who gets to make that determination—that would enable us to historicize experience, and to reflect critically on the history we write about it, rather than to premise our history on it.

[25] John E. Toews, "Intellectual History after the Linguistic Turn: The Autonomy of Meaning and the Irreducibility of Experience," *American Historical Review* 92 (October 1987): 881.

[26] Ibid., 881.

[27] Ibid., 882.

III.

How can we historicize "experience"? How can we write about identity without essentializing it? Answers to the second question ought to point toward answers to the first, since identity is tied to notions of experience, and since both identity and experience are categories usually taken for granted in ways that I am suggesting they ought not to be. It ought to be possible for historians to, in Gayatri Spivak's terms, "make visible the assignment of subject-positions," not in the sense of capturing the reality of the objects seen, but of trying to understand the operations of the complex and changing discursive processes by which identities are ascribed, resisted, or embraced, and which processes themselves are unremarked and indeed achieve their effect because they are not noticed.[28] To do this a change of object seems to be required, one that takes the emergence of concepts and identities as historical events in need of explanation. This does not mean that one dismisses the effects of such concepts and identities, nor that one does not explain behavior in terms of their operations. It does mean assuming that the appearance of a new identity is not inevitable or determined, not something that was always there simply waiting to be expressed, not something that will always exist in the form it was given in a particular political movement or at a particular historical moment. As Stuart Hall writes:

> The fact is "black" has never been just there either. It has always been an unstable identity, psychically, culturally and politically. It, too, is a narrative, a story, a history. Something constructed, told, spoken, not simply found. People now speak of the society I come from in totally unrecognizable ways. Of course Jamaica is a black society, they say. In reality it is a society of black and brown people who lived for three or four hundred years without ever being able to speak of themselves as "black." Black is an identity which had to be learned and could only be learned in a certain moment. In Jamaica that moment is the 1970s.[29]

To take the history of Jamaican black identity as an object of inquiry in these terms is necessarily to analyze subject-positioning, at least in part, as the effect of discourses that placed Jamaica in a late 20th-century international racist political economy; it is to historicize the "experience" of blackness.[30]

Treating the emergence of a new identity as a discursive event is not to introduce a new form of linguistic determinism, nor to deprive subjects of agency. It is to refuse a separation between "experience" and language and to insist instead on the productive quality of discourse. Subjects are constituted discursively, but there are conflicts among discursive systems, contradictions within any one of them, multiple meanings possible for the concepts they deploy.[31] And

[28] Gayatri Chakravorty Spivak, "A Literary Representation of the Subaltern: A Woman's Text from the Third World," in Spivak, *In Other Worlds*, 241.

[29] Stuart Hall, "Minimal Selves," in Appignanesi, ed., *Identity: The Real Me*, 45. See also Barbara J. Fields, "Ideology and Race in American History," in *Region, Race and Reconstruction: Essays in Honor of C. Vann Woodward*, ed. J. Morgan Kousser and James M. McPherson (New York: Oxford University Press, 1982), 143–77. Fields's article is notable for its contradictions: the way, for example, that it historicizes race, naturalizes class, and refuses to talk at all about gender.

[30] An excellent example of the historicizing of black women's "experience" is Hazel Carby's *Reconstructing Womanhood: The Emergence of the Afro-American Woman Novelist* (New York: Oxford University Press, 1987).

[31] For discussions of how change operates within and across discourses, see James J. Bono, "Science, Discourse, and Literature: The Role/Rule of Metaphor in Science," in *Literature and Science: Theory and Practice*, ed. Stuart Peterfreund (Boston: Northeastern University Press, 1990), 59–89. See also Mary Poovey, *Uneven Developments: The Ideological Work of Gender in Mid-Victorian England* (Chicago: The University of Chicago Press, 1988), 1–23.

[32] Parveen Adams and Jeff Minson, "The 'Subject' of Feminism," *m/f* 2 (1978): 52. On the constitution of the subject, see Michel Foucault, *The Archaeology of Knowledge* (New York: Pantheon, 1972), 95–96; Felicity A. Nussbaum, *The Autobiographical Subject: Gender and Ideology in Eighteenth-Century England* (Baltimore, MD: Johns Hopkins University Press, 1989); and Peter de Bolla, *The Discourse of the Sublime: Readings in History, Aesthetics, and the Subject* (New York: Blackwell, 1989).

subjects do have agency. They are not unified, autonomous individuals exercising free will, but rather subjects whose agency is created through situations and statuses conferred on them. Being a subject means being "subject to definite conditions of existence, conditions of endowment of agents and conditions of exercise."[32] These conditions enable choices, although they are not unlimited. Subjects are constituted discursively and experience is a linguistic event (it doesn't happen outside established meanings), but neither is it confined to a fixed order of meaning. Since discourse is by definition shared, experience is collective as well as individual. Experience is a subject's history. Language is the site of history's enactment. Historical explanation cannot, therefore, separate the two.

The question then becomes how to analyze language, and here historians often (though not always and not necessarily) confront the limits of a discipline that has typically constructed itself in opposition to literature. (These limits have to do with a referential conception of language, the belief in a direct relationship between words and things.) The kind of reading I have in mind would not assume a direct correspondence between words and things, nor confine itself to single meanings, nor aim for the resolution of contradiction. It would not render process as linear, nor rest explanation on simple correlations or single variables. Rather it would grant to "the literary" an integral, even irreducible, status of its own. To grant such status is not to make "the literary" foundational, but to open new possibilities for analyzing discursive productions of social and political reality as complex, contradictory processes.

For example, the question of representation is central to the magnificent autobiographical meditation by Samuel Delany, *The Motion of Light in Water* (1988), trading as it does in all the metaphors of visibility and transparency in experience with which I began. It is a question of social categories, personal understanding, and language, all of which are connected, none of which are or can be a direct reflection of the others. What does it mean to be black, gay, a writer, he asks, and is there a realm of personal identity possible apart from social constraint? The answer is that the social and the personal are imbricated in one another and that both are historically variable. The meanings of the categories of identity change and with them the possibilities for thinking the self. But the available social categories aren't sufficient for Delany's story. It is difficult, if not impossible to use a single narrative to account for his experience. Instead he makes entries in a notebook, in two columns, at the front about material things, at the back about sexual desire. Although one narrative "column" seems to be about society, the public, and the political, and the other about the individual, the private, and the psychological, in fact both are inescapably historical; they are discursive productions of knowledge of the self, not reflections either of external or internal truth.

[33] Delany, *Motion of Light in Water*, 212.

[34] Ibid., 29–30.

[35] See Dominick LaCapra, "Is Everyone a Mentalité Case? Transference and the 'Culture' Concept," *History and Criticism* (Ithaca, NY: Cornell University Press, 1985), 71–94.

The questions we need to ask about subjectivity are: Do the social and economic determine the subjective? Is the private entirely separate from or completely integral to the public? Delany voices the desire to resolve the problem: "Certainly one must be the lie that is illuminated by the other's truth."[33] And then he denies that resolution is possible since answers to these questions do not exist apart from the discourses that produce them:

> If it *is* the split—the space between the two columns (one resplendent and lucid with the writings of legitimacy, the other dark and hollow with the voices of the illegitimate)—that constitutes the subject, it is only after the Romantic inflation of the private into the subjective that such a split can even be located. That locus, that margin, that split itself first allows, then demands the appropriation of language—now spoken, now written—in both directions, over the gap.[34]

It is finally by tracking "the appropriation of language . . . in both directions, over the gap," and by situating and contextualizing that language that one historicizes the terms by which experience is represented, and so historicizes "experience" itself.

IV.

Reading for "the literary" does not seem at all inappropriate for those whose discipline is devoted to the study of change. It is not the only kind of reading I am advocating, although more documents than those written by literary figures are susceptible to such readings. Rather it is a way of changing the focus and the philosophy of our history, from one bent on naturalizing "experience" through a belief in the unmediated relationship between words and things, to one that takes all categories of analysis as contextual, contested, and contingent. How have categories of representation and analysis—such as class, race, gender, relations of production, biology, identity, subjectivity, agency, experience, even culture—achieved their foundational status? What have been the effects of their articulations? What does it mean for historians to study the past in terms of these categories and for individuals to think of themselves in these terms? What is the relationship between the salience of such categories in our own time and their existence in the past? Questions such as these open consideration of what Dominick LaCapra has referred to as the "transferential" relationship between the historian and the past, that is, of the relationship between the power of the historian's analytic frame and the events that are the object of his or her study.[35] And they historicize both sides of that relationship by denying the fixity and transcendence of anything that appears to operate as a foundation, turning attention instead to the history of foundationalist concepts themselves. The history of these concepts (understood to be contested and contradictory) then becomes the evidence by

which "experience" can be grasped and by which the historian's relationship to the past he or she writes about can be articulated. This is what Foucault meant by genealogy:

> If interpretation were the slow exposure of the meaning hidden in an origin, then only metaphysics could interpret the development of humanity. But if interpretation is the violent or surreptitious appropriation of a system of rules, which in itself has no essential meaning, in order to impose a direction, to bend it to a new will, to force its participation in a different game, and to subject it to secondary rules, then the development of humanity is a series of interpretations. The role of genealogy is to record its history: the history of morals, ideals, and metaphysical concepts, the history of the concept of liberty or of the ascetic life; as they stand for the emergence of different interpretations, they must be made to appear as events on the stage of historical process.[36]

Experience is not a word we can do without, although, given its usage to essentialize identity and reify the subject, it is tempting to abandon it altogether. But experience is so much a part of everyday language, so imbricated in our narratives that it seems futile to argue for its expulsion. It serves as a way of talking about what happened, of establishing difference and similarity, of claiming knowledge that is "unassailable."[37] Given the ubiquity of the term, it seems to me more useful to work with it, to analyze its operations and to redefine its meaning. This entails focusing on processes of identity production, insisting on the discursive nature of "experience" and on the politics of its construction. Experience is at once always already an interpretation *and* is in need of interpretation. What counts as experience is neither self-evident nor straightforward; it is always contested, and always therefore political. The study of experience, therefore, must call into question its originary status in historical explanation. This will happen when historians take as their project not the reproduction and transmission of knowledge said to be arrived at through experience, but the analysis of the production of that knowledge itself. Such an analysis would constitute a genuinely non-foundational history, one which retains its explanatory power and its interest in change but does not stand on or reproduce naturalized categories.[38] It also cannot guarantee the historian's neutrality, for deciding which categories to historicize is inevitably political, necessarily tied to the historian's recognition of his or her stake in the production of knowledge. Experience is, in this approach, not the origin of our explanation, but that which we want to explain. This kind of approach does not undercut politics by denying the existence of subjects; it instead interrogates the processes of their creation and, in so doing, refigures history and the role of the historian and opens new ways for thinking about change.[39]

[36] Michel Foucault, "Nietzsche, Genealogy, History," *Language, Counter-Memory, Practice: Selected Essays and Interviews*, trans. Donald F. Bouchard and Sherry Simon, ed. Bouchard (Ithaca, NY: Cornell University Press, 1977), 151–52.

[37] Ruth Roach Pierson, "Experience, Difference, and Dominance in the Writings of Canadian Women's History," in *Writing Women's History: International Perspectives*, ed. Karen Offen, Ruth Roach Pierson, and Jane Rendall (Bloomington: Indiana University Press, 1991), 79–106.

[38] Conversations with Christopher Fynsk helped clarify these points for me.

[39] For an important attempt to describe a poststructuralist history, see Peter de Bolla, "Disfiguring History," *Diacritics* 16 (Winter 1986): 49–58.

AISTHESIS

Jacques Rancière

For two centuries in the West, "aesthetics" has been the name for the category designating the sensible fabric and intelligible form of what we call "Art." In my other works, I have already had the opportunity to argue that, even if histories of art begin their narratives with cave paintings at the dawn of time, Art as a notion designating a form of specific experience has only existed in the West since the end of the 18th century. All kinds of arts and practices existed before then, to be sure, among which a small number benefited from a privileged status, due not to their intrinsic excellence but to their place in the division of social conditions. Fine arts were the progeny of the so-called liberal arts. The latter were distinguished from the mechanical arts because they were the pastime of free men, men of leisure whose very quality was meant to deter them from seeking too much perfection in material performances that an artisan or a slave could accomplish. Art as such began to exist in the West when this hierarchy of forms of life began to vacillate. The conditions of this emergence cannot be deduced from a general concept of art or beauty founded on a global theory of man or the world, of the subject or being. Such concepts themselves depend upon a transformation of the forms of sensible experience, of ways of perceiving and being affected. They formulate a mode of intelligibility out of those reconfigurations of experience.

The term *Aisthesis* has designated the mode of experience according to which, for two centuries, we perceive very diverse things, whether in their techniques of production or their destination, as all belonging to art. This is not a matter of the "reception" of works of art. Rather, it concerns the sensible fabric of experience within which they are produced. These are entirely material conditions—performance and exhibition spaces, forms of circulation and reproduction—but also modes of perception and regimes of emotion, categories that identify them, thought patterns that categorize and interpret them. These conditions make it possible for words, shapes, movements, and rhythms to be felt and thought as art. No matter how emphatically some may oppose the event of art and the creative work of artists to this fabric of institutions, practices, affective modes, and thought patterns, the latter [fabric] allows for a form, a burst of color, an acceleration of rhythm, a pause between words, a movement, or a glimmering surface to be experienced as events and

This text is adapted from Jacques Rancière, "Prelude," in his *Aisthesis: Scenes from the Aesthetic Regime of Art*, translated by Zakir Paul (London: Verso, 2013).

associated with the idea of artistic creation. No matter the insistence with which others oppose the ethereal idealities of art and aesthetics to the very prosaic conditions of their experience, these idealities still provide the markers for the work with which they try to demystify them. Finally, no matter the bitterness others still express at seeing our venerable museums welcome the works of the darlings of the market, this is merely a distant effect of the revolution constituted by the very birth of museums, when the royal galleries open to the public made visible popular scenes that German princes taken with exoticism had bought from dealers in the Netherlands, or when the republican Louvre was stacked with princely portraits and pious paintings looted by the revolutionary armies from Italian palaces or Dutch museums. Art exists as a separate world since anything whatsoever can belong to it.

[In my argument, there continue to be transformations of the forms of sensible experience.] A regime of perception, sensation, and interpretation of art is constituted and transformed by welcoming images, objects, and performances that seemed most opposed to the idea of fine art: vulgar figures of genre painting, the exaltation of the most prosaic activities in verse freed from meter, music-hall stunts and gags, industrial buildings and machine rhythms, smoke from trains and ships reproduced mechanically, extravagant inventories of accessories from the lives of the poor. [Such an argument] shows how art, far from foundering upon these intrusions of the prose of the world, ceaselessly redefined itself—exchanging, for example, the idealities of plot, form, and painting for those of movement, light, and the gaze, building its own domain by blurring the specificities that define the arts and the boundaries that separate them from the prosaic world.

Art is given to us through these transformations of the sensible fabric, at the cost of constantly merging its own reasons with those belonging to other spheres of experience. I have chosen to study these transformations [under the title] *Aisthesis*, echoing Erich Auerbach's *Mimesis*, which focused on a series of short extracts, from Homer to Virginia Woolf, to study the transformations in the representation of reality in Western literature. *Mimesis* and *Aisthesis* undoubtedly take on different meanings here, since they no longer designate categories internal to art, but rather regimes of the identification of art. [Rather than solely Auerbach's art of writing, I also study scenes of] the visual and performance arts, and those of mechanical reproduction. They do not show the transformations belonging to any given art. Instead, they show the way in which a given artistic appearance requires changes in the paradigms of art. Each one of these scenes thus presents a singular event, and explores the interpretive network that gives it meaning around an emblematic text. The event can be a performance, a lecture, an exhibition, a visit to a museum or to a studio, a book, or a film release. The network built around it shows how a performance or

an object is felt and thought not only as art, but also as a singular artistic proposition and a source of artistic emotion, as novelty and revolution in art—even as a means for art to find a way out of itself. Thus it inscribes them into a moving constellation in which modes of perception and affect, and forms of interpretation defining a paradigm of art, take shape. The scene is not the illustration of an idea. It is a little optical machine that shows us thought busy weaving together perceptions, affects, names, and ideas, constituting the sensible community that these links create, and the intellectual community that makes such weaving thinkable. The scene captures concepts at work, in their relation to the new objects they seek to appropriate, old objects that they try to reconsider, and the patterns they build or transform to this end. For thinking is always firstly thinking the thinkable—a thinking that modifies what is thinkable by welcoming what was unthinkable. . . . [1]

[There is a history to] the paradoxical links between the aesthetic paradigm and political community. By making the mutilated statue of Hercules the highest expression of the liberty of the Greek people, [Johann Joachim] Winckelmann established an original link between political freedom, the withdrawal of action, and defection from the communitarian body. The aesthetic paradigm was constructed against the representative order, which defined discourse as a body with well-articulated parts, the poem as a plot, and a plot as an order of actions. This order clearly situated the poem—and the artistic productions for which it functioned as a norm—on a hierarchical model: a well-ordered body where the upper part commands the lower, the privilege of action, that is to say of the free man, capable of acting according to ends, over the repetitive lives of men without quality. The aesthetic revolution developed as an unending break with the hierarchical model of the body, the story, and action. The free people, says [Friedrich] Schiller, is the people that plays, the people embodied in this activity that suspends the very opposition between active and passive. . . . [2] The renovators of dance and theater freed bodily movements from the shackles of a plot, but the emancipation of movement also distanced it from rational, intentional action directed towards an end. [Dziga] Vertov's film, which sought to replace the plots and characters of yesterday with the living links of activities that formed the sensible fabric of communism, begins and ends in a cinema where the evening's spectators seem to play with images that present them to themselves as the daytime actors of communism.[3] Emancipated movement does not succeed in reintegrating the strategic patterns of causes and effects, ends and means.

Hasty minds will undoubtedly see this as the sign of an irremediable breach between aesthetic utopia and real political and revolutionary action. Instead, I recognized the same paradox . . . as the one I encountered in the practices and theories of social emancipation. Emancipated workers could not repudiate the

1
Eds.: The author goes on to cite his earlier work, Jacques Rancière, *Courts voyages au pays du peuple* (Paris: Le Seuil, 1990), trans. James B. Swenson as *Short Voyages to the Land of the People* (Stanford: Stanford University Press, 2003). In the omitted passage, he refers to "Winckelmann's Germany, when Art begins to be named as such, not by closing itself off in some celestial autonomy, but on the contrary by giving itself a new subject, the people, and a new place, history" (Rancière, *Aisthesis*, xiii). This is further developed in chapter 1 of *Aisthesis*, "Divided Beauty," in which the author focuses on Winckelmann's interpretation of the Belvedere Torso.

2
Eds.: Writer Johann Christoph Friedrich von Schiller collaborated with Goethe during the German Enlightenment. Rancière celebrates Schiller's *Letters on the Aesthetic Education of Man* (1794), in which the leisure and carefree liberty of the Greek gods becomes a model for "the freedom of the modern people that gives itself a world through will power"—which Rancière examines as a moment of possibility foreclosed by Hegel's more conservative emphasis on "work and discipline, which left no room for reveries on the divine insouciance" (Rancière, *Aisthesis*, 34).

3
Eds.: Born in Poland as Denis Arkadievitch Kaufman, Dziga Vertov enrolled in the Petrograd Psychoneurological Institute in 1916. Following the Russian Revolution, he became one of the most influential filmmakers and film theorists of his generation, best known for *Man with a Movie Camera* (1929) and the doctrine of the "Kino-Eye," which positioned montage documentary in opposition to bourgeois narrative cinema. Vertov is the subject of Rancière's chapter 13 of *Aisthesis*, "Seeing Things Through Things," which opens with an analysis of Vertov's 1926 Soviet propaganda film *A Sixth Part of the World*.

hierarchical model governing the distribution of activities without taking distance from the capacity to act that subjected them to it, and from the action plans of the engineers of the future. All these workers could easily have opposed the militants of the Saint-Simonian religion reinstating work, who came to recruit soldiers for the new industrial army, with the ingenuous words spoken by one of them: "When I think of the beauties of Saint-Simonism, my hand stops." The fullest expression of the fighting workers' collective was called the general strike, an exemplary equivalence of strategic action and radical inaction. The scientific Marxist revolution certainly wanted to put an end to the workers' reveries, along with utopian programs. But by opposing them to the effects of real social development, it kept subordinating the end and means of action to the movement of life, at the risk of discovering that this movement does not want anything and does not allow any strategy to lay claim to it. Soviet critics responded to the filmmaker, who presented them with a vision of communism realized as the symphony of linked movements, that his so-called communism was doomed to an endless oscillation between pantheistic adoration of the irrational flux of things and pure formalist voluntarism. But what else could they oppose to this double defect except the return of artists to the old functions of moral illustration, whose inanity [Jean-Jacques] Rousseau and [Friedrich] Schiller had exposed a century and a half earlier? Was the filmmaker effectively doing anything other than giving his judges a mirror in which they could recognize the dilemma of their science? Social revolution is the daughter of aesthetic revolution, and was only able to deny this relation by transforming a strategic will that had lost its world into a policy of exception.

FIG. 1

SENSITIZING

Bruno Latour

FIGURE 1 (FACING)
Negotiators at the table, United Nations Framework Convention on Climate Change "Conference of the Parties" (COP) number 19, Warsaw, Poland, November 2013. From left to right, UNFCCC Secretariat Dan Bondi Ogolla, UNFCCC Executive Secretary Christiana Figueres, and COP 19 President Marcin Korolec.

FIGURE 2
Protesters at People's Climate March, New York, September 21, 2014. Photo by Bruno Latour.

To approach the ancient philosophy of common sense—the *sensus communis*—we might begin at the beginning, by asking: How do we make ourselves actually *sensitive*? In particular, how do we make ourselves sensitive to one specific character, an unusual character that has become increasingly important: *Gaïa*? This character brings together a strange mixture of science, religion, law, and politics. We can see this mixture illustrated by a very moving and beautiful image of diplomats around the negotiation table as part of a climate change conference in Warsaw in 2013, sponsored by the United Nations. (FIG. 1) They are negotiating about this strange figure Gaïa, and you might say they are trying to make a common sense. We see their dilemma in this photograph, which shows Christiana Figueres in the middle. She has the terrible responsibility of running this negotiation for Secretary-General of the United Nations Ban Ki-moon.[1] The man sitting to her left is the moderator, Marcin Korolec. These people are fully occupied with the question of climate change and the figure of Gaïa.[2] It's a poignant image, in which we can see they are concentrated on rendering not only themselves, but also the rest of the public, the rest of the planet, *sensitive* to a new phenomenon. I choose this example to suggest ways of knowing that involve sensory modalities, neuroscience, and art. I am claiming that these ways of knowing are also ways of rendering sensitivities.

With regard to the strange figure, Gaïa, it is, of course, not only the diplomats struggling to render themselves sensitive, but many others as well. For example, the climate march on September 21, 2014, in New York City, brought 400,000 people together around this problem. It was very moving to see the various methods and mediums through which people with different types of concerns tried scientifically or in a more joyful way to make themselves sensitive to the key issue of our time: climate change. As an example of this new sensitivity, see the photograph I took of a person at the march, holding a sign reading: *There is no planet B*. (FIG. 2)

There are many things to which we try to render ourselves sensitive. To capture that activity, I will use the word *aesthetic*—in the original Greek sense of *aisthesis*—perception, or making oneself sensitive to something.[3] I will make no distinction between making oneself sensitive for scientific purposes and making oneself sensitive through various formats associated with the arts. I'm not going

1
Costa Rican diplomat Christiana Figueres was named executive secretary of the UN Framework Convention on Climate Change (UNFCCC) on May 17, 2010.

2
Marcin Korolec is minister of the environment for Poland and served as president-designate of COP 19 ("Conference of the Parties") during the Climate Change meetings in Warsaw in 2013.

3
Eds.: The Greek term αἴσθησις, transliterated as aísthēsis (or, simply, aisthesis) can mean perception from the senses, such as feeling, hearing, seeing, etc.; perception by the intellect, as well as the senses; the phenomena that are perceived; the ability to perceive (i.e., discernment); cognition; or discernment in moral or ethical matters. See Rancière, *Aisthesis*, in this volume.

[4] See Bevil R. Conway and Margaret S. Livingstone, "Spatial and Temporal Properties of Cone Signals in Alert Macaque Primary Visual Cortex," *The Journal of Neuroscience* 26, no. 42 (October 18, 2006): 10826–10846, and recent work presented at the "Seeing" session of the Center for Art, Science & Technology (CAST) symposium "Seeing/Sounding/Sensing" at MIT on September 26, 2014.

[5] See William James, "'Consciousness,'" in this volume, and James J. Gibson, *An Ecological Approach to Visual Perception* (Boston: Houghton Mifflin, 1979).

[6] Bruno Latour, *An Inquiry into Modes of Existence: An Anthropology of the Moderns,* trans. Catherine Porter (Cambridge, MA: Harvard University Press, 2013).

to reference politics, but of course such distinctions refer to politics as well. Distinctions such as these are part of the problem, because they are often erected between science and art in particular—making it difficult for us to be sensitive, to make ourselves sensitive, and to make a common sense of this sensitivity. The crucial distinction is associated with matters of fact. I am not talking about the objectivity of science, but a strange and very puzzling definition of *matter of fact* that establishes a specific conceptual relationship between a subject and an object. This relation is extremely bizarre, and historians of science, historians of art, historians of psychology, and other scholars have begun to unravel its history as part of the European and Western tradition.

The idea is simple: there is a subject watching an object. But this simplicity is deceiving. It is never really the case that there is some stable subject watching an object, except in a laboratory situation. We can demonstrate the artifice of the situation by taking the case of the still life: there is a subject, who contributes a point of view, or POV, and an object, which is a still life. My argument is that a great deal of Western philosophy comes from the culturally specific genre of still life. We might call it a disease of the Dutch, so to speak; as we know, René Descartes and John Locke spent a lot of time in Holland, during which they saw too many still lifes. Still lifes gave them the idea that it actually makes sense to stop an object. But objects never actually stop. An object is a trajectory: the qualities of that object change over time and, in order to apprehend the object, our senses move through a complex cognitive process until a stable object is decided upon. The point is this: vision science reveals that an object is actually a transitory event in perception.[4] It has a trajectory, which means that, to even meet an object and to turn it into a matter of fact, you have to interrupt it in the middle of that trajectory. Then you have to create this very strange idea of a plane in between you and the object, where the object can be fixed. This situation is of course not so visible in science, but it is very visible in art, especially in the still life. Once you add this plane, it fixes the trajectory very specifically *for someone*. It isolates that POV, freezing both the object and the subject.

But subjects and objects are not natives to this world. They are not born here. No one is born a subject, watching an object. It's a very bizarre situation, as William James pointed out, and many other psychologists, such as James J. Gibson, have confirmed.[5] Such a bizarrely constructed view of the subject-with-object has been criticized by a lot of people within contemporary neuroscience as well. Why does this subject-object dyad exist? An anthropology of vision could begin to ask about the function of this strange position, one where you have a passive object and an active subject. Of course, it's not a real subject; it's an un-interrogated figure staging a conceptual relation.

FIGURE 3
Philippe Squarzoni, page from the English edition of his graphic novel *Climate Changed* (2014), 298.

Becoming sensitive requires taking account of the everyday experience of being. You need to imagine how you circulate yourself "naturally"—with the necessary quotes around that word—but, in any case, imagine yourself *not* face-to-face with an object. Art historians as well as historians of science will continue to interrogate this strange middle figure that mounts and stages the scenography of the object and the subject, but it's not the way we live. We are in the world, in spite of these abstractions and not because of them. In my attempt to figure this out, I have proposed an anthropology of the modern.[6] It's so unlikely that anyone would actually be a subject in front of an object, and yet this arrangement lies at the origin of much Western philosophy. It is the pretext for the still life, and it informs numerous cognitive scientists. Neuroscientists have enormous work to do, to escape from this odd idea that originates in still

FIG. 4A

FIG. 4B

FIGURE 4

(A) Atmosphere "puppet" (canopy design Frédérique Aït-Touati, fabrication Olivier Vallet) from *Gaïa Global Circus*. (B) Scene from *Gaïa Global Circus*. From left to right: Claire Astruc and Matthieu Protin with Jade Collinet in the background, amid a sea of plastics. Project by Bruno Latour, play by Pierre Daubigny, directed by Frédérique Aït-Touati and Chloé Latour, performed by Compagnie AccenT and Soif Compagnie at The Kitchen, New York, September 23, 2014.

life. Most of our philosophy, our epistemology, and our definition of science come from pictorial representations, not from an experience of vision or from an experience of actually seeing the world. How do we make ourselves sensible not to *matters of fact* as they are fictionalized in the subject-object scenario, but rather to *matters of concern*?[7] Matters of concern are still material. It's not so much their *factuality* or *materiality* that should interest us, but our *concern* with them. How can art and science sensitize us to these concerns?

I was fortunate enough to be able to attend the 2013 installation at HangarBicocca in Milan by Tomás Saraceno, and it was an opportunity to experience something made by an artist who sees the primacy of making us sensitive spatially to this new situation. What is it to be on an Earth that is actually moving, which makes even standing up impossible? Saraceno invented this amazingly beautiful, terribly expensive, and even a bit dangerous situation in which people are somehow suspended and yet glued into a space.[8] They cannot move or stand; they have to crawl around as if they are one-year-olds. They are put into a situation where they might begin to reimagine being in space without having the benefit of standing on stable ground. That's a very powerful way of rendering the difficulty of feeling and becoming sensitive to an unprecedented situation. Saraceno makes us realize again how rare and how unlikely it is to face a stable object; the HangarBicocca situation becomes the epitome of the impossibility of having a fixed subject-object relation. Neither in time nor in space is the tidy subject with its object possible here. We are in a very different time-space, and this is where the sensitivity, coming simultaneously from art and science, is so important. These are all sources of making oneself sensitive to things.

How do we produce this sensitivity to the new time-space in different registers and different mediums? In an experiment from 2013 with scientists and artists in Toulouse, called "aesthetics for the sciences of Gaïa," we asked people to explore, within their chosen medium, why it is difficult to register this change in our relation to the Earth and its passions. Why is it so difficult to make yourself sensitive to this new situation, this new space and time? Is one medium better than another for this task? If we remember the etymological sense of an aesthetic as *making sensitive*, how does a specific medium render us sensitive to things as they come to us? Things can come to you, but if you don't render yourself sensitive to them, you just don't get it.

Oliver Morton is a historian of science who has become an editor for the *Economist*, and he has written two absolutely splendid books, one on Mars and the other on Earth.[9] The second of those books, *Eating the Sun: How Plants Power the Planet*, has a sort of Lovelockian view, a sort of Gaïa-esque perspective on the Earth.[10] His writing begins with the difficulty of writing well about this question of ecology and the environment, and this matter of concern is animated, all the way from beginning to end, by a vocabulary related to plants.

[7] Bruno Latour, "Why Has Critique Run out of Steam? From Matters of Fact to Matters of Concern," *Critical Inquiry* 30 (Winter 2004): 225–48.

[8] See Tomás Saraceno, "Actions," in this volume.

[9] Oliver Morton, *Mapping Mars: Science, Imagination, and the Birth of a World* (New York: Picador, 2003); Oliver Morton, *Eating the Sun: How Plants Power the Planet* (New York: Harper, 2008).

[10] The reference is to James Lovelock, *Gaia: A New Look at Life on Earth* (Oxford: Oxford University Press, 1979).

Eds.: Since being coined by geologists Paul Crutzen and Eugene Stoermer in 2000, the term *Anthropocene* has been proposed to designate the era in which the effects of human activity have been deposited stratigraphically in the geological record, marking the current epoch as distinct from the Holocene. (Holo= present, Anthropo= man.) How this new stratum will be distinguished (for example, by carbon layers deposited from combustion at the beginning of the industrial revolution, or by Cesium laid down from the first atomic tests) is currently being adjudicated by the International Commission on Stratigraphy within the International Union of Geological Sciences, with a target date for their decision in 2016. See "Working Group on the 'Anthropocene,'" http://quaternary.stratigraphy.org/workinggroups/anthropocene/.

For instance, the book opens with a meditation on "pigment pools and sunlight traps," which is Oliver's way of describing the chemical activity of chlorophyll in photosynthesis. How do you write about science? How do you respond to the challenge of writing about science in a way that is simultaneously making yourself sensitive to it, especially if you are not a chlorophyll specialist, while presenting a precisely accurate understanding of the recent data on chlorophyll? This question about science writing can be framed in terms of genre and medium, which produce their own registers and their own difficulties, as with graphic novels, or model-making, or cinema.

When you change the scale of your representation, you immediately render yourself sensitive to new phenomena. Writing about a cell full of chlorophyll is one such move, cartooning is another kind of condensation. In particular, I want to explore the medium of the BDs (*bandes dessinées*, comic books or graphic novels). Philippe Squarzoni has, in my analysis, the best book on the topic of climate change. (FIG. 3) If it seems so impossibly difficult to talk about climate change, is it easier to *make it graphic*? His graphic novel *Climate Changed* is a poignant attempt that begins with the question: Why is no one going to understand this book, which is on the question of climate change? Why is this issue so invisible, and so boring? Why is it so impossible to show in the medium that I'm choosing to show it in? Squarzoni's book is a powerful and moving experiment in exploring the limits of a medium, right from the start. He uses the form of the *bande dessinée* itself to show the limits of the medium in talking about climate change. For instance, he has a long discussion with his wife, in which he makes fun of the impossibility of the task he has set himself. Then, he has another discussion about the shape of the planet, the blue planet you would recognize. But in his drawings, there's only one image of the blue planet where you see the whole Earth, because the others show only a partially illuminated crescent, like the moon. A large part of Squarzoni's novel explores the difficulty of making interesting graphics about talking heads. For example, he shows two famous French climatologists, Hervé Le Treut and Jean Jouzel, who are members of the French Intergovernmental Panel on Climate Change (IPCC). We see these scientists giving interviews to Squarzoni, in which he tries to make them talk on this impossible medium of the graphic novel—an analogy for the impossibility of making ourselves sensitive to the phenomenon I call *Gaïa*.

The problem he identifies is how do we alter our perceptual tools, such that climate change can be depicted in a graphic novel? How do we become, again, *sensitive*? Squarzoni spends some time working on his own imagination, revealing that effort, and trying to understand the necessary change that has to happen in how we conceive of imagination, so that it can be an imagination about the Earth taking us with it. To not be able to see far in time and space in the traditional sense was pre-Anthropocene.[11] To be on an Earth

that is not only moving its position but is also becoming an active agent itself, and taking us with it, this is the Anthropocenic point of view. How can we manage to see that situation? Squarzoni provides an exploration into the nuances of a different imagination, which can be mobilized in order to allow us to get into this question of ecology. In my view, ecology is only very rarely a *politicized* form. Usually the questions I am interested in—about sensitizing, about an Anthropocenic recognition of mobility, about process—these questions are sealed off by politics, and, surrounded by well-meaning self-righteousness. When they are sealed off in that way, they are not the occasion of arriving at another way of feeling the situation. And that's why it can be productive to compare different mediums to see if they can accomplish that different feeling, that way of sensitizing us to the situation.

Books, graphic novels, and puppets can be sensitizing mediums. Puppeteers are very interesting because of course their relation with their puppet has nothing to do with the subject-object connection. They are thought to be in control, but they always say, "No, no, no!" and emphasize that a good puppeteer is made to act *by the puppet*. Even though it's a metaphor for complete control, the puppet actually makes its puppeteer carry it somewhere else. It gets modified, mobilized, or moved—and you are then moved by the thing you move, which is the most interesting relation we have with the world. The reason why a puppeteer was necessary for the conversation about becoming sensitive to Gaïa is because he made it technically possible to implement Frédérique Aït-Touati's idea to have a little canopy hovering onstage in *Gaïa Global Circus*, of which I am one of the indirect authors (together with Chloé Latour and Pierre Daubigny) and which had a showing at The Kitchen in New York (September 24 and 25, 2014).[12] To render ourselves and others sensitive to this change of time and space we modified the décor, by which I mean the stage, so you could actually *feel* this puppet, this animate-atmosphere, up above you, but not so very far up. (FIG. 4A) A little canopy, suspended by helium balloons, was moving around in a way that made it possible to show an active mobilization of Gaïa as being both visible and palpable.

The canopy was sometimes above everyone, sometimes pulled down over the performers to serve as a shelter, and sometimes it became a projection surface for information—but it was always in motion, active, visible, and palpable. The audience and the actors alike were very disturbed by the canopy's physical movement, but that's part of the story—to see the canopy and to be disturbed by its emergence as an active agent from the background. One of the problems of rendering yourself sensitive to a situation was made clear to me: *you have to change the whole set*. Of course, theater is a mirror for that. I told them this canopy should be one of the actors on the stage. Because its position was constantly changing, serving at times to hide the performers, other times as a projection screen;

12
Puppeteer Olivier Vallet of Les Rémouleurs was invited to the 2013 Toulouse conference to discuss the importance of the puppet as artifact, and as possessing agency. Although he was not able to attend the event, Frédérique Aït-Touati made a film about him and his work to show to the group.

it was to become a model of the Earth, while also being part of the earth-modeling that is going on. In this sense, it is a model of the model. For this theatrical production, we worked with many scientists, but not in a straightforward or simple way. We aimed rather to relate to science in a contaminated way, which was meant to have resonance with the simplification of the data that scientists themselves manifest when they model the Earth or its atmosphere in climatology. Scientists have a relation to their model that is very much like that of puppeteers. If you say to a modeler, "Well, you made it up. It's entirely constructed, so it doesn't do anything *real*," then he or she would think you were completely ridiculous, and a puppeteer would think the same thing. Once the model is created, it has agency—its own internal logic and its manifestation within a given material gives it as much agency as the creator of the model.

On the stage in *Gaïa Global Circus*, we were trying to establish these resonances, these contaminated connections between art and science, to make audiences sensitive. (FIG. 4B) It was particularly interesting to have certain simultaneous issues overlapping between art and science: for instance, a physicist presented the problem of making a model of the ocean, facing the artistic question of coloring, which is a crucial element in most modeling, but rarely discussed. Such questions that come up in making a model of the Earth—related to assembling the data and making yourself sensitive to the transformation and the history, which, in this case, meant representing the salinity of the ocean—are not so different from the aesthetic questions confronting the artist, because scientists are not purely objective, nor are there purely subjective artists on the other side. As with artist Tauba Auerbach's process, the mathematical models of color space are also precise and rigorous, and the neuroscience of color perception can be subjective too; so, the objective and the subjective are not strictly on opposite sides, but are present at the same time. (See Tauba Auerbach, "Amphibian," and Conway, "Processing," in this volume.)

In sensitizing ourselves to the radical figure of Gaïa, all of our skills have been trying to understand what is coming—what unprecedented information is arriving to our senses due to the changes brought about by the instruments we have invented? Some instruments may be staged at the scale of humans in a theater, while other instruments reproduce the model at full scale. Every transformation you make in your sensitive instrument can capture other features at work. In this sense, the ridiculous distinction between art and science is part of the history of primary qualities, mapped on the aesthetic as strictly subjective. But, this is not what people actually do to sensitize themselves to Gaïa; it's not how the scientists do it, and it's not how the artists are doing it.

The cosmos has many dimensions, not just four. Four dimensions are a pretty dire reduction of the numbers of dimensions in which we live. None of us lives in only three dimensions or four

dimensions; we live in an infinite number of dimensions. We make artificial situations when we limit the numbers of dimensions, but it requires work to build these situations. It requires a laboratory setup, writing, inscription; it requires a whole staging and scenography. This is why it is interesting to work in the medium of performance. You can see the kind of work that has to be done. Just reducing the world to four dimensions in order to add psychology is not so interesting, but to show that what is being reduced are the *infinite* dimensions, that's really interesting. An action, event, or reenactment can provide a chance to start again, to refuse to see time as "merely" the fourth dimension, to reconceive space-time in order to be sensitive to Gaïa.

How do you absorb the arrival in the world of—let's call it by its name—*horror*? Of course, the solution that makes a lot of sense to most people is to become insensitive to it. Not thinking about it is probably the easiest solution. But it's not the best solution for civilization. At some point, you have to become sensitive to what is coming toward you. But *how?* How do we make ourselves sensitive to a new phenomenon? I don't have the equipment for answering that in an easy way. Neither do scientists. We scream everywhere: "Look, look, look, look!" and no one pays any attention, except to the ones who are marching in New York. It's a very difficult question of producing the right kind of communication to register on the already-insensitive, to produce the right register in which to make an address. Each of the cases I've outlined here illustrates different aspects of the problem related to medium and register. This research by specific individuals and groups is part of the greater project to build our sensitivity and to create a new aesthetic. It would be part of a beginning, of making ourselves sensitive to Gaïa.

WAITING FOR GAÏA

Bruno Latour

FIGURE 1
Final scene, *Gaïa Global Circus*. From left to right: Claire Astruc, Matthieu Protin, Luigi Cerri, Jade Collinet, performing at the Théâtre Sorano, Toulouse, France, September 29, 2013. Courtesy of Compagnie AccenT and Soif Compagnie.

The action takes place in a sort of circus tent; the audience occupies one part of the arena on stepped rows of seats; the actors perform either in the sandy arena or in the tiers of seats, which form a circular belt that runs, partly, behind the spectators.

Both actors and spectators find themselves under a canopy that can be lit up in various ways and on which different atmospheres can be projected—as in a geode or planetarium. In a way, this canopy screen is the lead actor in the play, the center of all the references and all the screenings. So, you need to anticipate being able to perform in either a hi-tech or a low-tech situation according to whatever spaces or budgets are available.

When they find themselves in the arena—and thereby on a level with the spectators, who occupy the other half of the circle—the actors play The Chorus; (FIG. 1) when they move to the bleachers, the actors play whatever the chorus members see, dream, or think.

For the entire show, the seats are divided into three different atmospheres and the chorus takes on the colors of these three zones successively according to the role they are playing in them.

This text is adapted from a play written by Bruno Latour, Frédérique Aït-Touati, and Chloé Latour, which was further developed and produced as *Gaïa Global Circus*. It appears here as translated from the French by Julie Rose, with kind permission of the authors.

The full-length theatrical production *Gaïa Global Circus* was presented at the Kitchen in New York City on September 24 and 25, 2014. This theater research project into the significance of public perceptions about the scientific evidence on climate change was generously supported by the French Ministry of Ecology (MEDDTL); Sciences Po (Institut d'études politiques de Paris, SPEAP Project); the Centre national des écritures du spectacle (La Chartreuse in Avignon); La Comédie, Reims Scène Nationale; The Bayerischer Rundfunk; and Soif Compagnie.

PROLOGUE

Darkness. A street entertainer bursts into the arena.

VOICE OF THE PROLOGUE
You who keep lamenting
The end of humanism
And the decline of the humanities
Will be reassured to learn
That a conference on geology
The thirty-fourth of its kind
In Brisbane, Australia
Is gearing up to bestow
The age we're all embarked on
With the fine name of the *Anthropocene*.
Will you be glad to learn
That at the very moment that the poets
Have abandoned all hope, even,
Of giving form to the human,
It's up to the learned societies

[1] Eds.: "Tepco" refers to Tokyo Electric Power Company, the managers of the nuclear power plant in Fukushima, which was destroyed by a tsunami in 2011.

To hug this giant to their hearts
A giant so outsized
He's now putting his stamp
On geology itself?
You mightn't find him especially life-like
This tectonic Atlas
A grimacing monster bending beneath the yoke
Of all the havoc he wreaks
Merging his deformed features
With the indiscernible features of Gaïa.
Unless what we see
In those two faces, now one,
Is the true icon,
Truly unforeseen
Of a Holy Face:
Ecce Homo Redux

THE NIGHT OF MULTIPLE HEAVENS

Darkness

The spectators find the chorus dozing in the arena in a dreamy atmosphere like on a summer's night after a day of work in some camp. Some are dressed in the uniform Japanese Tepco[1] workers wear, others in blue workers' overalls, still others in white lab coats.

Voices are of men and women indiscriminately, sometimes overlapping. After each period, the sentence may be taken up by another actor.

VOICE 1

That white dot, over there, that's Venus rising; I do wonder what it'll bring me? Love, success in love, that's what I hope for you. Venus, yes, but behind it, lying in ambush, I can see Mars, the red planet. Uh-oh, looks like someone's wife is cheating on him; what are you getting yourself mixed up in, now? Tomorrow, at the crack of dawn, I must check my horoscope. What're the stars saying about me? I can't quite work it out. Do you believe in all that, you lot, in the stars?

VOICE 2

Click, click, click, that's not a planet, it's a satellite, it's twinkling; can you see it? When I was a little girl, it knocked our socks off; our hearts would beat faster, you remember, you oldies? Cosmonauts, we all wanted to be cosmonauts. Outer space, infinite space, making a break for it, leaving this tiny planet behind at last; getting away from it all, sailing into the wide blue yonder; there was the Moon to conquer, then Mars, then way beyond that. *2001: A Space Odyssey*—it all seems so old-hat now, that whole future. Even the space shuttles, you know they've stopped them, too, now, all that's left is the Space Station. Maybe that's it, up there, flashing

its warning light at us: *Houston, we have a problem*. Don't talk about accidents. These things are so fragile; a few of them have blown up in flight, you know. Well, at least they died close to the Good Lord.

VOICE 3

You remember: "Our Father, who art in heaven, hallowed be thy name"? Our father who *is* in heaven, you don't arse about, you don't "art." God, all the same. "Who is in heaven"—isn't there more than one heaven? Yes, there are lots of heavens, probably, or skies if you like. You believe in all that, do you? More than in the stars, anyway. Do you remember Gagarin? Gagarin, what sort of name is that, anyway? A good name for a clown. He said that, up in heaven, the Russian one, you know—*space*. He said he didn't see God. As if God would be in the same heaven as him! "Thy kingdom come"—*that* was a beautiful prayer! Anyway, that he should appear in the heavens there, in front of us, that he should set the heavens ablaze all of a sudden—now that would really be something. Imagine the special effects. "Deliver us from evil. Amen." Yes, more than anything, deliver us from evil. Good idea! *Houston, we have a problem*. And you think God will answer: *Station God, Station God on the line, what's up folks?*

VOICE 4

None of that tells us what the weather will do tomorrow. That's our problem. If it rains on site again, we'll never finish the ark in time. Did anyone hear the weather report? They always get it wrong anyway. Like horoscopes. Like prayers that are never answered. It always rains too much or not enough; they're never happy. You have to have confidence in predictions all the same. But they can't forecast anything; more than three days ahead they don't know anything precise. Yes they do; they've got confidence indicators. Forecasts, not predictions.

VOICE 5

In the long run, it's going from bad to worse. No one can deny that. Tornados, cyclones, rising sea levels, glaciers shrinking and melting. Everything's out of time, the heat, the cold, the rain, the snow. Look, you can't even see the Milky Way anymore with all the dust, the pollution. It's cold for the season, don't you find? There *is* no season anymore; everything's out of whack. Our ancestors the Gauls were afraid of nothing, except the sky falling on their heads, and *voilà*, it's falling on our heads in earnest now. I couldn't care less. I'm not a Gaul. I am a Gaul, but I'm not scared, either. After all, it's not our fault if it rains. They can't forecast anything, anyway; they don't know. Yes, they do. They've got confidence indicators. Like with horoscopes? No! Like with prayers? No! No indicators, there. So, do you really think it's our fault, then, our most grievous fault?

They go back to sleep. Darkness.

THEATRUM MUNDI

All the actors put on white lab coats.

HAMID
Let's start again. We need established facts. Enough history, enough metaphors, enough monsters. Facts, nothing but facts.

CHRISTOF
Which we produce ourselves, so we can finally see how they're made.

HAMID
Exactly: verifiable, inspectable, falsifiable, unfalsifiable. Data, nothing but data.

LYNN
That's all very well, but you'll soon see that it's not all that easy. You spoke of monsters, Hamid—well, you're in for a fright.

HAMID
I'm not afraid of anything. I'm perfectly ready to look reality in the face. I want to look reality in the face.

CHRISTOF
Where do we start?

HAMID
With the globe, obviously, we want global data.

CHRISTOF
But we need to get away, then. It's too cramped here. We can't get the globe in here, surely?

LYNN
Yes, we can. This circus is a very good size. We just have to make a few alterations. The globe will fit in here very well. You'll see, we just need to learn how to transform the Earth into data, into terabytes of data.

Firstly, we have to ask all the weather bureaus of the world to get their data to us. We need giant screens, big mainframe computers too, good graphics palettes, powerful visualization instruments, satellites.

CHRISTOF
That makes, let's see, we'd need fifteen satellites, one hundred moored weather buoys, six hundred drifting buoys, three thousand planes, seven thousand three hundred boats (on condition that they all have the same forms to fill out), nine hundred stations equipped with radiosondes[2] (those are for atmospheric measurements), eleven thousand land-based stations, dedicated networks, and several very, very big mainframe computers. That would equal seventy-five million items for each twelve-hour period. With that we should be able to hold up. But it won't be at all cheap. And it will never fit into this room.

LYNN
Yes, it will. The world isn't any bigger, the orb of the known world. Do you want to get data or not? *[Addressing the chorus.]* For the world to get in here, we have to go out and look for it all over. You, you'll go and investigate. Us, we'll stay in this nice, calm, quiet,

Eds.: A radiosonde is a battery-powered telemetry instrument sent into the atmosphere, usually by a weather balloon, and set to measure various parameters. The resulting data travels via radio to a receiver on Earth.

air-conditioned room and make a giant immobile eye that will look the world in the face.

HAMID
Get to work, get to work.

On the screen, historic forms of weather bureaus and old "computing center" appear. [Lewis Fry] Richardson's computing center as imagined by [François] Schuiten. The chorus vanishes into the wings, scattering in all directions. A short-lived character bursts on the scene.

THEATER DIRECTOR
What is this mess? Where do you people think you are? This is a theater. This is a play you're supposed to be performing. We're not in a laboratory. You've already cost me an arm and a leg. The audience isn't here to learn something; they want to be entertained. Get all those white lab coats off for me and pick up the storyline— if you're still capable of finding the story for me.

LYNN
We're on the right track. Ask the audience if they wouldn't like to find out how the fate they've been saddled with works out.

HAMID
Without science, there is no play, no drama, no stakes—all that stems from the sciences. Is the climate getting warmer or not in your view?

THEATER DIRECTOR
How do I know?

LYNN
Well, exactly. You know nothing without them, without us. The plot can only lie there. We have to go through that narrow door.

CHRISTOF
Anyway, the audience isn't expecting anything precise on our part. They've lost all hope of escaping. There is no more Ark. So let them at least know where they are. That interests them a bit at the end of the day.

HAMID
They want facts. That's for sure, not opinions.

LYNN
We're putting the world on stage—that's not theater? Let's get on with our work. We've been interrupted enough. The real worksite is this one. Let the theater of the world enter.

THEATER DIRECTOR
But I warned you: no didactic theater. Read the contract again.

Exit the theater director, shoved outside by the three stooges and jostled on his way out by the chorus on their way back in. Bustling return of the chorus streaming in from all directions.

THE CHORUS
The data aren't easy to get. They've changed the calibration of the thermometers, we can't make comparisons. China refuses to

share its data on the pretext that it's fighting against capitalism. The stations are located in cities where it's too warm, and that changes everything. There are twelve models of radiosondes that aren't compatible. The boats take days to send their reports in, so we can't incorporate them.

> *They all sit down at the table. The sounds of Morse code, radio calls, log reports quoted over the air can be heard. Noise of teleprinters, fax machines, modems. They type up data by hand using keyboards. Noise of punch cards.*

LYNN
Let's try and see what it amounts to all the same.

> *In the dark, everyone holds their breath. A map of the globe appears on the screen but it is full of holes, almost impossible to recognize, made of enormous pixels.*

THE CHORUS
You can't see much. It's full of holes. Yawning gaps. If that's the world, it isn't a pretty sight. The weather girl on the telly does a lot better than that, and she's a lot more accurate with it.

LYNN
Obviously with the data you've collected . . . I acknowledge that's it's not a very pretty sight.

CHRISTOF
Can't we increase the resolution a bit?

> *The image becomes even more blurred.*

HAMID
I told you we couldn't know anything precise. It's not like geology, or cartography. The atmosphere and the oceans are far too complex. Earth and fire, that's still doable, water and air, pffft, they go all over the place. If you were hoping to convince us once and for all, it's backfired.

LYNN
We need more stations, more data points, more standardizations, more international institutions, more cooperation, more meetings, more forms.

HAMID
You think bureaucrats and congresses will give us confidence? Me, I'm like Saint Thomas, Lynn, I want to see things directly.

CHRISTOF
He didn't see all that directly either, yet he believed without touching.[3]

LYNN
It's not a matter of belief! You just need to have confidence in the institutions we've put in place.

Eds.: The references here are to the Christian saint Thomas the Apostle (also called "Doubting Thomas"), who initially stated that he could not believe Christ had been crucified until he could put his hands in or on the wounds—but when Jesus, crucified, appeared to him after the Resurrection he believed without touching. John 20: 24–29.

HAMID
The institutions! So, then, science is like the Catholic Church, a heavenly climate bureaucracy... the World Weather Watch, the GARP, the GATE, the FFGE, the NWP, the Global Historical Climatology Network, the MCDW... bureaus and more bureaus, meetings and more meetings, resolutions and more resolutions.

LYNN
Of course we need bureaus and records. Without infrastructure, there's no visible globe. Without those things you wouldn't even know the temperature in this room.

CHRISTOF
I take bets. I take measurements.

Stage direction: the chorus spread out with thermometers and barometers to the various corners of the room, under the seats, between spectators, and call out the results while one of them writes them down at the table. They get the data wrong, and have to go through everything again. It's a bit like an election night.

LYNN
It's the only way of bringing the world to them. Here in the theater we're changing the scale. We have to divide up, calibrate, standardize, collect, refine, interpolate, verify.

HAMID
Too many middlemen, far too many middlemen. We'd need scrutineers all over the place.

LYNN
Anyway things are looking up; the resolution's getting higher; the pixels are getting smaller; the stations moving closer; the satellite coverage is improving. Look.

In the darkness a new moving image of station coverage appears and it is in fact more precise. The images are drawn from the cartography of the tools of knowledge.

THE CHORUS
We still can't work out a thing. It's like a fly's eye, only the fly's blind. What exactly is happening? This stuff is just data sources. But the storyline, the crux of the plot, where's that?

LYNN
Obviously you can't see anything. You need a model to interpret the data.

HAMID
And, whaddya know, more middlemen.

LYNN
Without a model we'd never be able to correct the data.

HAMID
Go on, correct, interpolate, cook and recook—that'll really increase confidence!

Eds.: The quote is from Percy Bysshe Shelley, "Mont Blanc: Lines Written in the Vale of Chamouni," 1817.

LYNN
We'll show models without data, just to see what that produces.

The canopy then fills with visualizations of abstract simulations and this time all the points on the grid are filled. We see different forms of scenarios scroll past.

CHRISTOF
That's better, that's much better. The resolution is excellent, this time.

LYNN
Yes, but it's purely theoretical, it's what ought to happen if we understood anything, if we were capable of coming up with true laws of physics, if we could derive all the equations. That is not the reality.

CHRISTOF
Pity, you could see something. You felt like you could, anyway.

HAMID
Would you mind feeding some data into your model? Just a small dose from time to time.

LYNN
Just the right ones, well the most firmly established, the ones that have been corrected thanks precisely to models. All we can do is simulate. There's no way of doing anything else; afterward we inject properly recalibrated observations and we see where that leads us, in fifty or a hundred years.

New projections, this time moving images in color, the models gradually absorbing data.

ATLAS, ATLAS

It is once again night, under the starry vault. In the middle of the arena, there is nothing more now but a globe of the kind you find in schools.

A VOICE IN THE CHORUS
The everlasting universe of things
Flows through the mind, and rolls its rapid waves,
Now dark, now glittering, now reflecting gloom
Now lending splendor, where from secret springs
The source of human thought its tribute brings
Of waters, with a sound but half its own,
Such as a feeble brook will oft assume
In the wild woods, among the mountains lone,
Where waterfalls around it leap forever,
Where woods and winds contend, and a vast river
Over its rocks ceaselessly bursts and raves.

LYNN
"The everlasting universe of things"[4] . . . All that was before, long ago, in days gone by, in the time of poets, when you could count

on immutable nature, on ever-abundant springs, on the regular return of the seasons, on the eternal ice fields of the eternal poles. It's all over now. Reliable nature is a thing of the past. The Great Pan is dead.

HAMID
Nature is always there, indifferent to our worries and to our woes, unwilling consoler, vast amorphous worksite. It's not a matter of poetry, Lynn, but of engineers and scientists.

LYNN
If only nature had remained indifferent, but she no longer is. Hamid, we're weighing her down; apparently we're completely incapable of making a difference. Neither the poets nor the scientists foresaw that.

THE CHORUS
"Anthropogenic origin of global warming." "Anthropogenic origin of global warming"? How can we possibly weigh the Earth down to that extent? That's what we can't quite believe. Aren't we dwarves, cheese-mites, microbes? We're just puffs of air; we pass. All that stuff is just fairytales. It's for our great, great grandchildren, not for us. It can't concern us. It's just too big for us.

CHRISTOF
It's true that there's a real problem of size here. You can see we're not drawn to scale, not equal to the task. That they can't lumber us with the way everything's gone haywire. They can't get us to shoulder all that.

Lynn goes to the globe and spins it.

LYNN
Forty terawatts—that's the energy released by the Earth, the loyal, the earthy Earth, and us, all of us together, is already 13 terawatts. All of us together, of course, with our animals, our plants, our factories, not just you Hamid, not you, Christof, not you there either, all of you silently gathered together in this place. Yes, Christof, we are drawn to scale. We finally measure up. We didn't, it's true. Not in the days of the poets and the engineers. Now, yes.

The canopy shrinks as though the theater had become a stifling circle.

HAMID
The slightest volcanic eruption wreaks more havoc than we do. It's too implausible. The tiniest meteor.

LYNN
Volcanoes, it's true, do damage, but they aren't erupting 24/7, 365 days a year. We are! That's what changes all the calculations. As if we were a slow meteor, distributed, silent, but drawn to scale, completely to scale, and almost as powerful as the tectonic plates—that's what we're culp . . . capable of.

Eds.: The character plays with the aphorism, "Man is the measure of all things," attributed to the sophist Protagoras of Abdera, a pre-Socratic who lived circa 490–420 BCE and influenced Plato.

HAMID
We'd finally emerged from a world that was suffocating within limits that were merely human, and now you want to make us go back there again. We've moved on from ancient times; "man is not the measure of all things."

LYNN
It's the end and the beginning, at once. Man's little circle has expanded and now covers the great circle of life.

All around the stage apparatus the Ouroborus appears, curling around the spectators.

CHRISTOF
Locked down without a hereafter? Look at us, here, all together, and, up above, all that immensity, galaxy after galaxy, and around us, the indefinitely extended circle of the horizon. We've got room, plenty of room, and infinite space.

The canopy expands so that the theater is quite tiny.

LYNN
We *had* room. We *have had* room. Starting from the Moon and going beyond toward the stars, there may well be space, indifferent space to make poets dream and the engineers of NASA do sums, but below the Moon, no. Into that infinite space we will no longer go, you know very well, no Ark, no space station will take us there—we'd die, up there, anyway. We've come back down below the Moon. Just like before. The universe is a thing of the past.

THE CHORUS
"Anthropogenic origin of global warming." Why can't they just say "human origin" and be done with it? The evidence that we're responsible isn't quite in yet, happily. It may well be the Sun. Do *you* feel responsible?

HAMID
That's enough of all this human business. Anthropocentrism is so yesterday; it's finished. That's what we've left behind.

LYNN
That's what we've gone back to. After the Holocene, the Anthropocene, *I* didn't come up with the name.

On the canopy the following message is displayed:

> During the 34th International Geological Congress meeting in Brisbane, Australia, in August 2012, the special committee tasked with deciding the name of geological eras will in all probability adopt the term *Anthropocene* to refer to the current era, over the course of which human activity has dominated all other, natural, geological forces.

LYNN
"Man is the lack of measure of all things," of all earthly things.[5]

HAMID
God I hate this stifling little circle, this navel-gazing, this crushing soul-searching *in camera*, all these stuffy figures of anthropomorphism. Air, give me air, I'm suffocating. Let's get away from human limitations.

THE CHORUS
Anthropocene, anthropophagous, he thinks he's superman now, tectonic man! Either that or Atlas, the mythical giant. That puts us in our place a bit, that does! We've had the age of dinosaurs and the interglacial age. Now it's the age of geological humans. So human beings are going to disappear? We're dwarves, yes, yet we carry giants on our shoulders . . . I'm a lilliputian Atlas . . .

LYNN
You said it a moment ago, Hamid, "man is the lack of measure of all things." Well, then, here we are, no? We're finally the measure of all things, here below. We've got there. Once, people said it without believing it. Now, it's for real.

HAMID
We still have to measure up.

CHRISTOF
Here we are, standing on the shore, and we're waiting for the ferryman who will carry us on his back, to the other side.

The globe appears on the canopy and seems to crush the spectators as well as the actors who have turned into minuscule Atlases.

THE CHORUS
We're going to sink. Help. It's the Flood. I'm drowning.

The figure of St Christopher the cosmos-bearer then appears.

HAMID
We'll never get out of this.

LYNN
Hold on tight. We're already out of it.

CHRISTOF
Is that the face of Gaïa over there?

LYNN
Her disfigured face . . .

CHRISTOF
. . . Beneath the deformed face of the human.

HAMID
Hold on, you have to fight the current. Get to work, get to work.

Darkness. The chorus gather together in the middle of the arena.

THE CHORUS
It's weird: the very moment they're saying that the human is over, they're making him play the lead role. Yes, what a funny role they're making us play on stage in the theater, the Globe theater.

EPILOGUE

VOICE OF THE EPILOGUE

Adam. Father of mankind
Wonder of Creation
On the tree of knowledge of Good and Evil
Were three apples, that Eve gave you, one
after the other.
The first, they say, drove you from this Earthly Paradise
But the sentence was light
Since, through the pangs of childbirth,
Work, love and invention
Enchanted the earth
Preciously clasped
To the bosom of the Almighty
Cosmos of future blessings.
When you ate the second apple
It was the God of ancient promises
Who was driven from the world
But what a reward was this universe
This—infinite—universe
Offered up to your ingenuity
To go forth and multiply.
Deliverance, what deliverance it was!
But if we wore our mourning for the Beyond so gaily
It was because we didn't yet know
That nature, too, would one day be missing,
And here, in our teeth, we still have
Bits of the third apple
That we've only just bitten into:
It's from the universe, this time, that we find ourselves driven,
Brought back within the narrow confines
Of the tiny terrestrial world
Doomed like Atlas
To carry on our shoulders
The limited immensity of things
Encircled by this sphinx of air and fire
Gaïa
False nature and false divinity
And we must, with her, acquire
At last
Knowledge of Good and Evil.

Curtain

BACKMATTER

INDEX

A

"Absolute Film" (1925), 20
Abstract Speed (Balla), *61*
abstraction, 22, 44n32, 58–68, 71; *Abstract Speed* (Balla), *61*; dialectic with anthropomorphism, 24n28; film and, 21, 22; visual vocabulary of, 24
acoustics, 6, 136, 137, 139, 141; arachnid bioacoustics, 30; electroacoustics, 156, 156nn25–26, 157. *See also* sound
actions, 171–85; group dynamics, 181–82; intuitive language for, 181; language action, 182; spider web analogy, 180–85
Adorno, Theodor, 26, 26n36
advertisement, *18*, 20, *32*, 38, 46n35, 50n59, 91, 198, 199
Adzenyah, Abraham, 139
Aeolian harp, *162*, 163
Aesthetic transfiguration of an object (Van Doesburg), *21*
aesthetics, 44n32, 271; aesthetic disturbance, 246; aesthetic insularity, 244–45; criticism, 226–29; discourse, 228; embodied simulation, 242–44; experimental aesthetics, 238–39, 242–44; of modulation, 160; politics and, 311; terminology, 33n43; understanding and, 226–29. *See also* aisthesis; esthetics; neuroaesthetics
affect, 143–49, 238, 300–301, 311; color and, 90–91; nonpurposive feelings, 149; theory, 146n20, 148. *See also* emotion
agency, 296, 300–301, 302, 304; biology and, 205–12; subject and, 211, 304
aisthesis, 32, 32n43, 238, 309–12, 315, 315n3
Aït-Touati, Frédérique, 321
Albers, Josef: *Interaction of Color*, *104*, *104*
Altman, Nathan, 35
"Alvin" submersible vehicle, 165–66, *166*
Alzheimer's disease, 208
analogy, 21–22, 44, 57–58n3, 57–71 *passim*; definitions, 57; plastic analogy, 44, 57–71 *passim*; spider web analogy, 180–85
Androstadienone, 54, back endpaper
animals: consciousness, 75; vision, 105, *118*. *See also* Umwelt; specific animals
animation, 21–22, 43; animated film, 21–22; film stills, *18*, *190*; stop-action, 21–22, 189
Anthropocene, 320–21, 320n11, 325, 334, 335
anthropology, 8, 298, 316; cultural, 242; of sound, 165, 166n8
anthropomorphism, 17, 24n28

antigens, 206
Apollinaire, Guillaume, 59, 59n9
appreciations (James), 259–60
Archaeology of Knowledge, The (Foucault), 289
Aristotle, 273
Arnheim, Rudolf, 22, 24, 24n31; *Art and Visual Perception*, 27, *27*; disk in a box, 27; *Film as Art*, 27
art, 15–16, 309–12, 311n1; art criticism: 227n2; art production, 14; definitions, 26, 39, 43; differentiation, 226; as elemental, 36; embodied simulation and, 239; fine arts, 309; intention, 14, 19, 233; liberal arts, 309; paradigms, 310; as process, 51–52; role in *Experience*, 51–55; as sensitizing, 319; sound art, 140; "strange tools," 26, 28; understanding, 225–29. *See also* aesthetics
Art and Visual Perception (Arnheim), 27
Artificial Intelligence (AI), 187–93 *passim*, 207; self-driving cars, 188
Ashley, Robert, *142*, 143–49, 143n1; *Fancy Free*, 137; landscape, 145n14; "Landscape with Alvin Lucier," 143–49; television, 145n14. *See also Music with Roots in the Aether* (Ashley)
attribution theory, 19
Auerbach, Tauba, 27, 69, 74, 75, 103, 165; *Gradient Flip*, 52, *page edges*; intuitive cognition, 30; *RGB Colorspace Atlas*, 83; *Untitled (Fold)*, 31
aura, 47, 182
autonomy, 299–300. *See also* nervous system

B

bacteria, 8, 29, 205, 206
Balla, Giacomo, 60–62; *Abstract Speed*, 61, *61*
bandes dessinées: See graphic novels
Bataille, Georges, 216
Bauhaus, 36n4, 46n35, 49n57; Book 6, *21*
Bayesian networks, 190, 191
beauty, 20, 37, 44, 44n32, 217, 227, 237, 260, 309
bees, *118*
Begriff, 228, 228n3
being, 26, 77, 167, 298, 309, 317; "social being," 171, 299–300. *See also* appreciations (James)
Bell, Alexander Graham, *150*, 151–61, 164; deaf education, 151–61; ear phonautograph, 155; telephone, 156; voice-writing, 155
Bell, Alexander Melville, 153n14; modulation, 153n13; Visible Speech symbols, 152; vowels, 155n19
Benjamin, Walter, 21, 38–39.48–49, 44n34, *221*, 246
concepts: aura, 46–48; in G-Group, 38–42; human perception, 46; lightning metaphor, 217; mass culture, 44n34; media theory, 48n47;

memory, 51; photography, 47, 49, 50n59; print as medium, 38–42, 46; sameness, 221; technological modernization, 246
works: *Einbahnstraße*, 44–45; "Little History of Photography," 47, 49; *One-Way Street*, 46n34; *Passagenwerk*, 47n37; "The Work of Art in the Age of Its Technological Reproducibility," 46
Bergson, Henri, 63; human body, 63n23; influence on Futurists, 62n20
Berkeley, George, 252
Berlin, 43n29, 122; experimental film, 19, 21, 27; Gestaltists, 19, 22, 24–25, 27, 27n38; International Film Festival (1925), 20; Psychological Institute, 23. *See also* G-Group
Berson, Joshua, 195
Bhabha, Homi, 299n11
Biederman, Irving, 88, 89
biology: body-world schema, 205–12; feedback loops, 205; self and, 205–12; Umwelt, 25, 29, 33
Birth of the Clinic, The (Foucault), 289
Bloch, Ernst, 35
Bloom, William, 159
Blue Dancer, The (Severini), *62*, 63
Boccioni, Umberto, 62; *Muscular Dynamism*, 63
bodily framing. *See* human body
body. *See* human body
body schema, 205, 209–12
Bolyai, János, 116
Boring, Edwin, 19
Bose, Amar, 6
Boyd, Eric, 197
Bragaglia, Anton Giulio and Arturo, 63n24
Bragdoen, Claude: *A Primer of Higher Space*, 77
brain: aesthetics and, 237–45 *passim*; brainwaves, 134n2, 135, 200–201; cerebral cortex, 97; color as interpreted through, 103, 105, 106, 122; color as tool to understand, 100; drugs and influence on, 75, 221; extrastriate cortex, 104, 105n30, *106*; gut-brain axis (GBA), 209; hippocampus, 97; hypothalamic pituitary axis (HPA), 208–9; IT region, 97, 107, *108*; LGN (lateral geniculate nucleus of the thalamus), 97; mirror mechanism, 32, 240–45; mirror neuron, 32, 239n9, 240, 241n14; models of movements, 187–93 *passim*; as musical instrument, 133, 134–35, 139, 145, 165; reverse engineering and, 191–93; thalamus, 97, 147
breathing, 275
Brecht, Bertolt: photography and, 50n59
Breton, André, 216–19, 217n10; *Manifesto of Surrealism*, 216–19
Buehler, Markus, 171, 180n7, 183, 183n11, *185*
Bush, Vannevar, 111
butterfly effect, the, 184n14, 185

C

Cadava, Eduardo, 220
Cage, John, 135, 144; *Music of Changes,* 136
camera, 47–49, 61, 103; as mediator, 50; metaphor for eye, 103; as tool, 13, 172. *See also* "eyeborg"
Campbell, George, 158
Cannon-Bard theory of emotion, 147n22
canonical neurons, 240
Cantor, Georg, 116
carotenoids, 92
Carrà, Carlo, 64, 64n30
CAST (Center for Art, Science & Technology at MIT): "Seeing/Sounding/Sensing" symposium, 6, 8, 52
cat: color perception, *118*; consciousness, 75; photograph, *74*
causality, 17, 299n13; probable causes, 193
cell: asymmetry, 205–6; cellular co-transport theory, *54*; development, 205, 206, 209; differentiation, 205–12; migration, 206; neural crest cells, 209; neuron, 32, *107,* 240; polarity, 205–6; scanning electron micrograph, *204*; white blood cell, *204. See also* bacteria; cone (cell in retina); immune system
Certeau, Michael de, 299
change, 192, 195, 198–200, 289, 306, 307; bodily, 205–12 *passim*; identity, 305; technological, 35–39 *passim. See also* climate change
Chion, Michel, 167
Chladni, Ernst, 152n6
Chopin, Frédéric, 163
chromatic theory, 65n31, 65n32, 69n41
chromatopic maps, 105
chronophotography, 61
cinema. *See* film
cinematographic, 59n9
Clarke Institution for Deaf Mutes, 151, 152n3
class (concept), 300–301
classification, 24, 256n10
climate change, 55, 193, *314,* 315; atmospheric knowing, 222; *Climate Changed* illustration, *317*; protesters, *315*; United Nations Framework Convention on Climate Change, *314. See also* Anthropocene
Climate Changed (Squarzoni), *317,* 320
Closed Book (Lucier), 5, 129
cognition, 5, 8, 16–19 *passim,* 68; motor system and, 240–42; reverse engineering, 187–93 *passim. See also* processing
Cole, Harriet, 14–16, 16n8; nervous system, *17*
Coleridge, Samuel, 163, 244
collectivity, 37, 44, 48, 50, 292
Collingwood, R. G., 299; *The Idea of History,* 299–300
color, 65n32, 69n41, 80

function: categorization, *108*; constancy, 103, *108*; culture, 93, 96; emotion, 90–91, 96, 107, *108*; feature attention, 93, 109; grouping, *108*; health diagnosis, 91; hue, *108*; memory, *108*; popout, 92, *94–95, 108,* 109; primary reward, 93, 96, *108*; social cognition, 96, *108,* 109
mathematics and color, 119–25; four-color map problem, *110*
perception, *118,* 125n14; color blindness, 93, 106, 122, 164; context, 101; exclusion problems, 112; experience, 90–91; filters, 91, 101; hearing color, 164; human sensation, 122; individual difference, *102,* 103n26; isoluminance, 89, 90; judgment, 101; luminosity, 123; monochromatic weaving, 85; neuron response to, *107*; "Paradox of Monge," 101n23; prismatic sequence, 65–67; recognition, 88, 91; recognition error rates, 88; of sounds, 69n41; "the dress," 101–2, *102*; tonal distribution of color, 65n31; visible spectrum, 80; vision, 88–109
processing, 87–109, *106*; neuron response to, *107*
representation: color wheel, *84*; color-space, 112; colorspace mapping, *82*; models, 81; tonal distribution of color, 65n31
theory, *124*; Goethean theory of, 113; primary colors, 99–100, 121; private language and, 113n10; pure color, *86*; secondary colors, 121; trichromatic theory of color, 121; unitary colors, 121; yellow analysis, 123; zone theories of color, 125
Colour and Colour Theories (Ladd-Franklin), 119
comic books. *See* graphic novels
common ground, 297
common sense, 7, 8, 27, 31–33, 36–37, 50, 70, 123, 249, 315–16; common sense core, 187, 192; infants, 192; reverse engineering, 187–93
communication theory, 156n28, 158; communication engineering, 160; neuro-immune communication, 207; nonverbal communication, 183
computer: graphics, 191; interface theory, 50; medium *versus* tool, 50; metaphor for the brain, 97–98. *See also* Artificial Intelligence (AI)
cone (cell in retina), 81, 125n14; cone-opponency theory, *82*; spectral sensitivity, 99; three types, 99, *99. See also* eye
cone-opponency theory. *See* cone (cell in retina)
consciousness, 29, 75–84, 251n5, 256n12, 298; culture and, 15; film and, 43; James's argument of nonexistence, 249–61; mediation of world, 46; perpetual consciousness, 225;

self and, 84; technology and, 15. *See also* unconscious
Consider the Lobster (Wallace), 113
constructivism, 39n16
consumption, 199, 234
Content Object Design Studio, 55
Conway, Bevil, 30, 51, 86, 87
cosmos, 77n2; cosmic communication, 184; cosmic web, 171; dimensions of, 322–23
Cowan, Michael, 20
Crane, Richard Kellogg: cellular co-transport theory, *54*
Crane Hypothesis (Höller and Roche), *54*
Cross, Myrle V., *110*
Csibra, Gergely, 190
Csordas, Thomas, 247
Cubism, 35, 59
culture, 8; corporate culture, 234; cultural anthropology, 242, 298; cultural identity, 244; culture of the voice, 152; mass culture, 20, 44n34
cyborg and cybernetics, 50, 146, 164, 165, 200n11, 201. *See also* "eyeborg"
cytokines, 208

D

Damisch, Hubert, 59n8
dark matter, *170,* 171
Darwin, Charles: evolutionary tree, *190, 190,* 191n3; natural selection, 193
De Stijl, 36
deaf education, 151–61; ear phonautograph, 155–56; exercises in, *154, 155*; Visible Speech symbols, 152; voice-writing, 155
deep-brain stimulation (DBS), 93
dehumanization, 68
Delany, Samuel, 295n1; *The Motion of Light in Water,* 305
Delaunay, Robert, 59
Deleuze, Gilles, 159–60, 195
Denis, Claire: *L'intrus* (*The Intruder*), 236
depression, 208; and color, 107
Descartes, René, 258, 316
determinism, 246
Detroit Day School for the Deaf, *154*–55
development. *See* cell; human development; psychology; social development
Dewan, Edmond, 30, 134, 134n2, 135, 138
Dewey, John, 26, 227, 269, 282, 287; live creature, 269, 277; stasis, 272–73
Dickinson, Emily, 195
diffraction, 296n4
digestive system, *207,* 209; gut-brain axis (GBA), 209
digital technology: digital signal processing, 151. *See also* tracking
dimension (space), 30; fourth dimension, 68, 68n36, 77, *110,* 116, 116n20; fifth dimension, 68; of cosmos, 322–23; dimensionality (term), 70; geometry and, 114–15; higher dimensions, 30; hyperspace, 68, 77, 79; space-time, 30, 319; time, 79, 197–98

Discipline and Punish (Foucault), 291
discourse, 296–307, 297, 299, 304, 311; aesthetic, 228; experience and, 302–7; foundationalist, 297; identity and, 304; of modulation, 160
Disney, Walt, 21; *Fantasia,* 21
Dissanayake, Ellen, 242
documentary, 91; montage documentary, 311n3
Doesburg, Theo van, 21, 37
Doherty, Brigid, 42n24
dot product, 100, 100n22
dream state, 217n10
Drexel University, 16n8
Dudley, Theresa, *150,* 151–52
Dyhrberg, Mette: image "2.5 Years of My Weight," *194*

E

Eccles, William, 157
economics: choice-making, 193n5; economic utility theories, 193; neuroeconomics, 193n5
Edison, Thomas, 22; *Van Bibber's Experiment,* 19
Eggeling, Viking, 43
Ehrenzweig, Anton, 27
electricity and electromagnetism: electric wave filter, 158; electrical resonance, 157; electroacoustics, 156, 156nn25–26, 157; via electrodes, 105; electromagnetic paradigm, 156n26; electromagnetic spectrum, *80;* electrophorus, 215
Eliasson, Olafur, 52; "Contact," 29; dimensions, 30; *Map for unthought thoughts, 29; See-through compass,* cover, 55
Ellis, Alexander, 155
embodiment
embodied self, 205–12
embodied simulation, 237–47 (see also aesthetics); liberated, 244–45; why of, 244–45
See also human body
emotion, 143–49, 271, 274
color and emotion, 90–91, 96, 107, *108*
embodied simulation and emotion, 241
theories of, 147n22; Cannon-Bard theory of emotion, 147n22; James-Lange theory of emotion, 147n22; Schachter-Singer theory of emotion, 147n22; signs of the voice, *150*
empathy, 44n32, 263n1
empiricism, 117, 298
endocrinology, 55n66
epistemology, 112, 117
equiluminant objects, 89
Erfahrung, 26, 30, 220, 234, 246
Erlebnis, 25, 30, 220, 246; *Erlebnisgesellschaft,* 234, 234n2
Erlmann, Velt: *Reason and Resonance,* 158, 163
Esquirol, Étienne, 291
esthetics, 33n43, 260n16
Estratetraenol, front endpaper, 54

ethics, 70; science and, 119–25; tracking, 203
ethnicity, 301
Euclidean geometry, 114
evidence, 296; evidence of experience, 296; referential notions of, 296
evolution and evolutionary theory, 146, 260; of color, 89, 90n5, 123–24, *190,* 205; cultural, 239; and determinism, 246; evolutionary aesthetics, 242n20
experience, 8; body and experience, 302n22 (see also human body); color and experience, 90–91, 123 (see also color); conceptual experience, 256; definitions of experience, 292, 297; discourse and experience, 302–7; employment of term, 298–303; evidence of experience, 296 (see also evidence); evolution of experience, 298; expanding experience, 30; experience as category, 303; experience as fiction, 291; experience book (Foucault), 30–31, 31n41, 289–92; experience *versus* logic, 114; experienced relations, 254n6; fact *vs.* opinion, 256n12; having an experience, 269–75; historicizing experience, 295–307; language and experience, 305, 306; limit experience, 31, 290; lived *vs.* unlivable experience, 290; morality and experience, 120; naturalizing experience, 306; non-perceptual experience, 254n7; perpetual experience, 228; personal experience, 302n23; pure experience, 250, 256; reading books as experience, 292; referential notions of experience, 296; representative function of experience, 254n7; sensorimotor features, 238–47 (see also motor system); subjectivity and experience, 22, 35, 37, 50, 57
Experience (Jones, Mather, Uchill): content; interdisciplinary motivation of, 13; methodology, 7; purpose of, 13, 33, 36; role of art, 51–55
Experience Process: Space Poems (Green), 51–52, 277–88
experimental film. *See* film; "Heider-Simmel" film (1943)
Expressionism, 35, 48
eye, 263; as camera, 103n28; cones, 81, *83,* 99, *99,* 125n14; retina, 81, 98, 119; rods, 81, 98, 125n14. *See also* cone (cell in retina)
"eyeborg," 165n7

F

facial recognition, 89–90, 106, 107; Diana (Princess of Wales), *91*
Fantasia (Disney), 21
Faur, Christian, *114*
feelings. *See* affect; emotion

feminism: agency, 302; critique of objectivity, 301–2; female experience, 302; feminist osmosis thesis, 302n23
Fessenden, Reginald, 157
Figueres Olsen, Christina, *314,* 315
film: abstract, 13–23 *passim;* animated film, 21–22; coloring by hand, 20n21; embodied simulation, 32, *237;* figuration, 21; film stills, *18, 190;* "Heider-Simmel" film (1943), 13–23 *passim,* 189, 193; human consciousness and, 22, 43; human figure and, 14; Kino-Eye, 311n3; literalization, 21; live music, 20n21; montage, 19; montage documentary, 311n3; persistence of vision, 19; Perutz Nonflammable (film stock), 13, 13n1; as process, 43; projection (See projection); representation, 21; shapes in, 43n27; suture, 19
"Film as an Original Art Form, The" (Richter)
Film as Art (Arnheim), 27
Film und Foto exhibition, 49n55
Fischinger, Oskar, 20, 21
Fitbit (health monitoring device), 198–201; Fitbit Zip promotional video, *202*
fMRI, 105, 105n32, 237
Fontana, Lucio, 243
Fort, Jeanne, 58n7
Foucault, Michel, 30–31, 195, 289–92
concepts: genealogy, 306–7; medicine, 291, 292; modernity, 292; technologies of the self, 195; truth, 290, 291
works: *The Archaeology of Knowledge,* 289; *The Birth of the Clinic,* 289; *Discipline and Punish,* 291; *The History of Sexuality,* 289; *Madness and Civilization,* 289, 290, 291
writing process, 289–92; and experience, 289–92
foundationalism, 297, 302, 306
Foundations of Arithmetic (Frege), 114
four-color map theorem, 112
Fourier, Joseph, 154
France, 157, 158, 320; prisoners' movement, 292
Frank, Adam, 51, 69, 143
Frege, Gottlob, 114; *Foundations of Arithmetic,* 114
Futurism, 22, 59n9, 59nn10–11; human physicality, 63; influence of Bergson on, 62n20; sensation, 60–62; speed, 60–62. *See also* Italian Futurism

G

G: Material for Elemental Form-Creation, 36n4, 43n27; "Badly Trained Soul," 42, 44, *45;* dynamism, 42; "elemental" art, 36; layout, 42n24; mission, 35–36, 38; Realist Manifesto, 38; typography, 42n21, 46n34. *See also* G-Group
Gabo, Naum, 38

Gabor, Dennia, 156n28
Gaïa, 32, 315–23, 325–36; *Waiting for Gaïa*, 325–36
Gaïa Global Circus (Latour), 32, *32*, 55, *318*, 321, 322, *325*
Gallese, Vittorio, 32, 51, 237
Galvani, Luigi, 24n32
Gardner, Martin, *110*, 116
gender, 55, 163, 301; medical history of, 55n66
geology: Anthropocene, 321n11
geometry, 114–15; and abstraction, 14–23 *passim*; Euclidean, 114; geometric modeling, 172; non-Euclidean geometry, 68n36; patterns in art, 57–66; spider web, 171, 183
German Romantics, 111
Germany: Nazi-era aesthetics, 44n32. *See also* Berlin; Weimar Republic
GeSoLei exhibition (Düsseldorf), 18
Gestalt psychology, 19, 21, 25n34, 36n5; film and, 24; "unconscious form principles," 21
G-Group, *34*, 35–55 *passim*, 35n1; influence on Benjamin, 46n34
Gibson, James, 25n34, 27, 316
Goethe, Johann Wolfgang von, 111; *Theory of Colours*, 112n4
Golomb, Solomon, 111
Gombrich, Ernst, 27
Google self-driving cars, 188
Gorillaz band, 233
Gradient Flip (Auerbach), 52, page edges
Gräff, Werner, 35, 35n1, 36, 36n4; *Es kommt der neue Fotograf!*, 49; *Film und Foto* exhibition, 49n55; New Engineer, 35; New Photographer, 49
graphic novels, *317*, 320–21
Green, Renée, 33, 51–52, *278*; "Experience Dreams," 53; *Experience Process: Space Poems*, 51–52, 277–87
group dynamics, 181–82. *See also* proxemics
gut-brain axis (GBA), 209

H

Hall, Edward, 181, *181*; *The Hidden Dimension*, 181
Hall, Stuart, 304
Hammrick, Jessica, *191*
HangarBicocca, *191*, 319
Hansen, Mark, 51, 246
Hansen, Miriam Bratu, 47
HAPIfork (HAPILABS), 199
haptic and haptic sense, 111, 148, 246n34. *See also* tactile sense
Haraway, Donna, 50, 296n4
Harbisson, Neil, 164
Harvard University: Psychological Research Laboratory, *22*; Psychotechnics Laboratory, *23*
Hausenstein, Wilhelm, *35*
Hausman, Raoul, 36n4, 42n24
health: color and, 91–92; tracking, 195–203

hearing, 264. *See also* deaf education; sound
Heart Spark (Sensebridge), 197, *199*
Hegel, G. W. F., 26
Heidegger, Martin, 25; experience, 26nn35–36
Heider, Fritz, 14–33 *passim*; duration and, 24; *The Life of a Psychologist: An Autobiography*, 13n2, 24, 25n34; papers, 24n28; sketch from notebook, *25*; visual perception, 25n34
"Heider-Simmel" film (1943), 13–23 *passim*, 24n31, 189, 193; human figure and, 14; lack of content, 14; Perutz Nonflammable (celluloid), 13. *See also* projection
Helmholtz, Hermann von, 119, 122, 154, 164, 220; *On the Sensations of Tone*, 155
Helmreich, Stefan, 6, 70, 162, 163
Henderson, Linda Dalrymple, 62n20, 68n36
Hensel, Carl, 81
Hering, Ewald, 120, 121, 122
Hertz, Heinrich, 157
Hilberseimer, Ludwig, 43
Hinton, Charles, 116; *The Fourth Dimension*, *110*; *A New Era of Thought*, *110*, 116
history and historiography: authority of historian, 299–300, 307; categories of representation, 296–307 *passim*; crisis and, 295; critique of normative practices, 297; documenting experience, 295–307; historians of difference, 295–307; historical contingency, 50, 297; historicizing experience, 295–307; transferential relationships, 306; truth and, 295
History of Sexuality, The (Foucault), 289
Hodgson, Shadworth, 256
Höller, Carsten, 54, *54*; *Smelling Zöllner Stripes*, 52, endpapers
Hubel, David, *86*, 87
human body, 63n23, 182, 263–66, 302n22; body-world schema, 205–12; corporeal interrelation (subject and world), 62n21; embodied representation, 64; embodied simulation, 32; embodiment *versus* supersensible interconnectivity, 67; experience and, 302n22; framing, 237–47; movement, 181–83, 311; predictive coding model, 209–10; self and, 29; tracking, 195–203. *See also* specific systems
human development, 190, 196; infants, 192. *See also* psychology
human perception, 16, 46, 69, 112, 263–66; auditory, 70 (*see also* deaf education; sound); brain *vs*. body systems, 205–12; comprehending, 16 (*see also* understanding); as medium, 47; processing, 87–109; sensitizing, 315–23

Hunt, Frederick, 156
Hunter, Sam, 135
Husserl, Edmund, 62n21, 263; phenomenology, 25
Hustvedt, Siri, 239
hypercube, 78–79 *passim*, 117
hypothalamic pituitary axis (HPA), 208–9

I

I Am Sitting in a Room (Lucier), 51, 51n63, 130–31, 136, 139, 165
Iacono, Alfonso, 244
idea, 234, 252
Idea of History, The (Collingwood), 299–300
identity, 55, 102, 221, 244, 303–6
If the Universe Is Teeming with Aliens . . . Where Is Everybody? (Webb), 184
image and imagining, 16, 237–47; fictional, 245
immune system, 206–12; adaptive, 206–7; innate, 206–7; neuro-immune communication, 207; non-self and, 206
Impressions d'Afrique (Roussel), 218
Incan sacred stone, *268*
indexicality, 61, 167n12, 243
individualism, 48n49, 58. *See also* subject; subjectivity
infants: common sense, 192; looking time, 192
information theory, 164
Ingold, Tim: *The Perception of the Environment*, 242
inscriptions, 167n12
Instagram, 91
"Interaction of Color, The" (Albers), 104
International Space Station, 173
intersubjectivity. *See* subjectivity
intertextuality, 50
intracephalic muscular adjustments, 260
intuition, 181–82, 264–66; inferring, *190*; intuitive behaviors, 29, 181–82; intuitive physics, 32–33, 187–90, *191*, 192; reverse engineering, 187–93; "Simulation as an Engine of Physical Scene Understanding," *191*; workshop scene, *186*
irradiation, 65
isoluminant objects, 89, 90
isotype, 22n24
Italian Futurism, 22, 57–71 *passim*; divide between words and image, 59; radicalism, 60; sensation, 60–62; speed, 60–62. *See also* Futurism
Italy, 59, 62n20, 137n3. *See also* Italian Futurism

J

James, William, 22, *22*, 25, 62n21, 249, 275; "blooming buzzing," 167
James-Lange theory of emotion, 147n22
Jameson, Fredric, 298
Jarzombek, Mark, *268*

344

INDEX

Jay, Martin, 58n5
Jennings, Alice, 153–54; *Heart Echoes*, 154; *The Silent Worker*, 160
Jones, Caroline, 6–7, 13
Jouzel, Jean, 320
Joyce, James, 217
Ju, Ginny, 89
Judson dancers, 136
Jünger, Ernst, 26, 35

K

Kahn, Douglas, 164, 214, 215
Kahneman, Daniel, 193n5
Kandinsky, Wassily, 59
Kane, Brian, 14, 69, 134
Kant, Immanuel, 227, 249
Kanwisher, Nancy, 88
Kelly, Kevin, 196
Kelly, Leah, 28, 205
Keywords: A Vocabulary of Culture and Society (Williams), 298
Kiesler, Frederick, 36
Kim-Cohen, Seth, 167
kinesthesis, 265–66
kinetic motion, 62. *See also* speed
kinetoscope, 22
Kinney, Leila, 7
Kino-Eye, 311n3
Kircher, Athanasius: "Machinamentum X," *162*
Klein Bottle, *84*
Kline, Franz, 243
knowledge, 69, 295–307; by acquaintance, 112; analysis of knowledge production, 307; as assemblage of accurate representations, 298n10; atmospheric knowing, 222; by description, 112; experience as origin, 296, 298; experiment and knowledge production, 298; mathematical knowledge, 111–17; private mind, 112; pure experience and, 250; sensitizing, 315–23; shared acts of knowing, 112; sociology of knowledge, 298; tracking and, 197–201
Köhler, Wolfgang, 19
König, Arthur, 122
Koren, Anne, 143
Korolec, Marcin, *314*, 315, 315n2
Korzicki, Scott, 202
Kracauer, Siegfried, 35
Krause, Wallace, 160
Kupka, František, 59
Kurtz, Rudolf: *Expressionism and Film*, 44

L

Lacan, Jacques, 16n11
LaCapra, Dominick, 306
Ladd-Franklin, Christine, 69, 119–25, 119n1, 121n6, *124*; *Colour and Colour Theories*, 119; illustration, *118*; theory of cones and rods, 125n14
Land, Edwin, 101, 103
"Landscapes with Alvin Lucier," *142*, 143–49

language theory, 302–3, 305
Latour, Bruno, 51, 63, 70, 167, 182, 315, 318; *Gaïa Global Circus*, 32, *32*, 55, 318, 321, 322, *325*
Latour, Chloé, 321
Lauretis, Teresa, 299
Le Treut, Hervé, 320
Lefebvre, Henri, 242
lesbianism, 55n66
Lichtenberg, Georg, 215, 220
Lichtenberg figures. *See* lightning
Life of a Psychologist: An Autobiography, The (Heider), 13n2
light: cones and rods sensing, 125n14; wavelengths of, 121n6
lightning, 215–23; Lichtenberg figures, 215; lightning flowers, 215, *220*; Popov invention, *222*
limit experience. *See* experience
linguistics, 302–3; experience and, 305
L'intrus (The Intruder) (Denis), *236*
Lippitt, Jeanie, 155–56
Lissitzky, El, 36, 39, 42, 59; constructivism, 39n17; print design, 42n20; *Proun Room*, 39
Lista, Giovanni, 60n16
"Little History of Photography" (Benjamin), 47, 49
localization, 264–66
Locke, John, 25, 252, 271, 316
Lodge, Oliver, 62n20, 63, 157n32
logic, 117
López, Francisco: Klein Bottle, *84*
Lorenz, Edward, 184n14
Lucier, Alvin, 6, 30, 51, 51n63, 69, 134, 143–49, 143n1
commentary: acoustics, 137; brainwave amplifier, 135, 144–45; drone, 144; duration, 144; interview, 134–41; objectivity *versus* subjectivity, 140; purification, 148; repetition, 136; resonance, 139; simplification, 148; speech, 137; stuttering, 137; technology as landscape, 145
works: *Closed Book*, 51, 129; *The Duke of York*, 140; *Fancy Free*, 137; *(Hartford) Memory Space*, 140; *I Am Sitting in a Room*, 51, 51n63, 130–31, 136, 139, 165; *In Memoriam Jon Higgins*, 138–40; *Music for Solo Performer*, 51, 133, 134, 139, *142*, 144–45, 146, 165; *Navigation for Strings*, 140; *The Only Talking Machine of Its Kind in the World*, 137; *Outlines of Persons and Things*, 143; *Rare Books*, 51; *Sferics*, 165, 223; *A Tribute of James Tenney*, 139
Lukács, Georg, 35

M

macaque monkey. *See* monkey
Mach, Ernst, 25
Madness and Civilization (Foucault), 289, 290, 291
Makanna, Philip, 143

Making of the English Working Class (Thompson), 300
Malevich, Kazimir, 59
Man with a Movie Camera (Vertov), 311n3
Manifesto of Surrealism (Breton), 216–17
Map for unthought thoughts (Eliasson), *29*
Marey, Étienne-Jules, 61
Marinetti, Filippo Tommaso, 57–58n3
Markun, David, 91
Marx, Karl, 46, 312
Massachusetts Institute of Technology (MIT): CAST (Center for Art, Science & Technology): symposium, 6, 8, 52
Matheke, Susan, 143
mathematics, 111–17; color and, 119–25; Euclidean geometry, 114; four-color map problem, *110*; geometry, 114–15; non-Euclidean geometry, 68n36; transfinite numbers, 113, 116
Mather, David, 6, 22, 44, 57
McDermott, Josh, 6
McDowell, John, 227
"mean proportional," 273
media and mediating, 35–55; computer as medium, 50; consciousness and, 46; human perception and, 47; media as applied physiology, 151n1; medium (term), 46; print as, 38–42, 45, 46; sensitizing and, 319; technology and, 50; theory, 48n47. *See also specific medium*
medicine, 292; healthy color, 91–92. *See also* health
medium, 38; *Medium*, 46–47, 49–50. *See also* media and mediating; *Mittel*
memory, 212; implicit priors, 101; transgenerational memory, 207
Mendel, Gregor, 193
Merleau-Ponty, Maurice, 62n21
microbiota, 209
Mies van der Rohe, Ludwig, 36
Mills, Mara, 70, 151
Mills College, 140
mimesis, 310
Minsky, Marvin, 87
mirroring, 17, 39, 245; digital, 196–200; mirror image of eye, 263n1; mirror mechanism (Gallese), 241, 244; psychoanalytic, 16n11; reflection, 163. *See also* brain (mirror neuron)
Mittel, 43n28, 46, 47, 50
modeling, 13–33; causal trajectory, 17; consciousness and, 28; definitions, 24; reverse condition, 17
modernity, 291; confinement, 291; medicine, 292; speed, 63; urban life, 58
modulation, 70, 151–61, 153n13, *157*, 161n50, 161n51; aesthetics, 160; definition, 151, 158n33; discourse of modulation, 160; electroacoustics and, 157; inflect, 157; mold, 157;

345

pulse code, *158*; signal processing, 160; use of term, 159n40
Mohanty, Chandra Talpade: feminist osmosis thesis, 302n23
Moholy-Nagy, László, 20, 49, 49n57
Molderings, Herbert, 49n55
Monge, Gaspard, 101n23
monkey: macaque, 89, 240–41; microelectrode recordings, 105; trichromat primates, 92n9; vision, 89; visual-object processing, *96*
morality, 272; experience and, 120; science and, 119–25
Morton, Oliver, 319
motion, 60n16, 63n24
Motion of Light in Water, The (Delany), 305
motor system, 240–42; motor intentionality, 242
Müller, Georg Elias, 122
Müller-Lyer illusion, 229
multimodality, 239–42
Münsterberg, Hugo, 22, *22*, 254; *The Photoplay: A Psychological Study*, 22; psychotechnics lab of, 22
Muscular Dynamism (Boccioni), *63*
museums, 310
music: emotions in, 143; experimental, 134–41; modern, 164; modulation, 151; performance, 134–41; recordings, 141; repetition, 136
Music for Solo Performer (Lucier), 51, 133, 134, 139, *142*, 144–45, 146, 165
Music with Roots in the Aether (Ashley), *142*, 143–49, 143n1, 165

N

Nancy, Jean-Luc, *237*; *The Experience of Freedom*, *283*
narrative, 17, 296, 304
Nazi-era aesthetics, 44n32
Nebeker, Frederik, 159
nerve signals: afferent nerves, 66; efferent nerves, 66
nervous system, 14, 207–8; autonomic nervous system (ANS), 209; central nervous system (CNS), 207; diagram of Cole, *17*; enteric nervous system (ENS), *207*, 209; neural crest cells, 209; neuro-immune communication, 207; synapses, 15n7
Neue Sachlichkeit (New Objectivity), 22, 36, 48
Neurath, Otto, 22n24
neuroaesthetics, 237, 238
neuroeconomics, 193n5
neuron, 32, *107*, 240
neuroscience, 28, 237, 317; cognitive, 238, 246; color processing, 87–109
New Era of Thought, A (Hinton), 116
Newton, Isaac, 80, 193; color wheel, *84*
Newton, Judith, 302
Nietzsche, Friedrich, 151n1
Noë, Alva, 51, 225; *Out of Our Heads*, 225; *Varieties of Presence*, 225

O

object. *See* subject, the
object recognition, 89
objectivity, 22, 48, 117, 256
observation, 123
opponency, cone theory. *See* cone (cell in retina)
oppression, 302n23
Other, the, 245, 295
Otis, Laura, 159
Out of Our Heads (Noë), 225

P

Paradox of Monge, 101, 101n23
Peirce, Charles Sanders, 119, 125
Perception of the Environment, The (Ingold), 242
"Perceptions of Geometrical Figures" (Heider and Simmel), *12*
performance, 134–41; recordings, 141; repetition, 136
peripersonal space, 240. *See also* proxemics
Peters, H. M., 173n3
Peters, John Durham, 151n1
Pevsner, Antoine, 38
phenomenology, 25, 46, 116–17, 147, 202, 263, 290, 297. *See also* experience; haptic and haptic sense; tactile sense
photogrammetry, 172
photography, 47, 49; blurry, 91; color, 88, 103; "dress, the," 101–2, *102*; edge qualities, 91; filters, 91; Lichtenberg figures in photographic film, *214*; as mirror, 39; modern life and, 49n57; perception and, 49n57; photomontage, 45; reality and, 50n59
"Photography from the Verso" (Tzara), 48
physics, 14; intuitive physics, 187–90, *191*, 192; quantum physics, 234
Picasso, Pablo, 59, 59n10
plasticity, 57n2; plastic problems, 59n9. *See also* analogy
Plato, 228
Poincaré, Henri, 115
Popov, Alexander, *222*
positivist philosophy: architecture and, 22n24; art and, 22n24
power, 297, 299
pragmatism, 25, 26
Prampolini, Enrico, 69n41
Prandoni, Paolo, 159n41
Pratt, Minnie Bruce, 296n4
Priestly, Joseph, 219
Primer of Higher Space, A (Bragdoen), 77
primitivism, 44n32
print (medium), 38–42; layout, 42n24; as mediation, 45; photomontage, 45; role in *Experience*, 51–52; spatial arrangement, 38; typography, 38, 42, 42n21, 44, 45, 46n34
private mind, 112
processing, 87–109; Anthropocenic recognition of process, 321; experience through space poetry, 279–87; multimodality, 239–42; signal, 159–61. *See also* color; visual processing
projection, 16–20, 21–22, 24; projective test, 17, 146
Protagoras of Abdera, 337n5
Protin, Matthieu, *32*, *318*, *324*
proxemics, *181*, 181–82, *240*
psyche, 24, 37
psychedelics, 111, 165, 171
psychiatry: antipsychiatry, 291, 292
psychology, 14, 46; developmental, 28, 147, 187, 188, 189, 193; intuitive psychology, 187, 190, 192. *See also* Gestalt psychology
psychophysiology, 8, 44, 61, 63, 69, 71, 144, 245
psychotechnics, 22, 46n35
pulse code modulation, 151, 158
puppet, *318*, 321, 321n12

Q

Quantified Self (QS), 196–203

R

race, 301, 304
radiosonde, 328n1
Raffeiner, Arno, 233
Ramón y Cajal, Santiago: theory of cones and rods, 125n14
Rancière, Jacques, 32
realism: existential reality, 68; film and, 22; reality as it is, 69
reality, 50n59, 64n27, 68n35, 68n39, 217n10; external, 256n10; ideal, 256n10; reality as it is, 69; thought *versus* thing, 258n14
recording society, 52, 234
recordings, 141, 234
referentiality, 67; referential notions of experience, 296
reflective gaze, 290
relativism, 246
representation: categories of representation, 296–307 *passim*; embodied representation, 64; film, 21; knowledge as assemblage of accurate representations, 298n10; motor representation, 240–43; representation of self (biological), 205–12 *passim*; representational form, 44n32; representations as mental constructs, 98, 193; representative function of experience, 254n7; space of representation, 115; speech and sound, 158. *See also* analogy; body schema
repression, 297; return of repressed, 298
resistance, 296
resonance, 139, 154, 157, 158, 163; cyborg, 165; electrical, 157; spiders and, 183–84; unsound and, 163
Reverdy, Pierre, 216
reverse engineering, 187–93 *passim*; definition, 190
Rhythmus 21 (Richter), 44, *45*

Rhythmus 23 (Richter), 44, *45*
Richmann, Georg, 219
Richter, Hans, 20, 36, 38n13, 43, 43n27; "Badly Trained Soul," 42, 44; "Demonstration of the Materials," *40*; *Film und Foto* exhibition, 49n55; "Just No Eternal Truths," *40*; *Rhythmus 21*; *Rhythmus 23*; "The Badly Trained Soul," *45*; "The Film as an Original Art Form," 47
Riley, Denise, 302
Robertson, David, 158
Roche, François, *54*
Rodgers, Tara, 167
Roh, Franz, 35, 48
Rossi, Michael, 69, 118, 119
Rousseau, Jean-Jacques, 312
Roussel, Raymond, 216
Royce, Josiah, 255
Russell, Bertrand, 116; fourth dimension, 116n20
Russia: interface between film and psychology, 19n15
Ruttmann, Walter, 19, 23, 44n32; "Art and Film" essay, 21; film stills, *18*

S

Sagan, Carl, 76, 77n2
Saint-Simonism, 312
Sanders, George, 160n46
Saraceno, Tomás, 170, 171, 174, 319; *14 Billions*, *180*; *Galaxies Forming along Filaments, like Droplets along the Strands of a Spider's Web*, *172*; *Nephila* spider, *30*; *In Orbit*, *183*; *Social Strings*, *54*, 174–79; *On Space Time Foam*, *54*, 171–85, *181*; spiders, 29, 54; stereoscopic-photogrammetric images, *173*
Schachter-Singer theory of emotion, 147n22
Schiller, Friedrich von, 311, 311n2, 312
Schiller, Lawrence, *74*
Schlözer, Karl von: "The Romance of a Telegraph Wire," *164*
Schüll, Natasha, 28, 50, 194
Schumann, Friedrich, 27n38
Schwartz, Frederic J., 46n35
science: morality and, 119–25
Scott, Joan, 33, 50, 295
Sea=Dancer (Severini), *56*, 57, 63
See-through compass (Eliasson), cover, 52
Sehgal, Tino, 32, 52, 233–34; *On Experience*, 233–34; *This Variation*, 233
self, 28–29, 75, 299; biology of, 205–12; categories of identity and, 305; consciousness and, 84; embodied self, 29, 205–12; emotion and, 149; exoself, 197, 202; fourth-person self, 201; predictive coding model, 209–10; Quantified Self (QS), 196–203; self-awareness, 58; self-reflection, 299n11; technologies of the self, 195, 234; time-series self, 198; transgenerational memory, 207
Selz, Guyet, *221*

Selz, Jean, 221, *221*
sensationalism, 25
Sensebridge (company), 197
senses (human senses), 46, 58–60, 69, 212, 233, 263–66, 316, 322; denial of, 119, 124; as historically defined modalities, 69; knowledge production, 43, 69; sensation, 60–62; "sensings," 264–65; somatosensory, 62, 66, 211, 239; synesthesia, 68. See also *aisthesis;* common sense; human perception; projection; *specific senses*
sensitizing, 29, 32, 70, 163, 182, 315–23. See also aisthesis
sensorimotor processes, 62–63, 238–45 passim
Sensus Communis. See common sense
SETI (Search for Extra-terrestrial Intelligence), 184n13
Severini, Gino, 57–71 passim
 concepts: analogies, 60; apprehending phenomena, 64n28; artistic translation, 69n43; color, 65n32; conceptual range, 60; embodied representation, 64; embodiment *versus* supersensible interconnectivity, 67; Futurist radicalism, 60; human body, 63n23; irradiation, 65; lack of *telos*, 71; plasticity, 57n2; realism, 64; reality, 64n27, 68n35, 68n39, 69n43; referentiality, 67; religious art, 69n42; sensation, 60–62; speed, 60–62, 60n13
 works: autobiography, 59n10; *The Blue Dancer*, *62*, 63; exhibition catalogue essay, 57n2; *Muscular Dynamism*, *63*; *Sea=Dancer*, *56*, 57, 63; *Spherical Expansion of Light* series, 64–67
Severini, Jeanne, 58
sexuality, 55, 292, 295, 297, 301
Shelley, Mary, 24n32
Shelley, Percy Bysshe, 332n4
sign language, 160
signage, 22n24
signal, 151, 156–57; multiplexing, 157; processing, 159–61
Simmel, Marianne, 14–33 passim
simulation. see embodiment; modeling
Singer, Edward, Jr., 146
Sinha, Pawan, et al., 90
smell, 181, 222, 223
Smelling Zöllner Stripes (Höller), endpapers, 52
social cognition, 96, *108*, 109
social development, 312
social interaction: group dynamics, 181–82; spider web analogy, 180–85. See also actions
Social Strings (Saraceno), *54*, 174–79
somatosensory. See senses (human senses)
sound: aelectrosonic, 164; anthropology of, 165; articulation, *150*; electromagnetic paradigm, 156n26;

hearing color, 164; loudness, *150*; noise, 67, 133, 134, 136–37, 144, *157*, 158, 165; pitch, *150*, 153, 153n13; pitch compared to visible spectrum, 80–81; signal analysis, 156n28; signal processing, 159n41; sonic properties of webs, 173; sound waves, 6, 167; timbre, 155n18; transducing and transduction, 163–67; vibrations, 152n6, 173, 184. See also acoustics; resonance
sound art, 140
Southgate, Victoria, *190*
space, 68n39; dimensions of (see dimension); ether of space, 62n20; geometric *versus* representational, 115; higher, 116; hyperspace, 68, 77, 79; space-time, 30, 319
space poems (Green), 279–87; *Space Poem #3*, *278*
spectrum: electromagnetic spectrum, *81*; pitch compared to visible spectrum, 81; visible spectrum, 81, 99–100
speech: articulation, 154, *157*, 161n50; modulation, 151–61, *157*; pitch control, *150*; pronunciation, 153n14; representation, 158; resonance, 154; speech curve, *150*; speech symbols, *150*; stuttering, 137; transmission, 151–61; Visible Speech symbols, 152; Visible Speech word pictures, 153n14; voice, 151; vowels, 155n19
speed, 60–62, 60n13
Spencer, Herbert, 258n14
Spherical Expansion of Light (Severini), 64–68 passim, 64n30, *65*, *66*
spherical expansion theory, 64n30, 66, 68
spider webs, *170–73*, *174–79*; black widow web, 172; orb webs, 171; resonance, 183–84; sonic properties of webs, 173; three-dimensional webs, 171–85; vibrations of webs, 173, 184
spiders, 29, 54, 171–85, 172n1, *185*; experiments, 173n3, 180n6; orb spiders, 171, 173n3
spirit, 47, 59, 63, 63n24, 70, 71, 145, 249, 252, 261
Squarzoni, Philippe, *317*; *Climate Changed*, *317*, 320
Stansell, Christine, 302
stasis, 272–73
Stein, Gertrude: landscape theater poetics, 145n14
Steingart, Alma, 30, 69, 110, 111
Stone, Sasha, 46n35
stress, 208
Struth, Tomas: *Pergamon Museum 4, Berlin*, *240*
subject, the, 290, 296–307, 297; agency and, 304; construction of, 299; corporeal interrelation (subject and world), 62n21; desubjectivation, 290; object trajectory, 316; subject

position, 301, 304; subject-object dyad, 316
subjectivity, 22, 35, 37, 48n49, 50, 57, 58n5, 117, 119, 203, 211, 256, 256n12; female, 302; intersubjectivity, 239, 242; questions to ask about, 305–6
Suchman, Lucy, 203
supersensible data, 64, 67–68
Suprematism, 35
surveillance monitoring. *See* tracking
suspension of disbelief, 244
Swan, Melanie, 201
Swett, Lucy, 160n46

T

tactile sense, 67, 115, 152, *155*, 163, 239–40, 263–66
technology, 7; affect and, 37, 143–49; as mediation, 8, 46, 50, 182; technological change, 9, 34–39, 60, 151–52; understanding and, 225–29. *See also specific technologies*
telecommunication, 222; telephone, 156
telegraphy, 157, 161n51, 165n4
Tenenbaum, Josh, 24, 24n31, 186, *191*
Tepco, 326n1
tesseract, 84, *110*, 116
tetrachromats, 30, 81, 81n4, 84
The Hidden Dimension (Hall), 181
Thematic Apperception Test, 17, 146
theories of mind, 193
thermal ink. *See* See-through compass
Thomas the Apostle (Doubting Thomas), 330n3
Thompson, E. P., 300; *Making of the English Working Class*, 300
Thoreau, Henry David, 163
time, 68n39, 79; space-time, 30, 319
Titchener, Edward, 125
Toews, John, 302–3
Tomkins, Silvan, 69, 143–49, 147n22; *Affect Imagery Consciousness*, 146
Tomkins-Horn Picture Arrangement Test, 146
tools. *See* art ("strange tools")
topology. *See* Klein Bottle
tracking, 195–203; applications, 198–201; breathing patterns during information work, *201*; control societies, 195; data exhaust, 202; ethics, 203; feedback loops, 201
Tractatus Logico-Philosophicus (Wittgenstein), 112
transcendental ego, 249
transducing and transduction, 156, 163–67; as active process, 165; sonic energy, 166–67; transductive anthropology, 166n8
transformation, 292, 310
Transmission Systems for Communications (AT&T), 158
trichromacy, 81, *83*, 89, 92, *118*, 121, 123, 125
Triumph 830 Wobbulator oscillograph machine, 167, *167*
Trombadori, Duccio, 289
Trumball, George, 251n5
truth, 290, 291; external *versus* internal, 297, 298–99; *versus* fiction, 291; history and, 295
Tudor, David, 135, 136
tuned circuits, 157, 158
Turning, Alan, 205
Tyndall, John, 220
typography. *See* print (medium)
Tzara, Tristan: "Photography from the Verso," 48

U

Uchill, Rebecca, 6, 34, 35
Uexküll, Jakob von, 25
Umwelt, 25, 29, 33
unconscious, 206, 211, 245n24. *See also* consciousness
understanding, 225–29; comprehending, 16; concepts, 228; context, 229; purposiveness, 227
unifying aspect of, 301
United Nations Framework Convention on Climate Change, *314*, 315

V

Vallet, Olivier, 321n12
Van Doesburg, Theo: *Aesthetic transfiguration of an object, 21*; "On Elemental Form-Creation," 37
Varella, Kimberly, 55
Varèse, Edgard, 140
Varieties of Presence (Noë), 225
Vertov, Dziga, 19n15, 311, 311n3; Kino-Eye, 311n3; *Man with a Movie Camera* (Vertov), 311n3
vestibular system, 210
Vetterli, Martin, 159n41
"Views of the Tessaract [sic]" (Hinton), *110*
Vine, Allyn, 165
Viseu, Ana, 203
visible spectrum, 67, 81, *81*, 99–100; compared to pitch, 81
vision, 263–66, 296n4; binocular, 115; blind spot, 25n34, 196; color-blind vision, 122; computer algorithms, 193; definition, 295; environmental perspective, 25n34; haptic vision, 246; models of, 98; multimodality of, 239; night vision, 119, 122; peripheral vision, 30, 244; physiology of, 120; seeing through imagination, 98; studies of, 239n2; understanding through color, 88–109; visual imperialism, 239–42. *See also* color; embodiment (embodied simulation)
visual neuroscience, 87–109
visual processing, 87–109; bottom up vs. top down, 98–99; parallel, 97; serial, 97
vocoder, 159
voice, 151. *See also* speech

W

Wagner, Karl Willy, 158
Waiting for Gaïa (Latour), 325–36
Wallace, David Foster, 113; *Consider the Lobster*, 113; private language, 113n10
Warring Triangles. *See* "Heider-Simmel" film (1943)
Watson, Thomas A., 156, 164
waveform, 167
Weaver, Rufus Benjamin, 14–16, *17*
Webb, Stephen: *If the Universe Is Teeming with Aliens . . . Where Is Everybody?*, 184
webs. *See* spider webs
Weimar Republic, 20, 35, 44n32
Weiss, Paul, 159
Wertheimer, Max, 19, 24, 24n31, 25n34
Wesleyan College, 140
Wheatstone, Charles, 154
Wiener, Norbert, 146, 164
Wiesel, Torsten, 87
Wilke, Tobias, 46
Williams, Raymond, 151, 298; *Keywords: A Vocabulary of Culture and Society*, 298; structures of feeling, 300n19
Winckelmann, Joachim, 311
Witt, Peter N., 173n3
Wittgenstein, Ludwig, 112; perspicuous overview, 226; *Tractatus Logico-Philosophicus*, 112
Wittgenstein Ludwig, 112n4; solipsism, 113n10; two types of knowledge, 112n7
Wittje, Roland, 156–57, 156n26
Wolf, Gary, 196
Woolgar, Steven, 167
working class, 300–301, 312
Worringer, Wilhelm, 44n32
writing process, 269; Walter Benjamin and, 47, 49, 229; books of method, 289; definition, 295; exploratory books, 289; Renée Green and, 51
Wundt, Wilhelm, 22

Y

Young, La Monte, 166

Z

Zeki, Semir, 237
Zeliger, Leslie, 203
Ziporyn, Evan, 9, 134, 139, 141
Zola, Emile, 64n26
Zöllner illusion. *See Smelling Zöllner Stripes* (Höller)
zone theories of color, 125
Zweckmässigkeit: 227n3

CREDITS AND PERMISSIONS

Höller, Endpapers *Smelling Zöllner Stripes*, 2015; the artist extends his thanks to Saygel & Schreiber, Berlin.

Jones, Fig. 1 Courtesy Harvard University Collection of Historical Scientific Instruments and Harvard Film Archive, Harvard College Library.

Jones, Fig. 3 All images courtesy Michael Cowan (also see Jones, note 19).

Jones, Fig. 4 Courtesy MIT Libraries, Cambridge MA.

Jones, Figs. 5 and 6 Courtesy Harvard Collection of Historical Scientific Instruments, Harvard University Archives.

Jones, Fig. 9 Courtesy of Olfaur Eliasson; neugerriemschneider, Berlin; Tanya Bonakdar Gallery, New York. Photographer Iwan Baan.

Jones, Fig. 10 Works depicted are © Studio Tomás Saraceno, 2015.

Jones, Fig. 11 © Tauba Auerbach, courtesy Paula Cooper Gallery.

Jones, Fig. 12 Photograph by David Bornstein.

Uchill, Fig. 1 Courtesy Getty Research Institute, Los Angeles (87-S1338). © Hans Richter Estate.

Uchill, Figs. 2 and 3 Courtesy Getty Research Institute, Los Angeles (87-S1338). © Hans Richter Estate; El Lissitzky: © 2015 Artists Rights Society (ARS), New York; © 2015 Artists Rights Society (ARS), New York/ADAGP, Paris and © 2015 Artists Rights Society (ARS), New York/VG Bild-Kunst Bonn.

Uchill, Fig. 4 Courtesy Getty Research Institute, Los Angeles (87-S1338). © Hans Richter Estate.

Uchill, Fig. 6 Courtesy of Carsten Höller, François Roche, and Tinguely Museum, Basel; Air de Paris, Paris. Photograph by Bettina Matthiessen.

Mather, Fig. 1 © 2015 Artists Rights Society (ARS).

Mather, Fig. 2 © De Agostini Picture Library I Art Resource, NY. Photo M. E. Smith.

Mather, Fig. 3 De Agostini Picture Library I G. Nimatallah I Bridgeman Images I Art Resource, NY. © 2015 Artists Rights Society (ARS), NY I SIAE, Rome.

Mather, Fig. 4 © The Museum of Modern Art I Licensed by SCALA I Art Resource, NY.

Mather Fig. 5 De Agostini Picture Library I Bridgeman Images. © 2015 Artists Rights Society (ARS), NY I ADAGP, Paris.

Mather, Fig. 6 Courtesy of Munson-Williams-Proctor Arts Institute, NY. Gino Severini: © 2015 Artists Rights Society (ARS), NY.

Auerbach, Fig. 1 © Lawrence Schiller.

Auerbach, Fig. 5A Drawn by Heidi Erickson, after Arne Valberg, *Light Vision Color*, 2005.

Auerbach, Fig. 5B From Rolf G. Kuehni and Andreas Schwarz, *Color Ordered: A Survey of Color Systems from Antiquity to the Present*, 2008, page 351.

Auerbach, Fig. 7 Binding co-designed by Daniel E. Kelm and Tauba Auerbach, bound by Daniel E. Kelm assisted by Leah Hughes at the Wide Awake Garage. Photograph Vegard Kleven.

Auerbach, Fig. 9 Courtesy Munsell Color Foundation.

Auerbach, Fig. 10A Wikimedia (unrestricted use).

Auerbach, Fig. 10B From Rolf G. Kuehni and Andreas Schwarz, *Color Ordered: A Survey of Color Systems from Antiquity to the Present*, 2008, page 287.

Auerbach, Fig. 12 Courtesy Standard (Oslo). Photograph by Vegard Kleven.

Conway, Fig. 1 © Rosa Lafer-Sousa, 2015. Inspired by Richard L. Gregory, "Vision with Isoluminant Colour Contrast." (See Conway, note 4.)

Conway, Fig. 2 Reprinted from Biederman and Ju (1988). (See Conway, note 3.) With permission of Elsevier.

Conway, Fig. 5 Photograph by Tristan Savatier.

Conway, Fig. 7A © Bevil R. Conway, Katherine Hermann, and Rosa Lafer-Sousa, 2015.

Conway, Figs. 7B, 8B, 9–11 © Bevil R. Conway, 2015.

Steingart, Fig. 1 Courtesy Boston University Libraries.

Steingart, Fig. 2 From Raymond Louis Wilder Papers, 1914–1982, Archives of American Mathematics, Dolph Briscoe Center for American History, University of Texas at Austin. box 3.5/86-36/1, folder 3 "General Correspondence F."

Steingart, Fig. 3 Courtesy of Christian Faur.

Rossi, Figs. 1 and 2 Originally printed in Christine Ladd-Franklin, *Colour and Colour Theories* (London: Kegan Paul, Trench, Trubner & Co., © 1929). Reproduced by permission of Taylor & Francis Books UK.

Lucier, p. 129–33 *Closed Book* (2015), first published in this volume. Scores to works by Alvin Lucier are published by Material Press and © Alvin Lucier (BMI) and Material Press, Frankfurt (GEMA). Used by permission.

Frank, Fig. 1A Photograph by Philip Makanna. Courtesy Lovely Music.

Frank, Fig. 1B Video by Philip Makanna. Courtesy Lovely Music.

Mills, Fig. 1 Alexander Graham Bell Family Papers, Courtesy of Library of Congress, Washington, DC.

Mills, Fig. 2 Collection of Mara Mills.

Mills, Fig 3 Courtesy MIT Libraries.

Helmreich, Fig. 4 Photograph courtesy Richard Sears.

Saraceno, Fig. 1A © Max Planck Institute, 2005.

Saraceno, Fig. 1B © Max Planck Institute, 2005. Courtesy Volker Springel and the Virgo Consortium.

Saraceno, Fig. 2 With the support of Fondazione Garrone, Genoa, and Fondazione Sambuca, Palermo. Special thanks to Pinksummer Contemporary Art, Genoa. Photograph © Alessandro Coco, 2009.

Saraceno, Fig. 3 © Studio Tomás Saraceno, 2010.

CREDITS AND PERMISSIONS

Saraceno, pp. 174–79 *Social Strings,* 2015. © Tomás Saraceno, 2015.

Saraceno, pp. 174–75 *Solitary, semi social mapping of TNJ0924-2201 by one Nephila clavipes-one week, three Cyrtophora citricola, one week. Spidersilk, paper, glue, ink.* © Tomás Saraceno, 2015.

Saraceno, pp. 176–77 *Solitary, semi social mapping of BR2237-0607 LA2 by one Nephila clavipes-five weeks, two Cyrtophora citricola-two weeks, detail,* 2015. Spider silk, paper, glue, ink. © Tomás Saraceno, 2015.

Saraceno, pp. 178–79 *Solitary, semi social mapping of TNJ0924-2201 by one Nephila clavipes-one week, three Cyrtophora citricola, one week, detail,* 2015. Spider silk, paper, glue, ink. © Tomás Saraceno, 2015.

Saraceno, Fig. 4 Commissioned by Bonniers Konsthall, Stockholm, 2010. Courtesy Tomás Saraceno; Pinksummer Contemporary Art, Genoa; Tanya Bonakdar Gallery, New York; Andersen's Contemporary, Copenhagen. Installation © Tomás Saraceno, 2010. Photograph © Studio Tomás Saraceno.

Saraceno, Fig. 5 Drawn by Heidi Erickson.

Saraceno, Fig. 6 Courtesy HangarBicocca. Installation © Tomás Saraceno, 2012–2013. Photograph © Alessandro Coco.

Saraceno, Fig. 7 Courtesy Tomás Saraceno; Pinksummer Contemporary Art, Genoa; Tanya Bonakdar Gallery, New York; Andersen's Contemporary, Copenhagen; Esther Schipper Gallery, Berlin. © Tomás Saraceno, 2013.

Saraceno, Fig. 8 © Massachusetts Institute of Technology.

Tenenbaum, Fig. 1B Photograph by Jim Henderson.

Schüll, Fig. 1 Courtesy Mette Dyhrberg.

Kelly, Fig. 1 © Max Planck Institute for Infection Biology.

Kelly, Fig. 2 Courtesy Naomi Tjaden and Paul Trainor, Stowers Institute for Medical Research, Kansas City, MO.

Kahn, Fig. 1 Image from the Science Service Historical Images Collection, National Museum of American History, Smithsonian Institution, Washington, DC. Courtesy General Electric.

Kahn, Fig. 4 © Museum der Dinge-Werkbundarchiv, Berlin.

Kahn, Fig. 5 Courtesy Private Collection, The Stapleton Collection, and Bridgeman Images.

Gallese, Fig. 1 Courtesy Claire Denis and Pyramide International. © Pyramide International.

Gallese, Fig. 2 © Thomas Struth. Courtesy Marian Goodman Gallery, NY.

Husserl, pp. 263–66 Republished with permission of Kluwer Academic Publishers, Boston; from *Ideas Pertaining to a Pure Phenomenology and to a Phenomenological Philosophy: Second Book; Studies in the Phenomenology of Constitution* (1989); permission conveyed through Copyright Clearance Center, Inc.

Green, pp. 277–88 Banners reproduced in *Experience Process: Space Poems.* All images by Renée Green. Courtesy of Renée Green and Free Agent Media.

Green, p. 277 *The Live Creature,* from *Space Poem #1,* 2007. Double-sided banner, 32 × 42 in.

Green, p. 280 *I Am Still Alive,* from *Space Poem #1,* 2007. Double-sided banner, 32 × 42 in.

Green, p. 281 *"I" Am Still Alive,* from *Space Poem #1,* 2007. Double-sided banner, 32 × 42 in.

Green, p. 283 *The Experience of Freedom,* from *Space Poem #3 (Media Bicho),* 2012. Double-sided banner, 17.5 × 22 in.

Prisoner of Love, from *Space Poem #3 (Media Bicho),* 2012. Double-sided banner, 17.5 × 22 in.

After The Last Sky, from *Space Poem #3 (Media Bicho),* 2012. Double-sided banner, 17.5 × 22 in.

Terrible Honesty, from *Space Poem #3 (Media Bicho),* 2012. Double-sided banner, 17.5 × 22 in.

Green, pp. 284–85 *Discovery But A Fountain Without Source,* from *Space Poem #2 (Laura's Words),* 2009. Double-sided banner, 32 × 42 in.

Legend of Mist and Lost Patience, from *Space Poem #2 (Laura's Words),* 2009. Double-sided banner, 32 × 42 in.

The Body Swimming in Itself, from *Space Poem #2 (Laura's Words),* 2009. Double-sided banner, 32 × 42 in.

Green, pp. 284–85 (cont.)

Is Dissolution's Darling, from *Space Poem #2 (Laura's Words),* 2009. Double-sided banner, 32 × 42 in.

With Dripping Mouth It Speaks A Truth, from *Space Poem #2 (Laura's Words),* 2009. Double-sided banner, 32 × 42 in.

That Cannot Lie, In Words Not Born Yet, from *Space Poem #2 (Laura's Words),* 2009. Double-sided banner, 32 × 42 in.

Matteo Ricci, from *Space Poem #4,* 2013. Double-sided banner, 32 × 42 in.

Georges Polti, from *Space Poem #4,* 2013. Double-sided banner, 32 × 42 in.

Elvira Notari, from *Space Poem #4,* 2013. Double-sided banner, 32 × 42 in.

Pier Paolo Pasolini, from *Space Poem #4,* 2013. Double-sided banner, 32 × 42 in.

Lina Bo Bardi, from *Space Poem #4,* 2013. Double-sided banner, 32 × 42 in.

Félix Guattari, from *Space Poem #4,* 2013. Double-sided banner, 32 × 42 in.

Years, 1887–1896, from *Space Poem #5 (Years & Afters),* 2015. Double-sided banner, 17.5 × 22 in.

After I Am Dead Darling, from *Space Poem #5 (Years & Afters),* 2015. Double-sided banner, 17.5 × 22 in.

Years, 1897–1906, from *Space Poem #5 (Years & Afters),* 2015. Double-sided banner, 17.5 × 22 in.

After Melville, from *Space Poem #5 (Years & Afters),* 2015. Double-sided banner, 17.5 × 22 in.

Years, 1907–1916, from *Space Poem #5 (Years & Afters),* 2015. Double-sided banner, 17.5 × 22 in.

After Their Quarrel, from *Space Poem #5 (Years & Afters),* 2015. Double-sided banner, 17.5 × 22 in.

Green, p. 286 *A Chronicle of Social Experiments,* from *Space Poem #1,* 2007. Double-sided banner, 32 × 42 in.

Foucault, pp. 289–92 Excerpted from *Power: Essential Works of Foucault, 1954–1984.* © 1994 by Editions Gallimard. Compilation, introduction, and new translations © 2000 by The New Press. Reprinted by permission of The New Press. www.thenewpress.com.

Rancière, pp. 309–12 Excerpted and adapted from Jacques Rancière, "Prelude," originally published in *Aisthesis: Scenes from the Aesthetic Regime of Art* (London and New York: Verso, 2013), pp. ix–xvi. Reprinted by permission of Verso Books, UK.

Latour, Fig. 1 p. 314 Courtesy International Institute for Sustainable Development (IISD)/Earth Negotiations Bulletin.

Latour, Fig. 3 © Philippe Squarzoni and Abrams Books, 2014.

Latour, Figs. 4A and 4B Photograph by Paula Court. Courtesy The Kitchen, NY, Compagnie AccenT, Paris, and Soif Compagnie, Vaux sur Seine.

Latour, Fig. 1 p. 324 Photograph by David Bornstein. Courtesy Compagnie AccenT, Paris, and Soif Compagnie, Vaux sur Seine.

Eliasson, p. 352 Drawing for *See-through compass*, 2015. Courtesy of Olafur Eliasson.